45.00
Jan 24

NATIONAL GALLERY OF ART

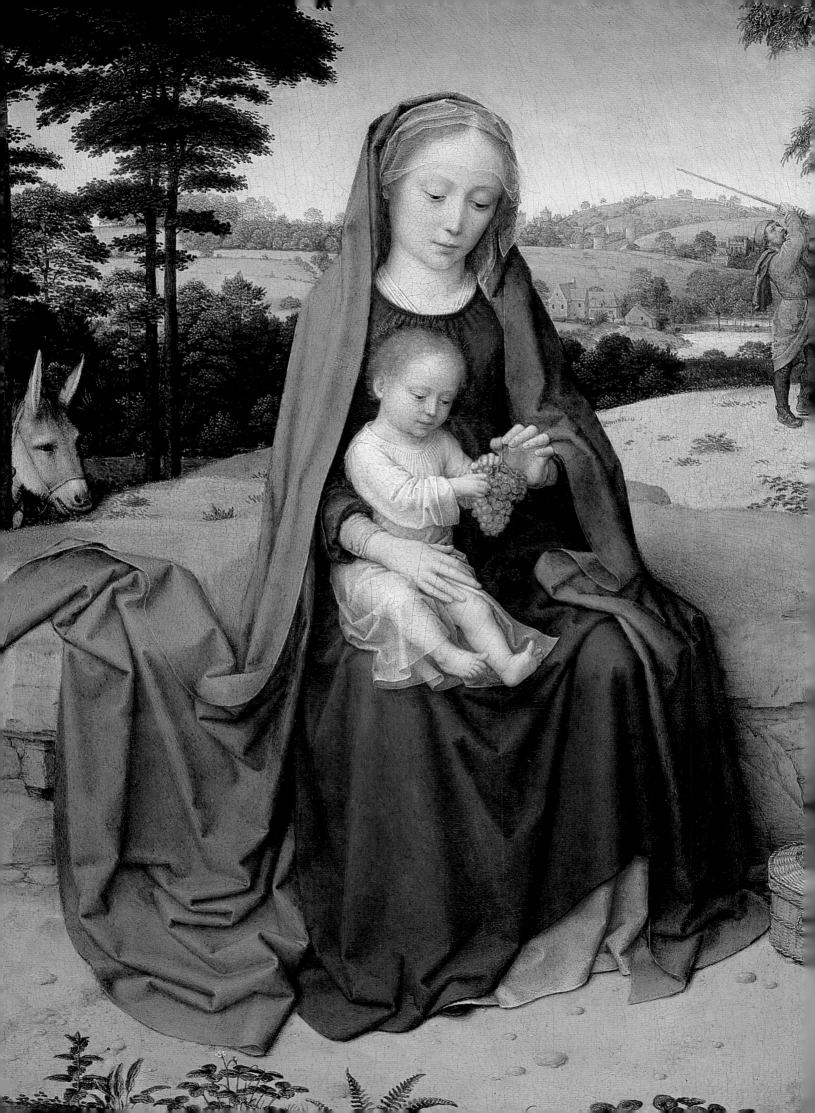

National Gallery *of* Art Master Paintings *from the* Collection

Selected and with commentaries by
John Oliver Hand
Curator of Northern Renaissance Paintings

Foreword by
Earl A. Powell III, *Director*

National Gallery of Art, Washington,
in association with
Harry N. Abrams, Inc., Publishers

Produced by the Publishing Office, National Gallery of Art, Washington

Editor in Chief, Judy Metro
Edited by Tam Curry Bryfogle
Designed by Margaret Bauer
with production assitance from Rio DeNaro, Mariah Shay, Amanda Sparrow, and Nancy van Meter

Typeset in Celeste and Cronos. Printed by Arnoldo Mondadori Editore in Verona, Italy, on Gardamatt, 150 gsm.

10 9 8 7 6 5 4 3 2 1

Details on pages:

ii: Gerard David, *The Rest on the Flight into Egypt* (no. 92)

vi: Paul Cézanne, *Boy in a Red Waistcoat* (no. 324)

xi: Francisco de Goya, *Señora Sabasa García* (no. 216)

2–3: Duccio di Buoninsegna, *The Nativity with the Prophets Isaiah and Ezekiel* (no. 2)

14–15: Rogier van der Weyden, *Saint George and the Dragon* (no. 31)

76–77: Albrecht Dürer, *Lot and His Daughters* (no. 111, reverse)

152–153: Juan van der Hamen y León, *Still Life with Sweets and Pottery* (no. 127)

232–233: Antoine Watteau, *Italian Comedians* (no. 214)

298–299: Joseph Mallord William Turner, *Keelmen Heaving in Coals by Moonlight* (no. 278)

402–403: Richard Diebenkorn, *Berkeley No. 52* (no. 378)

Unless otherwise noted, all photographs of works of art were taken by staff and contract photographers at the National Gallery of Art and are copyright © 2004 Board of Trustees, National Gallery of Art, Washington. Our grateful appreciation to Dean Beasom, supervisor of photography, and David Applegate, Ricardo Blanc, Rick Carafelli, Philip Charles, Lorene Emerson, Lee Ewing, Robert Grove, Lyle Peterzell, and Rob Shelley.

xii: West Building photograph © Dennis Brack / Black Star

Published in 2004 by the National Gallery of Art, Washington, in association with Harry N. Abrams, Incorporated, New York

National Gallery of Art
Sixth Street and Constitution Avenue NW, Washington, DC
Mailing address:
2000B South Club Drive
Landover, MD 20785
www.nga.gov

Harry N. Abrams, Inc.
100 Fifth Avenue
New York, NY 10011
www.abramsbooks.com
Abrams is a subsidiary of
La Martinière Groupe

Library of Congress
Cataloging-in-Publication Data

Hand, John Oliver, 1941–
National Gallery of Art: master paintings from the collection / selected and with commentaries by John Oliver Hand; foreword by Earl A. Powell III.

p. cm.

includes index.
ISBN 0-89468-321-7 (hardcover; alk. paper)
1. National Gallery of Art (U.S.) — Catalogs. 2. Painting — Washington (D.C.) — Catalogs. I. National Gallery of Art (U.S.) II. Title.

N856.H36 2004
750'.74'753 — dc22

2

14

13th and
14th Centuries

SCHOOLS
Italian

15th Century

SCHOOLS
Italian
Netherlandish
German
Hispano-Flemish
French

Contents

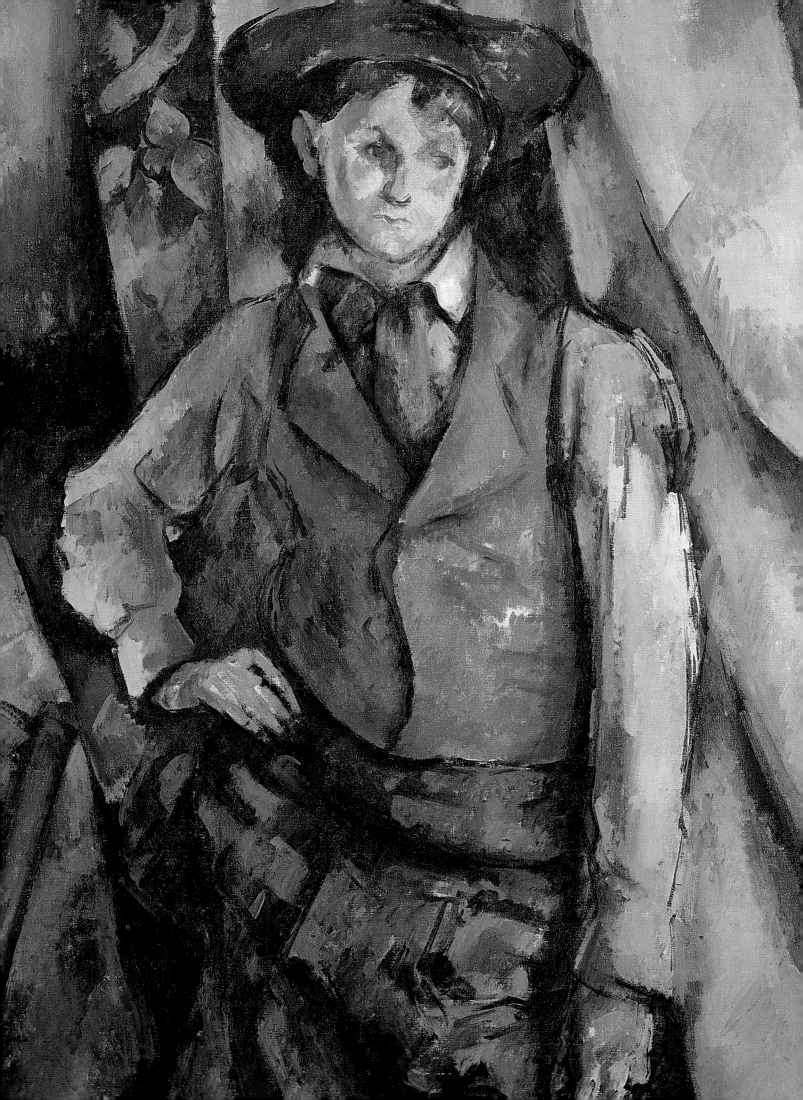

Director's Foreword

EARL A. POWELL III

• By any measure the National Gallery of Art, which opened to the public in 1941, is a young museum, with collections formed entirely in the twentieth and now twenty-first centuries. That the scope and quality of its holdings should rival those of the great national picture galleries of Europe is a testament to the commitment and democratic impulse of its founder, Andrew W. Mellon, and of all those benefactors who have joined and follow him still in presenting their gifts of art to the nation. The National Gallery is a "new" museum even within a North American context, its sister institutions—such as the Metropolitan Museum of Art in New York, the Museum of Fine Arts in Boston, the Art Institute of Chicago, the Philadelphia Museum of Art, and the National Gallery of Canada—having been founded in the nineteenth century. Elsewhere the Hermitage in St. Petersburg, the Alte Pinakothek in Munich, the Louvre in Paris, and the Prado in Madrid have benefited enormously from royal collecting over long periods of time. When one considers the massive and intense collecting of Catherine the Great, the expansive holdings acquired for the Pinakothek by the ducal family of Bavaria, or the succession of reigns reflected in the core of the Louvre's or the Prado's collections, one is struck by the realization that the National Gallery of Art's collection bears a patina that belies its youthful formation. In the course of just sixty or seventy years it has become one of the world's great repositories of European and American masterpieces.

What began with Andrew W. Mellon's collection of 121 old master paintings spanning the Byzantine era to the nineteenth century has become a collection of collections numbering more than one hundred thousand objects and extending nearly to the present day. Mellon's decision not to bestow his name on the gallery he built was perhaps a prescient gift, for it opened more doors to collectors wishing to add their works to "the nation's gallery of art" than would a museum named after its singular founder. Today the painting collection alone comprises more than three thousand works, acquired through

the generosity of many donors following in Andrew Mellon's footsteps—notable among them Samuel H. Kress, Joseph A. Widener, Chester Dale, Paul Mellon, Ailsa Mellon Bruce, John Hay Whitney, W. Averell Harriman, and Robert and Jane Meyerhoff.

Selecting roughly four hundred "master paintings" for this volume posed a challenge for our curatorial team, whose aim was not to provide a complete or necessarily balanced overview of the paintings in the National Gallery of Art but rather to present the high points of the collection as measured from the present moment in the history of art and taste. Certainly there are precedents at the National Gallery for this volume. In fact, since the early 1940s the Gallery has featured its finest works of art in a succession of books for the lay public, none more popular than John Walker's now classic *National Gallery of Art, Washington,* originally issued in 1975, then revised and enlarged in 1984 in response to the growth of the Gallery's collections. Selected and introduced by Walker, the National Gallery's first chief curator and second director, the volume was hailed in its time as a landmark that lent "a sense of order to the huge sprawl of art history." It was among the first of its genre—the lavishly illustrated museum publication addressed to a general audience—and became the impetus for an entire generation of books highlighting the collections of various museums around the world.

Walker's book was of course the model and inspiration for this new volume, but the collection has grown and become more comprehensive since 1984 as a result of several capital campaigns and a large number of private gifts. Understandably, the curators were eager to highlight the painting collection as it stands today, some twenty years later. In particular our modern and contemporary art collection has been the locus of marked growth during the past two decades, and we have built on strengths and filled lacunae in nearly every other area of the collection as well. The result, *National Gallery of Art: Master Paintings from the Collection,* is an entirely fresh perspective on seven centuries of painting—from Giotto's *Madonna and Child* to Anselm Kiefer's *Zim Zum*—housed in the paired buildings of the nation's art museum.

Readers will find here ninety masterworks acquired since 1984, either as gifts or purchased with funds donated for acquisitions. Among the new additions are major impressionist and post-impressionist paintings by Mary Cassatt, Paul Cézanne, Edgar Degas, Claude Monet, Henri de Toulouse-Lautrec, and Vincent van Gogh; and landmarks of twentieth-century art by Jasper Johns, Ellsworth Kelly, Roy Lichtenstein, Henri Matisse, Barnett Newman, Georgia O'Keeffe, and Mark Rothko. Other new acquisitions include works from the Renaissance through the nineteenth century, by such artists as Bernardo Bellotto, Albert Bierstadt, Jean-Baptiste-Camille Corot, Winslow Homer, Luis Meléndez, Jusepe de Ribera, John Singer Sargent, and Veronese.

These works join towering accomplishments from the core collections—by Sandro Botticelli, Jean Siméon Chardin, Francisco de Goya, El Greco, Leonardo da Vinci, Raphael, Rembrandt van Rijn, Peter Paul Rubens, Titian, Jan van Eyck, and Johannes Vermeer as well as by Edouard Manet, Pablo Picasso, and Jackson Pollock—to form a remarkable account of Western painting here in the nation's capital.

We are grateful to John Oliver Hand, curator of Northern Renaissance paintings, the pilot of this project, who made the initial selection of the works, fine-tuned the list with his curatorial colleagues, and composed the insightful picture commentaries that run throughout the book. The review process included many members of the curatorial staff, from deputy director and chief curator Alan Shestack and senior curators Philip Conisbee and Franklin Kelly to curators David Alan Brown, Jeffrey Weiss, and Arthur K. Wheelock Jr. and their staffs. Margaret Bauer, design manager, gave the book its beautiful form, and our editor in chief, Judy Metro, kept the project on course.

Although paintings are inarguably a principal component of the National Gallery of Art's collections, the museum houses rich holdings in sculpture, prints and drawings, photographs, and the decorative arts. It is our hope to follow this publication with one devoted to the highlights of our sculpture collection, and to move on perhaps to other aspects of the collection. For readers who wish a more comprehensive and scholarly look at our collections, we continue to produce our systematic catalogues (fifteen volumes have been published to date, with about as many to come), exhaustive studies of entire holdings in specific schools and time periods.

With this book we beckon a wider audience, some of whom may never visit Washington, D.C., others of whom are familiar friends here, all of whom we hope will be enlightened and inspired by these paintings.

Acknowledgments

JOHN OLIVER HAND

• This publication would not have been possible without the dedicated efforts of many talented people. I am indebted to the following colleagues on the curatorial staff of the National Gallery of Art, who reviewed and refined my selection of paintings, generously shared their expertise in answering my questions, and critically read my commentaries: Nancy Anderson, David Alan Brown, Deborah Chotner, Betsy Coman, Philip Conisbee, Leah Dickerman, Gretchen Hirschauer, Kimberly Jones, Franklin Kelly, Jeffrey Weiss, and Arthur K. Wheelock Jr. In addition my fellow curators graciously contributed their expertise and writing to the introductory text for this volume. I made extensive use of dossiers on individual paintings contained in the department of curatorial records, and I thank Nancy Yeide and Anne Halpern for their assistance.

The National Gallery's publishing office played an essential role in the creation of this book, and it is a pleasure to thank Judy Metro, editor in chief, Margaret Bauer, design manager, Chris Vogel, production manager, and publishing assistants Mariah Shay, Amanda Sparrow, and Rio DeNaro. Sara Sanders-Buell performed an invaluable service in assembling all of the required transparencies and photographs. It was a delight to work again with Tam Curry Bryfogle, now a freelance editor, whose eagle eye saved me from many an egregious error and who offered suggestions with grace and humor. Special thanks go to Elizabeth Concha, staff assistant for the department of Renaissance paintings, who cheerfully and patiently coped with my handwriting when entering text and revisions into the computer.

Throughout, Alan Shestack, deputy director and chief curator, kept a firm but fatherly eye on the project, offering support and suggestions. At critical junctures Earl A. Powell III, director, and Carol Kelley, deputy to the director, offered sage advice, while Ysabel Lightner and Don Henderson of the Gallery Shops brought their extensive experience to discussions of marketing and display.

Lastly, I would like to honor the memory of Frances Smyth, the Gallery's beloved editor in chief, who was a driving force at the inception of this project and who, I hope, would have been pleased with its outcome.

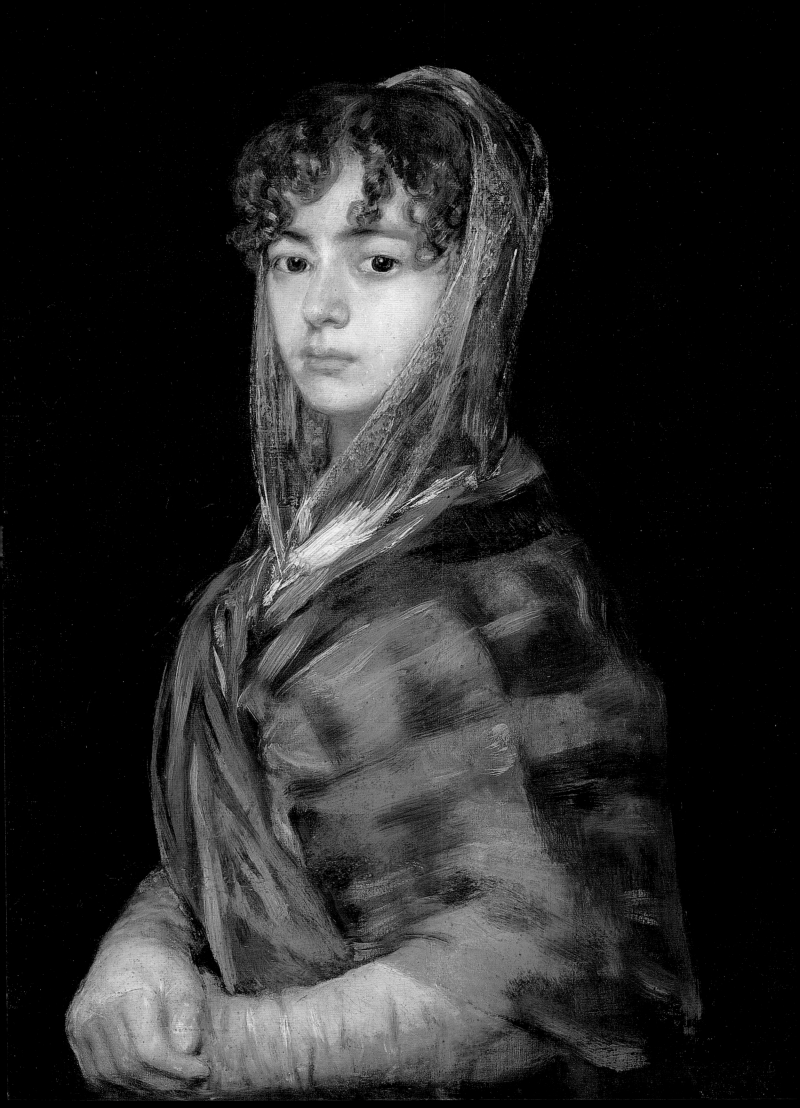

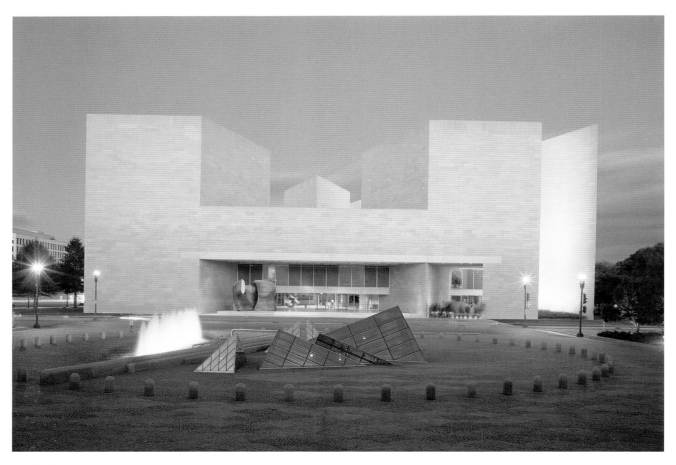

East Building

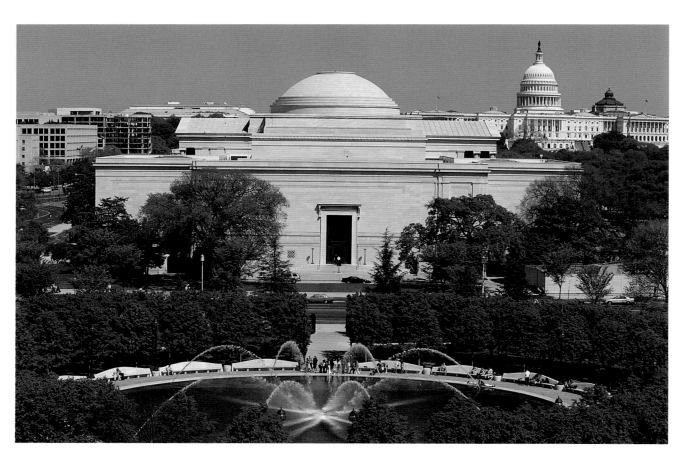

West Building with the Sculpture Garden fountain

The National Gallery of Art: The Sum of Its Collections

· When the National Gallery of Art was founded in 1937, it was modeled after
the National Gallery in London, which had opened its doors in 1824. The
museum in London began, like the National Gallery of Art, with the donation
of several private collections, but from the outset London's stated intention
was to build a collection that would illustrate the history of Western European
painting from the first stirrings of the Renaissance to modern times. Indeed,
after two centuries London has what is one of the most comprehensive collec-
tions of European paintings anywhere in the world.

The illustrious collection that began taking shape on this side of the
Atlantic more than a century later with Andrew W. Mellon's gift included
many of the canonical names in Western art, such as Raphael and Rembrandt,
El Greco and Johannes Vermeer, Francisco de Goya and Thomas Gainsborough,
and it inarguably set the standard of quality for future acquisitions at the
National Gallery of Art. As in London, the broad objective in Washington was
to present a survey of Western art from the Middle Ages to the present, but
rather than emphasizing historical comprehensiveness, Mellon and the found-
ing benefactors of the National Gallery of Art set as their goal the creation of a
collection of masterworks by the most renowned European and American artists.

That we have been able to maintain such high standards in augmenting
core collections rich with masterpieces is a tribute to a new generation of
donors and to the astuteness of our curatorial staff over the years. As the avail-
ability of master paintings declines and prices soar, the search for stellar works
of art becomes ever more challenging. To acquire paintings at the same level of
quality as our Rembrandts or our French impressionists often entails plumb-
ing areas of art history that have been overlooked or forgotten as well as areas
that were unknown to or out of favor with the original benefactors. Indeed, the
large and diverse permanent collection of the National Gallery of Art is fun-
damentally a collection of collections, shaped to some degree by the personal
tastes of its donors, who in turn were deeply influenced by contemporary canons
of taste. As we know, the canon itself is historically determined. It shifts and

expands with time, celebrating and carrying forward the reputation and work of some artists while leaving others to history, at times only to be overturned or reclaimed by a later generation.

The Joseph A. Widener and Samuel H. Kress collections, formed from the 1940s through the 1960s, had few nineteenth-century works but added true breadth in terms of the artists then considered to be the greatest in European art history, among them some of the preeminent masters of the Italian Renaissance: Sandro Botticelli, Giovanni Bellini, Raphael, and Titian. In this respect the Kress Collection, for example, bore the clear influence of art historian and connoisseur Bernard Berenson and his focus on Italian early and high Renaissance art. John Walker, the Gallery's first chief curator and later director, had studied with Berenson, while J. Carter Brown, the Gallery's director from 1969 until 1992, had as a young man paid homage at I Tatti, Berenson's home in the Florentine hills. Both directors shared Berenson's aversion to the eclecticism and emotionalism of Italian baroque art, and despite the tremendous development of Italian baroque studies during the Gallery's first fifty years—much of which was undertaken by American scholars—relatively few Italian baroque paintings were selected for the Gallery during that time. Academic scholarship modified the canon of seventeenth-century masters, adding the names of Caravaggio and Guido Reni to those of Rembrandt and Peter Paul Rubens, but it was not until the 1990s that the weighty tradition of Gallery taste shifted to include acquisitions in this area.

Although the Gallery's holdings in Italian Renaissance paintings are considered the finest and most comprehensive in America, adding to their number today is difficult, for the stream of available pictures has dwindled to a trickle and prices have risen accordingly. The Gallery is most fortunate, therefore, to have been able to turn to private donors for recent gifts of Cariani's *A Concert* and for Giulio Cesare Procaccini's emotional *Ecstasy of the Magdalen*. Both are splendid works by masters whose names would not have been familiar to our founders.

In 1963 the National Gallery of Art acquired the Chester Dale Collection, which was formed from the 1930s through the 1950s by financier Chester Dale with the advice of his wife Maud, an artist and critic. It is one of the great collections anywhere of French impressionist, post-impressionist, and School of Paris paintings, and it has been hugely augmented in more recent times by the collections of Mr. and Mrs. Paul Mellon, Ailsa Mellon Bruce, the John Hay Whitneys, and W. Averell Harriman. In these collections, built mainly since World War II, the influence of John Rewald was nearly as great as Berenson's had been for earlier generations. Rewald's monumental *History of Impressionism* (1946) established the scholarly basis for the powerful influence of his taste and connoisseurship, which he exercised through his personal advice to leading American collectors. In these ways Rewald played a considerable role in guiding American collecting taste. As a result the National Gallery of Art may

claim with pride iconic works by, among others, Mary Cassatt, Paul Cézanne, Edgar Degas, Edouard Manet, Claude Monet, Georges Seurat, and Henri de Toulouse-Lautrec.

In contrast, American museums founded in the nineteenth century, such as the Metropolitan Museum of Art, New York; the Museum of Fine Arts, Boston; and the Philadelphia Museum of Art, are rich in French academic art and works of Barbizon and realist landscape schools of nineteenth-century France, because that is what their founders collected prior to the fervor for impressionism that had taken hold among collectors by the 1930s. Thus, although the Gallery has wonderfully strong holdings in French impressionist art, we have only recently begun to redress an early lack of attention to the Barbizon School, most notably with the acquisition in 1995 of Constant Troyon's *Approaching Storm*.

Just as the vision for London's National Gallery proudly included British masterpieces in its extraordinary survey of paintings, so too was it Andrew Mellon's intention for American paintings to be displayed in Washington alongside masterworks from the European schools. Indeed, he acquired many important works by Gilbert Stuart, Thomas Sully, Albert Pinkham Ryder, and others that were among the dozen or so American paintings that entered the collection during the 1940s. Today the Gallery can boast one of the finest collections of American paintings in existence, numbering more than one thousand works and ranging from the eighteenth through the early twentieth century. Unlike the Gallery's holdings in other national schools, and notwithstanding Mellon's founding donation, this distinguished collection is not the result of one or more transformative gifts. Rather the collection has grown steadily over the years through generous gifts from many individuals and, especially in recent times, through purchase. The Avalon Fund and the Patrons' Permanent Fund have been used to acquire important works such as Rembrandt Peale's *Rubens Peale with a Geranium* and Winslow Homer's *Right and Left*, while generous monetary donations earmarked for American art have enabled the purchase of key works such as Albert Bierstadt's *Lake Lucerne*, William Michael Harnett's trompe-l'oeil masterpiece *The Old Violin*, Martin Johnson Heade's *Giant Magnolias on a Blue Velvet Cloth*, Sanford Gifford's *Siout, Egypt*, and John La Farge's extraordinary *The Last Valley—Paradise Rocks*. And the collection continues to be enriched by significant gifts, including such works as Raphaelle Peale's *A Dessert*, arguably that painter's single greatest achievement.

Art historical research in the last fifty years has greatly expanded our knowledge and understanding, and many artists and movements once overlooked are now recognized for their exemplary contributions. The Gallery's curators, fully cognizant of the strengths and needs of the collections in their care, are committed to exercising their knowledge and connoisseurship in identifying works for acquisition. In carrying out this commitment, the curators' perpetual guide is Andrew Mellon's own mandate to seek out the best art for the nation's gallery.

In Dutch and Flemish painting, for example, the Mellon and Widener collections created a wonderful core of paintings by some of the greatest masters of the seventeenth century, including Rembrandt, Frans Hals, Johannes Vermeer, and Anthony van Dyck. Neither of these collectors, however, was particularly interested in still-life painting, so this area was until now poorly represented at the Gallery. With recent acquisitions of paintings by Ambrosius Bosschaert the Elder, Osias Beert the Elder, Jan Brueghel the Elder, Willem Claesz Heda, and Jan van Huysum, the Gallery now possesses one of the finest collections of Dutch and Flemish still-life paintings in the world. Other acquisitions have likewise brought new dimensions to the collection: marine paintings, which range in type from the quiet activities of a scene along the Dutch coast in Simon de Vlieger's *Estuary at Dawn* to the dramatic storm-tossed ships in Ludolf Backhuysen's *Ships in Distress off a Rocky Coast*, low-life genre scenes, including Adriaen Brouwer's *Youth Making a Face*, and history paintings, most importantly Hendrik Goltzius' *The Fall of Man*. Among the other artists that did not fit into the canon of painters collected by Mellon and Widener was Johannes Verspronck, whose exuberant masterpiece *Andries Stilte as a Standard Bearer*, 1640, now hangs proudly together with portraits by his more famous Haarlem contemporary, Frans Hals.

We have recently strengthened our Italian baroque collection with works such as the resplendent *Triumph of Galatea*, c. 1650, by the Neapolitan Bernardo Cavallino, and *The Rebuke of Adam and Eve*, 1626, by Domenichino, a classicizing work. In landscape painting by Italian artists, the 1993 acquisition of *The Fortress of Königstein*, 1756–1758, by Bernardo Bellotto, brought us a true masterpiece by the itinerant Venetian painter working in Saxony. Fortifying the Gallery's holdings in Spanish art has been another important goal of late, and our acquisition in 2000 of Luis Meléndez' splendid *Still Life with Figs and Bread*, 1760s, not only adds new luster to the Spanish galleries but recognizes one of the greatest still-life painters of eighteenth-century Europe.

The Gallery has also recently turned to the landscape painters of the early nineteenth century. Our 1996 exhibition *In the Light of Italy: Corot and Early Open-Air Painting*, drew attention to the effects captured by artists painting outdoors in the conducive climate of Italy, several decades before the plein-air work of the impressionists. Among our new acquisitions in this area is one by a leader of the movement, Pierre-Henri de Valenciennes, whose *Study of Clouds over the Roman Campagna*, c. 1787, captures an evanescent moment outside the Eternal City, and André Giroux's view from his window in Rome depicting *Santa Trinità dei Monti in the Snow*. Jean-Baptiste-Camille Corot was the best known of these open-air painters, and the Gallery acquired in 2001 a masterpiece he made in Rome between 1825 and 1828, *The Island and Bridge of San Bartolomeo, Rome*.

The history of collecting modern and contemporary art at the National Gallery is much more recent than its pursuit of art predating 1900. Twentieth-century art first entered the collection in 1963 with the Chester Dale bequest, and it was only at that time that the museum lifted its early prohibition against acquiring works by living artists. Modern work in the Dale collection was largely devoted to the so-called School of Paris, including paintings by Pablo Picasso—among them the large and celebrated *Family of Saltimbanques* from 1905—Henri Matisse, Amedeo Modigliani, and André Derain.

Despite these pivotal works, however, collecting modern art at the National Gallery remained a fairly cautious enterprise until the opening of I. M. Pei's East Building in 1978. At that time the museum established a Collectors Committee, which was formed to commission large-scale works for the atrium of the new building. Instead of disbanding once it had realized this important goal, the Committee has become a critical force in the ongoing acquisition of modern and postwar art. Among its purchases included in this volume are definitive works by René Magritte and Richard Diebenkorn. With the understanding that the East Building signaled a new era in the museum's commitment to twentieth-century art, gifts and acquisitions were also actively pursued through other means.

An early emphasis was placed on European high modernism and American art of the abstract expressionist generation. During the 1970s and 1980s, for example, major modernist works by Piet Mondrian, Wassily Kandinsky, and Max Beckmann were added to the collection, along with a remarkable group of large, late "cut-out" pictures by Matisse. In the area of postwar art, acquisitions included landmark works by Jackson Pollock, Barnett Newman, Clyfford Still, and Mark Rothko, including over one hundred works on canvas by Rothko, which came to the museum as a gift from the artist's estate. During this time the generosity of private collectors has been an essential factor. Above all, gifts from Robert and Jane Meyerhoff have added substantially to the museum's holdings. Artists, too, have been important supporters: Roy Lichtenstein and Ellsworth Kelly, among others, have made generous gifts of their own work. More recently, the museum's ambitions have continued to advance along the historical timeline. While true contemporary art remains beyond its scope, new areas of interest include minimal, post-minimal, and conceptual art of the 1960s and 1970s, including works by Robert Ryman and Edward Ruscha.

As the twenty-first century advances, the historical reach of the collection will continue to expand. And as scholarship deepens our awareness and understanding of previously overlooked artists, artistic styles, or art forms, these will be sought out, as well, to fulfill the Gallery's commitment to provide the nation with a collection of the world's great art in all its richness and diversity. Meanwhile, the many beautiful reproductions that follow swing open the door to a national treasury of art at the century's turn.

Note to the Reader

• The organization of this book follows the general layout and curatorial staffing of the National Gallery of Art itself, with paintings presented according to historical periods and national "schools" or styles. Thus the publication opens with thirteenth- and fourteenth-century paintings from the Italian school and proceeds in roughly chronological order through subsequent centuries and styles up to the end of the nineteenth century, almost as if taking the reader on a tour of the galleries in the West Building. The modern and contemporary art, displayed primarily in the East Building, falls outside the rubric of national schools and embraces work from the start of the twentieth-century to the present. These divisions are not rigidly observed either in the book or in the galleries; instead they reflect curatorial and design judgments.

Occasionally an artist of one nationality is part of a different national school. For instance, Mary Cassatt, an American artist, is most closely identified with French impressionism; and Jusepe de Ribera, a Spaniard, is considered with the Italian seventeenth-century school.

The dimensions refer to the image size, not the framed work of art. Measurements are given in centimeters, followed by inches within parentheses. Height precedes width, unless otherwise specified.

Not all master paintings in the National Gallery's collections are on display in Washington at all times. Works may be on loan to other institutions for temporary exhibition or may be removed from the galleries for conservation or study purposes. This publication does present many of the best-loved masterpieces usually available for viewing at the National Gallery of Art.

The Web site of the National Gallery (*www.nga.gov*) also offers a wealth of information not only about the permanent collection but about special exhibitions and programs as well.

All works of art at the National Gallery of Art were either donated or purchased with private funds specifically designated for acquisitions. Although the federal government is responsible for the maintenance and basic operation of the Gallery, the acquisition of works continues to be supported entirely by the private sector.

CATALOGUE

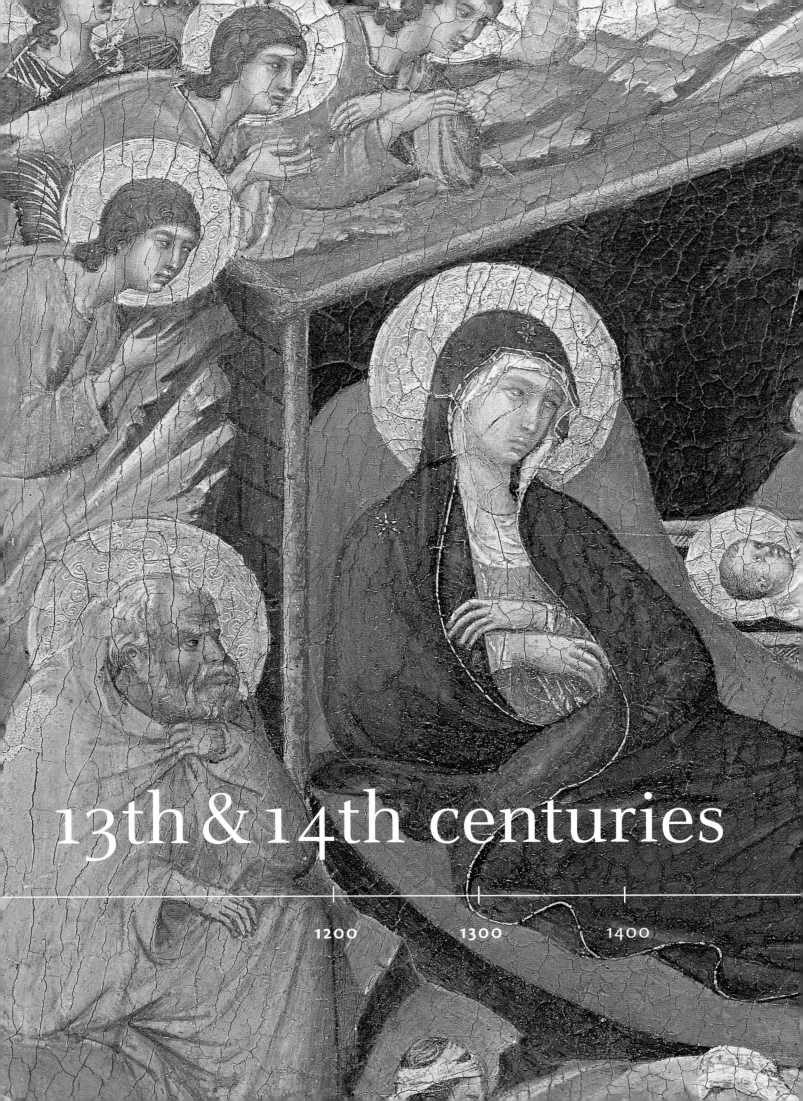

13th & 14th centuries

1200　　　　1300　　　　1400

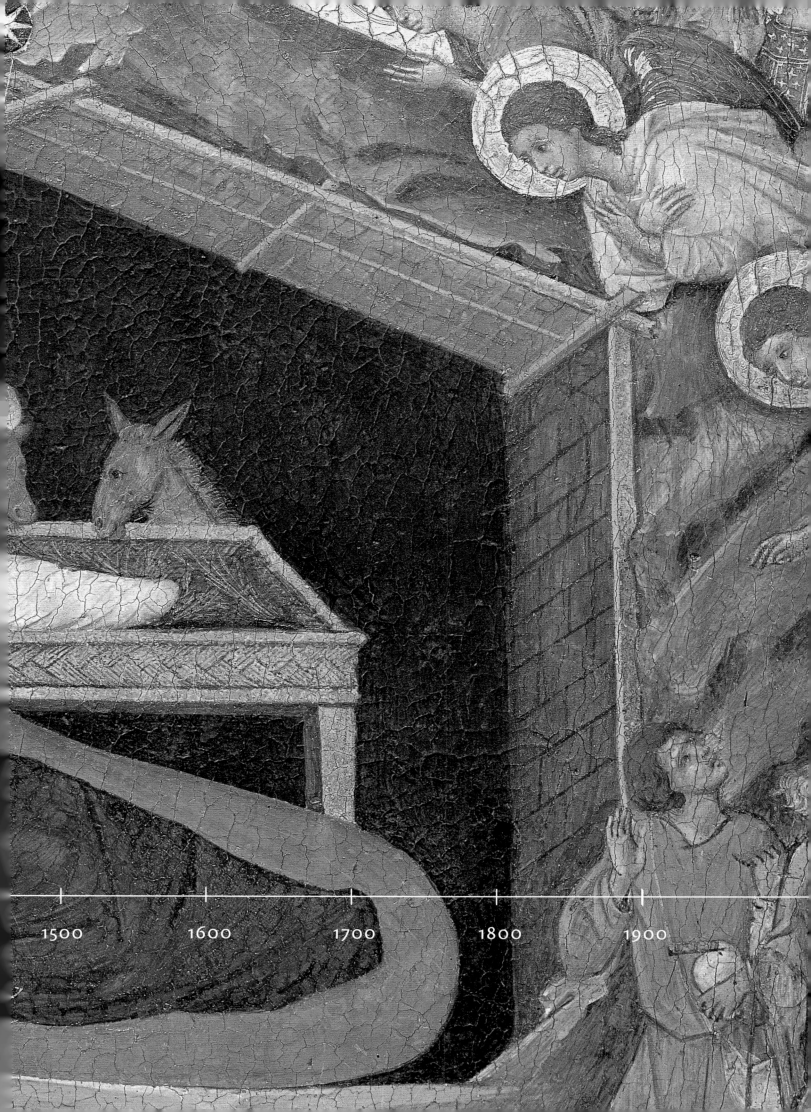

Enthroned Madonna and Child

• By virtue of its large size and excellent state of preservation, this is an outstanding example of an icon, or holy image. In terms of both subject matter and style, the panel belongs to the centuries-old tradition of Byzantine art produced for the Eastern Orthodox Church in eastern Europe and southwestern Asia. The Virgin, seated upon a massive throne, is represented as the Queen of Heaven. In gesturing with her right hand toward the Christ Child, she is also identified as a type of Madonna known in Greek as "Hodegetria": that is, one who points the way to Christ as savior of the world. The infant Christ raises his right hand in blessing and holds in his left hand a scroll of paper or parchment, a possible reference to the Word of God. In the upper corners of the panel are medallions containing archangels who hold orbs and scepters, symbols of both imperial and heavenly rule.

There is no sense of the physical bodies beneath the clothing of the Virgin and Christ Child in this painting. The Virgin's robes in particular have been reduced to a flat, nearly abstract pattern of blue cloth with gold highlights. It is only in the faces that one finds any attempt at suggesting volume through shading or modeling. Aided by the gold background, which denotes a celestial, otherworldly realm, the overall effect is formal and hieratic, yet filled with light and color, which emphasizes the regal status of the Madonna and Child.

Although the high quality and importance of the *Enthroned Madonna and Child* is universally recognized, there is no agreement as to where the picture was produced. Several scholars believe the painting comes from Tuscany—possibly Florence, Siena, or Pisa—based on the Christ Child's traditional Western gesture of blessing and the use of perspective in rendering the throne. Others maintain that the painting is the work of a Byzantine artist in Constantinople or possibly Cyprus. A third possibility is that it was produced in Constantinople for a Western patron, such as a Crusader ecclesiastic. If anything, the lively, ongoing debate demonstrates the widespread pervasive influence of the Byzantine style.

1

Byzantine 13th century
Enthroned Madonna and Child
13th century, tempera on panel
131.1 × 76.8 (51 ⅝ × 30 ¼)
Gift of Mrs. Otto H. Kahn
1949.7.1

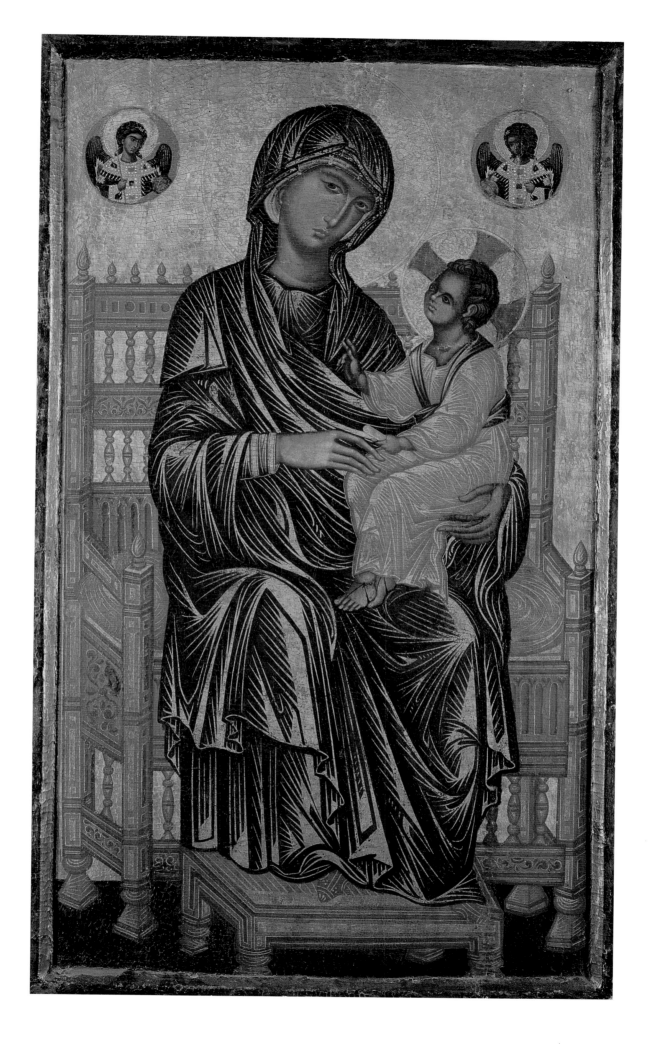

The Nativity with the Prophets Isaiah and Ezekiel

DUCCIO DI BUONINSEGNA

• In 1308 Duccio was commissioned to paint a very large altarpiece for the high altar of the cathedral of Siena. Known as the *Maestà*, the work was approximately fourteen feet wide and seventeen feet high and contained at least eighty-nine separate images on both front and back. On 9 June 1311 the city's shops were ordered closed, and the *Maestà*, accompanied by clergy and townspeople, was paraded through the streets and installed in the cathedral. In 1771 and again in 1878 the altarpiece was dismantled, and although most of it remains in the Museo dell'Opera del Duomo in Siena, ten sections made their way to England and the United States. The National Gallery of Art owns two sections from the predella at the base of the altarpiece.

The *Nativity* is a fascinating mixture of Byzantine and Western medieval conventions. Setting the event in a cave is a Byzantine device, as is the disproportionately large Virgin, who was also the patron saint and protectress of the city of Siena. The annunciation to the shepherds, seen at the right, the adoration of the newborn Child by the ox and the ass, and at bottom left, the Christ Child's first bath, all appear to happen at the same time. This is called "simultaneous narrative," and it was a technique used frequently by medieval artists. Duccio shares with other Gothic painters the ability to create elegantly stylized figures coupled with a keen observation of nature (the sheep, for example, are realistically depicted).

Flanking the central scene are standing figures of Old Testament prophets. On the left is Isaiah holding a scroll inscribed: "Behold, a young woman shall conceive and bear a son, and shall call his name Immanuel" (Isaiah 7:14). On the right is Ezekiel, whose scroll reads: "I saw a door in the house of the Lord that was closed, and no man went through it. The Lord only enters and goes through it" (variant of Ezekiel 44:2). Together these provide continuity between the Old and the New Testaments: Isaiah foretells the birth of Christ, while Ezekiel affirms Mary's virginity.

Duccio di Buoninsegna
(Sienese, c. 1255–1318)
The Nativity with the Prophets Isaiah and Ezekiel
1308/1311, tempera on panel
left section: 43.8 × 16.5 (17 ¼ × 6 ½)
center section: 43.8 × 44.4 (17 ¼ × 17 ½)
right section: 43.8 × 16.5 (17 ¼ × 6 ½)
Andrew W. Mellon Collection
1937.1.8 a–c

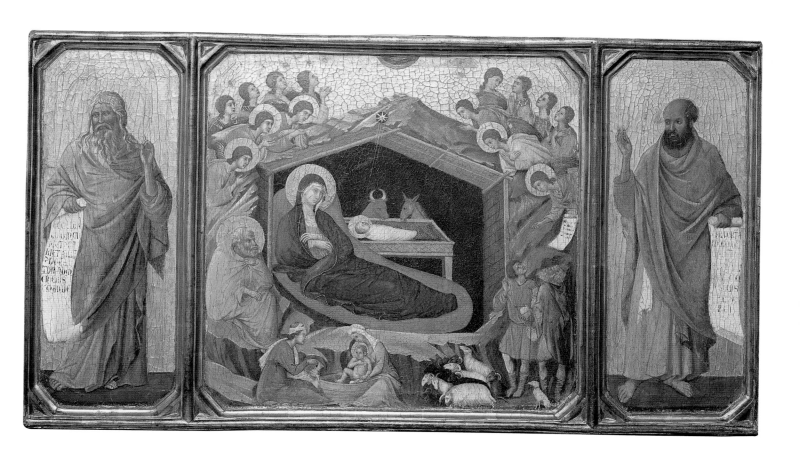

Madonna and Child

GIOTTO

• Giotto is a figure of singular importance in the history of art. During his lifetime he was praised by such writers as Dante, a fellow Florentine, as well as Petrarch and Boccaccio. His fame continued past his death. In the fifteenth century the autobiography of the artist Lorenzo Ghiberti contains a discussion and essentially a catalogue of Giotto's paintings and frescoes. For both his contemporaries and later generations Giotto was at once the revolutionary who broke free of the prevailing Italo-Byzantine style and the reviver of the classical tradition.

Giotto's accomplishment can been seen with the *Madonna and Child*, which was painted rather late in his career and is one of the very few works by him in the United States. His figures are massive and solid, and their bulk creates the effect of a nearly sculptural relief against the flat gold background. In contrast to the supernatural aloofness of the Byzantine tradition, Giotto here emphasized the humanity of the Virgin and Child. In a life-like gesture the Christ Child grasps his mother's finger with his left hand and reaches toward a white rose, a symbol of the Virgin's purity, with his other hand.

The *Madonna and Child* is not an isolated composition but was the center section of an altarpiece most likely painted for the church of Santa Croce in Florence. The other surviving components are *Saint Stephen* (now in the Horne Foundation, Florence) and *Saint John the Evangelist* and *Saint Lawrence* (both in the Abbaye royale de Châalis). A fifth panel is lost, but it may have depicted *Saint Francis*, patron of Santa Croce.

3

Giotto
(Florentine, probably 1266–1337)
Madonna and Child
probably 1320/1330, tempera on panel
85.5 × 62 (33 5/8 × 24 3/8)
Samuel H. Kress Collection
1939.1.256

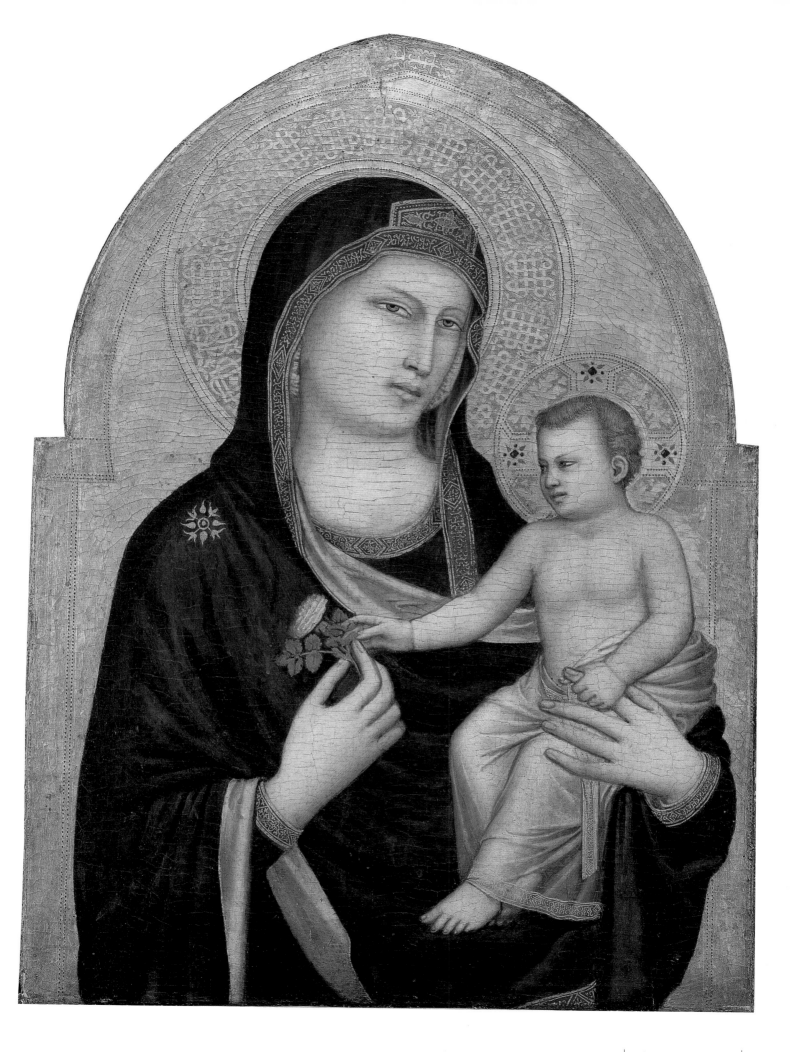

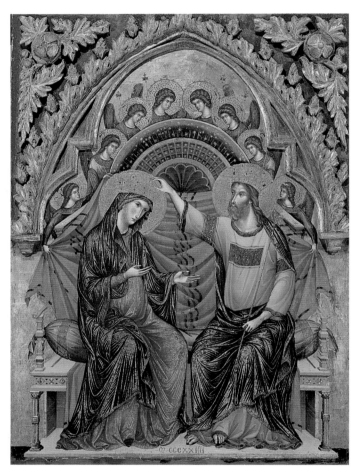

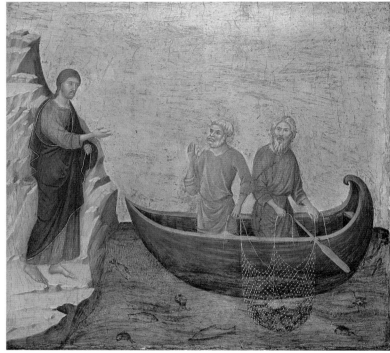

4

5

Paolo Veneziano
(Venetian, active 1333–1358/1362)
The Coronation of the Virgin
1324, tempera on panel
99.1 × 77.5 (39 × 30 ½)
Samuel H. Kress Collection
1952.5.87

Duccio di Buoninsegna
(Sienese, c. 1255–1318)
The Calling of the Apostles Peter and Andrew
1308/1311, tempera on panel
43.5 × 46 (17 ⅛ × 18 ⅛)
Samuel H. Kress Collection
1939.1.141

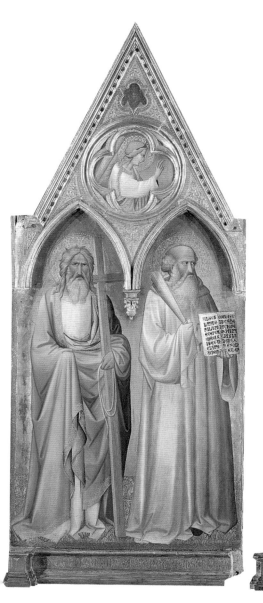
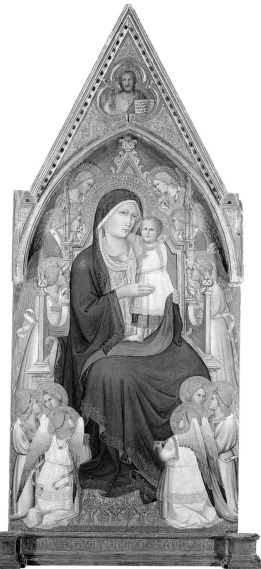
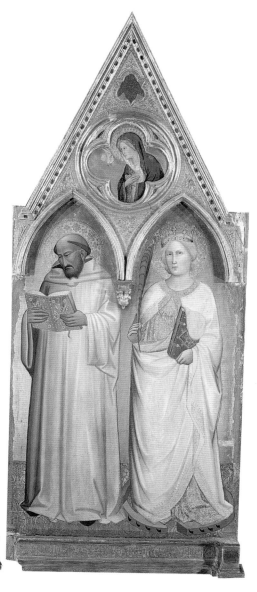

6

Agnolo Gaddi

(Florentine, active 1369–1396)

Madonna Enthroned with Saints and Angels

1380/1390, tempera on panel

left panel: 197.2 × 80 (77 ⅝ × 31 ½)

center panel: 203.8 × 80 (80 ¼ × 31 ½)

right panel: 194.6 × 80.6 (76 ⅝ × 31 ¾)

Andrew W. Mellon Collection

1937.1.4 a–c

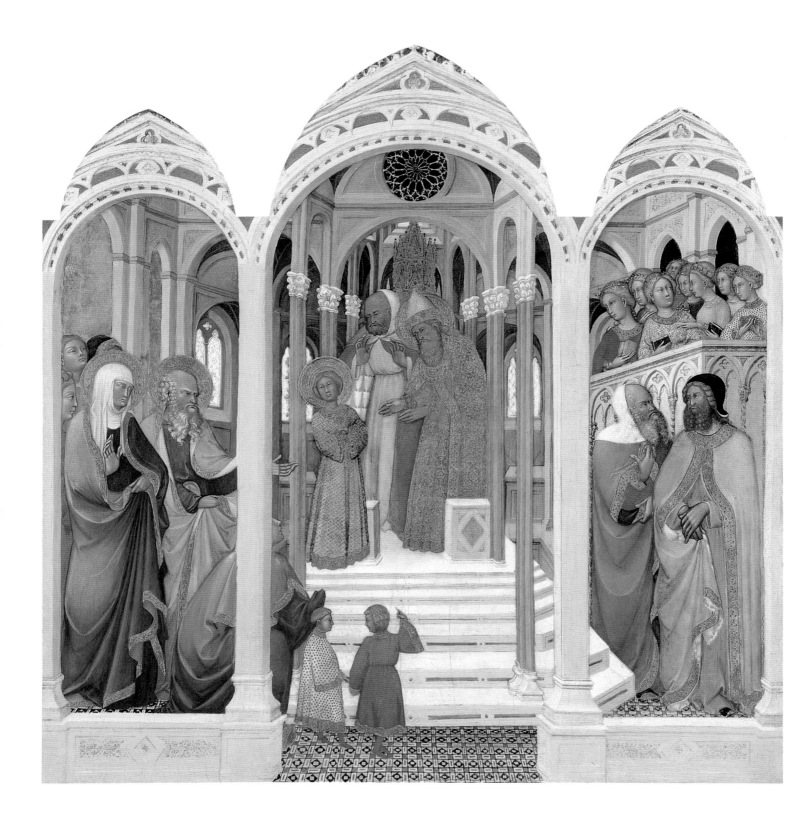

Paolo di Giovanni Fei
(Sienese, mentioned 1369–1411)
The Presentation of the Virgin
c. 1400, tempera on wood
transferred to hardboard
147.1 × 140.4 (57 ⅞ × 55 ¼)
Samuel H. Kress Collection
1961.9.4

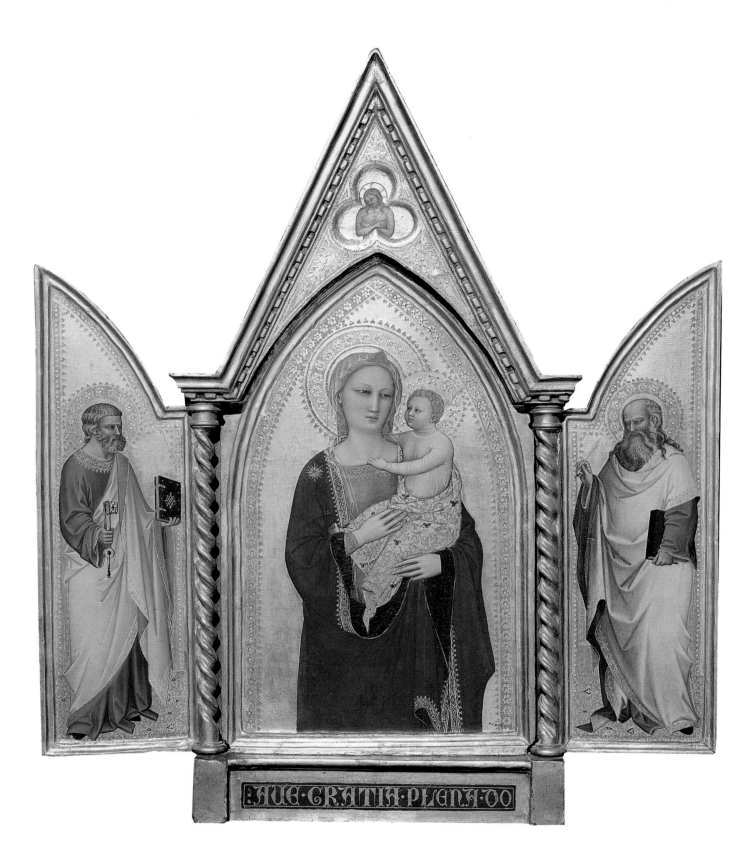

8

Nardo di Cione
(Florentine, active 1343–1365/1366)
*Madonna and Child with Saint Peter
and Saint John the Evangelist*
probably c. 1360, tempera on panel
left panel: 49.1 × 15.3 (19 ¼ × 6 ¼)
center panel: 76.7 × 34.9 (30 ¼ × 13 ¾)
right panel: 49.1 × 16.2 (19 ¼ × 6 ⅜)
Samuel H. Kress Collection
1939.1.261 a–c

15th century

1200 1300 1400

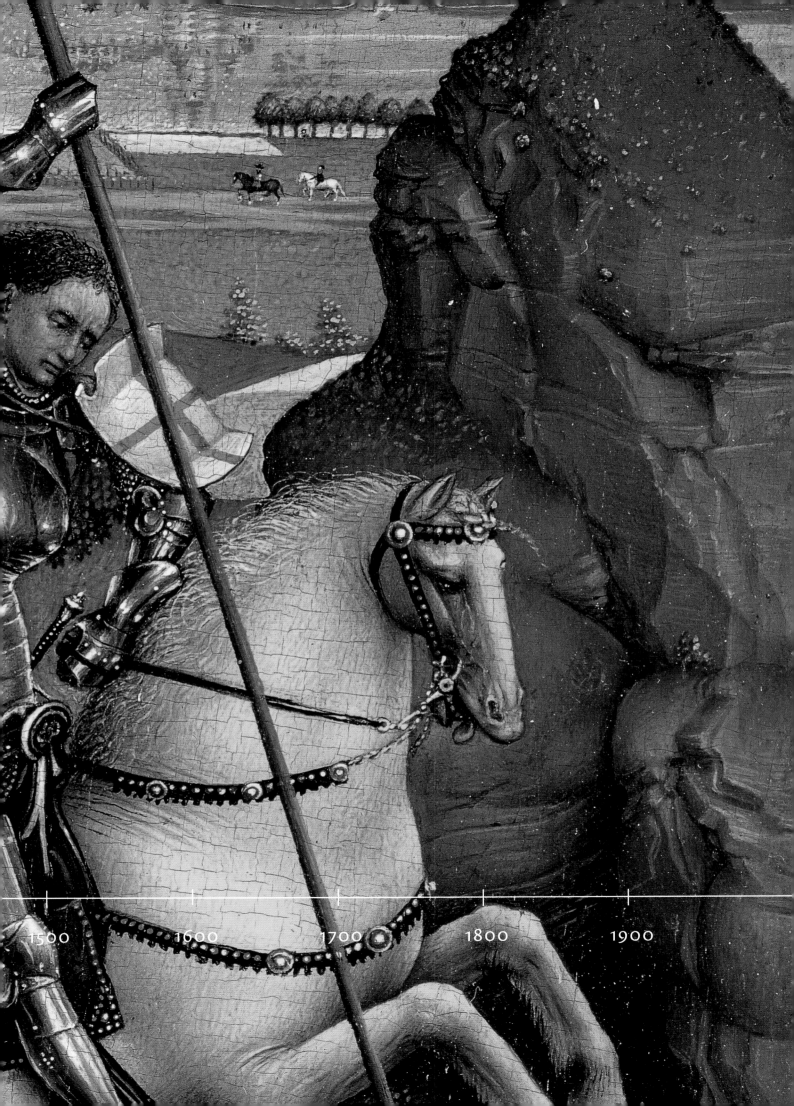

1500 1600 1700 1800 1900

The Youthful David

ANDREA DEL CASTAGNO

• Made of leather attached to a wooden form, this is a rare surviving example of a fifteenth-century parade shield. The fact that the image it bears was painted by a major Florentine artist makes it virtually unique. Although modeled on the type used to protect archers in battle, this shield was purely ceremonial in function and would have been carried through the streets on special occasions.

David, a hero of the Old Testament, is shown preparing to attack the giant Goliath; one of the "five smooth stones" chosen from the riverbed is in his sling and will soon be unleashed with deadly accuracy (1 Samuel 17:32–49). David's body is taut and muscular, expressing energy and determination. His pose, with widespread legs and upraised arm, may be derived from a Greek or Roman sculpture, although the exact prototype remains unknown. The outcome is already evident in the severed head of Goliath at the bottom of the composition, and the drama of the moment is heightened by the setting: a strong wind blows David's hair and clothing into agitated disarray and sends thin clouds streaming across the sky.

Although the circumstances of the commission are not known, the shield was almost certainly produced for a Florentine patron or institution. In the minds of its inhabitants, Florence was equated with the young David, for both triumphed over larger, more powerful adversaries through a combination of pride, independence, and intelligence. The same message is to be found in sculptures of David by Donatello and Michelangelo.

Andrea di Bartolo di Simone was called Andrea del Castagno after the village of his birth, Castagno d'Andrea, which is near Florence.

Andrea del Castagno
(Florentine, before 1419–1457)
The Youthful David
c. 1450, tempera on leather on wood
height: 115.5 (45 ½)
width at top: 76.5 (30 ⅛)
width at bottom: 40.6 (16)
Widener Collection
1942.9.8

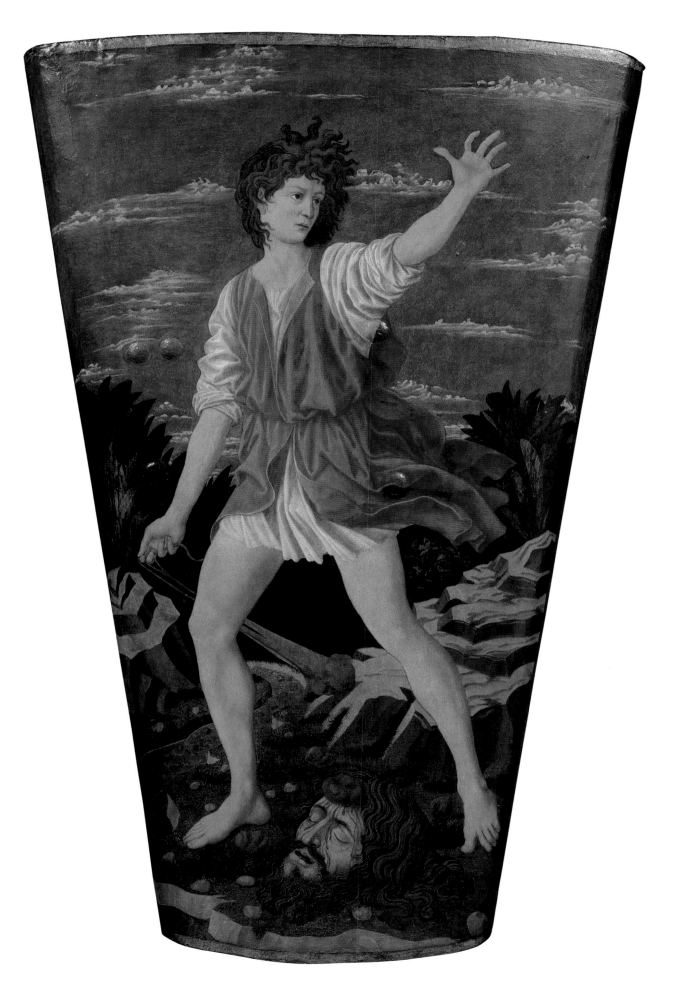

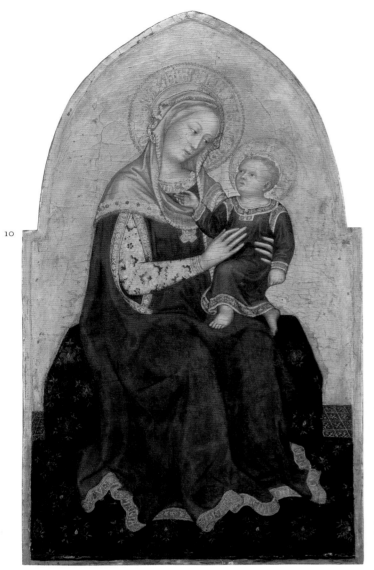

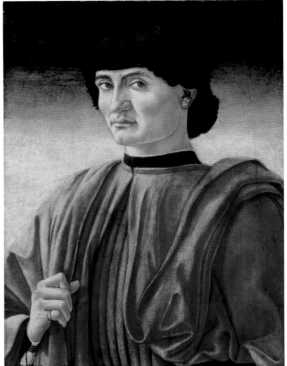

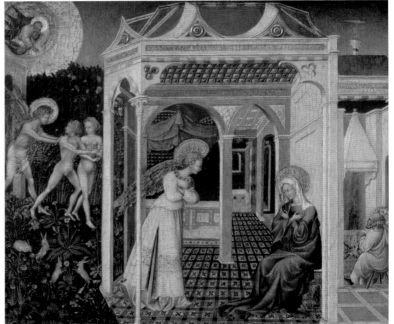

10

11

12

Gentile da Fabriano
(Umbrian, c. 1370–1427)
Madonna and Child
c. 1422, tempera on panel
95.7 × 56.5 (37 ⁵⁄₈ × 22 ¹⁄₄)
Samuel H. Kress Collection
1939.1.255

Andrea del Castagno
(Florentine, before 1419–1457)
Portrait of a Man
c. 1450, tempera on panel
54.2 × 40.4 (21 ³⁄₈ × 15 ⁷⁄₈)
Andrew W. Mellon Collection
1937.1.17

Giovanni di Paolo di Grazia
(Sienese, c. 1403–1482)
The Annunciation
c. 1445, tempera on panel
38.7 × 44.7 (15 ¹⁄₄ × 17 ⁵⁄₈)
Samuel H. Kress Collection
1939.1.223

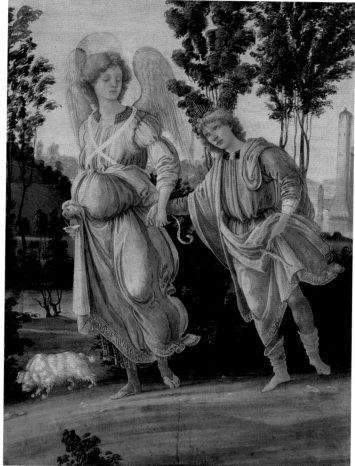

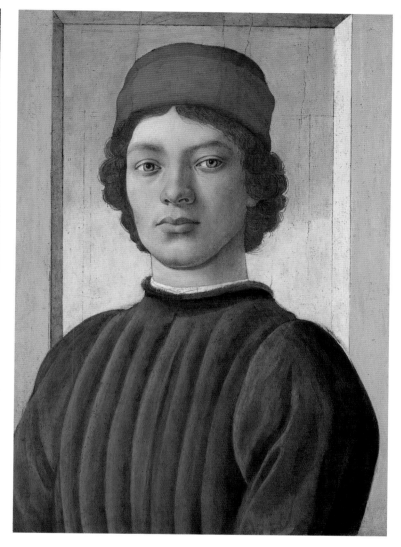

13

14

Filippino Lippi
(Florentine, 1457–1504)
Tobias and the Angel
probably c. 1480, oil and tempera (?) on panel
32.7 × 23.5 (12 ⅞ × 9 ¼)
Samuel H. Kress Collection
1939.1.229

Filippino Lippi
(Florentine, 1457–1504)
Portrait of a Youth
c. 1485, oil and tempera on panel
52.1 × 36.5 (20 ½ × 14 ⅜)
Andrew W. Mellon Collection
1937.1.20

The Adoration of the Magi

FRA ANGELICO AND FILIPPO LIPPI

• This circular panel, or tondo, is one of the most glorious paintings of the Italian Renaissance—and among the most complex and mysterious. In the foreground the three Magi offer gifts and kneel before the Christ Child, who sits on his mother's lap and raises his right hand in blessing. The arrival of the Magi symbolizes the recognition of Christ's divinity by the secular world, and it is celebrated on 6 January, the feast of the Epiphany. The Magi were especially venerated in Florence, and on this day, from the late Middle Ages onward, there were processions through the city. It is likely, therefore, that the contemporary viewer would find familiar the multitudes of people, clad in red, yellow, and blue, who are shown leaving their houses at the upper right and streaming in joyous profusion through the portal at the left. Although the star that guided the Magi is not depicted, its presence is clearly indicated by the bearded man in red at the left who gazes into the heavens and raises his arms in awe.

Certain elements in the paintings are easily interpreted. The oversized peacock perched on the shed is a well-known symbol of the Resurrection and eternal life. The juxtaposition of a ruined building with the simple if oddly distorted shed probably alludes to the replacement of pagan beliefs by Christianity that occurred with the Nativity. Other details, such as the young men clad only in loincloths who stand on the walls of the ruin, defy satisfactory explanation.

It has long been observed that more than one artist worked on the *Adoration of the Magi,* and it is generally agreed that two of the masters of Florentine painting in the early fifteenth century, Fra Angelico and Filippo Lippi, had a hand in its creation. The Magi, for example, were painted by Lippi, while the face of the Madonna is closer to the style of Fra Angelico. A lively debate continues among specialists regarding the date and sequence of the authorship. One hypothesis has the older artist, Fra Angelico, designing the composition and beginning to paint, when for an unknown reason, he abandoned the project. It was left to Filippo Lippi to complete the painting. It is possible that the *Adoration of the Magi* is the tondo listed in the inventory of Lorenzo de' Medici at the time of his death in 1492. If so, then it was most likely commissioned by a member of the Medici family, powerful patrons of the arts in Florence.

Fra Angelico and Filippo Lippi
(Florentine, c. 1395–1455; Florentine, c. 1406–1469)
The Adoration of the Magi
c. 1445, tempera on panel
diameter: 137.3 (54)
Samuel H. Kress Collection
1952.2.2

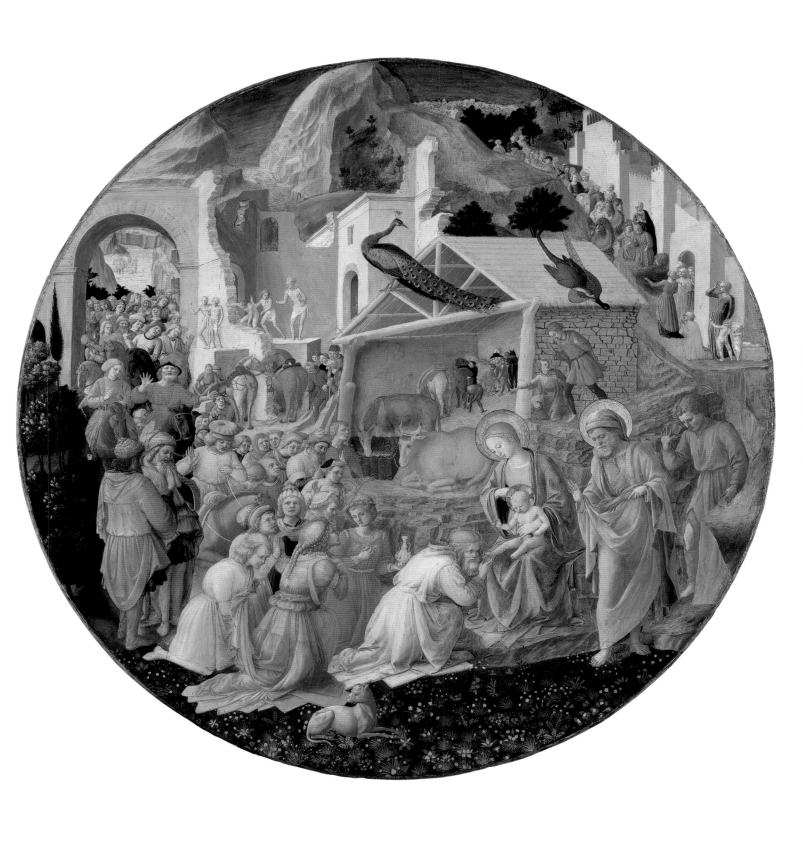

Saint John in the Desert

DOMENICO VENEZIANO

• John the Baptist was at once the last prophet of the Old Testament and, because of his beheading, the first martyr of the Christian faith. As prophet, he proclaimed the appearance of Jesus as the Messiah: "I am the voice of one crying in the wilderness, 'Make straight the way of the Lord'" (John 1:23). The wilderness is represented here as a barren, windswept mountainous landscape punctuated by isolated patches of vegetation and by a stream at the lower right. In a scene that is rarely depicted, John casts his clothing on the ground in order to replace it with the rough camel's hair robe of the hermit or penitent. Rarer still is the way that John is depicted: not as a gaunt, bearded ascetic, but as a young, athletic nude, whose bodily proportions were inspired by Greek or Roman statuary. In the hands of a Renaissance artist such as Domenico Veneziano, the idealized classical nude is no longer pagan but imbued with spirituality. John the Baptist is as pure and pristine as the landscape he inhabits.

This panel was once part of the predella of an altarpiece that was originally installed in the church of Santa Lucia de' Magnoli in Florence. The National Gallery of Art also possesses a second predella panel, *Saint Francis Receiving the Stigmata*. The altarpiece is considered one of Domenico Veneziano's most important works, and when it was dismantled, probably in the nineteenth century, the main portion—representing the Madonna and Child with Saints Francis, John the Baptist, Lucy, and Zenobius—went to the Galleria degli Uffizi, Florence. Two other predella panels are in the Fitzwilliam Museum, Cambridge, and one is in the Staatliche Museen, Berlin.

As his name implies (a nickname actually), Domenico Veneziano came from Venice and was first trained in that city, or perhaps in Padua. It is not known exactly when he came to Florence, but it may have been around 1485. The altarpiece in Santa Lucia de' Magnoli confirmed his reputation as a preeminent artist in Florence and exercised a decisive influence on younger artists.

Domenico Veneziano
(Florentine, c. 1410–1461)
Saint John in the Desert
c. 1445, tempera on panel
28.4 × 31.8 (11 1/8 × 12 1/2)
Samuel H. Kress Collection
1943.4.48

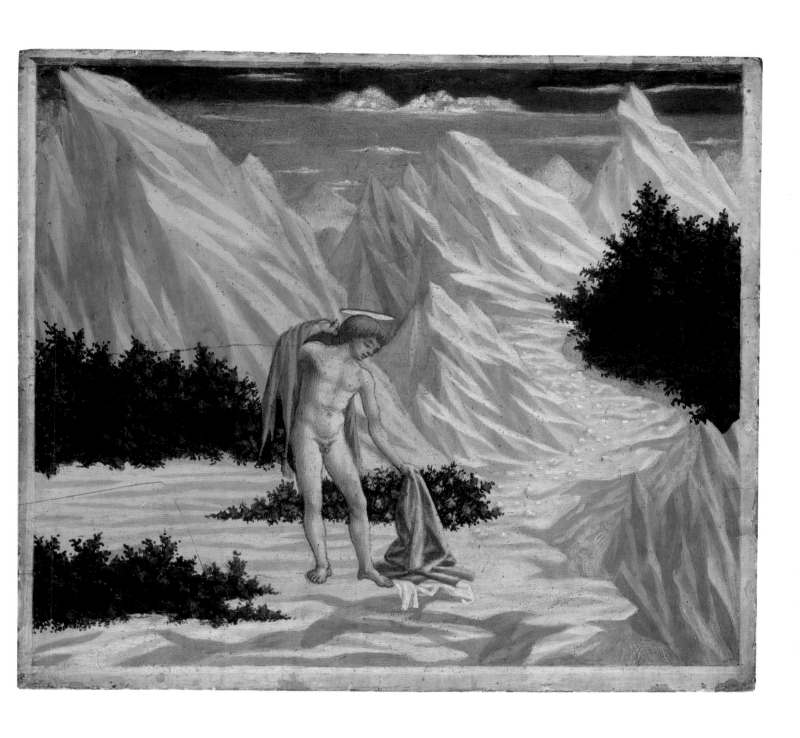

The Adoration of the Magi

SANDRO BOTTICELLI

• This magnificent painting demonstrates a major accomplishment and goal of fifteenth-century Italian painting: the depiction and organization of the external world. Botticelli here displays a mastery of both aerial perspective (the softening of forms in the distant atmosphere) and linear perspective (the use of a unified, mathematically determined system of recession in space and delineation) to re-create on a two-dimensional surface the illusion of three-dimensional reality. The placement of people and objects reflects the artist's need to fashion a harmonious and meaningful two-dimensional composition as well, however. Note how the Magi and others kneeling in the foreground create strong diagonals that lead the eye toward the Madonna and Child, the focal point of the picture; and the throngs of people at left and right who have followed the Magi complete this angulation in a stable W configuration. The lines of the temple structure also direct attention to the Virgin and Child. This building can be interpreted symbolically. As a classical temple in ruins, it may signify the collapse of pagan religion after the birth of Christ. The new wooden structure that shelters the Holy Family would thus refer to the new Christian religion.

Although Botticelli lived and worked for most of his life in Florence, he was summoned to Rome in 1481–1482 to help decorate the Sistine Chapel. It is possible that the *Adoration of the Magi* was painted while he was in Rome. Those who believe so point to the figure at the right of a groom subduing a horse, which is clearly derived from the large antique statues of horse tamers (Dioscuri) that graced the Baths of Constantine on the Quirinal Hill in Rome. Others note that drawings of the sculptures were well known in Florence in the fifteenth century. The painting contains another possible connection with the city of Florence; it has been suggested that the young man with crossed arms in the right foreground is Piero de' Medici, and the older man next to him might be a portrait of his father, Cosimo de' Medici. The theme of the Adoration of the Magi had special significance in Florence, and the Medici family was the major patron of a reenactment of the journey of the Magi that was held in the city every five years.

17

Sandro Botticelli
(Florentine, 1446–1510)
The Adoration of the Magi
early 1480s, tempera and oil on panel
68 × 102 (26 ¾ × 40 ⅛)
Andrew W. Mellon Collection
1937.1.22

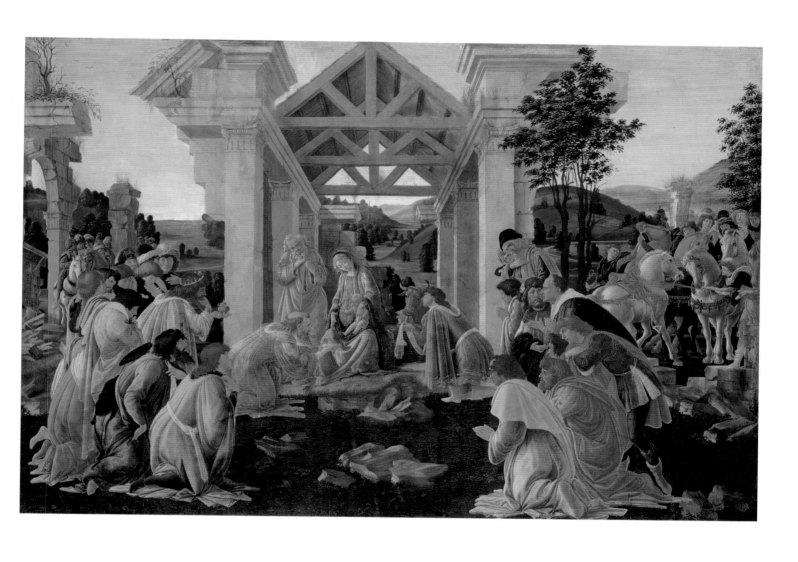

18

19

Cosmè Tura

(Ferrarese, c. 1433–1495)

Madonna and Child in a Garden

c. 1455, tempera (and possibly oil) on panel

53.4 × 37.2 (21 × 14 ⅝)

Samuel H. Kress Collection

1952.5.29

Carlo Crivelli

(Venetian, c. 1430/1435–1495)

Madonna and Child Enthroned with Donor

c. 1470, tempera on panel

125.3 × 50.7 (49 ⅜ × 20)

Samuel H. Kress Collection

1952.5.6

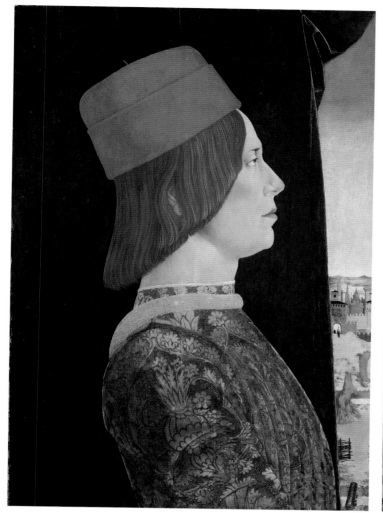 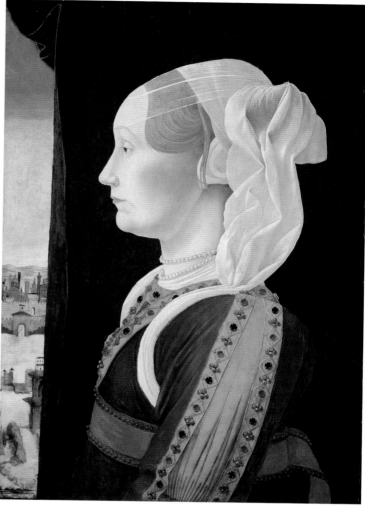

20 21

Ercole de' Roberti Ercole de' Roberti
(Ferrarese, c. 1455/1456–1496) (Ferrarese, c. 1455/1456–1496)
Giovanni II *Bentivoglio* *Ginevra Bentivoglio*
c. 1480, tempera on panel c. 1480, tempera and oil on panel
54 × 38.1 (21 ¼ × 15) 53.7 × 38.7 (21 ⅛ × 15 ¼)
Samuel H. Kress Collection Samuel H. Kress Collection
1939.1.219 1939.1.220

Ginevra de' Benci

LEONARDO DA VINCI

• In the fields of both art and science Leonardo da Vinci stands as one of the true geniuses of the Renaissance. Yet because of his restless curiosity and love of experimentation, he actually realized very few of his projects, including paintings. This portrait of Ginevra de' Benci, a member of a wealthy Florentine family, has the distinction of being the only painting by Leonardo in the Western hemisphere.

Two relationships in the sitter's life may have direct bearing on this portrait. The first is that in 1474, when she was sixteen years old, Ginevra married Luigi di Bernardo Niccolini, also a member of a prominent Florentine family. It is possible that the portrait was ordered on the occasion of their marriage. Second, the Venetian humanist and ambassador Bernardo Bembo was posted to Florence in 1475–1476 and 1478–1480, and during one stay he designated Ginvera the object of his Platonic love. Bembo's affection was reciprocated, and their mutual admiration was revealed in several contemporary poems that praised Ginevra's beauty, intelligence, and chastity. The reverse of the portrait depicts branches of laurel and palm encircling a sprig of juniper, accompanied by a scroll with the words VIRTUTEM FORMA DECORAT (Beauty Adorns Virtue). Juniper (*ginepro*, in Italian) is a pun on the sitter's name, while the wreath of laurel and palm has been identified as Bernardo Bembo's personal emblem. This raises the possibility that Bembo commissioned the portrait or had the reverse modified.

Leonardo was one of the first Italian artists to abandon the use of a profile for portraits, and here, influenced by Netherlandish examples, he presents Ginevra in a three-quarter view. The panel has been cut at the bottom; originally it was probably a half-length composition that included the sitter's hands. The picture is in excellent condition, and Leonardo's technical virtuosity is on full display. Note particularly how the delicate modeling of flesh tones and subtle gradation of light and shade in Ginevra's face combine to produce an almost sculptural solidity. In transitional areas Leonardo used his fingers in the wet paint to soften contours and edges imperceptibly. Note also the very fine, precise, and energetic brushwork that highlights the curls framing her face. The dark juniper bush behind Ginevra is rendered with botanical accuracy, while the landscape at the far right dissolves in a blue haze. Whether one characterizes the portrait as pensive, resigned, or melancholy, it is clear that Leonardo has captured an essential element of Ginevra's personality, but what lies behind it will likely remain a mystery.

detail, *Ginevra de' Benci* (see pages 30–31)

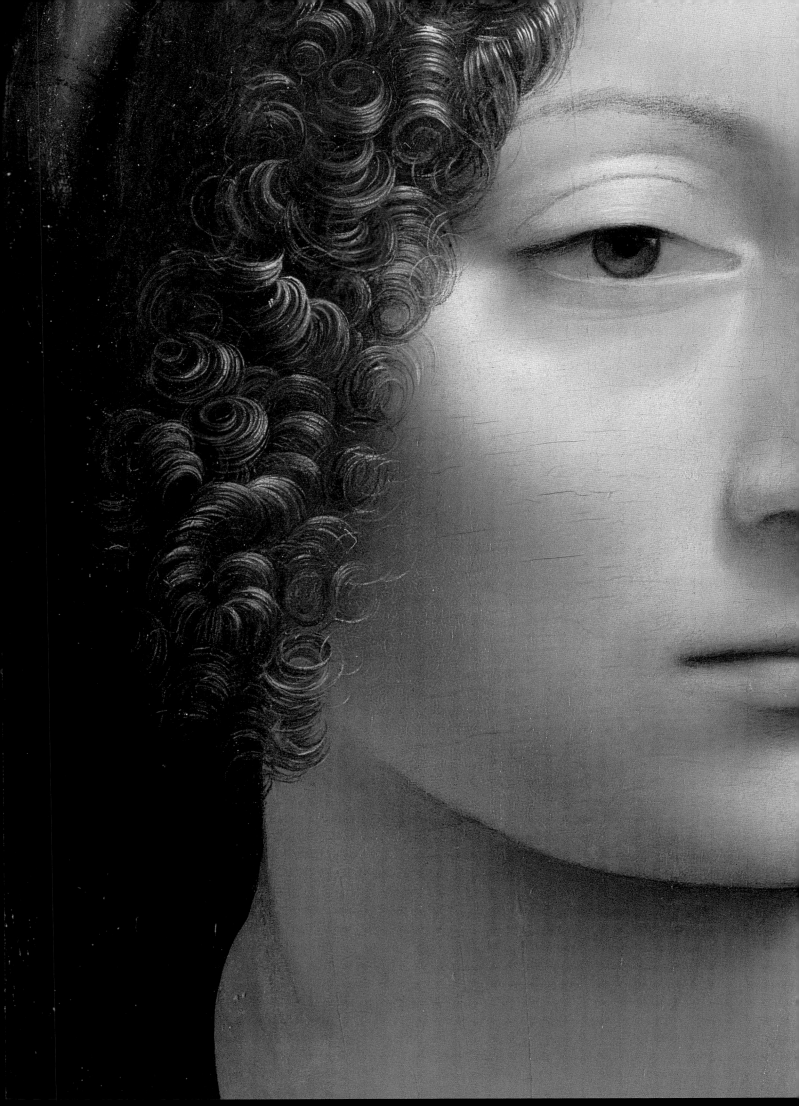

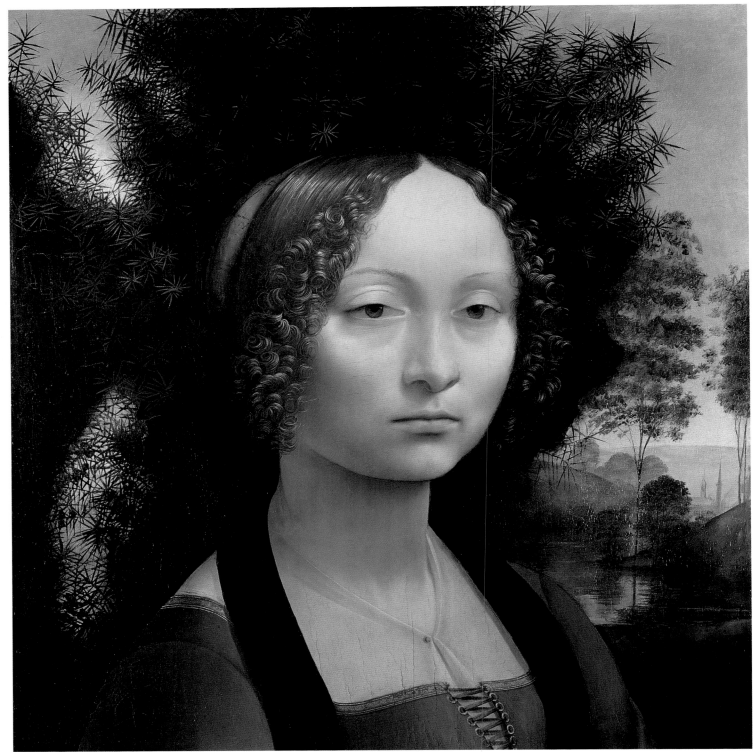

22

Leonardo da Vinci
(Florentine, 1452–1519)
Ginevra de' Benci (obverse and reverse)
c. 1474, oil on panel
38.1 × 37 (15 × 14 ½)
Ailsa Mellon Bruce Fund
1967.6.1 a–b

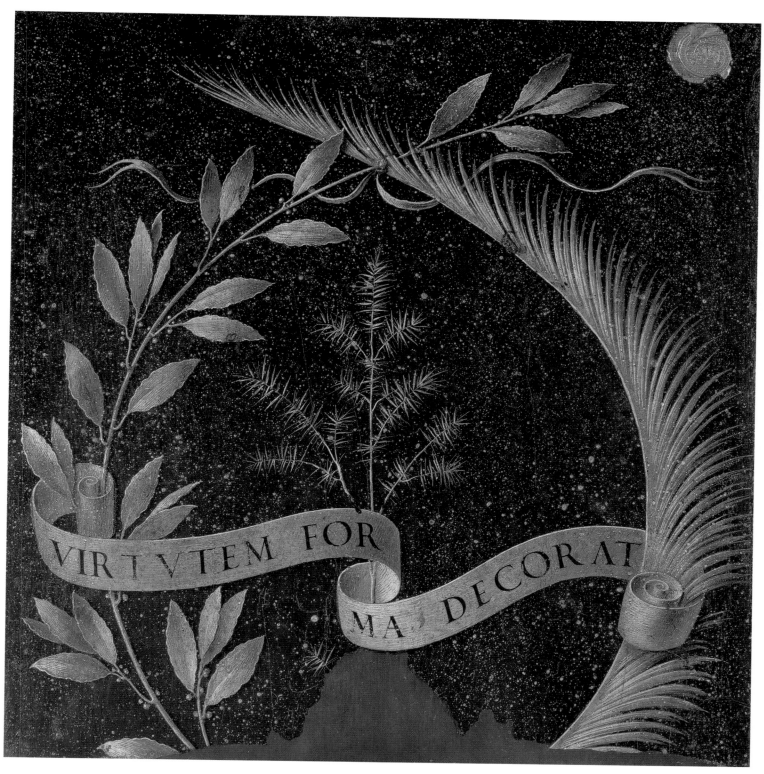

The Visitation with Saint Nicholas and Saint Anthony Abbot

PIERO DI COSIMO

• This nearly square panel was painted for the chapel of Gino Capponi in the church of Santo Spirito, Florence. In the center of the painting is depicted the Visitation, known from the Gospel of Luke (1:39–56), which recounts that Mary, having just learned that she will give birth to the Son of God, goes to see her cousin Elizabeth, who despite her advanced age is six months pregnant with John the Baptist. The two women recognize their extraordinary situations, with Elizabeth exclaiming to Mary, "Blessed are you among women, and blessed is the fruit of your womb!"

Also present are two saints, who must have had special significance for the Capponi family. At the left is Saint Nicholas, who is reading from the Old Testament book of the Wisdom of Solomon (Proverbs). The three golden balls beside him refer to the gold he anonymously provided to a poor family as dowry for their three daughters. At the right is Saint Anthony Abbot, with a bell at his feet whose sound repelled the devil; in the background is the saint's attribute, a pig, symbol of the tempting sin of gluttony. Lying in the center foreground is a single sprig of wallflower, which was thought to enhance fertility and ease the pain of childbirth, both appropriate to the condition of Mary and Elizabeth.

The background includes scenes that continue the biblical narrative. The Nativity of Christ and Adoration of the Shepherds take place at the far left. At the right is a depiction of the Massacre of the Innocents, Herod's attempt to kill the infant Jesus by ordering the deaths of all male children in Bethlehem under the age of two. Even the Annunciation can be found at the distant right, painted on the side of a building. There is a deliberate and effective contrast between the busy and somewhat cluttered background and the simple triangular shapes and clear outlines of the foreground figures, who appear to be illuminated by strong sunlight.

Beginning in 1550 with Vasari, almost every author who has discussed the *Visitation with Saint Nicholas and Saint Anthony Abbot* has remarked on the exceptional realism of many details. Vasari was struck by the illusionism of Anthony's parchment book and the reflections on golden balls in which one can almost make out the interior of the Capponi chapel. Piero di Cosimo was among several artists who were strongly influenced by both the realism and the technique of painting in oils found in Netherlandish paintings imported into Florence during the last quarter of the fifteenth century.

23

Piero di Cosimo
(Florentine, 1462–1521)
The Visitation with Saint Nicholas and Saint Anthony Abbot
c. 1490, oil on panel
184.2 × 188.6 (72 ½ × 74 ¼)
Samuel H. Kress Collection
1939.1.361

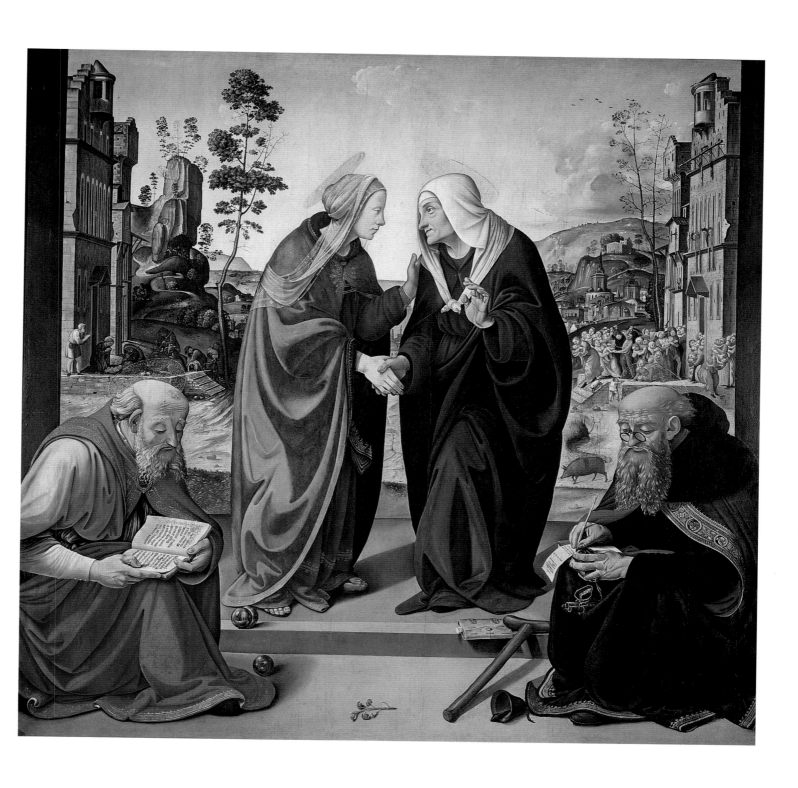

The Crucifixion with the Virgin, Saint John, Saint Jerome, and Saint Mary Magdalen

PERUGINO

• Painted around 1485, this altarpiece was most likely commissioned by Bartolomeo Bartoli, bishop of Cagli, and given by him to the church of San Domenico in his hometown of San Gimignano. The occasion for the donation may have been the consecration of the church in 1496, an event attended by Bartoli, which suggests that he used the altarpiece for his private devotions for about ten years. The center panel contains the traditional grouping of Mary and John the Evangelist on either side of the crucified Christ, who is silhouetted against a nearly cloudless sky. On the right wing Mary Magdalen, the repentant sinner, can be identified by her ointment jar. Saint Jerome is on the left wing, and his attribute, the lion, appears in the background. Jerome lived in the fourth century, thus he witnesses the Crucifixion mystically.

Far from a depiction of pain and anguish, this painting is a serene and harmonious meditation on Christ's sacrifice. All four attending figures incline their heads and bodies in positions that direct attention upward to Christ and also form stable triangular shapes. A counterbalancing V shape is created by the rocky landscape that continues through all three panels and is even echoed in the angle of the two small pieces of wood at the base of the cross. Perhaps the finest work by Perugino in the United States, this altarpiece is noteworthy for its precisely painted, carefully finished forms. The plants in the foreground are portrayed with great accuracy and can be interpreted symbolically. In the center panel, for example, there is a red poppy, emblematic of sleep and death; as well as a dandelion, whose bitterness alludes to the Passion of Christ; and a violet, a well-known symbol of humility. Perugino was strongly influenced here by the naturalism of Netherlandish painting, in particular a *Crucifixion* altarpiece now in Brussels that was from the workshop of Rogier van der Weyden and made for members of the Sforza family. That work could have been seen by Perugino in Pesaro.

Famous in his own time, the artist, whose real name is Pietro Vannucci, was active in Perugia (the source of his nickname) and Florence. In 1481–1482 he was summoned to Rome to work in the Sistine Chapel and could have become known there to Bartolomeo Bartoli, who was a confessor to Pope Sixtus IV. Perugino is best known as the teacher of Raphael, and with the pupil eclipsing the master, credit for this exquisite *Crucifixion* was given to Raphael from the seventeenth to the late nineteenth century.

24

Perugino
(Umbrian, c. 1450–1523)
The Crucifixion with the Virgin, Saint John, Saint Jerome, and Saint Mary Magdalen
c. 1482/1484, oil on panel transferred to canvas
left panel: 95 × 30.1 (37 3/8 × 11 7/8)
center panel: 101.5 × 56.5 (40 × 22 1/4)
right panel: 95 × 30.1 (37 3/8 × 11 7/8)
Andrew W. Mellon Collection
1937.1.27 a–c

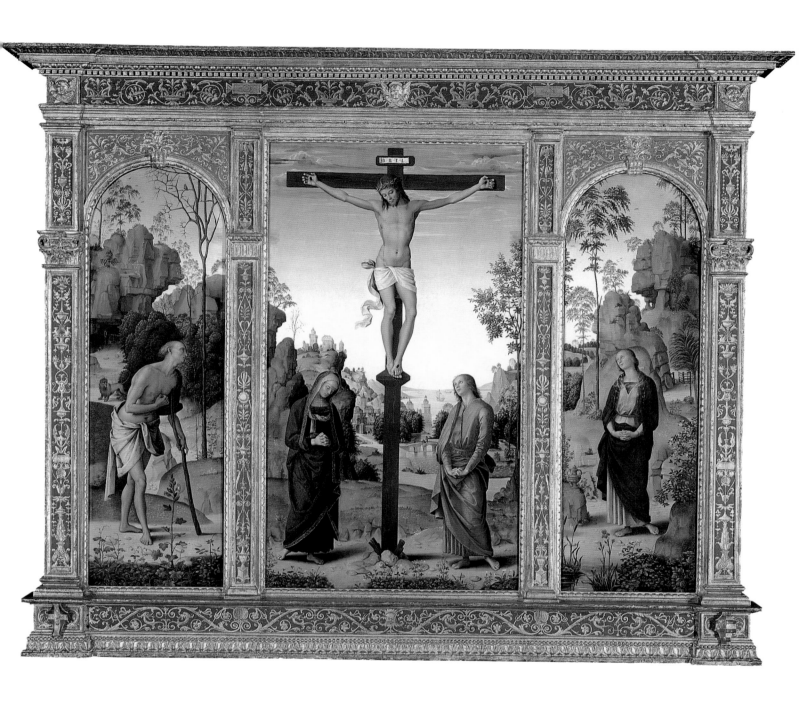

Judith and Holofernes

ANDREA MANTEGNA

• As recounted in the Apocrypha of the Old Testament, the Israelites of Bethulia were under attack and on the verge of defeat at the hands of the Assyrians when the beautiful Judith put on elegant clothing and, accompanied only by her servant, went to the tent of Holofernes, the Assyrian commander. Holofernes had hoped to seduce Judith, but he drank too much and passed out, at which point Judith cut off his head and put it into a sack held by the servant, as seen here, then escaped from the camp. The head of Holofernes was displayed on a pole outside the walls of Bethulia, and the Assyrians, now leaderless and demoralized, were easily defeated. The story of the Jewish heroine who saved her people was very popular during the Renaissance and was subject to different interpretations. Judith symbolized the power of women to vanquish men through cunning and sexual allure, and she also represented the triumph of virtue over vice.

This painting clearly presents a heroic Judith. With an impassive expression she looks away from her gruesome trophy while reaching across her torso with a twisting motion to place the head in a sack. Her strong contrapposto stance is in fact derived from an antique marble statue, the *Venus Felix* (now in the Vatican Museum), that was discovered in Rome in the late fifteenth century. Mantegna's reverence for the classical past can also be seen in Judith's hairstyle and robes. His classicism was learned in Padua from his teacher and foster father Francesco Squarcione, who directed students to copy Greek and Roman art, especially sculpture. Mantegna was influenced by Donatello as well. In 1460 he moved to Mantua to work for Ludovico Gonzaga and other members of the court there. He was in Rome for two years before returning to Mantua, this time to find a patron in Isabella d'Este, the young wife of Francesco Gonzaga. Mantegna married a daughter of the Venetian artist Jacopo Bellini and thus was well acquainted with the work of his brothers-in-law Gentile and Giovanni Bellini.

Technically, this painting is a marvel of refinement and delicacy; small brush strokes precisely define each form, with gold paint used in the legs of the bed and silver in Judith's blue robe. It is the elegance of execution that has prompted a succession of critics to wonder whether *Judith and Holofernes* might be from the hand of a miniaturist working from one of Mantegna's designs.

25

Andrea Mantegna
(Paduan, c. 1431 – 1506)
Judith and Holofernes
c. 1495, tempera on panel
30.1 × 18.1 (11 7/8 × 7 1/8)
Widener Collection
1942.9.42

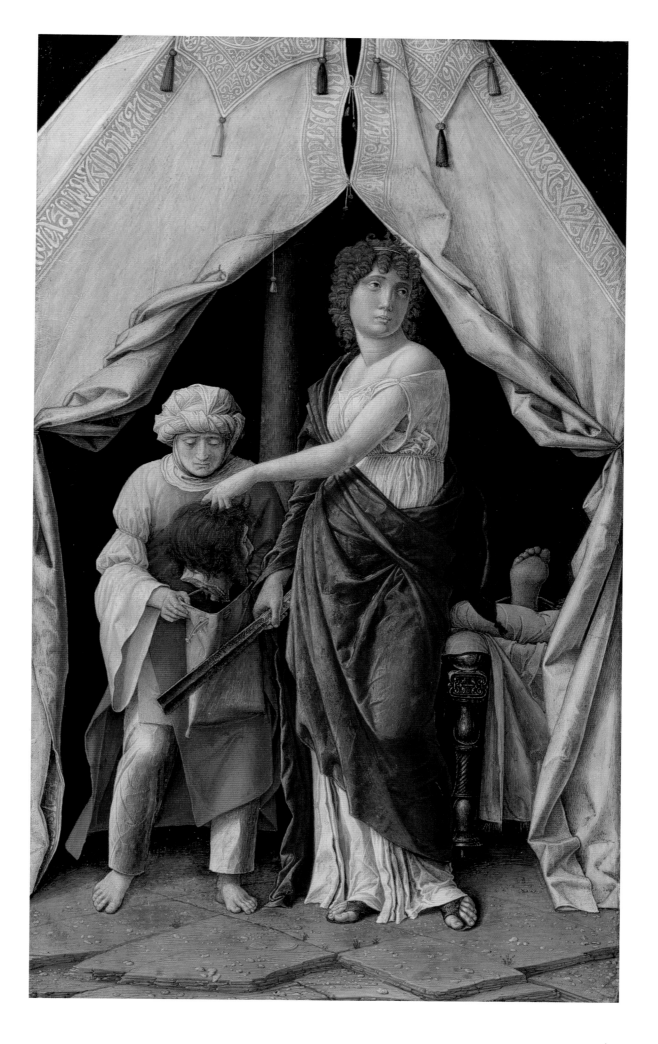

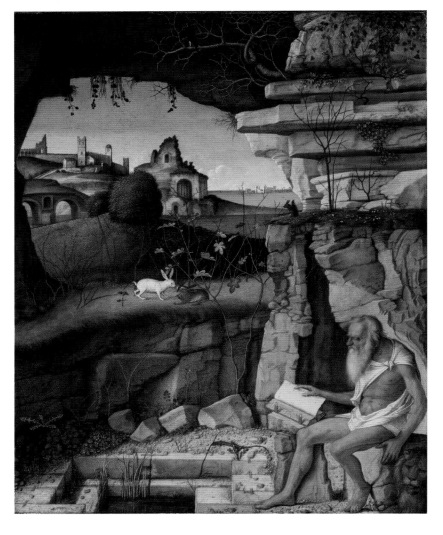

26

27

28 (see pages 40 and 41)

Giovanni Bellini
(Venetian, c. 1430/1435–1516)
Saint Jerome Reading
1480/1490, oil on panel
47 × 37.5 (18 ½ × 14 ¾)
Samuel H. Kress Collection
1939.1.217

Neroccio de' Landi and
Master of the Griselda Legend
(Sienese, 1447–1500;
Umbrian-Sienese, active early 1490s)
Claudia Quinta
c. 1494, tempera on panel
105 × 46 (41 ⅜ × 18 ⅛)
Andrew W. Mellon Collection
1937.1.12

Jan van Eyck
(Netherlandish, c. 1390–1441)
The Annunciation
c. 1434/1436, oil on canvas transferred from panel
90.2 × 34.1 (35 ½ × 13 ⅜)
Andrew W. Mellon Collection
1937.1.39

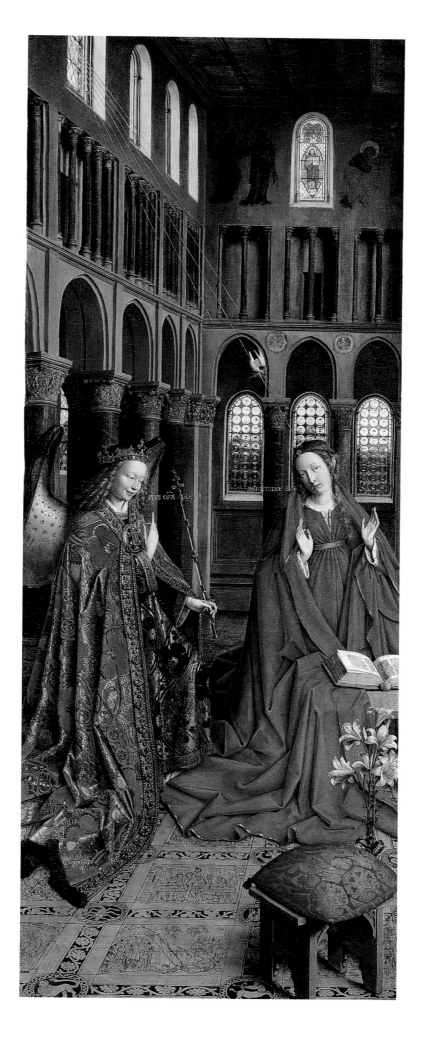

The Annunciation

JAN VAN EYCK

• Jan van Eyck is acclaimed as one of the greatest artists of all time and as a founder of the early Netherlandish school of painting. Among the rare paintings by Van Eyck in the United States, the *Annunciation* offers ample evidence of his skill and erudition.

As described in the Gospel of Luke (1:26–38), the angel Gabriel announces to the Virgin Mary that she will conceive and give birth to Jesus, the Son of God. This moment of incarnation marks the beginning of Christ's human life; and around the event Van Eyck has created an image of amazing complexity in which every object is imbued with meaning. The words of the angelic salutation, "AVE GRATIA PLENA" (Hail, full of grace), issue visibly from Gabriel's mouth, while the Virgin's reply, "ECCE ANCILLA DOMINI" (Behold, the handmaid of the Lord), is written upside down so that it can be read from above, possibly by the Lord, who appears in the stained-glass window at the top of the back wall.

One main theme of the picture concerns the transition from Old to New Testament that occurred with Christ's incarnation and birth. In the architecture of the church itself the rounded arches of the older Romanesque style at the top contrast with the newer Gothic style of slightly pointed arches in the lower story; and the single window at the top is juxtaposed with three lead-shot windows behind the Virgin, making visually explicit the passage from the Jewish idea of one God to the Christian concept of a Triune God. Two scenes from the life of Moses flank the window at the top of the back wall and can be interpreted as prefigurations of the life of Christ. The Ten Commandments given to Moses formed the old covenant and anticipated the new covenant that began with the coming of Christ.

The symbolic program continues in the images inlaid in the floor, with signs of the zodiac as they were sometimes incorporated into medieval churches to demonstrate God's dominion over the universe, including the movement of the planets. At the lower left is the sign of Leo the lion, associated with the house of the sun and thus with Christ as the "the light of the world" or with the Old Testament "sun of justice." Additionally, there are representations of Old Testament stories that medieval theologians interpreted as prefigurations of New Testament events: Samson's destruction of the temple presaged the Crucifixion and Last Judgment, while the scene below it of David beheading Goliath symbolized Christ's victory over the devil. In general, the upper zone of the painting alludes to Christ's divine nature and his association with the Lord of the Old Testament, while the lower portion refers to Christ's human existence and sacrificial death. These two zones come together in the body of the Virgin, who often acts as intermediary between God and man.

The complex theological symbolism of the *Annunciation* is more than equaled by Jan van Eyck's mastery of the medium of painting in oils and his astonishing realism. He is able to differentiate between the soft, diffuse illumination at the top of the church and the strong natural light that strikes the figures from the right. His acuteness of observation and his ability to reproduce the textures and palpable appearances of things remain unsurpassed and can perhaps best be seen in the vestments worn by the angel Gabriel, where the varied qualities of gems, pearls, cloth-of-gold, and velvet are recreated in paint. Objects that are real, such as the red damask cushion in the foreground, and objects less likely to be real, such as Gabriel's rainbow-hued wings, are all depicted with the same degree of actuality.

detail, *The Annunciation* (see pages 38–39)

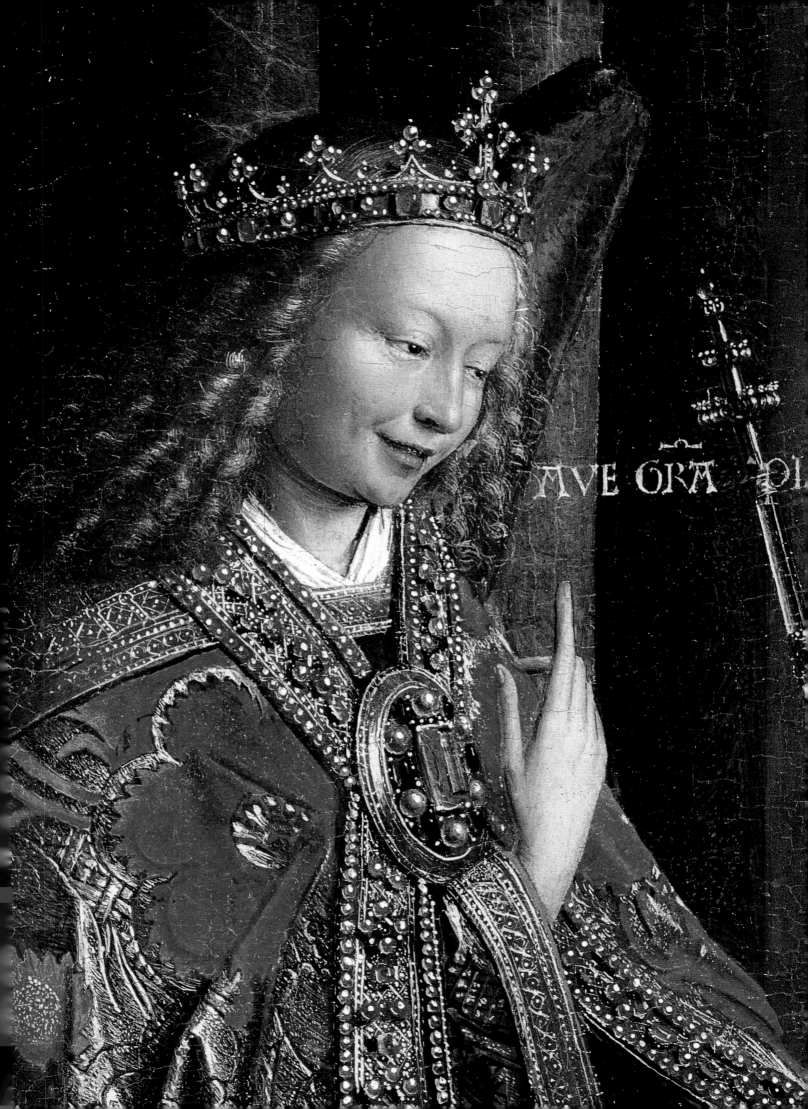

Portrait of a Lady

ROGIER VAN DER WEYDEN

• There is a certain inimitable assurance and conciseness about the late works of great artists, whether by Titian, Beethoven, or, in this instance, Rogier van der Weyden. No coats of arms or other elements in the *Portrait of a Lady* identify the sitter, yet from the elegant severity of her costume, enlivened only by a red belt, and her modest yet poised bearing and expression, we assume she was a member of the nobility. One hallmark of Rogier's style, particularly evident in his last paintings, is the controlled precision of his compositions. Here the interlocking diagonals and strong contrasts of light and dark achieve a nearly abstract grace. Within this framework the curves of the woman's cheek, forehead, and neck are delineated with exquisite care, and surfaces are modeled with extreme subtlety; see, for example, how a minute band of white defines the edge of the translucent veil as it clings to her forehead.

Rogier van der Weyden is esteemed as a premier Netherlandish artist of the fifteenth century. He was born in Tournai and apprenticed with Robert Campin, becoming a master in Tournai in 1432. By 1435/1436 he had moved to Brussels and became official painter to the city. Unlike Jan van Eyck, Rogier left no signed or dated paintings, and only three extant pictures can be associated with documents. Nonetheless, it has been possible to identify his paintings through stylistic analysis. His inventive, emotionally powerful works were enormously inspiring.

Rogier van der Weyden
(Netherlandish, 1399/1400–1464)
Portrait of a Lady
c. 1460, oil on panel
34 × 25.5 (13 3/8 × 10)
Andrew W. Mellon Collection
1937.1.44

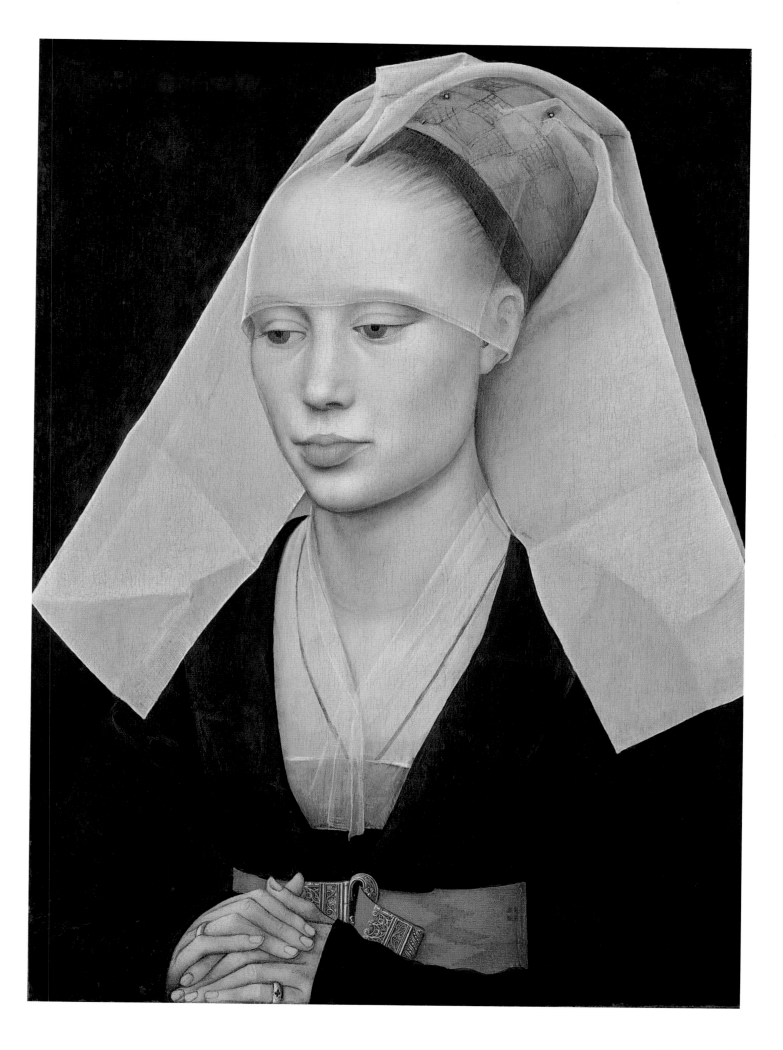

The Nativity

PETRUS CHRISTUS

• The late fourteenth-century mystic Saint Bridget of Sweden, in her tremendously influential *Revelations*, described a vision of the Nativity with the newborn Christ Child lying naked on the earth as the Virgin knelt in adoration, with Joseph and angels in attendance. By the second half of the fifteenth century this type of Nativity had gained wide currency, but here Petrus Christus transforms it into an image of extraordinary power and complexity.

A number of devices explain the purpose of Christ's coming and, even at the moment of his birth, the necessity for his sacrificial death. In the portal that frames the Nativity are statues of Adam and Eve and scenes that depict the expulsion from paradise, Adam tilling the soil and Eve spinning, episodes from the story of Cain and Abel, and the departure of either Cain or Seth. These refer to original sin and the subsequent strife in the world before the arrival of Christ. Similarly, the crumbling wall and ruined roof may imply that the law of the Old Testament yields to the grace of the New

Testament, much as the plant grows out of the horizontal beam directly above the Christ Child. The angels wear Eucharistic vestments, including a deacon's cope, indicating that this is the first Mass. The role of celebrant is reserved for Christ himself, who serves as both priest and victim. Underscoring this message is a depiction of the temple in Jerusalem, associated with Christ's Passion, which has been set into the placid Flemish village in the background.

Petrus Christus was one of the first Netherlandish artists to use perspective to construct unified, coherent spaces. Moreover, his figures have a palpable solidity, and light and shadow are sensitively observed. All of this would have increased the devotional immediacy and impact of this painting.

Petrus Christus
(Bruges, active 1444–1475/1476)
The Nativity
c. 1450, oil on panel
127.6 × 94.9 (50 ¼ × 37 ⅜)
Andrew W. Mellon Collection
1937.1.40

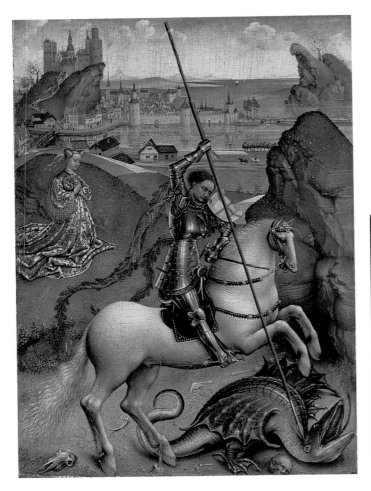

31

32

Rogier van der Weyden
(Netherlandish, 1399/1400–1464)
Saint George and the Dragon
c. 1432/1435, oil on panel
14.3 × 10.5 (5 ⅝ × 4 ⅛)
Ailsa Mellon Bruce Fund
1966.1.1

Dirck Bouts
(Netherlandish, c. 1415/1420–1475)
Madonna and Child
c. 1465, oil on panel
22.5 × 15.5 (8 ⅞ × 6 ⅛)
Patrons' Permanent Fund
1986.67.1

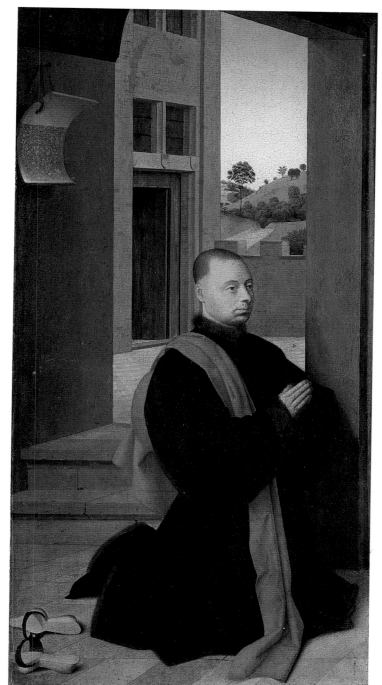

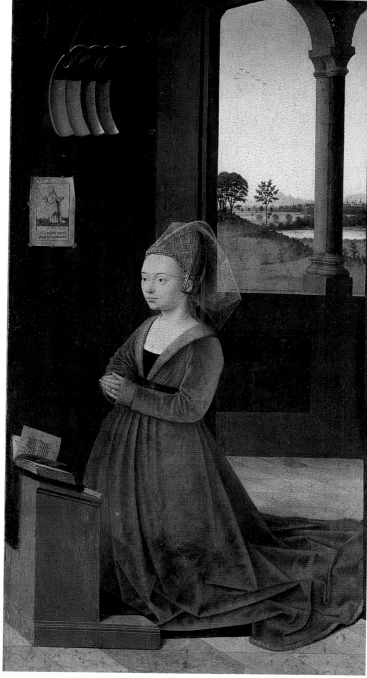

33

34

Petrus Christus
(Bruges, active 1444–1475/1476)
Portrait of a Male Donor
c. 1455, oil on panel
42 × 21.2 (16 ½ × 8 ⅜)
Samuel H. Kress Collection
1961.9.10

Petrus Christus
(Bruges, active 1444–1475/1476)
Portrait of a Female Donor
c. 1455, oil on panel
41.8 × 21.6 (16 ½ × 8 ½)
Samuel H. Kress Collection
1961.9.11

Madonna and Child with Angels

• Hans Memling is first mentioned in 1465 when he became a citizen of Bruges; the records also indicate that he was born in Germany, in the Middle Rhenish town of Seligenstadt. Nothing is known of his travels or training, although it is evident that he, like many others, borrowed heavily from the compositions of Rogier van der Weyden. Memling prospered in Bruges, receiving commissions locally as well as from foreign merchants who lived in the city. Tax records from the 1480s reveal that he was one of Bruges' wealthiest citizens.

Memling died in 1494, and knowledge of his life and art fell into obscurity in the course of the sixteenth century. He was all but unknown in the seventeenth and eighteenth centuries, but in the early nineteenth century he was rediscovered, and writers of the romantic era praised him as the perfect embodiment of "Gothic" mysticism and religious sentiment. The 1920s and 1930s saw a dramatic decline in Memling's reputation, and even into the 1970s he was considered a minor artist, dependent on Rogier van der Weyden and unable to progress beyond him. Fortunately, a more balanced and positive understanding of Memling's accomplishment is now possible.

In its combination of technical assurance, placid mood, and religious symbolism the *Madonna and Child with Angels* is typical of Memling. The apple offered by the angel at the left denotes Christ as the "new Adam," who will redeem mankind after the Fall. As in the *Nativity* by Petrus Christus, the angels wear liturgical garments that refer to the Mass, as does the grapevine depicted in the molding of the arch, alluding to the wine of the Eucharist. The Old Testament antecedents of Christianity are represented by the two statues atop the porphyry and crystal columns: at the left with his harp is King David, an ancestor of Christ; and at the right, holding a saw, is the prophet Isaiah, whose words, "Behold, a young woman shall conceive and bear a son" (Isaiah 7:14), foretell the virgin birth of Jesus.

Hans Memling
(Bruges, active c. 1465–1494)
Madonna and Child with Angels
after 1479, oil on panel
57.6 × 46.4 (22 ⅝ × 18 ¼)
Andrew W. Mellon Collection
1937.1.41

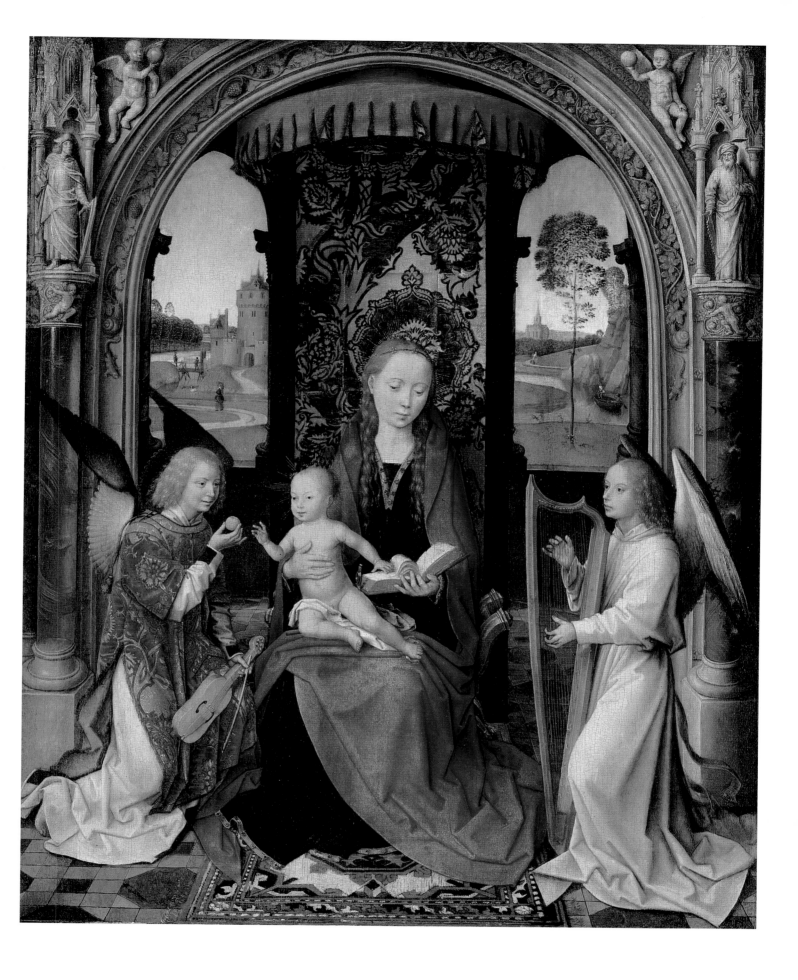

Saint Veronica (obverse) / Chalice of Saint John the Evangelist (reverse)

HANS MEMLING

• The front of this panel depicts Saint Veronica holding the sudarium, a cloth that has been miraculously imprinted with the face of Christ. On the reverse a chalice containing a serpent refers to a legend in which John the Evangelist drank a cup of poison but suffered no ill effects; the serpent symbolizes the poison departing the chalice.

It is generally agreed that the National Gallery of Art's panel was once part of a diptych and that the other half is now in the Alte Pinakothek, Munich, bearing the image of *Saint John the Baptist* on the front and a skull on the reverse. This small altarpiece was intended for private devotions, and the choice of subject matter would have had personal significance for the original owner. In general the diptych referred to the redeeming power of Christ and the triumph over death or illness. As an eyewitness to the Passion of Christ, Veronica was a potent saint to whom people prayed for remission of penance and who was perceived to have nearly magical powers of healing.

The commission for this diptych is not documented, but several scholars believe the work was likely acquired by Bernardo Bembo, who, as Venetian ambassador to the Burgundian court, lived in the Netherlands from 1471 to 1474. The diptych is first mentioned in 1502 as being in Bernardo's collection, where it remained until his death in 1519, and it is almost certainly the same work that belonged to his son, the poet and humanist, Pietro Bembo. From this and other examples, one can gauge the popularity of Memling's paintings with foreign, especially Italian, collectors. The influence of Memling's distinctive landscape types can be seen in the paintings of such artists as Fra Bartolomeo and Raphael, including the latter's *Saint George and the Dragon* (see no. 55).

36

Hans Memling
(Bruges, active c. 1465–1494)
Saint Veronica (obverse)
Chalice of Saint John the Evangelist (reverse)
c. 1470/1475, oil on panel
30.3 × 22.8 (11 ⅞ × 9)
Samuel H. Kress Collection
1952.5.46 a–b

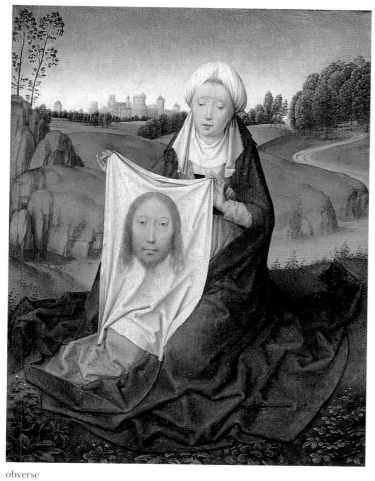

obverse

reverse

Mary, Queen of Heaven

• This large painting, filled with colorful figures, was probably commissioned by a Spanish nobleman, Don Pedro Fernández de Velasco, for the convent of Santa Clara in Medina de Pomar, near Burgos. The artist, known only by a nickname, was active in Bruges from the 1480s into the first decade of the sixteenth century. Several of his paintings have Spanish provenances, and it has been suggested that he lived in Spain for a time.

Mary, Queen of Heaven is unusual in combining three themes from the life and legend of the Virgin. First, it represents her corporeal assumption into heaven, which is said to have occurred three days after her death. Second, the crescent moon on which she stands identifies her as the Woman of the Apocalypse mentioned in the book of Revelation and connects her with the doctrine of the immaculate conception, which asserts that she was conceived free from sin. And third, the stage is set for the coronation of the Virgin by the Trinity to take place in the heavenly realm at the top of the painting.

Accompanying the Virgin is a host of angels, many of whom sing or play instruments that are depicted with remarkable accuracy. In fact, the painting's title derives from the musical score held by the angels on either side of the Virgin's head. It is a Marian antiphon, "Ave Regina Caelorum," similar to the compositions of Walter Frye, an Englishman whose works were popular at the Burgundian court. As one might imagine, this painting is beloved by musicologists, who point out that closest to actual performance practice is the uppermost group flanking the Trinity, composed of angels singing and playing "soft" instruments: recorders, lute, dulcimer, and harp. The "hard" instruments, shawms and trumpets, found in the lower group would have drowned out the singers.

Master of the Saint Lucy Legend
(Bruges, active c. 1480–c. 1510)
Mary, Queen of Heaven
c. 1485/1500, oil on panel
199.2 × 161.8 (78 3/8 × 63 3/4)
Samuel H. Kress Collection
1952.2.13

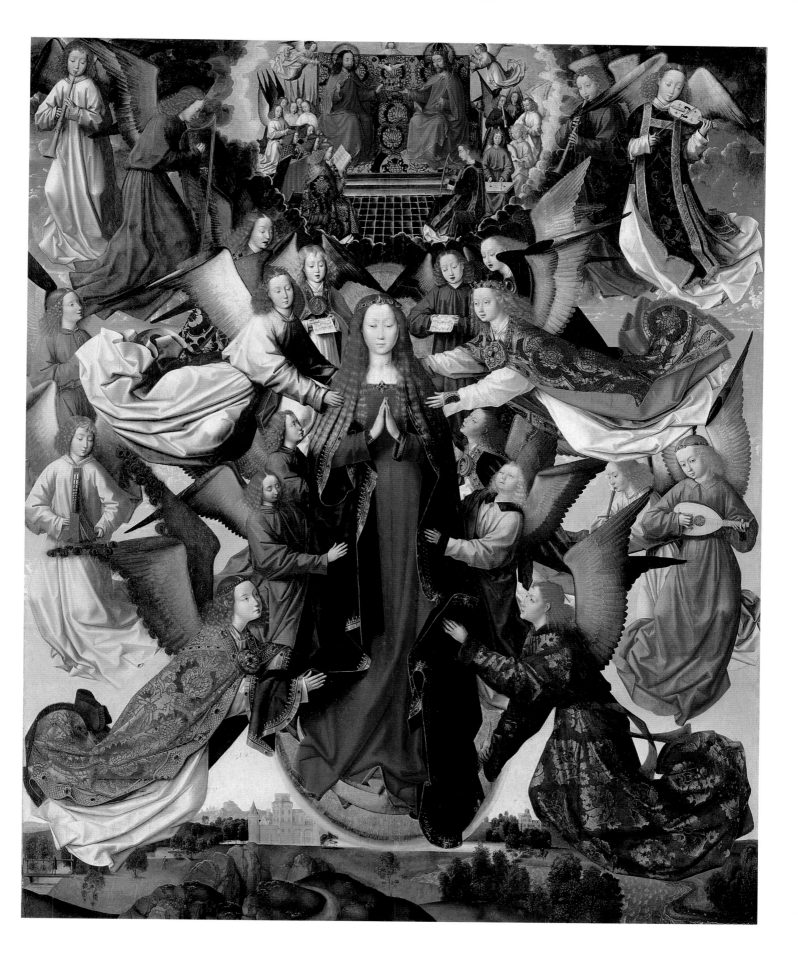

Portrait of Diego de Guevara (?)

MICHEL SITTOW

• This painting was once the right-hand portion of a diptych; the left half was a *Madonna and Child* now in the Staatliche Museen, Berlin, thus the sitter was originally shown adoring the Virgin. Although it is not absolutely certain, it is most likely that the portrait is of Don Diego de Guevara, a Spanish nobleman who worked at the Burgundian court for many years. Diego de Guevara also collected art and is the first recorded owner of Jan van Eyck's *Portrait of Giovanni (?) Arnolfini and His Wife* (National Gallery, London), which he eventually gave to Margaret of Austria, regent of the Netherlands.

The peripatetic life of a Renaissance court artist is amply illustrated by the career of Michel Sittow. He was born in Reval (now Tallinn) in Estonia; he probably received some training from his father until around 1484, then moved to Bruges where he may have studied with Hans Memling. By 1492 Sittow was in Spain, in service to Queen Isabella of Castile. After Isabella's death in 1504 he may have visited the court of Henry VIII, but he was working for

Philip the Fair in the Netherlands by 1505/1506. He went back to Reval in 1506, then between 1514 and 1518 he was at the courts of Denmark, the Netherlands, and Spain, before returning to Reval where he lived comfortably until his death.

Although there were several occasions when Sittow's and de Guevara's paths could have crossed, the National Gallery of Art's portrait and its pendant in Berlin are usually dated to Sittow's mature years, c.1515/1518. In 1517 de Guevara was awarded a high rank in the Order of Calatrava, and part of the cross of this order was painted over the front of his doublet and is visible just above his fingers. Sittow's portrait allows one a compelling insight into the intense inner life of the sitter. Although it may not be possible to give a name to the exact emotion portrayed, there can be no doubt as to the depth of feeling or the humanity of Don Diego de Guevara.

Michel Sittow
(Netherlandish, c. 1469–1525/1526)
Portrait of Diego de Guevara (?)
c. 1515/1518, oil on panel
33.6 × 23.7 (13 ¼ × 9 ¼)
Andrew W. Mellon Collection
1937.1.46

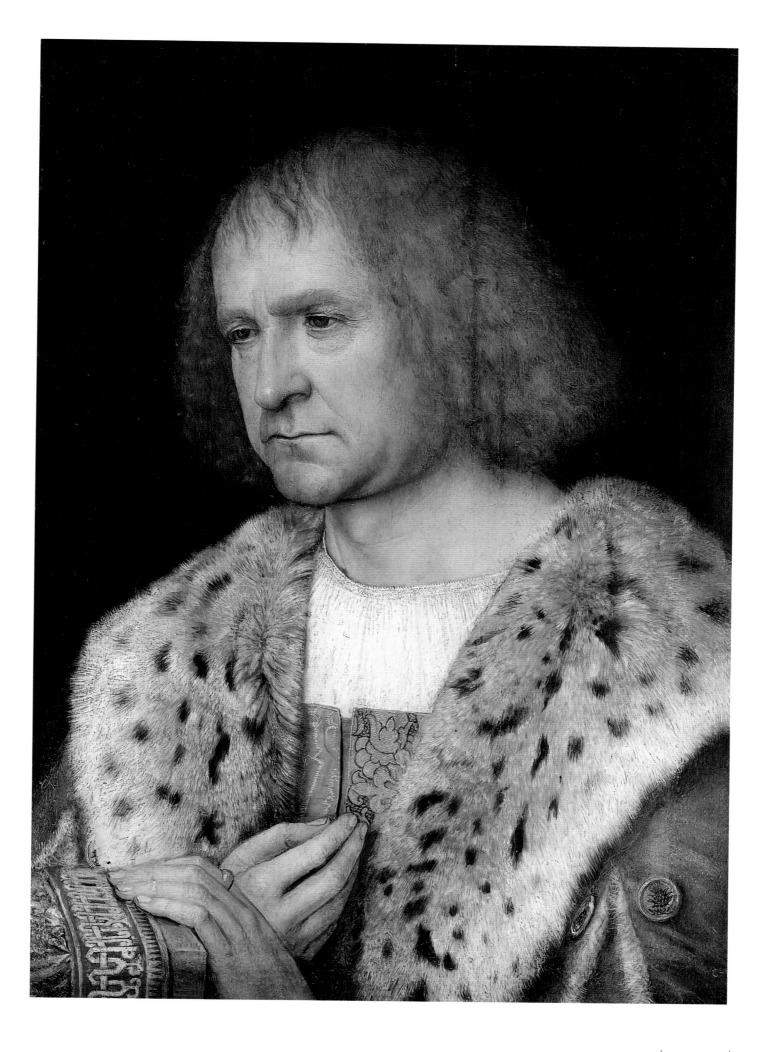

The Assumption of the Virgin MICHEL SITTOW
The Temptation of Christ JUAN DE FLANDES

• During his journey to the Netherlands the German artist Albrecht Dürer visited the city of Mechelen and the palace of Margaret of Austria, regent of the Netherlands. His diary for 7 and 8 June 1521 reads, "On Friday Lady Margaret showed me all her beautiful things: among them I saw about 40 small oil pictures, the like of which for precision and excellence I have never beheld." These paintings originally belonged to a series depicting episodes from the lives of Christ and the Virgin that was created for Queen Isabella of Castile. An inventory made at the time of Isabella's death lists forty-seven paintings, many of which were purchased for Margaret of Austria. Only twenty-seven panels now survive in American, British, and European museums and private collections.

The aptness of Dürer's praise can be seen in two panels belonging to the National Gallery of Art. Most of the pictures, based on accounts in the Gospels of Matthew (4:1–10) and Luke (4:1–3), were created by Juan de Flandes, whose *Temptation of Christ* (no. 40) shows the devil dressed in brown robes and fingering a rosary but betrayed by his horns and reptilian feet. In the foreground the devil dares Christ to turn a stone into bread; standing atop a temple in the distance at the right he asks Christ to prove his divinity by jumping off the building; and on a mountaintop to the left he offers Christ the kingdoms of the world if he will but fall down and worship Satan.

The *Assumption of the Virgin* (no. 39) occupied a special place in the collection of Margaret of Austria; it was framed as a diptych along with an *Ascension of Christ* (now in a private collection), and in Margaret's inventories both were described as coming from the hand of Sittow. Particularly noteworthy is the feeling for light, air, and color that infuse this depiction of the Virgin's journey into heaven, which takes place high above an atmospheric landscape of delicately rendered hills and buildings. Sittow's color harmonies are subtle and sophisticated; angels are clad in robes of tangerine, deep green, and various shades of blue. A dramatic contrast to the surrounding steel-gray and blue-gray clouds is the zone of pink- and lemon-colored light that surrounds the Virgin.

39

40

Michel Sittow
(Netherlandish, c. 1469–1525/1526)
The Assumption of the Virgin
c. 1500, oil on panel
21.1 × 16.2 (8 ¼ × 6 ⅜)
Ailsa Mellon Bruce Fund
1965.1.1

Juan de Flandes
(Hispano-Flemish, active 1496–1519)
The Temptation of Christ
c. 1500/1504, oil on panel
21 × 15.5 (8 ¼ × 6 ⅛)
Ailsa Mellon Bruce Fund
1967.7.1

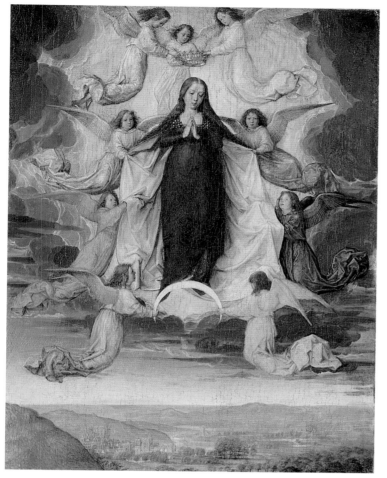

39

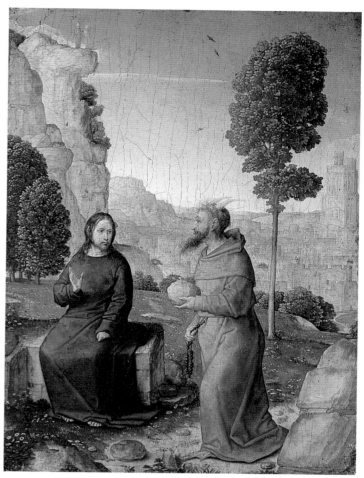

40

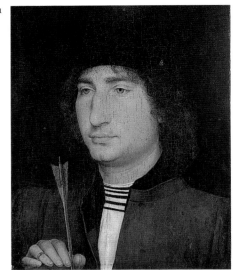

41

42

43

41

Hans Memling
(Bruges, active c. 1465–1494)
Portrait of a Man with an Arrow
c. 1470/1475, oil on panel
31.3 × 25.1 (12 ⅜ × 9 ⅞)
Andrew W. Mellon Collection
1937.1.42

42

Juan de Flandes
(Hispano-Flemish, active 1496–1519)
The Annunciation
c. 1508/1519, oil on panel
110.2 × 78.4 (43 ⅜ × 30 ⅞)
Samuel H. Kress Collection
1961.9.22

43

Juan de Flandes
(Hispano-Flemish, active 1496–1519)
The Nativity
c. 1508/1519, oil on panel
110.5 × 79.3 (43 ½ × 31 ¼)
Samuel H. Kress Collection
1961.9.23

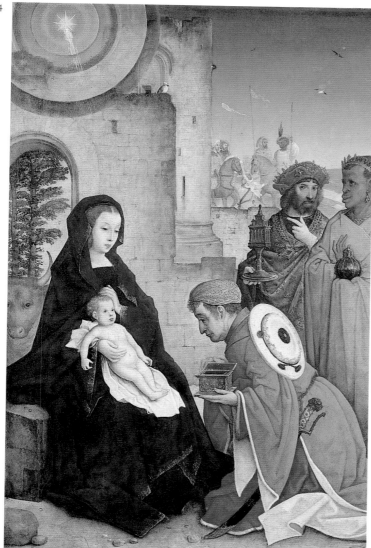

44

Juan de Flandes
(Hispano-Flemish, active 1496–1519)
The Adoration of the Magi
c. 1508/1519, oil on panel
124.7 × 79 (49 ⅛ × 31 ⅛)
Samuel H. Kress Collection
1961.9.24

45

Juan de Flandes
(Hispano-Flemish, active 1496–1519)
The Baptism of Christ
c. 1508/1519, oil on panel
124.2 × 79 (48 ⅞ × 31 ⅛)
Samuel H. Kress Collection
1961.9.25

The Death of Saint Clare

MASTER OF HEILIGENKREUZ

• Saint Clare (1194–1233) was a disciple of Saint Francis of Assisi and the founder of Poor Clares, the Second Order of Saint Francis. According to legend, Clare was visited on her deathbed by the Virgin Mary and a group of sainted virgins. It is generally accepted that it is Mary who holds Clare's head in her hands. The other saints may be identified by their attributes. At the foot of the bed Margaret holds a miniature dragon; the saint above her at the far left with flowers and a small basket is probably Dorothy; next is Saint Barbara with a tower, possibly Saint Helena with a garland of flowers, and Saint Catherine holding a wheel. The woman on the viewer's side of the bed is probably Agnes, Clare's younger sister, who is accompanied by a tiny lamb, symbol of her name. Because Agnes has not yet achieved sainthood, she wears a plain blue dress and does not have a halo.

Together with the *Death of the Virgin* in the Cleveland Museum of Art, this panel most likely formed a diptych that came from a convent of the Poor Clares located either in the present-day Czech Republic or in Hungary. The artist was active in this region and takes his name from a diptych that once belonged to an abbey in Heiligenkreuz in southeastern Austria, not far from the Hungarian border. Paintings by the Master of Heiligenkreuz are extremely rare. The bulbous heads, small pointed chins, and long spidery fingers are idiosyncratic and immediately recognizable. His use of punches and tooling to create halos, decorative borders, and groups of music-making angels in the gold background is typical of the International Style that flourished in various court centers, such as Paris and Prague, in the late fourteenth and early fifteenth centuries.

Master of Heiligenkreuz
(Austrian, active early 15th century)
The Death of Saint Clare
c. 1400/1410, oil on panel
66.3 × 54 (26 ⅛ × 21 ¼)
Samuel H. Kress Collection
1952.5.83

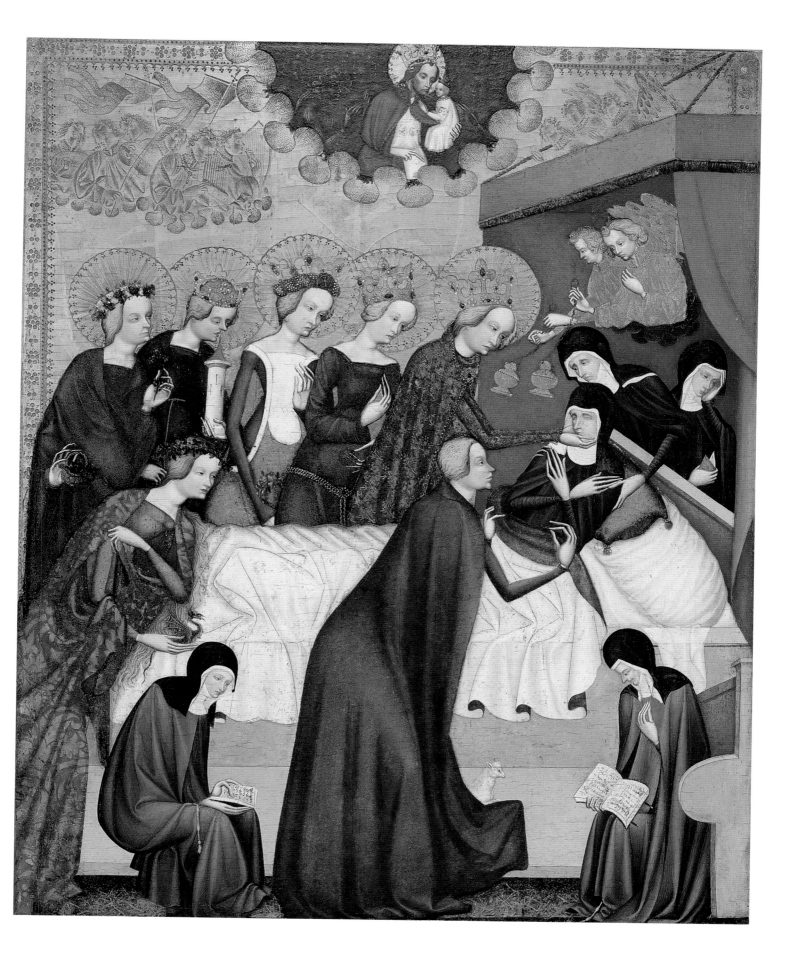

The Crucifixion

MASTER OF SAINT VERONICA

• The young monk kneeling at the foot of the cross can be identified by his white robes as a member of the Carthusian order. Although it cannot be verified, it is possible that this painting was originally located in the Charterhouse, or Carthusian monastery, of Saint Barbara in Cologne. The Carthusians are a contemplative order, and this *Crucifixion* probably would have been placed in a monk's cell for his solitary prayer and devotions. In addition to the monk, the Virgin and Saint John the Evangelist are shown; the fourth person present is Saint Longinus, who kneels at the left of the cross. Drops of blood fall from the tip of the spear held by Longinus, who was, according to legend, the centurion assigned by Pilate to pierce Christ's side, but who converted to Christianity and was miraculously cured of an eye ailment by a single drop of Christ's blood. Three of the angels who collect Christ's blood in tiny chalices allude to the veneration of the wounds of Christ and the holy blood.

The anonymous artist who painted the *Crucifixion* was active in Cologne from the last years of the fourteenth century until around 1420. He is named for a painting of *Saint Veronica Holding the Sudarium* in the Alte Pinakothek, Munich. The *Crucifixion* is perhaps the earliest and certainly one of the most splendid of the master's works and is notable for its soft, delicate modeling, symmetrical composition, and refined color harmonies.

Master of Saint Veronica
(Cologne, active c. 1395/1420)
The Crucifixion
c. 1400/1410, tempera on panel
40.7 × 25.2 (16 × 9 ⅞)
Samuel H. Kress Collection
1961.9.29

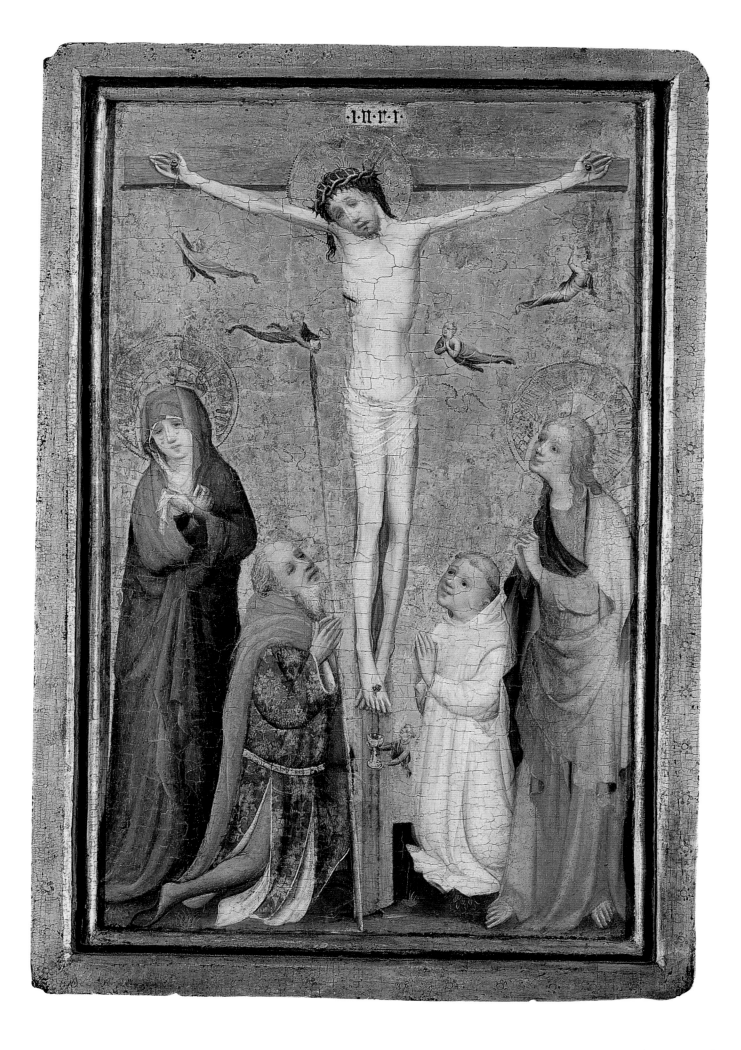

The Baptism of Christ

• Despite his anonymity, the Master of Saint Bartholomew is a fascinating and engaging personality, who, as seen here, was endowed with the ability to create figures that are at once realistically observed and almost childlike in their innocence. At the center of the painting John the Baptist baptizes Christ in the Jordan River. Directly overhead are the dove of the Holy Spirit and God the Father, whose words, "This is my beloved Son, with whom I am well pleased," appear on a banderole. A wonderfully magical and, one might say, anachronistic element is added by the fourteen saints who emerge from a bank of clouds to witness the baptism. The shimmering gold background reinforces the mystical feeling of the event. At the same time, the artist is capable of depicting the columbine, plaintain, mint, and strawberries in the foreground with keen accuracy and of convincingly rendering the drops of water on Christ's head.

This *Baptism of Christ* is iconographically unique and without visual or literary precedent. Considering its large size, it was most likely an altarpiece in a church, possibly in Arnhem in the northern Netherlands, and the choice of subject and the individual saints was dictated by the person or persons who commissioned the retable.

Master of the Saint Bartholomew Altar
(Cologne, active c. 1475/1510)
The Baptism of Christ
c. 1485/1500, oil on panel
104.3 × 169.7 (41 × 66 ¾)
Samuel H. Kress Collection
1961.9.78

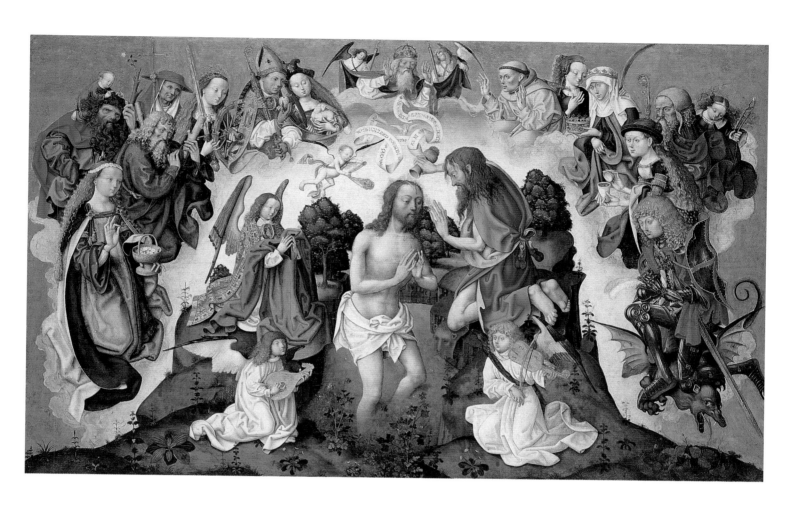

The Raising of the Cross

• This is one of the few examples of an intact folding triptych surviving from the fifteenth century. The exceptional state of preservation of both interior and exterior panels is especially notable and suggests that the work was highly treasured and protected. Two popular saints, Saint Barbara and Saint Catherine, are depicted on the exterior wings, and they often represented the active life and contemplative life, respectively. Opening the triptych reveals a depiction of the *Raising of the Cross*. The landscape is continuous through all three panels, with the main action taking place in the center and two very different groups of onlookers on the wings. Among the lamenting women on the left wing are Mary Magdalen kneeling in the foreground, Saint Veronica at the far left holding the sudarium, and the Virgin wearing a light blue robe over her head and weeping. On the right wing are soldiers, spectators, and in the foreground the unrepentant thief, hands tied behind his back, who awaits his crucifixion.

The attachment of Christ's body to the cross and the elevation of the cross are not described in the Gospel narratives. Rather, the subject grows out of the piety and devotion of the late Middle Ages, in particular the religious practice known as the Modern Devotion, which urged the faithful to empathize with the Passion of Christ and with his pain and suffering.

The modest size of the *Raising of the Cross* triptych indicates that it was used for private devotion, most likely as a house altar or possibly in the family chapel of a church. The coat of arms at the bottom of the center panel identifies the original owner as a member of the patrician Starck family of Nuremberg.

The painting's style can be securely associated with two of Nuremberg's leading artists, Hans Pleydenwurff and Michael Wolgemut. When Pleydenwurff died in 1472, Wolgemut was quick to marry his widow and take over the workshop and practice. The artist who painted the *Raising of the Cross* remains unknown, but it is likely that he was a member of the Pleydenwurff-Wolgemut atelier. Michael Wolgemut is best remembered as the teacher of Albrecht Dürer, and this triptych—with its bright, clear colors, animated but somewhat doll-like figures, and extensive landscape— offers an insight into art in Nuremberg in the moment before Dürer's ascendancy.

Master of the Starck Triptych
(German, active c. 1480–c. 1495)
The Raising of the Cross
c. 1480/1490, oil on panel
left panel: 66 × 23.5 (26 × 9 ¼)
center panel: 66 × 48.3 (26 × 19)
right panel: 66 × 23.5 (26 × 9 ¼)
Patrons' Permanent Fund
1997.100.1 a–c

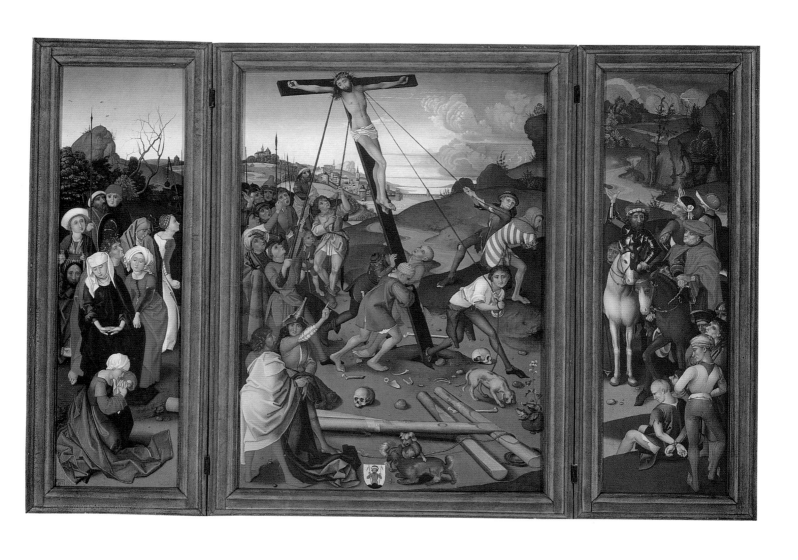

Calvary

MASTER OF THE DEATH OF SAINT NICHOLAS OF MÜNSTER

• This large and powerful painting was almost certainly an altarpiece in a church or a religious institution of some type. In the center of the panel is represented the crucified Christ, with hovering angels who collect his holy blood in small chalices. This is an allusion to the Mass, which celebrates the redemption of mankind through Christ's sacrificial death on the cross.

The painting makes clear what might be called the moral consequences of right and left. To be at the right hand of Christ (that is, to the viewer's left) is a good thing, for here one finds the Virgin, John the Evangelist, and Mary Magdalen. The bearded figure on horseback pointing to his eye is Longinus, the centurion who came to believe in Christ as the Son of God and was cured of an eye malady by a drop of Christ's blood. At the far left is the "good" thief, who repented and whose soul is being carried to heaven by an angel. At Christ's left side are a Pharisee and a group of soldiers, including a centurion in full armor on horseback, holding the banner of imperial Rome. At the far right hangs the "bad" thief, who did not repent and whose soul is seized by a demon.

In addition to an array of figures in the foreground, there is a remarkable series of episodes from the life of Christ embedded in the background hills, beginning at the left with Christ's entry into Jerusalem and ending at the right with Christ in Limbo, when he redeems the righteous figures of the Old Testament. Beneath the feet of the bad thief is shown the body of Judas, who has hanged himself from a tree. These images would have aided the devout viewer who wished to make a mental pilgrimage to experience the Passion of Christ.

The artist remains anonymous but takes his nickname from a panel depicting the Death of Saint Nicholas in the Westfälisches Landesmuseum in Münster. He worked in the Lower Rhine region, an area between Cologne and the Netherlands. It is not surprising, therefore, to learn that the pose of the Magdalen is lifted from a painting by the Netherlander Dirck Bouts. The Master of the Death of Saint Nicholas uses clear, strong colors and forceful gestures to convey emotional intensity. He is also skilled at creating a complex composition of diagonals that moves the viewer's gaze around the painting. Note, too, how the background hills mirror the groupings of the foreground figures, forming a V shape that isolates and directs attention to the body of the crucified Christ.

Master of the Death of Saint Nicholas of Münster
(German, active c. 1460–1490)
Calvary
c. 1470/1480, oil on panel
129.5 × 199.5 (51 × 78 ½)
Patrons' Permanent Fund
2001.70.1

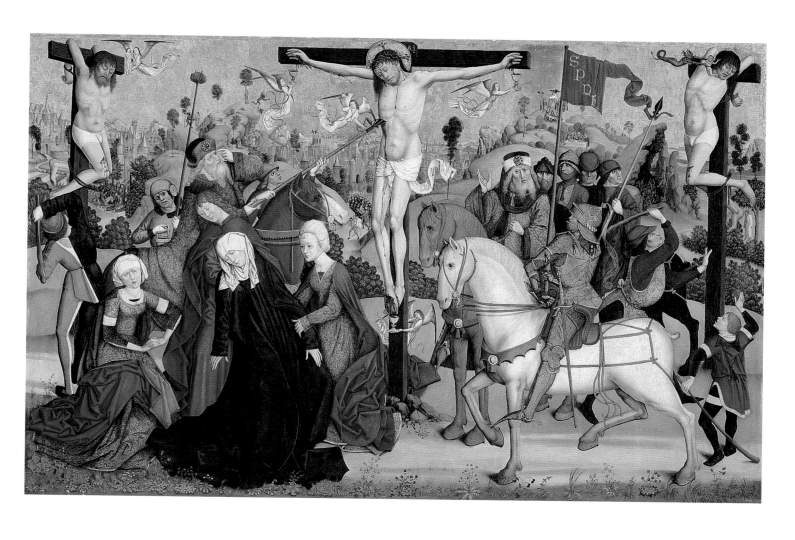

The Marriage at Cana / Christ among the Doctors

MASTER OF THE CATHOLIC KINGS

• These two large paintings were originally part of an altarpiece installed in a church or convent in Spain. Six other panels can be associated with the same altarpiece; five are in museums in the United States, and one is in a private collection in England. Dimly visible on the upper back wall of the *Marriage at Cana* are the coats of arms of the Holy Roman Empire, Flanders, and Brabant, and the combined arms of Castile and Leon, the territories of the Catholic Kings of Spain, Ferdinand of Aragon and Isabella of Castile. It is thus likely that the altarpiece commemorates the marriage of Ferdinand and Isabella's daughter, Juana of Castile, to Philip the Fair, son of Maximilian I, the Holy Roman Emperor, which took place in September 1496 and was followed in April 1497 by the marriage of their son, Juan of Castile, to Maximilian's daughter, Margaret of Austria. This double marriage was an event of immense importance for the political, economic, and cultural history of Europe.

The artist who painted these works remains unknown, but there seems little doubt that he was Spanish, as indicated by the somber, saturated colors and sober expressions. In *Christ among the Doctors* the smudged, sooty shadows and the rough-hewn features of those debating Christ border on the grotesque. At the same time, in his ability to render accurately the appearance and texture of things, the master was clearly inspired by the technique and style of painting in the Netherlands.

51

Master of the Catholic Kings
(Castilian, active c. 1485/1500)
The Marriage at Cana
c. 1495/1497, oil on panel
155.7 × 95.8 (61 ¼ × 37 ¾)
Samuel H. Kress Collection
1952.5.42

52

Master of the Catholic Kings
(Castilian, active c. 1485/1500)
Christ among the Doctors
c. 1495/1497, oil on panel
155.2 × 93 (61 ⅛ × 36 ⅝)
Samuel H. Kress Collection
1952.5.43

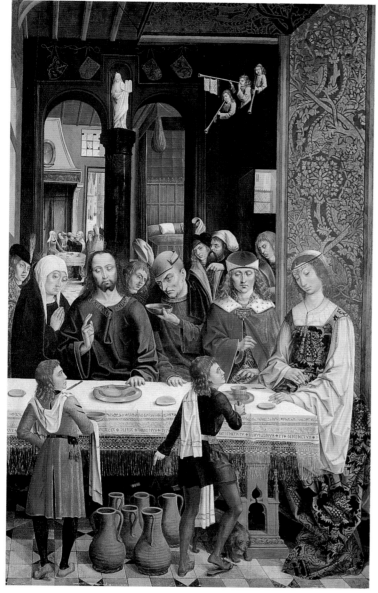

51

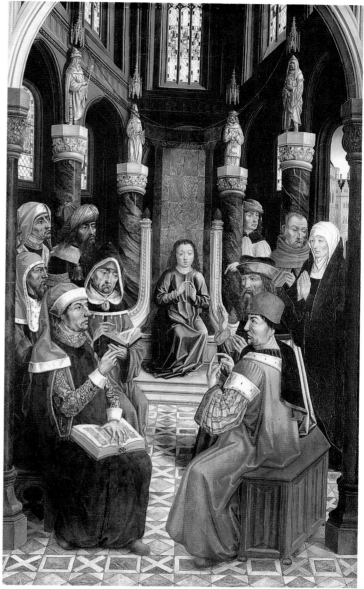

52

Profile Portrait of a Lady

FRANCO-FLEMISH 15TH CENTURY

• This is an extremely rare example of an independent portrait that has survived from the early fifteenth century. The artist is unknown, and the best one can say is that he probably belonged to a group of painters who came from the Netherlands to work for the Burgundian and French courts. The sitter also has resisted identification, but she was undoubtedly a member of the nobility and a person of considerable power and prestige. Her costume is consistent with her social standing. She wears an elegant blue dress with a gold design and a fur collar, while a double strand of ornate gold beads curves across her body, attaching at her shoulder. Her belt and the wide choker around her neck are made of metallic foil, and her headdress may once have been adorned with metalwork as well. The use of a mixed technique, paint and metalwork, is a hallmark of the International Style of the late fourteenth and early fifteenth centuries.

53

Franco-Flemish 15th Century
Profile Portrait of a Lady
c. 1410, oil on panel
52 × 36.6 (20 ½ × 14 ⅜)
Andrew W. Mellon Collection
1937.1.23

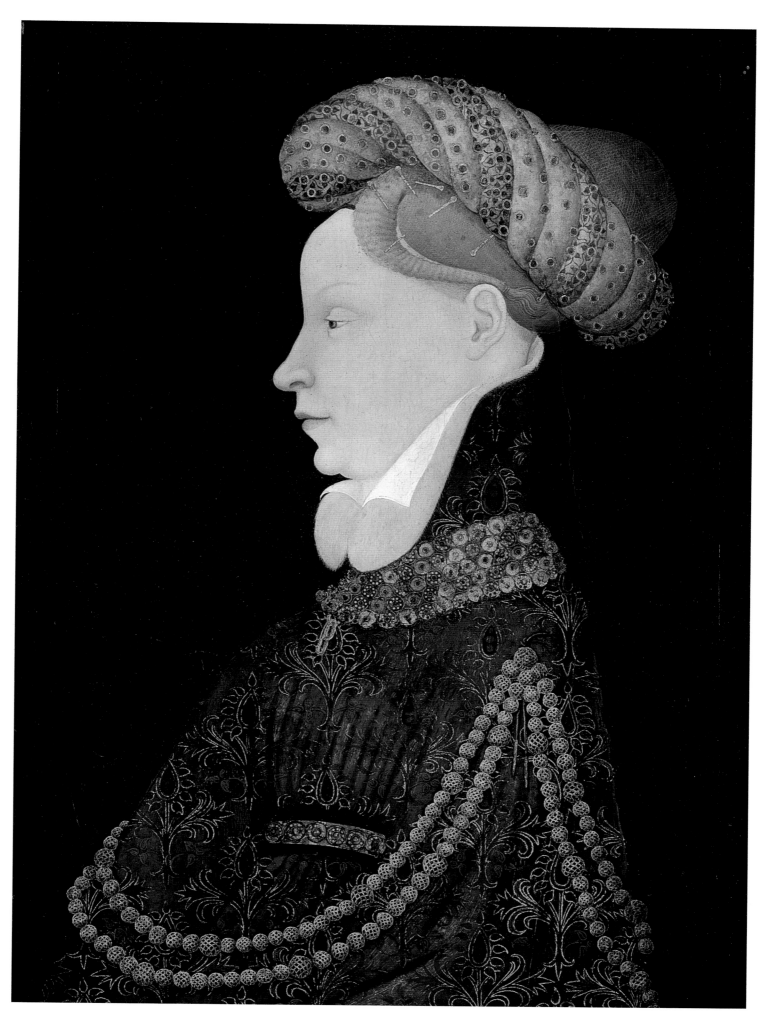

The Baptism of Clovis

MASTER OF SAINT GILES

• Standing naked in a baptismal font, Clovis, the Merovingian king of the Franks, is baptized by Saint Remy, the bishop of Reims, who stands to his right. The event took place around 490, and through his baptism and conversion Clovis became the first Christian king of France, inaugurating in the eyes of many a privileged relationship between God and the French monarchy. There has been no attempt at historical accuracy in this painting; rather the event has been translated into contemporary terms, and the costumes are those worn around 1500. The contemporary viewer would also have recognized the baptism as taking place in Paris, specifically in the Sainte-Chapelle, part of the royal palace on the Île de la Cité. The artist has accurately rendered and combined portions of the upper and lower chapels.

The *Baptism of Clovis* is one panel from a dismembered altarpiece that referred to the French kings and the city of Paris. The National Gallery of Art possesses a second work, *Episodes from the Life of a Bishop Saint*, while two other panels in the National Gallery, London, represent scenes from the life of Saint Giles. The artist takes his name from the London paintings, and as can be seen in the individualized faces, which might be portraits, or in the beautifully observed textures and details of the garments, he is grounded in the Netherlandish style and technique. He could, however, just as easily be a Frenchman trained in the Netherlands as a Netherlander working in France.

Master of Saint Giles
(Franco-Flemish, active c. 1500)
The Baptism of Clovis
c. 1500, oil on panel
61.5 × 45.5 (24 1/4 × 18)
Samuel H. Kress Collection
1952.2.15

1200 1300 1400

16th century

1500 1600 1700 1800 1900

Saint George and the Dragon

RAPHAEL

• Of enduring popularity is the medieval legend of Saint George, a knight who slays a dragon, rescues a princess, and converts the inhabitants of her village to Christianity. George is the embodiment of chivalry, of the power of good over evil, and by extension of Christianity's victory over pagan heresy. He is the patron saint of England and of that country's Order of the Garter. This is relevant to Raphael's sparkling little painting because just below George's knee is a blue cloth inscribed HONI in gold, the first word of the motto of the Order of the Garter, "Honi soit qui mal y pense," which roughly translates as "evil to him who evil thinks." In May 1504 Duke Guidobaldo of Urbino was made a knight of the Order of the Garter by King Henry VIII of England. It is now thought that Raphael's panel was a gift from the duke to Sir Gilbert Talbot, the knight who brought the insignia and robes of the order to Italy and was responsible for correctly outfitting the duke.

Born in Urbino, Raphael was a prodigy, who, having learned all he could from his first teacher, studied with Perugino in Perugia before moving to Florence in 1504. *Saint George and the Dragon* was painted when he was only about twenty-three years old and demonstrates how quickly and easily Raphael was able to incorporate elements from his Florentine con-temporaries into his own graceful style. The painting owes much to Donatello's sculpture of the same subject on the church of Or San Michele, Florence, and to Leonardo da Vinci, who explored the theme of horsemen fighting dragons in a number of drawings—and whose dragons are quite similar to the one shown here. The landscape, most notably the golden-highlighted trees, was inspired by the paintings of Hans Memling, in particular a small diptych that Raphael could have seen on a trip to his hometown of Urbino: one panel of Memling's diptych, *Saint Veronica*, belongs to the National Gallery of Art (see no. 36).

Raphael's *Saint George and the Dragon* is remarkable for the dynamic equilibrium of its composition. The strong diagonals formed by the horse and the dragon are perfectly counter-balanced by the diagonals of George's lance, right arm and left leg, and even his billowing cloak. Set against a landscape of rounded, over-lapping hills and trees, this dramatic moment appears frozen in time.

55

Raphael
(Central Italian, 1483–1520)
Saint George and the Dragon
c. 1506, oil on panel
28.5 × 21.5 (11 1/8 × 8 3/8)
Andrew W. Mellon Collection
1937.1.26

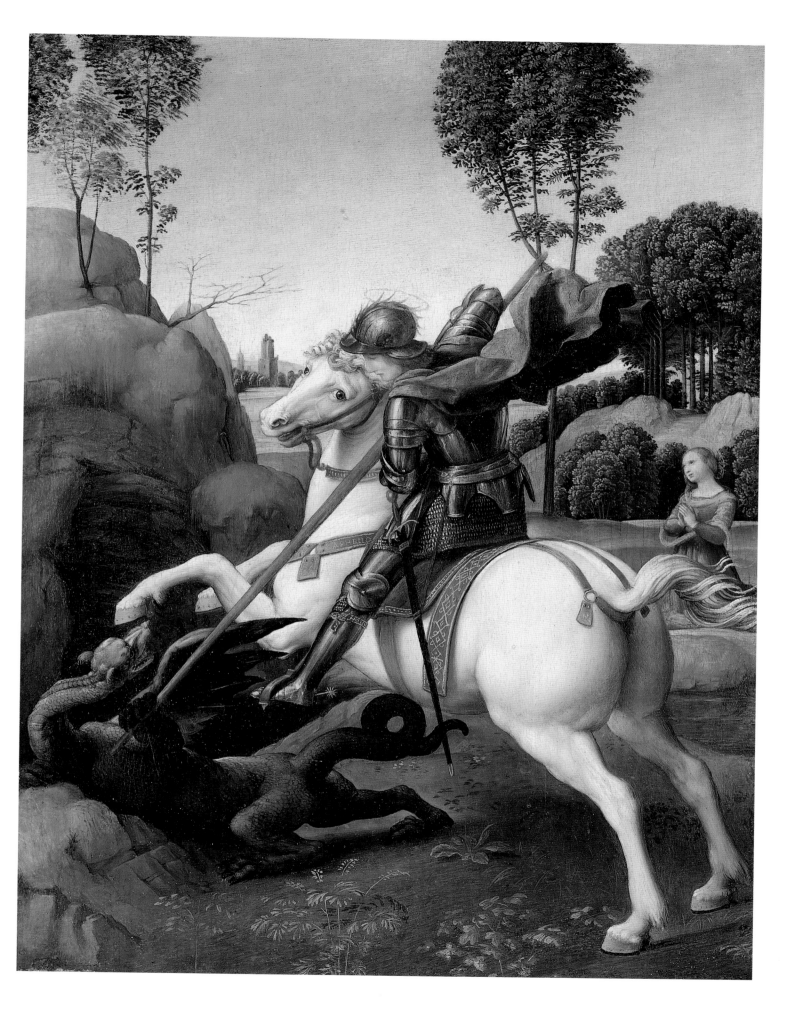

The Alba Madonna

RAPHAEL

• In 1508/1509 Raphael was called from Florence to Rome, where he first worked in the Vatican designing frescoes for the Stanza della Segnatura. The *Alba Madonna*, painted a year or two after his arrival in the Eternal City, testifies to Raphael's mastery of composition as well as his talent for assimilating pictorial ideas from a variety of sources. The use of the tondo format is distinctly Florentine, as seen in the *Adoration of the Magi* by Fra Angelico and Filippo Lippi (no. 15). Within its circular shape the figures of Mary, Jesus, and John the Baptist are set into a broad, horizontal landscape, and all three focus on the cross held by Jesus and John the Baptist, a reference to Christ's future death. The seriousness of the theme is paralleled by the perfectly balanced pyramidal arrangement of bodies, which is physically and emotionally stable and weighty. The Madonna in particular is imbued with an almost sculptural monumentality that reveals Raphael's study of Michelangelo's massive forms. An admiration for the works of antiquity that could be seen in Rome is also evident in her costume, notably her sandals. Showing Mary seated on the ground recalls earlier images of the "Madonna of humility."

Like his teacher Perugino, Raphael here accurately portrays plants and flowers that bear symbolic messages. At the right are three vertical stalks of *Galeum*, or "lady's bedstraw," said to be present in the hay at the Nativity. The cyclamen in front of it alludes to the Virgin's love and sorrow, while the violet in the right foreground is a symbol of her humility. On the left side one finds dandelion, a reference to the bitterness of Christ's Passion, and in John's lap, white anemones, a symbol of the Resurrection.

It is not known with certainty for whom Raphael painted this picture, but it was possibly Paolo Giovio, who may have given it to the church of Monte Oliveto, near Naples, where it is first documented. From the last years of the seventeenth century until 1802 it belonged to the Spanish dukes of Alba, and it is from them that the picture gets its popular name (distinguishing it from Raphael's other depictions of the Madonna). In 1836 the *Alba Madonna* was purchased for the Imperial Hermitage Gallery in St. Petersburg, Russia, where it remained until 1931, when, with a number of works now in the National Gallery of Art, it was acquired by Andrew W. Mellon.

Raphael
(Central Italian, 1483–1520)
The Alba Madonna
c. 1510, oil on panel transferred to canvas
diameter: 94.5 (37 ¼)
Andrew W. Mellon Collection
1937.1.24

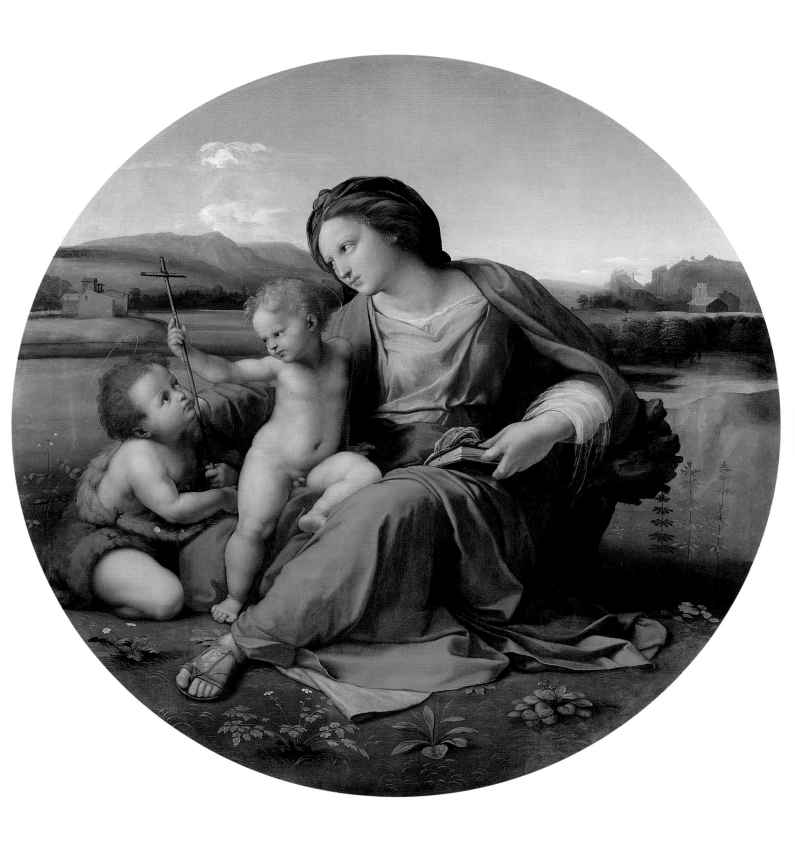

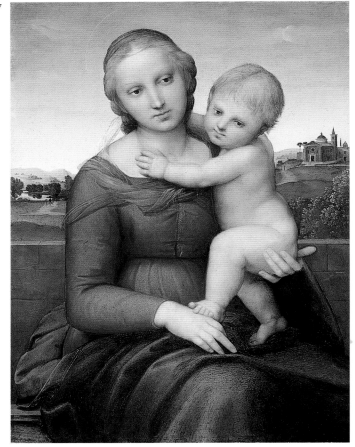

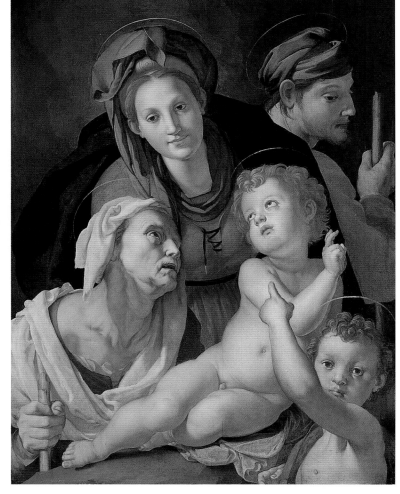

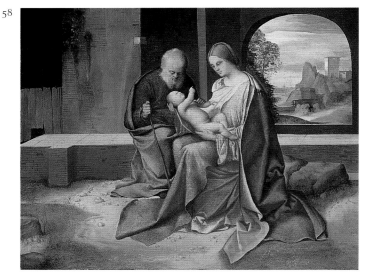

57	58	59

Raphael
(Central Italian, 1483–1520)
The Small Cowper Madonna
c. 1505, oil on panel
59.5 × 44 (23 ³⁄₈ × 17 ³⁄₈)
Widener Collection
1942.9.57

Giorgione
(Venetian, 1477/1478–1510)
The Holy Family
probably c. 1500, oil on panel
transferred to hardboard
37.3 × 45.6 (14 ⁵⁄₈ × 17 ⁷⁄₈)
Samuel H. Kress Collection
1952.2.8

Agnolo Bronzino
(Florentine, 1503–1572)
The Holy Family
c. 1527/1528, oil on panel
101.3 × 78.7 (39 ⁷⁄₈ × 31)
Samuel H. Kress Collection
1939.1.387

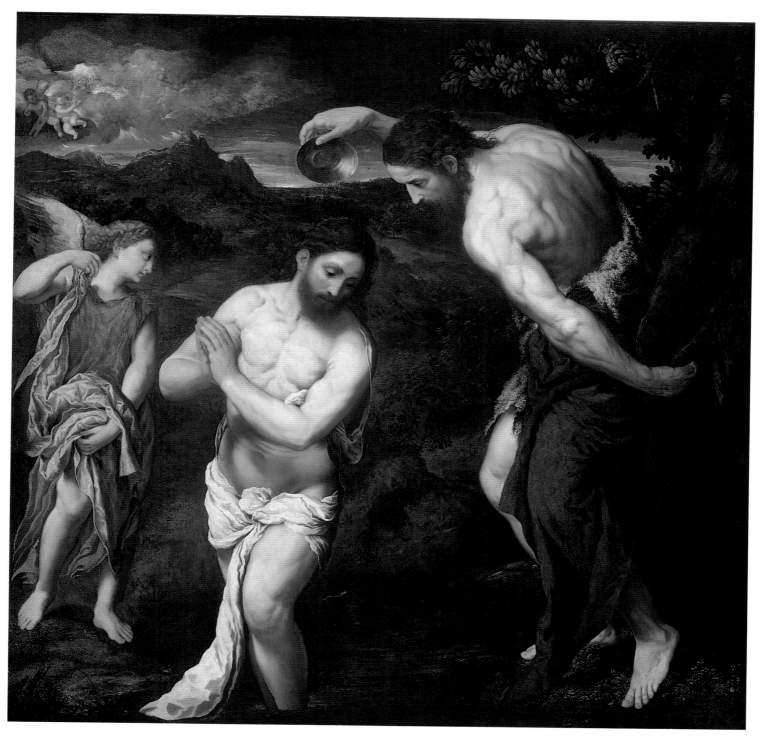

60

Paris Bordone
(Venetian, 1500–1571)
The Baptism of Christ
c. 1535/1540, oil on canvas
129.5 × 132 (51 × 52)
Widener Collection
1942.9.5

The Feast of the Gods

GIOVANNI BELLINI AND TITIAN

• Painted when Bellini was well into his eighth decade, this is a masterful rendering of a profane, even erotic, subject by an artist best known for his religious works. As recounted in the *Fasti* by Ovid, the gods gathered in a woodland dell to feast and drink wine accompanied by nymphs and satyrs. Beginning from the left, the identifiable deities include a youthful Bacchus filling a pitcher with wine, Mercury holding a caduceus and wearing a metal helmet, Jupiter accompanied by an eagle, Neptune with a trident on the ground beside him, and Apollo bringing a bowl to his lips and holding a *lira da braccio* (forerunner of the violin) out to his side. At the far right Priapus, who was enamored of the beautiful sleeping nymph Lotis, begins to lift her robe. In the next moment, however, Silenius' ass, seen at the left, will bray, alerting the gods, who then make fun of Priapus and thwart his amorous intentions.

The *Feast of the Gods* was the first of a series of paintings on bacchanalian themes commissioned by Duke Alfonso d'Este to decorate the *camerino d'alabastro* (alabaster study) in his castle in Ferrara. Unfortunately, the study was dismantled, but three paintings by Titian survive: the *Worship of Venus* and *Bacchanal of the Andrians* (both in the Museo del Prado, Madrid) and *Bacchus and Ariadne* (National Gallery, London). Titian was in Ferrara in 1524, 1525, and 1529, and during one or more of these visits he altered Bellini's painting, adding the mountain at the left and a good deal of the foliage at the upper right. It is generally thought that the changes were made to bring Bellini's painting into greater harmony with Titian's canvases. The result is a unique combination of the talents of the two foremost painters of the Renaissance.

When the German artist Albrecht Dürer visited Bellini in 1506, he wrote in a letter, "He is very old, but he is still the best painter of them all." The *Feast of the Gods* justifies this opinion in the glowing colors and sense of atmosphere that pervades the scene. Note especially how the repetition of white, blue, and green in the gods' costumes creates the equivalent of musical cadence to carry the eye across the surface to the figures of Priapus and Lotis.

Giovanni Bellini and Titian
(Venetian, c. 1430/1435–1516;
Venetian, c. 1490–1576)
The Feast of the Gods
1514/1529, oil on canvas
170.2 × 188 (67 × 74)
Widener Collection
1942.9.1

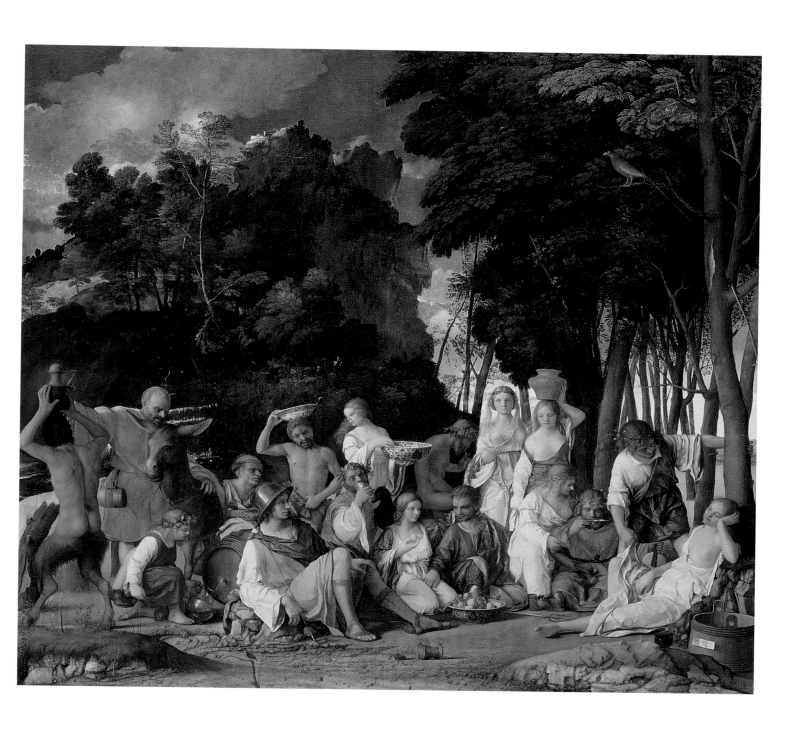

The Miraculous Draught of Fishes

JACOPO BASSANO

• Illustrated here are episodes from the life of Christ, as told in the Gospel of Luke (5:1–11). Having preached from a boat on Lake Gennesaret, Christ directed the fishermen to cast their nets into the water, even though they had worked all night and had caught nothing. At the right Zebedee uses an oar to hold the boat steady while his sons James and John struggle to lift the net, which has miraculously been filled with fish. In the second boat Simon Peter, astonished and chastened by the miracle, kneels in front of Christ to confess his sins. Christ blesses him and replies, "Do not be afraid; henceforth you will be catching men." It is in this moment that the men become Christ's disciples.

Although Jacopo Bassano studied in Venice in the 1530s and is considered a member of the Venetian school, he spent most of his long career in the town of his birth, Bassano del Grappa, which lies about thirty miles northwest of Venice, not far from Vicenza. Prints were a pivotal means of transmitting visual information during the Renaissance, and despite his geographical isolation Bassano was able to keep abreast of artistic developments by amassing a collection of prints. In the case of the *Miraculous Draught of Fishes*, his design is based on a chiaroscuro woodcut by Ugo da Carpi that reproduced, in reverse, a tapestry cartoon by Raphael. Scarcely more than an outline, Carpi's woodcut served only as a starting point. Bassano enlivened the composition with high-keyed hues of pink, green, and orange and with dramatic devices such as the billowing cloak on the standing figure, generally identified as Andrew.

Because the painter's account books have survived, it is known that the *Miraculous Draught of Fishes* was commissioned in April 1545 by Pietro Pizzamano, the Venetian governor of Bassano del Grappa. In August of that year Pizzamano returned to Venice and probably brought the picture with him. Looking at the picture would have brought back memories of his stay, for in the distance to the right the artist has included a view of Bassano, located inaccurately but poetically in front of Monte Grappa.

Jacopo Bassano
(Venetian, c. 1510–1592)
The Miraculous Draught of Fishes
1545, oil on canvas
143.5 × 243.7 (56 ½ × 96)
Patrons' Permanent Fund
1997.21.1

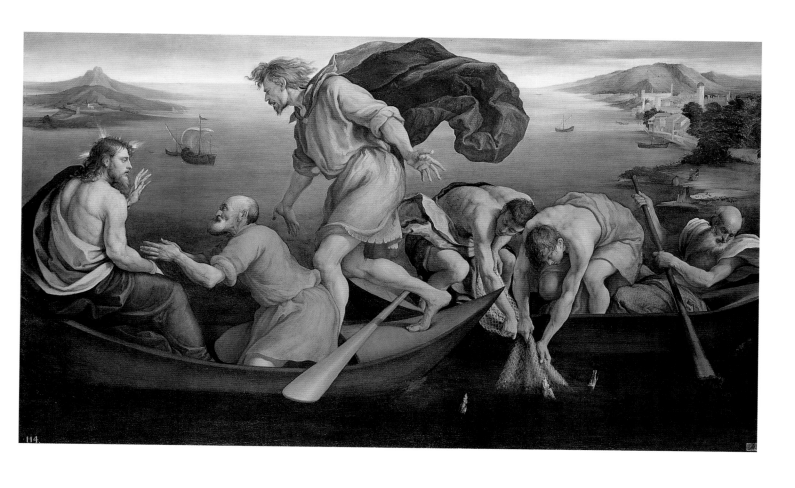

Circe and Her Lovers in a Landscape

• Naked, except for the garland of flowers in her hair, the sorceress holds a tablet inscribed with a magical spell. At her feet is an open book displaying a diagram used for incantations. Arrayed around her are her lovers, whom she has transformed into birds and beasts: spoonbill, owl, and falcon, doe, stag, greyhound, and perhaps most appealing, a white puppy. This painting is most often thought to be based on the tenth book of Homer's *Odyssey*, where Circe, who lives on the island of Aiaia with the lions and wolves she has enchanted, turns Odysseus' companions into swine. The creatures depicted here do not match those cited by Homer, however, which has led some to identify the sorceress as the malevolent Alcina in Ariosto's *Orlando Furioso*. But the image does not correspond to that text either. Thus it seems likely that this Circe is an amalgam drawn from various sources, both classical and contemporary.

Dosso Dossi came from a small city near Ferrara and Mantua and spent his career as a court artist. Because none of his paintings is dated and documents are often lacking, the exact chronology of his works is uncertain. Now considered an early work, *Circe and Her Lovers in a Landscape* is dated c. 1511–1512 and may have been painted for Dosso's first patron, Francesco II Gonzaga, marchese of Mantua.

There is a strong influence of Venetian masters in this picture: the sensitively observed and carefully described animals and birds recall Giovanni Bellini, while the poetic mood created by the warm light and feathery brushwork in the landscape is indebted to Giorgione. In 1513 Dosso moved to Ferrara to work for Francesco's brother-in-law Alfonso d'Este, and at some point in the 1520s he was joined by his younger brother Battista. The two artists continued to work for Alfonso's son Ercole II until their deaths. The counts at Mantua and Ferrara, the latter especially, were among the most cultured and learned in Europe, and the full meaning of many of the mythological and allegorical paintings produced by Dosso and Battista Dossi may never be completely understood.

Dosso Dossi
(Ferrarese, active 1512–1542)
Circe and Her Lovers in a Landscape
c. 1511–1512, oil on canvas
100.8 × 136.1 (39 5/8 × 53 1/2)
Samuel H. Kress Collection
1943.4.49

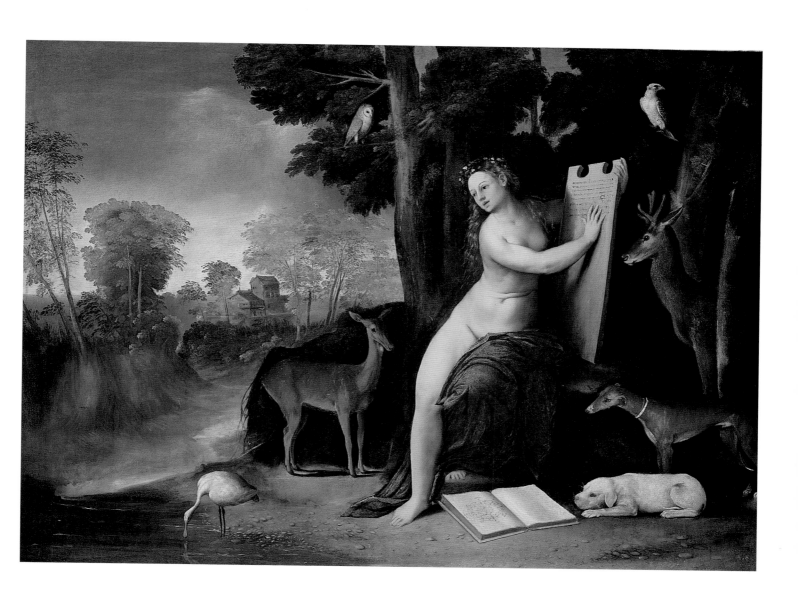

The Adoration of the Shepherds

• Among the greatest artists of the Renaissance, Giorgione is also one of the most elusive and mysterious. Of humble birth, he came to Venice from Castelfranco, a center of humanistic culture in the Veneto. In Venice he was influenced by Giovanni Bellini and seems to have had access to images in the drawings of Leonardo da Vinci. His only known public commission is an altarpiece sent to the cathedral in Castelfranco; instead, Giorgione was patronized by what was probably a small group of wealthy, aristocratic Venetians who shared a taste for obscure or unusual subjects—several of his pictures are without precedent.

Giorgione was only about thirty-two or thirty-three when he died of the plague, yet his influence pervades Venetian painting. Only about twenty paintings are accepted as autograph, and even these can be the subject of debate. Titian was Giorgione's most famous pupil, and at various times the *Adoration of the Shepherds* has been attributed to Titian or seen as a collaboration between the two men.

Most scholars, however, believe that the full measure of Giorgione's genius is to be seen in this painting. At the right Mary and Joseph are joined by shepherds in ragged clothing as they all silently worship the newborn babe. In keeping with Franciscan ideals of poverty and with Saint Bridget of Sweden's mystical vision, the Christ Child is depicted lying naked and humble on the ground, with only a thin cloth between him and the cold earth. Interestingly, Giorgione has reverted to the older, essentially Byzantine iconography of setting the Nativity in front of a cave rather than in a manger (see Duccio's *Nativity*; no. 2); this underscores Venice's long-standing ties with the East and the Byzantine world. Inside the cave are the ox and ass, with glowing cherub heads hovering over them. A series of curving forms leads from foreground to background, until one reaches a crepuscular radiance on the horizon that marks the literal and metaphorical dawning of a new day.

Giorgione was an extraordinary colorist, as can be seen in the flamelike brilliance of Joseph's golden cloak, the intense saturated blue of the Madonna's robe, or the chords of red, white, blue, olive green, and brown in the herdsmen's costumes. Perhaps the most remarkable aspect of this painting is the moist, limpid light that suffuses the entire scene, creating an indefinable but palpable poetic atmosphere that unifies man and nature.

Giorgione
(Venetian, 1477/1478–1510)
The Adoration of the Shepherds
1505/1510, oil on panel
90.8 × 110.5 (35 ¾ × 43 ½)
Samuel H. Kress Collection
1939.1.289

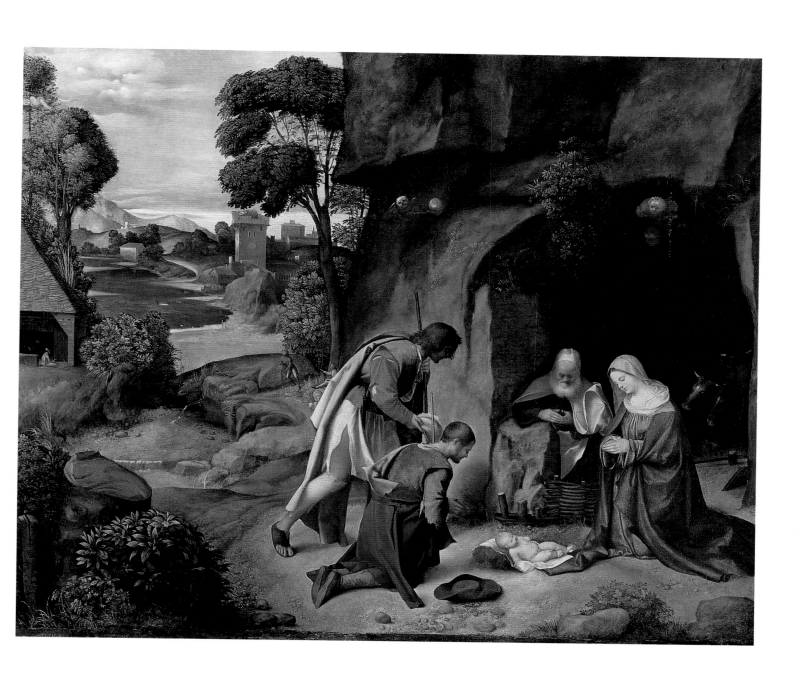

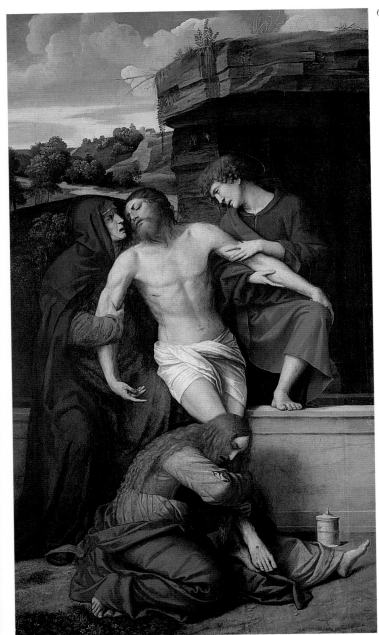

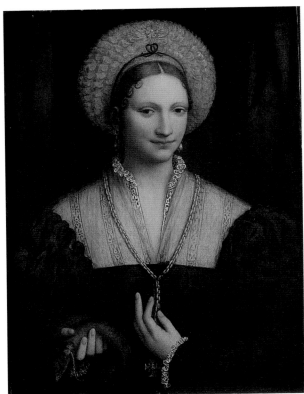

65

Bernardino Luini
(Milanese, c. 1480–1532)
The Magdalen
c. 1525, oil on panel
58.8 × 47.8 (23 ⅛ × 18 ⅞)
Samuel H. Kress Collection
1961.9.56

66

Bernardino Luini
(Milanese, c. 1480–1532)
Portrait of a Lady
1520/1525, oil on panel
77 × 57.5 (30 ⅜ × 22 ½)
Andrew W. Mellon Collection
1937.1.37

67

Moretto da Brescia
(Brescian, 1498–1554)
Pietà
1520s, oil on panel
175.8 × 98.5 (69 ⅛ × 38 ¾)
Samuel H. Kress Collection
1952.2.10

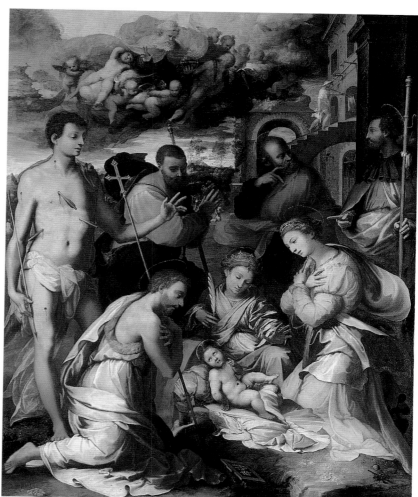

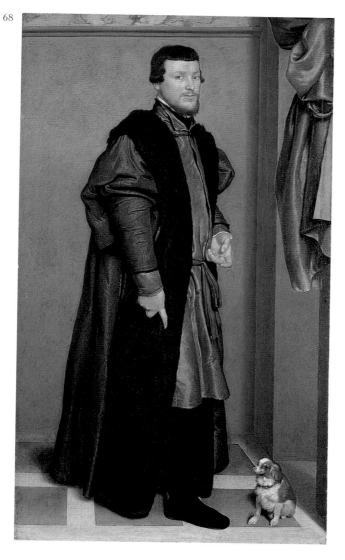

68

Giovanni Battista Moroni
(Bergamo, c. 1525–1578)
Gian Federico Madruzzo
c. 1560, oil on canvas
201.9 × 116.8 (79 ½ × 46)
Timken Collection
1960.6.27

69

Perino del Vaga
(Central Italian, 1501–1547)
The Nativity
1534, oil on panel transferred to canvas
274.4 × 221.1 (108 ¼ × 87 ⅛)
Samuel H. Kress Collection
1961.9.31

Charity

ANDREA DEL SARTO

• This artist's real name was Andrea d'Agnolo, but because his father was a tailor, he was called "del Sarto." Born and trained in Florence, Andrea spent virtually his entire life in that city and was well acquainted with the art of Leonardo, Fra Bartolomeo, and Michelangelo. He collaborated with less well known painters Franciabigio and Bacchiacca. In 1518–1519 Andrea was in Fontainebleau working for the French king, Francis I, and there is evidence that he made a trip to Rome. In his frescoes and paintings Andrea achieved what might be called a classical High Renaissance style, and he also anticipates certain element of mannerism.

This work was painted not long before Andrea died of the plague in 1530. Commissioned by Giambattista della Palla, an agent for Francis I, the panel was probably intended for the French king. But della Palla was either exiled or imprisoned before he could take possession of it, and the picture remained in Andrea's studio at the time of his death, passing first to his widow and then to his pupil Domenico Conti, who also inherited his drawings.

Charity is a theological virtue traditionally considered along with faith and hope, and here it is given the personification of a woman who nourishes several children. The painting was first designed as a Holy Family, similar in composition to Andrea's painting of c. 1527/1528 in the Metropolitan Museum of Art, New York; only later was it transformed into a figure of *Charity*. Visible between the two eldest children is a hand resting on a globe, a remnant from the earlier subject.

Andrea's masterful brushwork and gifts as a colorist are evident in the woman's shimmering yellow sleeves and her red dress, which modulates from pink to white. The painting's spatial ambiguities and the twisting, slightly unstable pose of the foremost infant look forward to the kind of mannerism practiced by Andrea's two most famous pupils, Pontormo and Rosso Fiorentino.

Andrea del Sarto
(Florentine, 1486–1530)
Charity
before 1530, oil on panel
119.5 × 92.5 (46 ⅞ × 36 ⅜)
Samuel H. Kress Collection
1957.14.5

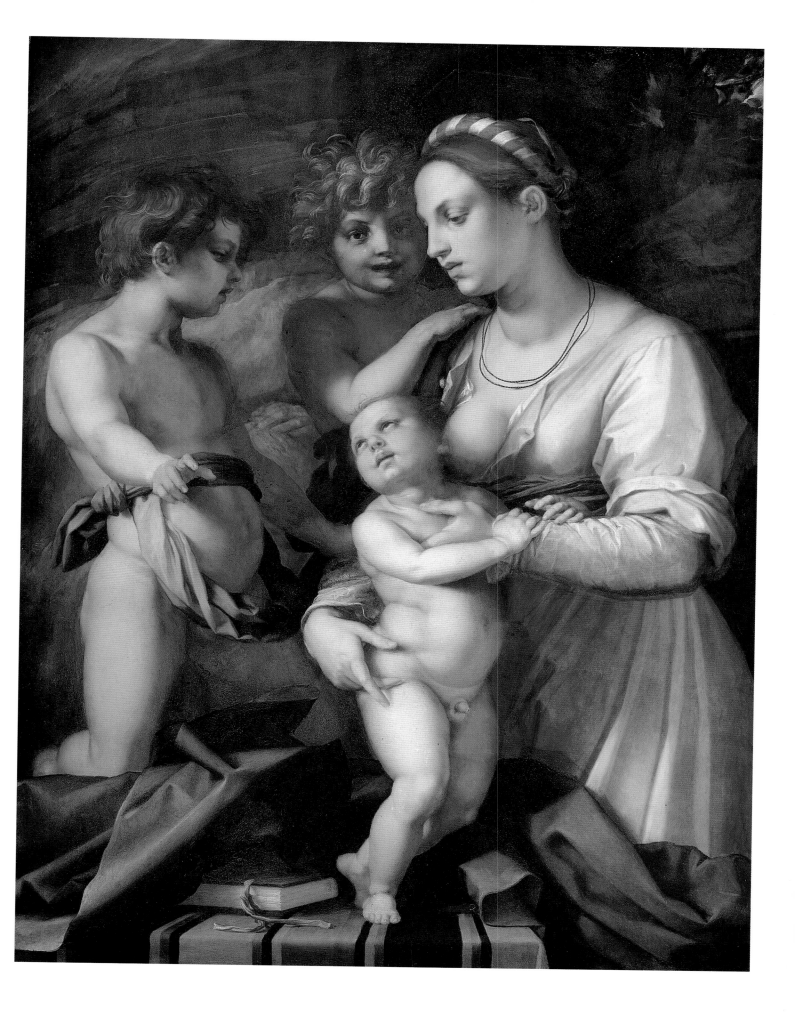

Cardinal Bandinello Sauli, His Secretary, and Two Geographers

SEBASTIANO DEL PIOMBO

• Cardinal Bandinello Sauli is shown wearing the red and white liturgical garments of his office. To his left an unidentified man, probably his secretary, appears to be conversing with him. Sauli was known for his patronage of men of letters, and immediately to his right is Giovanni Maria Cattaneo, while at the far right is Paolo Giovio, both of whom were celebrated humanists and poets. The men are seated around a table covered with a Turkish carpet, known as a "Lotto carpet" because the type often appears in the paintings of Lorenzo Lotto. On the table is the focus of the discussion, a folio volume illustrated with maps, calling to mind the discovery and exploration of the New World. Also on the table is a bell inscribed with an abbreviated form of the cardinal's name; this may allude to the bell rung during the Sanctus of the Mass. The painting contains two illusionistic devices: the piece of folded paper at the lower right that bears the date 1516, and the fly on the cardinal's knee. The fly can be seen simply as a clever example of trompe l'oeil or as a talisman that protects against disease.

The careers of Bandinello Sauli and the artist, Sebastiano del Piombo, demonstrate something of the vicissitudes of religious politics in Rome in the early sixteenth century. A native of Genoa, Sauli became a bishop in 1509 and was made a cardinal by Pope Julius II in 1511. In 1517, a year after this picture was completed, he was accused of being part of a plot against Pope Leo X and imprisoned in the Castel San Angelo. He recanted and was released but died in 1518. Sebastiano, whose family name was Luciani, was probably born in Venice and was influenced by Bellini and Giorgione. In 1511 Sebastiano accompanied the Sienese banker Agostino Chigi to Rome and chose to remain in the city, which was being transformed by the innovations of Raphael and Michelangelo. Although he admired Raphael, Sebastiano became a good friend to Michelangelo, who provided him with drawings. Following Raphael's death in 1520, Sebastiano became the leading painter in Rome, especially renowned for his portraits. Because of his loyalty to the pope during and immediately following the sack of Rome in 1527, Sebastiano was rewarded with a sinecure and appointed Keeper of the Papal Seals (Piombatore), hence his nickname "del Piombo."

71

Sebastiano del Piombo
(Venetian, 1485–1547)
Cardinal Bandinello Sauli,
His Secretary, and Two Geographers
1516, oil on panel transferred to canvas
121.8 × 150.4 (48 × 59 ¼)
Samuel H. Kress Collection
1961.9.37

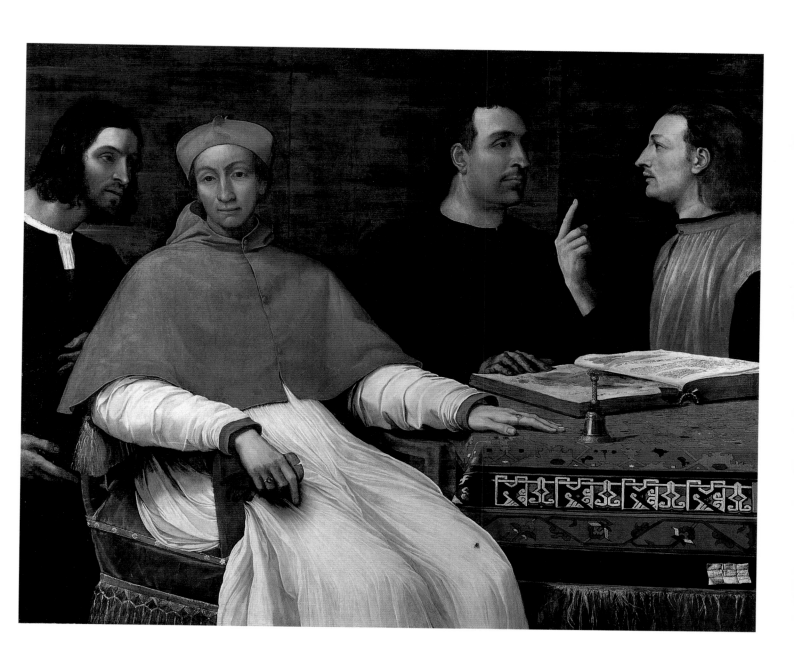

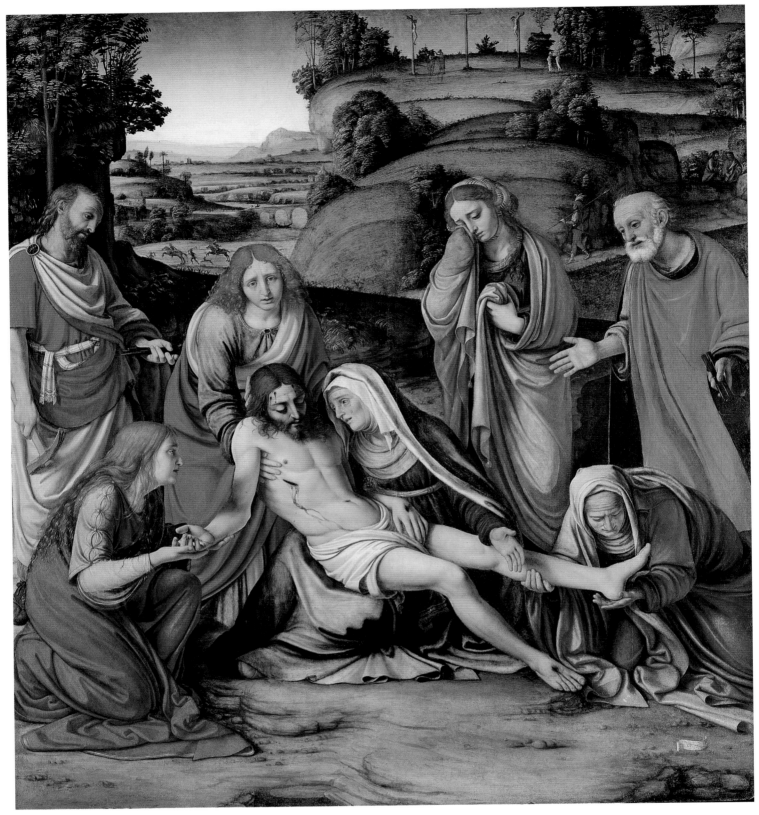

72

Andrea Solario
(Milanese, active 1495–1524)
Lamentation
c. 1505–1507, oil on panel
168.6 × 152 (66 ³/₈ × 59 ⁷/₈)
Samuel H. Kress Collection
1961.9.40

73

Rosso Fiorentino
(Florentine, 1494–1540)
Portrait of a Man
early 1520s, oil on panel
88.7 × 67.9 (34 ⁷/₈ × 26 ³/₄)
Samuel H. Kress Collection
1961.9.59

74

Jacopino del Conte
(Florentine, 1510–1598)
*Madonna and Child with Saint Elizabeth
and Saint John the Baptist*
c. 1535, oil on panel
161.3 × 119 × 2.9 (63 ¹/₂ × 46 ⁷/₈ × 1 ¹/₈)
Ailsa Mellon Bruce Fund
1985.11.1

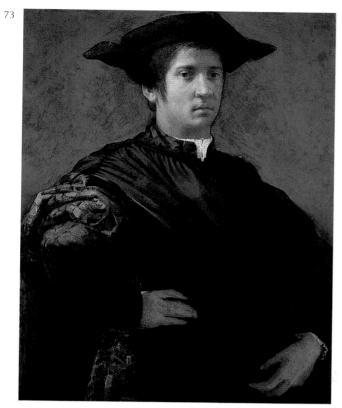

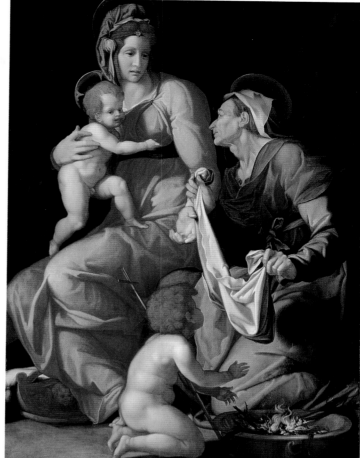

75

76

Pontormo
(Florentine, 1494–1556/1557)
Monsignor della Casa
probably 1541/1544, oil on panel
102 × 78.9 (40 ⅛ × 31)
Samuel H. Kress Collection
1961.9.83

Veronese
(Venetian, 1528–1588)
The Martyrdom and Last
Communion of Saint Lucy
c. 1582, oil on canvas
139.7 × 173.4 (55 × 68 ¼)
Gift of The Morris and Gwendolyn
Cafritz Foundation and Ailsa
Mellon Bruce Fund
1984.28.1

Venus with a Mirror

TITIAN

• This depiction of the goddess of love and beauty clearly manifests the artist's ability not only to absorb the classical past but to transform it into a sensuous reality. The figure's pose, with her left arm raised to cover her breast and her right arm crossed in front of her lower torso, is found in antique statuary and identifies her as *Venus pudica* or "modest Venus." It is likely that Titian knew a famous statue of this type, the Venus de' Medici, that was in Rome in the sixteenth century. As one cupid reaches to place a wreath of flowers on her head, Venus admires her reflection in the mirror held by a second cupid. In a clever visual conceit, however, viewers realize that by looking in the mirror she is returning their gaze. As befits a goddess, Venus wears a large pearl earring, has a strand of pearls braided into her hair, and is further adorned with rings and bracelets. Her fur-lined robe appears to be made of velvet with a border decorated with gold and silver threads, a luxurious garment that contrasts with her warm, pliant skin and enhances her nakedness.

This is one of the most important and influential of Titian's paintings. Although a number of versions of the subject have been associated with the artist, this *Venus with a Mirror* is the only one considered an autograph work by the master. Moreover, Titian's composition continued to be used by later generations of artists, such as, for example, Rubens, whose copy is now in the Museo Thyssen-Bornemisza, Madrid.

Venus with a Mirror evidently had special significance for Titian, because he kept it in his house until his death and it was inherited by his son Pompeo Vecellio. In 1589 the house and its contents were sold, and the painting passed to the Barbarigo family of Venice, where it remained until around 1850 when it was sold to Czar Nicholas I and entered the Imperial Hermitage Gallery in St. Petersburg, Russia. In 1931 it was purchased from the Hermitage and sold to Andrew W. Mellon, and it is one of the paintings that hung in galleries at the inauguration of the National Gallery of Art in 1941.

Titian
(Venetian, c. 1490–1576)
Venus with a Mirror
c. 1555, oil on canvas
124.5 × 105.5 (49 × 41 ½)
Andrew W. Mellon Collection
1937.1.34

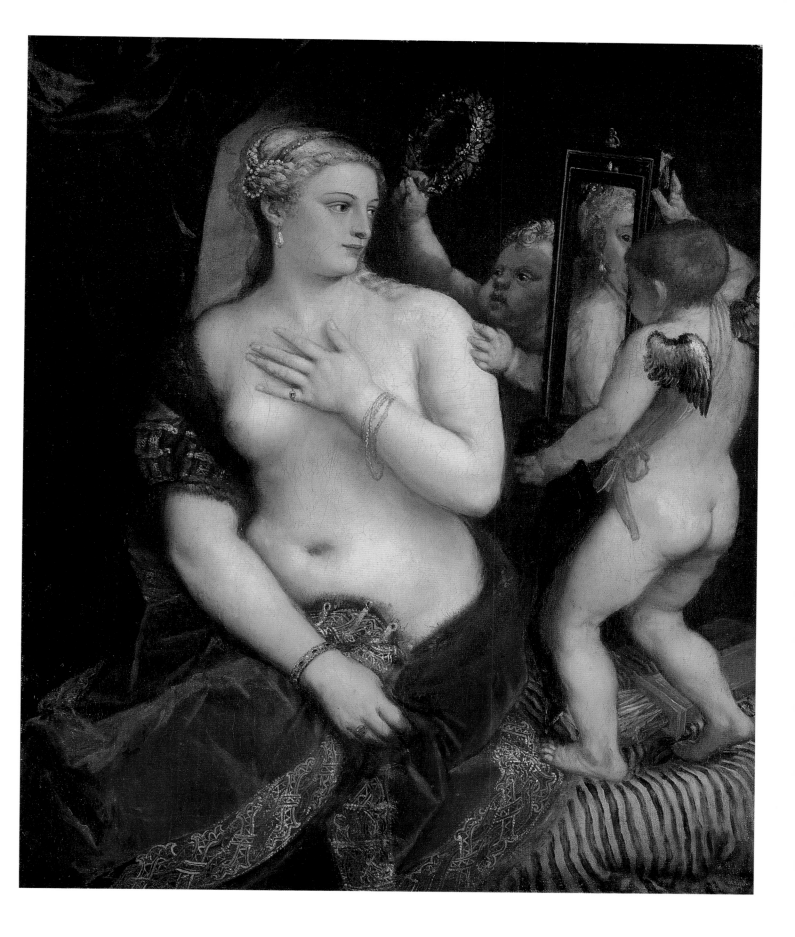

Ranuccio Farnese

TITIAN

· In the course of a long professional life, which included positions at several European courts, Titian painted many portraits, but few are as brilliant or as insightful as this. The sitter is Ranuccio Farnese, who was twelve years old in 1542 at the time Titian portrayed him. It was in this year that Ranuccio's grandfather, Alessandro Farnese, who had earlier become Pope Paul III, sent the boy to Venice to assume the position of prior at San Giovanni dei Forlani, which belonged to the Knights of Malta. Ranuccio is depicted wearing a black cloak on which appears the white cross of the order, originally founded in the Middle Ages to assist travelers and pilgrims in the Holy Land.

As an ecclesiastic, Ranuccio Farnese was something of a prodigy. He was the archbishop of Naples when he was fourteen years old and was elected a cardinal the following year. A succession of positions in the church followed, but Ranuccio died in 1565 when he was only thirty-five years old.

With a palette restricted to black, white, and red, augmented by golden highlights, Titian's virtuoso brushwork evokes the varied textures of satin and velvet in Ranuccio's stately costume as well as the luminosity of his youthful complexion. More astonishing is the way Titian has captured the individual character of this adolescent on the cusp of an adult career. His features are not fully formed, his ears are too large for his face, and he is almost overwhelmed by his cloak, yet Ranuccio appears shyly poised and ready to embrace his vocation.

This portrait was ordered by Andrea Cornaro, a guardian of the young man, as a gift for Ranuccio's mother, Girolama Orsini, wife of Pier Luigi Farnese. This was Titian's first commission for the Farnese family, among the most prominent and powerful in Italy, and it was obviously well received, for the artist went on to produce a number of notable paintings for the Farnese.

Titian
(Venetian, c. 1490–1576)
Ranuccio Farnese
1542, oil on canvas
89.7 × 73.6 (35 ¼ × 29)
Samuel H. Kress Collection
1952.2.11

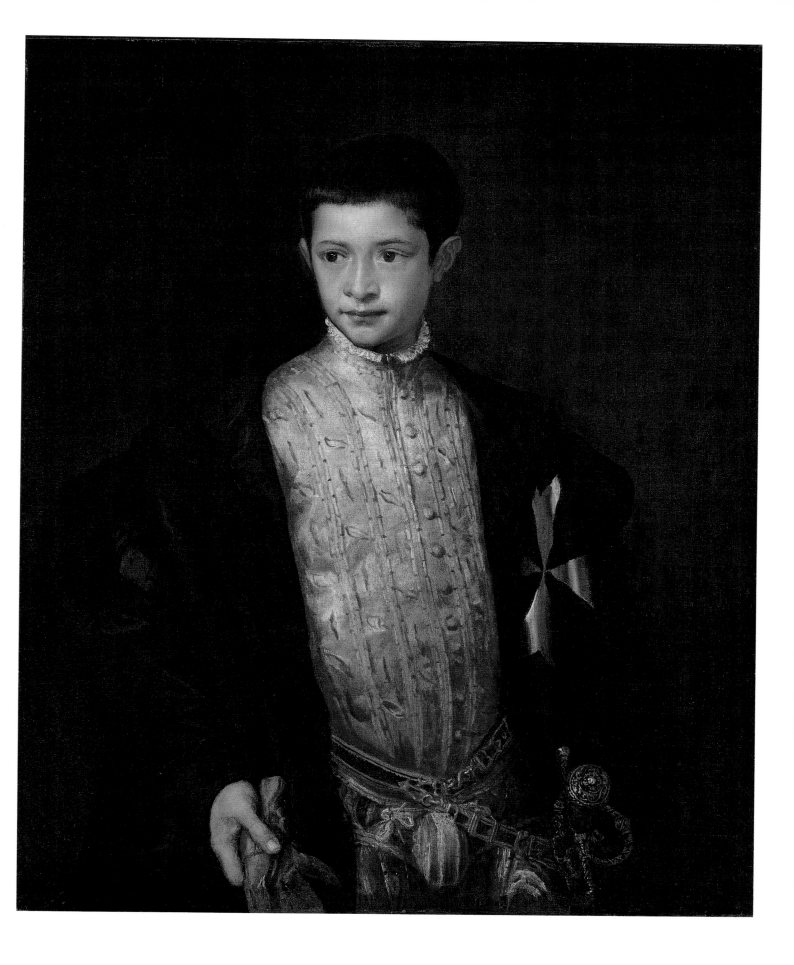

Doge Andrea Gritti

TITIAN

• Unique in Italy, Venice was a republican oligarchy led by a doge, who was chief executive, magistrate, and figurehead. He was elected in a complicated process that was designed to prevent dominance by any of the city's patrician families. Pictured here is Andrea Gritti, who wears the distinctive cap, or *cornetto*, and cloak that are emblems of the office. After an outstanding career as a diplomat and military leader, Gritti was elected doge in 1523 when he was sixty-eight years old. He remained at the helm of the Venetian Republic until his death at the age of eighty-three in 1538. Doge Gritti's tenure was successful on both the political and the cultural level; following the sack of Rome in 1527 he welcomed artists and scholars to Venice and was instrumental in awarding civic commissions to Titian and others.

Stylistic analysis has established that this a posthumous portrait, painted sometime between 1546 and 1548, in which Titian created a Doge Gritti whose physique and character are magnificently imposing. Set against a neutral background, Gritti's massive bulk dominates the picture, while a curving line of decorative buttons on his cloak leads the eye toward the doge's head. One glance at Gritti's severe, intense expression is enough to convince one that this was a man determined to have his own way. In 1545 and for part of 1546 Titian was in Rome, and critics have noted that Gritti's powerful hand was modeled after the hand in Michelangelo's statue of *Moses*, which Titian could have seen on the tomb of Pope Julius II.

The portrait of Doge Andrea Gritti strikingly demonstrates Titian's skill as a painter. Taking advantage of the rough texture of the canvas and using only red, gold, brown, and white paint, Titian used a wide range of techniques, from thin layers of glaze to thick impasto. The cloak is rendered in broad strokes that have a nearly abstract quality. The energy of the brushwork accords perfectly with the forceful vigor of Gritti's personality.

Titian
(Venetian, c. 1490–1576)
Doge Andrea Gritti
1546–1548, oil on canvas
133.6 × 103.2 (52 ½ × 40 ⅝)
Samuel H. Kress Collection
1961.9.45

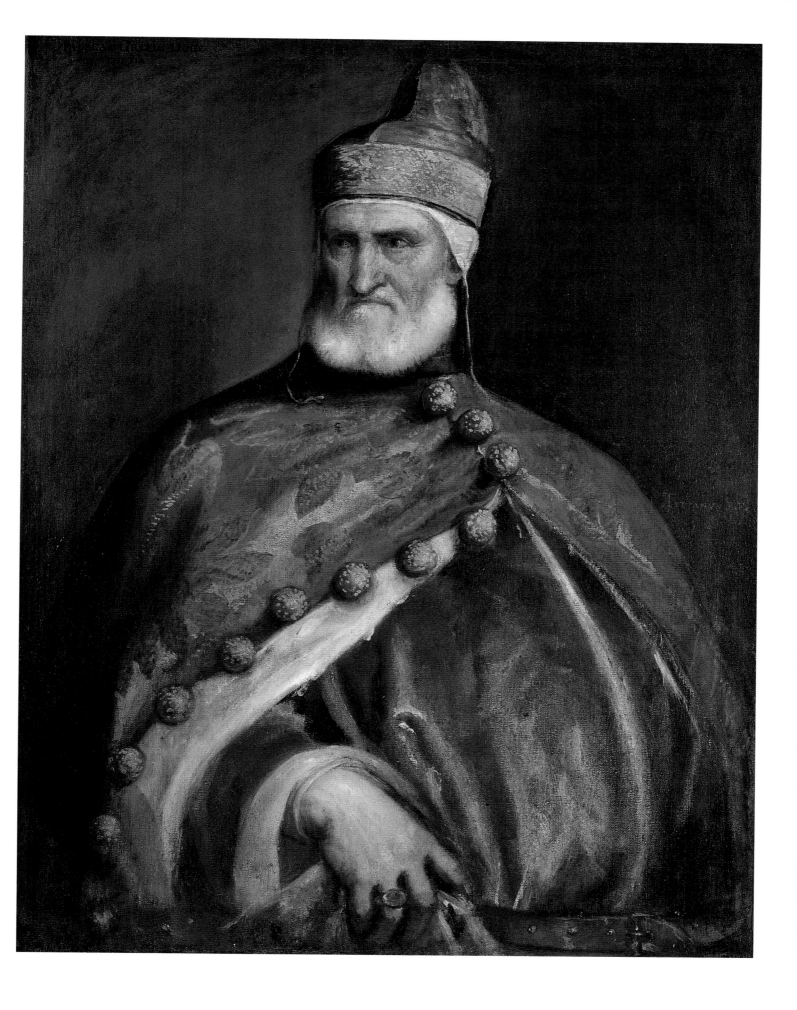

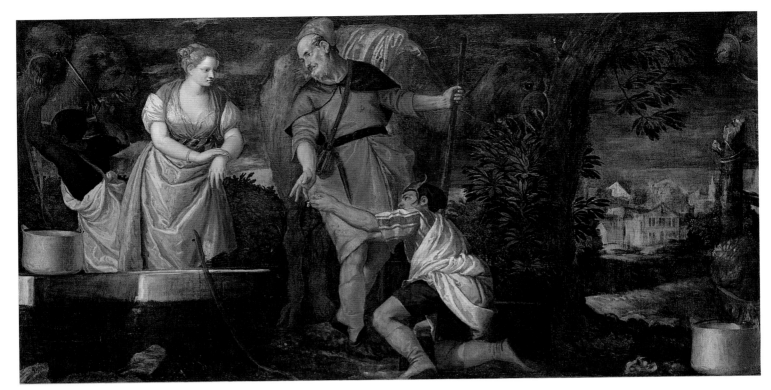

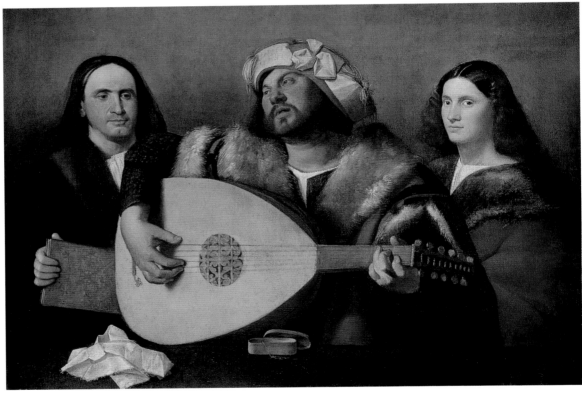

Veronese
(Venetian, 1528–1588)
Rebecca at the Well
1580/1585, oil on canvas
145.5 × 282.7 (57 ¼ × 111 ¼)
Samuel H. Kress Collection
1952.5.82

Cariani
(Venetian, 1485/1490–1547 or after)
A Concert
c. 1518–1520, oil on canvas
92 × 130 (36 ¼ × 51 ⅛)
Bequest of Lore Heinemann
in memory of her husband,
Dr. Rudolf J. Heinemann
1997.57.2

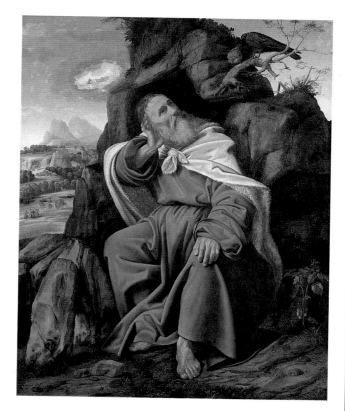

82

83

Giovanni Girolamo Savoldo
(Brescian, c. 1480–1548 or after)
Elijah Fed by the Raven
c. 1510, oil on panel transferred to canvas
168 × 135.6 (66 ¹⁄₈ × 53 ³⁄₈)
Samuel H. Kress Collection
1961.9.35

Giulio Cesare Procaccini
(Lombard, 1574–1625)
The Ecstasy of the Magdalen
1616/1620, oil on canvas
215.9 × 146.05 (85 × 57 ¹⁄₂)
Patrons' Permanent Fund
2002.12.1

Allegory of Virtue and Vice

LORENZO LOTTO

• In the fifteenth and sixteenth centuries it was common practice to provide covers for portraits to protect the image. Now lost, an inscription originally on the reverse of this panel indicated that it belonged with a depiction of Bernardo de' Rossi, bishop of Treviso, "age 36 years, 10 months, 5 days. Painted by Lorenzo Lotto July 1, 1505." Lotto's portrait of the cleric is in the Museo e Gallerie Nazionale di Capodimonte, Naples, and it is slightly smaller than this panel. Bernardo de' Rossi was Lotto's first major patron, and the artist worked for him after leaving his native Venice, from about 1503 until 1506.

Although there is scholarly debate over the sources and precise interpretation of various elements in this painting, the general meaning is clear. Life offers a choice between the virtuous but difficult way and the easy way that has bad consequences in the long run. At the right a drunken satyr embraces a container of wine as more wine drains from a pot next to him. Milk spills from the classical vessel in front of him, a reference to the failure of good beginnings. In the stormy background a ship is on the verge of sinking. In contrast, a putto on the left holds a pair of dividers and is surrounded by mathematical and musical instruments, symbols of intellectual and spiritual achievement.

After overcoming the barrier of rocks and dead branches, the putto, now equipped with two sets of wings, ascends a steep path toward the light. The tree trunk in the center of the painting continues the symbolism; it is dead and broken on the right but has put forth a sturdy, leafy branch on the left. At the base of the tree is a shield bearing Rossi's coat of arms, which, as one might expect, face the side of diligence and virtue. In many regards Lotto's allegorical "portrait" on this cover was as accurate as the portrait itself, for Bishop Bernardo de' Rossi was a contentious personality who was forced to leave his posts in Treviso and later Bologna, and he was interested in natural science and antiquity.

Lorenzo Lotto was a brilliant yet idiosyncratic sixteenth-century Italian artist. Born and trained in Venice, he spent most of his career working in the smaller cities in the Veneto, such as Bergamo and Treviso, and in the Marches, such as Ancona, Recanati, and Loreto, where he died. It is only recently that a series of exhibitions have rekindled interest in Lotto's paintings.

Lorenzo Lotto
(Venetian, c. 1480–1556/1557)
Allegory of Virtue and Vice
1505, oil on panel
56.5 × 42.2 (22 ¼ × 16 ⅝)
Samuel H. Kress Collection
1939.1.156

Laocoön

EL GRECO (DOMENIKOS THEOTOKOPOULOS)

• El Greco, whose real name was Domenikos Theotokopoulos, emigrated from Crete to Italy, arriving first in Venice by 1568, then moving to Rome in 1570. He absorbed both the glowing colors and bravura brushwork of the Venetians and the mannerist style practiced in Rome. He was unable to establish himself as an artist in Rome, however, and by 1577 he had moved to Toledo, Spain, where his work was appreciated and where he spent the rest of his life.

Laocoön was painted in El Greco's last years and is his only surviving excursion into the realm of classical mythology. Several versions of the legend were available to the artist. Perhaps the best known of these is found in Virgil's *Aeneid*, where Laocoön, a Trojan priest, angered the goddess Minerva by throwing a spear at the wooden horse that the Greeks had built and dedicated to her, saying "Fools, trust not the Greeks, even when bearing gifts." As punishment she sent serpents to kill Laocoön and his two sons. The Trojans interpreted this as a sign that the horse, filled with Greek soldiers, should be brought into the city. Another, older legend says that Laocoön was a priest of Apollo and was ordered slain by the god because he had married and fathered children.

The standing male at the right is sometimes identified as Apollo, and the woman next to him could be Venus. What is almost certainly the Trojan horse can be seen in the middle distance just left of center. The city in the background is not Troy, however, but Toledo, in the unearthly light of a stormy sky.

This is easily among the most original and emotionally wrenching of El Greco's paintings. The nude, hyper-elongated bodies of Laocoön and one of his sons are contorted with anguish in their desperate efforts to escape the deadly serpents. The second son, perhaps already dead, lies on his back in an extremely foreshortened, disturbing position. The patterns of light and shade play over the figures to produce an eerie, flickering, flamelike effect. The ambiguous spatial setting reinforces the threatening, violent mood. It is no wonder that El Greco's expressive power spoke to a number of artists in the early twentieth century who wished to increase the emotional impact of their own work.

El Greco (Domenikos Theotokopoulos)
(Spanish, 1541–1614)
Laocoön
c. 1610/1614, oil on canvas
137.5 × 172.5 (54 1/8 × 67 7/8)
Samuel H. Kress Collection
1946.18.1

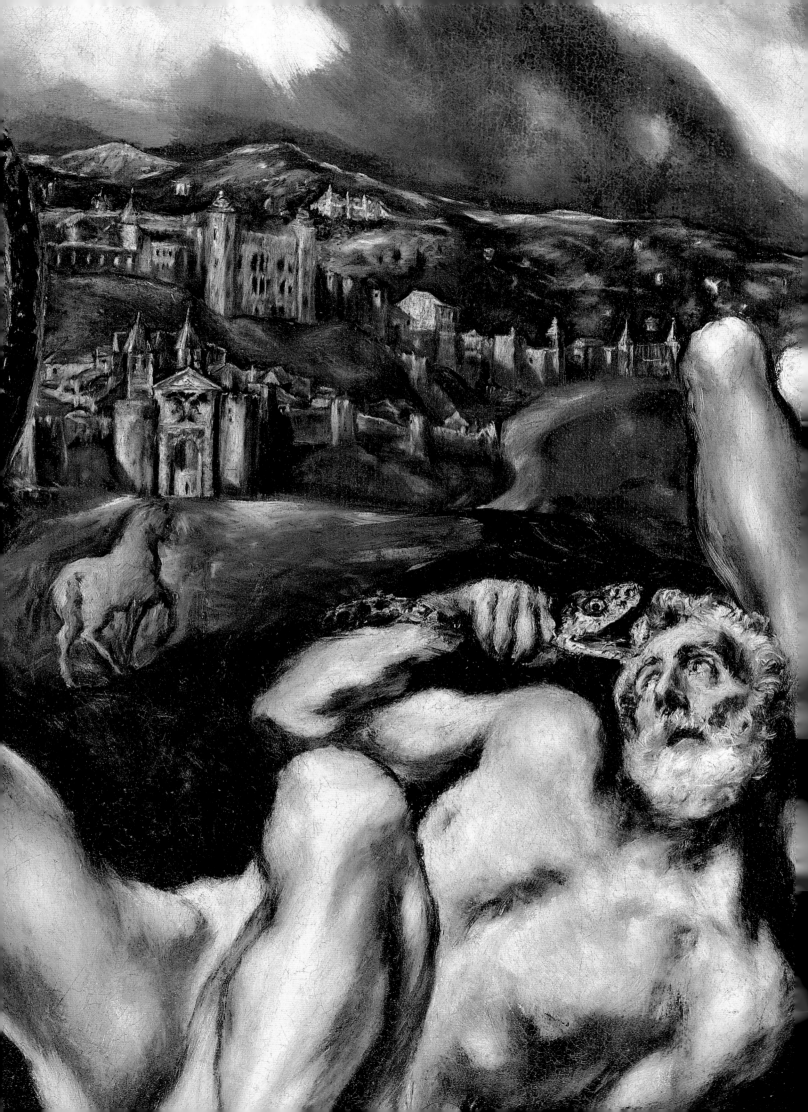

86

87

86

87

detail, *Laocoön*
(see pages 110–111)

El Greco (Domenikos Theotokopoulos)
(Spanish, 1541–1614)
Saint Martin and the Beggar
1597/1599, oil on canvas
with wooden strip added at bottom
193.5 × 103 (76 ⅛ × 40 ½)
Widener Collection
1942.9.25

El Greco (Domenikos Theotokopoulos)
(Spanish, 1541–1614)
Madonna and Child with
Saint Martina and Saint Agnes
1597/1599, oil on canvas,
wooden strip added at bottom
193.5 × 103 (76 ⅛ × 40 ½)
Widener Collection
1942.9.26

Portrait of a Man

CORNEILLE DE LYON

• The identity of this young man is not known, but it has been suggested that because he wears a brown tunic with a cowl and a soft cap of the same fabric he might be a member of the Franciscan order. It must be kept in mind, however, that academic dress grew out of clerical garb, and in the sixteenth century the two were often quite similar. Thus the sitter may have been attending a university. This splendid portrait by Corneille de Lyon captures with great sensitivity the young man's shyness and introspection as well as his intelligence.

It is likely that the frame in which the panel is shown today has been on the painting since its completion, for tabernacle frames—so called because they are shaped like the cabinets that held the consecrated bread for the Eucharist—were manufactured in France and northern Italy and used regularly by Corneille.

Born in The Hague, the artist has no known family name, and "de Lyon" refers to the city where he was active from 1533 until his death in 1575. Corneille was exclusively a portraitist, and he often worked on a small scale, as seen here. In more than two hundred paintings he created vivid characterizations of the nobility and bourgeoisie of France.

Corneille de Lyon
(French, active 1534–1574)
Portrait of a Man
c. 1540, oil on panel
16.5 × 14.3 (6 ½ × 5 ⅝)
Ailsa Mellon Bruce Fund
1965.8.1

A Lady in Her Bath

• One of only two signed paintings by François Clouet, *A Lady in Her Bath* is work of surpassing quality and a major monument in the history of French painting. It is also a sensuous and mysterious picture whose full implications may never be known. The naked woman seated in the bath is likely to be a mistress or courtesan, but the cool, idealized beauty has resisted repeated attempts to identify her. The woman's pose is derived from a lost depiction of a mistress by Leonardo da Vinci, who, it must be remembered, died in France and whose compositions were widely copied. Public bathhouses during the Renaissance were often associated with licentious behavior, but only the rich could afford the luxury of a private bath such as the one shown here. The wooden tub is lined with a white cloth and the red drapes were probably meant to protect the bather from drafts. In the background a servant girl, in front of a fireplace, holds a pitcher that probably contains hot water to be added to the bath. To the left of the fruit bowl in the foreground are sprigs of oregano, rosemary, and juniper that would add fragrance to the bathwater.

There are numerous elements in the painting that defy interpretation, such as the boy reaching for the fruit or the robust peasant nursing an infant, her coarse features and ruddy complexion in strong contrast to the flawless ivory skin of the woman in the tub. Is this possibly a reference to the mistress' duty to raise and educate children in the royal household? Especially contradictory and perhaps satirical is the unicorn, traditional symbol of virginity, embroidered on a chair in the background and the pink held by the woman, a flower associated with engagement and marriage and, by extension, purity. The significance of these may have been understood only in the atmosphere of the French court in the later sixteenth century.

The artist, François Clouet, was painter and "valet de chambre" to four successive French monarchs — Francis I, Henry II, Francis II, and Charles IX — and thus well acquainted with court intrigues. *A Lady in Her Bath* combines the Netherlandish love of the particular with the more abstract stylistic devices of Titian, Raphael, and Italian mannerists like Bronzino and Salviati. Italian artists were generously represented in the collection formed by Francis I and thus would have been available to Clouet.

89

François Clouet
(French, 1522 or before–1572)
A Lady in Her Bath
probably c. 1571, oil on panel
92.1 × 81.3 (36 ¼ × 32)
Samuel H. Kress Collection
1961.9.13

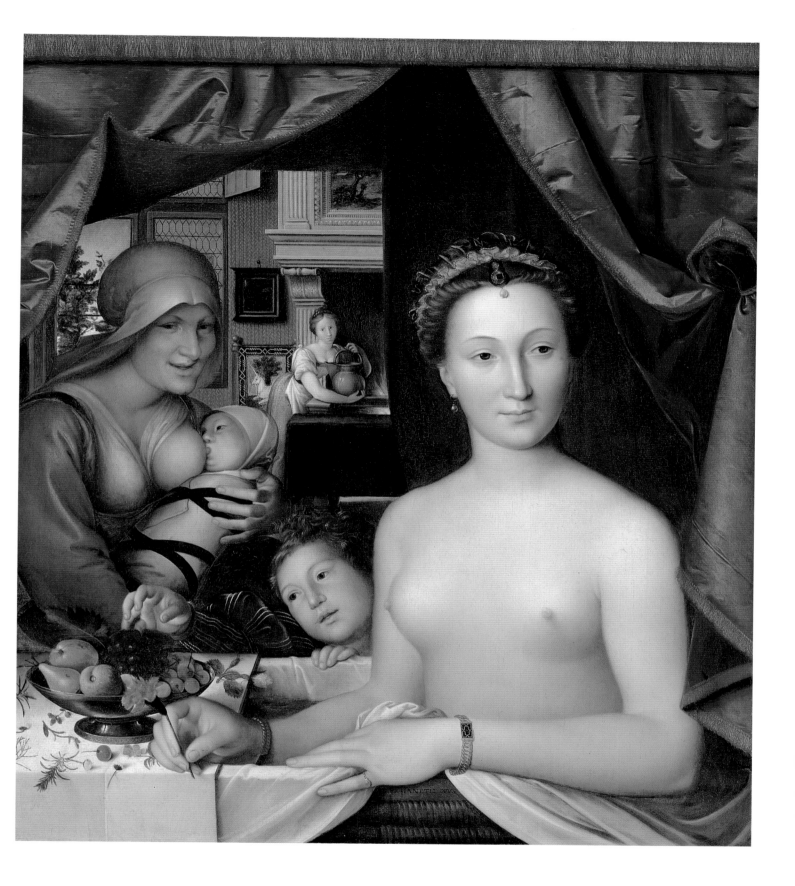

Death and the Miser

HIERONYMUS BOSCH

• Hieronymus Bosch is easily the most inscrutable of Netherlandish artists. His true name was Jeroen van Aken, but he signed seven of his paintings with a Latinized version of his first name combined with a shortened form of 's-Hertogenbosch, the northern Brabant city where he was born. Working in 's-Hertogenbosch in seeming isolation, Bosch was nonetheless patronized by such men as Philip the Fair, duke of Burgundy, and Hendrik III of Nassau, who owned and may have commissioned the famous triptych of the *Garden of Earthly Delights* (Museo del Prado, Madrid).

Despite the expenditure of enormous energy in myriad arcane areas of knowledge, the full meaning of Bosch's pictures defies coherent explanation. What one can say, however, is that Bosch is at heart a moralist who believes that men are essentially sinful and corrupt. *Death and the Miser* illustrates this view. The subject of the painting is based on a text written around 1400 entitled the "Ars Moriendi" (The Art of Dying), which discusses the battle between good and evil for a dying man's soul. Here, as a skeleton holding the arrow of death advances through a doorway, the bedridden man must choose between Christian salvation, represented by the crucifix in the upper window, and the sack of money offered by the demon who has emerged from the tester. At the foot of the bed an old man, who may be the alter ego of the dying miser, attempts to serve both "God and mammon" by putting coins into a sack with one hand while fingering a rosary with the other. The sack is held by a rat-faced creature, while under the chest another demon holds up a paper with red wax seal, perhaps an allusion to the usurous money-lending practices of misers. Atop the canopy a demon holding a torch (or a bit of hellfire?) looks down awaiting the miser's choice. It appears probable that avarice and damnation will prevail.

Death and the Miser was most likely the exterior left wing of an altarpiece, and perhaps for this reason no convincing explanation has been put forward for the cloak and sleeved garment or the armor in the foreground. It has been suggested that the *Ship of Fools* (Musée du Louvre, Paris) and the *Allegory of Intemperance* (Yale University Art Gallery, New Haven) were once part of the same altarpiece.

Hieronymus Bosch
(Netherlandish, c. 1450–1516)
Death and the Miser
c. 1485/1490, oil on panel
93 × 31 (36 5/8 × 12 1/4)
Samuel H. Kress Collection
1952.5.33

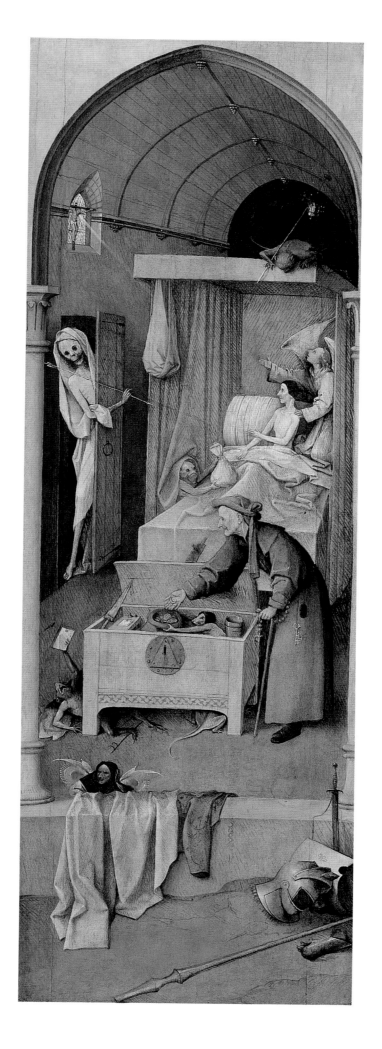

The Temptation of Saint Anthony

FOLLOWER OF PIETER BRUEGEL THE ELDER

• In the year 272, at the age of twenty-one, Anthony gave away his possessions to live as a hermit in the Egyptian desert and seek God. There he was visited by the devil and various demons who attempted without success to break his spiritual resolve to lead a pure and ascetic life. Two episodes from the temptation of Saint Anthony Abbot are represented here: at the right, menaced by grotesque demons, Anthony sits under a makeshift lean-to, while at the upper left he has been carried high into the air and is tormented by wasplike creatures. These events take place in an extensive landscape that is the real subject of the painting.

The artist was clearly under the spell of Pieter Bruegel the Elder. The figure of Anthony in his hut is taken from a Bruegel drawing. But one can also see the influence of two artistic personalities who were critical to the development of Bruegel's landscapes: the panoramic river view at the left is indebted to the innovations of Joachim Patinir, who worked in Antwerp until 1524; while the multitudes of demons and monsters derive from the inventions of Hieronymus Bosch, though they are hardly as terrifying. The author of the *Temptation of Saint Anthony* remains unidentified and no other works by him are known, yet as can be seen in the sensitively rendered effects of light and atmosphere, he was an artist of great skill.

Follower of Pieter Bruegel the Elder
The Temptation of Saint Anthony
c. 1550/1575, oil on panel
58.5 × 85.7 (23 × 33 ¾)
Samuel H. Kress Collection
1952.2.19

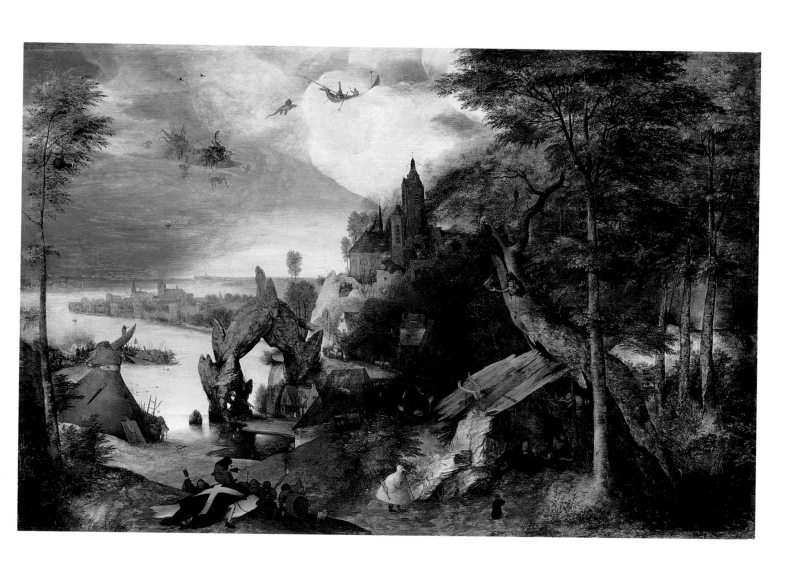

The Rest on the Flight into Egypt

GERARD DAVID

• While a brief account of the departure of Mary, Joseph, and Jesus for Egypt is found in the Gospel of Matthew (12:13–14), it was left for later apocryphal writings to expand the theme and make it more anecdotal. This panel shows the Holy Family pausing for rest and nourishment. In one of several miracles associated with the subject, the Christ Child causes a spring to issue forth so that they can quench their thirst; and at the extreme right one can glimpse water flowing out of the rocks.

Gerard David translated the biblical event into the Netherlandish vernacular here, for the scene takes place in the verdant countryside of Flanders. As is often the case with Netherlandish art, the real and the symbolic coexist. The bunch of grapes held by the Virgin is a well-known emblem of the Eucharist and may have broader overtones of divine salvation and refreshment as well. The row of plants in the foreground may be interpreted symbolically: the plantain at the far left alludes to Christ's death; the mint next to it is a purifying herb representing virtue; the tripartite leaves of the strawberry plant are emblems of the Trinity, while its fruit refers to the blood and wounds of Christ; ferns protect against evil; and the violet symbolizes the humility of both Virgin and Child. In the background Joseph gathers food by hitting a chestnut tree with a stick; and although chestnuts have connotations of modesty, they were also an integral part of the northern European diet. Even the donkey appears happy to have something to eat.

This exceptionally lovely and serene painting by Gerard David achieves a sense of harmony and peace through the overlapping, gently curving planes of the hills, the atmospheric cohesion of figures and landscape, and a remarkable sensitivity to color, especially the varied shades of blue and blue gray that imbue the scene with calmness.

Gerard David
(Bruges, c. 1460–1523)
The Rest on the Flight into Egypt
c. 1510, oil on panel
41.9 × 42.2 (16 ½ × 16 ⅝)
Andrew W. Mellon Collection
1937.1.43

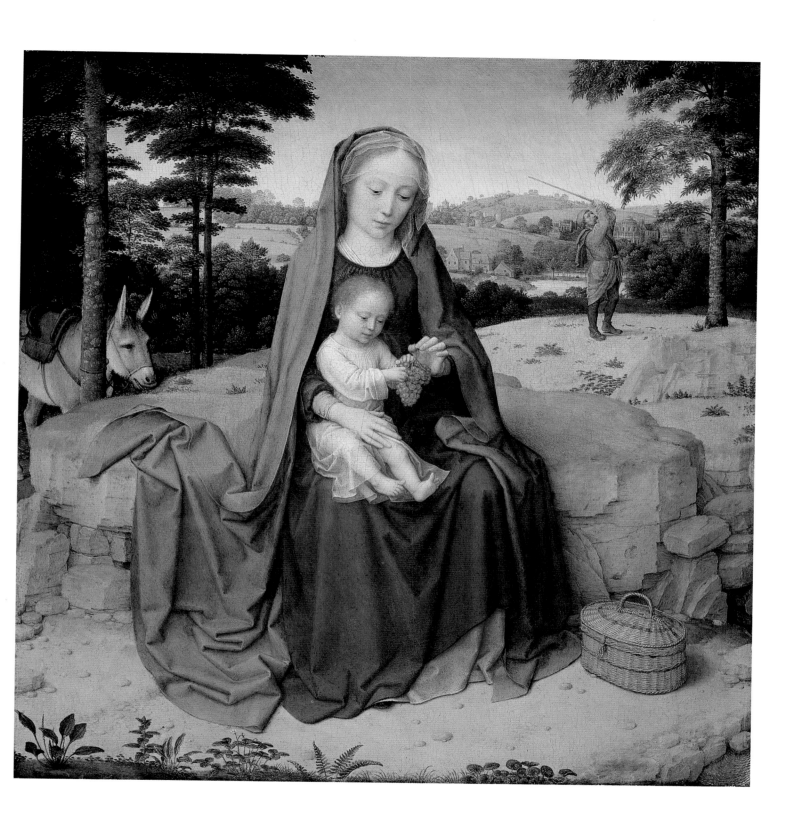

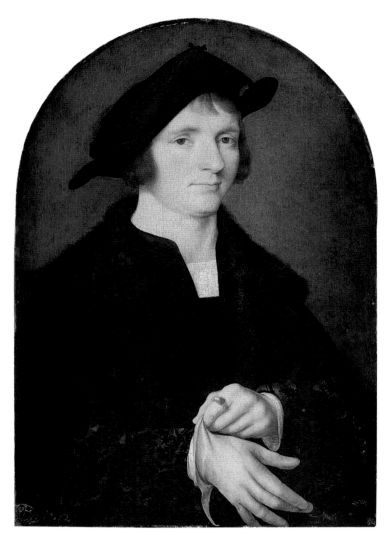

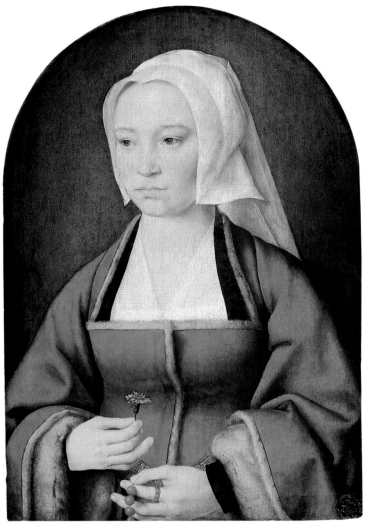

93

94

Joos van Cleve
(Antwerp, active 1505/1508–1540/1541)
Joris Vezeleer
probably 1518, oil on panel
56.3 × 38.2 (22 ⅛ × 15)
Ailsa Mellon Bruce Fund
1962.9.1

Joos van Cleve
(Antwerp, active 1505/1508–1540/1541)
Margaretha Boghe, Wife of Joris Vezeleer
probably 1518, oil on panel
55.1 × 37.2 (21 ⅝ × 14 ⅝)
Ailsa Mellon Bruce Fund
1962.9.2

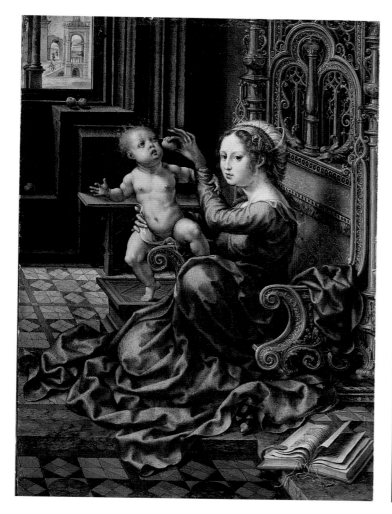

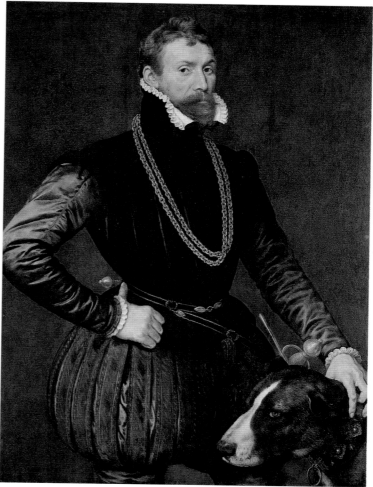

95

96

Jan Gossaert
(Netherlandish, c. 1478–1532)
Madonna and Child
c. 1532, oil on panel
34.4 × 24.8 (13 ½ × 9 ¾)
Gift of Grace Vogel Aldworth
in memory of her grandparents
Ralph and Mary Booth
1981.87.1

Antonis Mor
(North Netherlandish, c. 1516/1520–c. 1575/1576)
Portrait of a Gentleman
1569, oil on canvas
119.7 × 88.3 (47 ⅛ × 34 ¾)
Andrew W. Mellon Collection
1937.1.52

Portrait of a Merchant

JAN GOSSAERT

• The sixteenth century witnessed the birth of modern capitalism, and in the first half of the century the economic hub of Europe was situated in the north, particularly in Antwerp, which was the home of the bourse, or financial exchange, and a focal point for both transcontinental and international trade. The merchant class consequently became a dominant force in society.

This superb portrait depicts a man of commerce amid the comfortable clutter of the tools of his trade: at the right is a metal holder for quill pens, sealing wax, and paper; at the far left is a shaker containing talc or sand, used to dry ink on the page. Also visible are scissors, an ink pot, gold and silver coins, and a pair of scales; the latter was necessary to ensure that coins had not been adulterated. The writing in the ledger on the desk is illegible, but the inscriptions on the batches of papers on the back wall can be read: at left is "Alrehande Missiven" (miscella-neous letters), and at right, "Alrehande Minuten" (miscellaneous drafts). Because of the letters IS on his ring and the IAS on the pin in his beret it has been suggested that the sitter might be Jerome Sandelin, who was a tax collector and financial officer in Zeeland.

The *Portrait of a Merchant* was painted only a few years before the artist's death. The large, imposing triangle formed by the merchant's body is balanced by the numerous smaller objects in the painting. The painting is in excellent condition, preserving the beautifully rendered blue violet shadows in the face and hands.

97

Jan Gossaert
(Netherlandish, c. 1478–1532)
Portrait of a Merchant
c. 1530, oil on panel
63.6 × 47.5 (25 × 18 ¾)
Ailsa Mellon Bruce Fund
1967.4.1

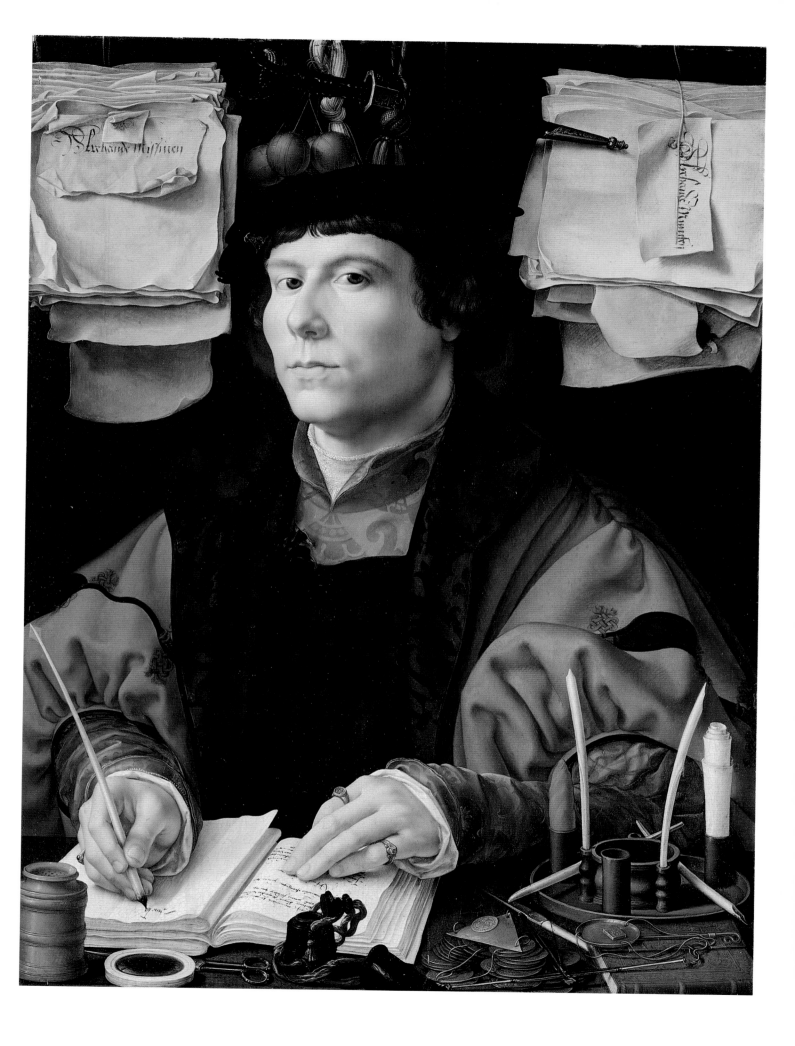

The Rest on the Flight into Egypt

MAERTEN VAN HEEMSKERCK

• The son of Jacob van Veen, a farmer, Maerten took his last name, Heemskerck, from the village where he was born. From 1527 to 1530 the artist was in the nearby city of Haarlem, where he had gone to work with Jan van Scorel. Heemskerck's aim was to assimilate the new style that Scorel had acquired in Venice and Rome, and he succeeded so well that the *Rest on the Flight into Egypt* has often been mistaken by scholars for the work of Scorel. Particularly italianate are the muscular contrapposto of the Christ Child's body and the classically inspired ruins in the broad, windswept landscape. On the other hand, the Madonna, wearing a colorful dress and her hair in braids, is essentially Northern in type. The Christ Child holds a butterfly, symbol of the Resurrection, and sits precariously atop a crystal globe containing a cross, which together represent his dominion over the world and the redemption of mankind through his death.

In 1532 Heemskerck journeyed to Rome, where he stayed for four years studying antiquities and the art of Raphael and Michelangelo. Returning to Haarlem, he used his Italian experiences to create a "Romanist" style that was highly influential.

98

Maerten van Heemskerck
(North Netherlandish, 1498–1574)
The Rest on the Flight into Egypt
c. 1530, oil on panel
57.7 × 74.7 (22 ¾ × 29)
Samuel H. Kress Collection
1961.9.36

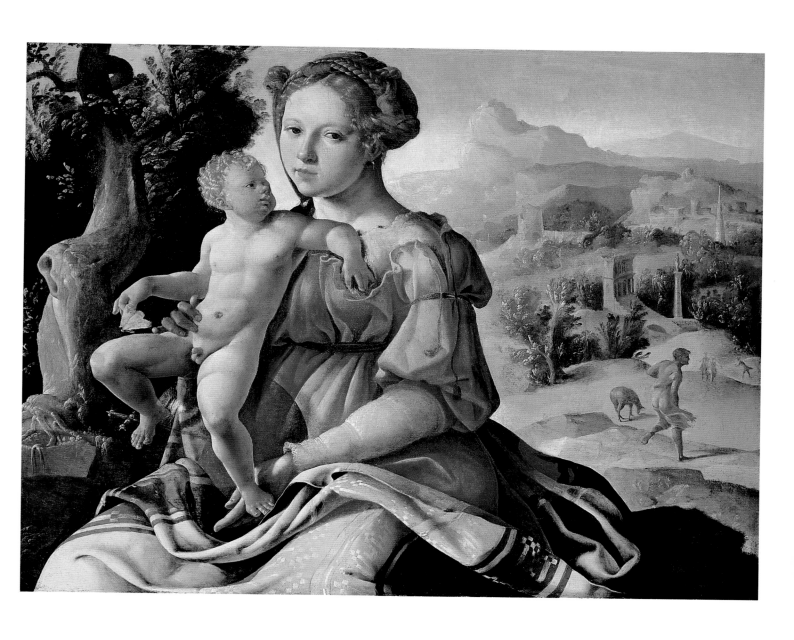

Ill-Matched Lovers

QUENTIN MASSYS

• The essential meaning of this painting may be summed up in the proverb, "no fool like an old fool," and the same sentiments are familiar in Dutch and German. The theme of "ill-matched" couples, which also includes old women and young men, can be found during antiquity in the comedies of Plautus, and it survived into the Middle Ages and Renaissance. In both literature and the visual arts the subject was very popular in northern Europe in the early sixteenth century, and it occurs in such works as Sebastian Brant's *Ship of Fools* and Erasmus' *Praise of Folly.*

In Massys' painting the figure at the far left is not an observer but an active participant, who receives the old man's purse from the young woman. The cards and coins at the left allude to gambling, which was equated with licentious behavior. The sexual power of women was thought to cause men to behave irrationally and, as seen here, to lose their wits as well as their wealth.

Ill-Matched Lovers illustrates the increasing focus on secular subjects in northern European art. Massys, who worked in Antwerp from 1491 until his death, was a cosmopolitan and sophisticated artist. As evident in the leering, distorted face of the old man, he was aware of the grotesques of Leonardo da Vinci, which were transmitted to Antwerp through copies.

99

Quentin Massys
(Antwerp, 1465/1466–1530)
Ill-Matched Lovers
c. 1520/1525, oil on panel
43.2 × 63 (17 × 24 ¾)
Ailsa Mellon Bruce Fund
1971.55.1

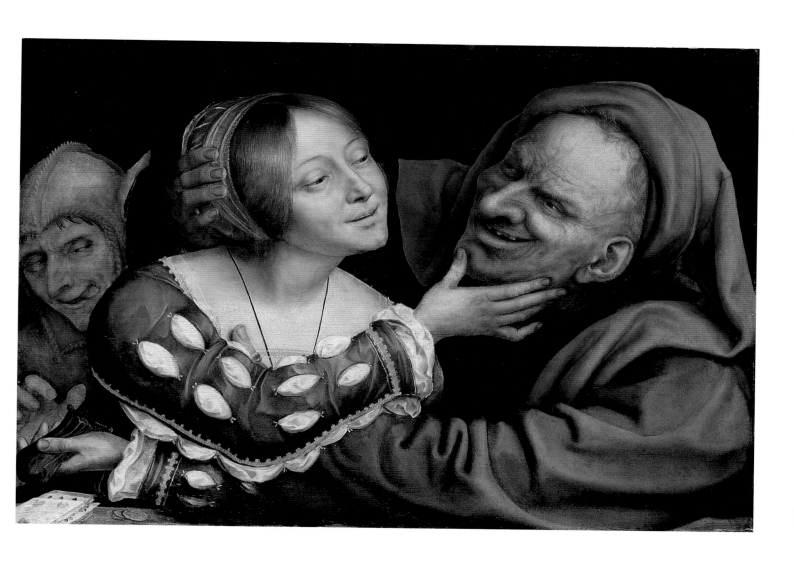

The Nymph of the Spring

LUCAS CRANACH THE ELDER

• The key to the subject of this painting is found at the upper left in the Latin inscription, which may be translated, "I am the nymph of the sacred spring. Do not disturb my sleep. I am resting." The words paraphrase a poem that was thought to be classical and supposedly adorned a fountain with a statue of a sleeping nymph discovered on the banks of the Danube River. The poem was in fact written in the late fifteenth century, but this was not known until well into the nineteenth century. In the sixteenth century the poem and accompanying imagery were popular with humanists in both Italy and Germany, and the subject was treated several times by Cranach and his workshop.

The nymph here is not, however, sleeping. Her eyes are open as she lies against her dress, and her nakedness is emphasized by her jewelry and the transparent fabric that covers her body. The nymph is more than the protectress of the sacred spring. The bow and arrows hanging from the tree at the right probably refer to Diana, the chaste goddess of the hunt. The two partridges at the base of the tree were often associated with Venus, *luxuria*, and sexual excesses. It is hard to surmise how a contemporary viewer would have reconciled the seemingly contradictory allusions to Diana, the sight of whom was fatal to mortals, and the erotic allure of Venus. Perhaps the painting was intended to convey a complex moralizing message.

Lucas Cranach the Elder
(German, 1472–1553)
The Nymph of the Spring
after 1537, oil on panel
48.4 × 72.8 (19 × 28 ⅝)
Gift of Clarence Y. Palitz
1957.12.1

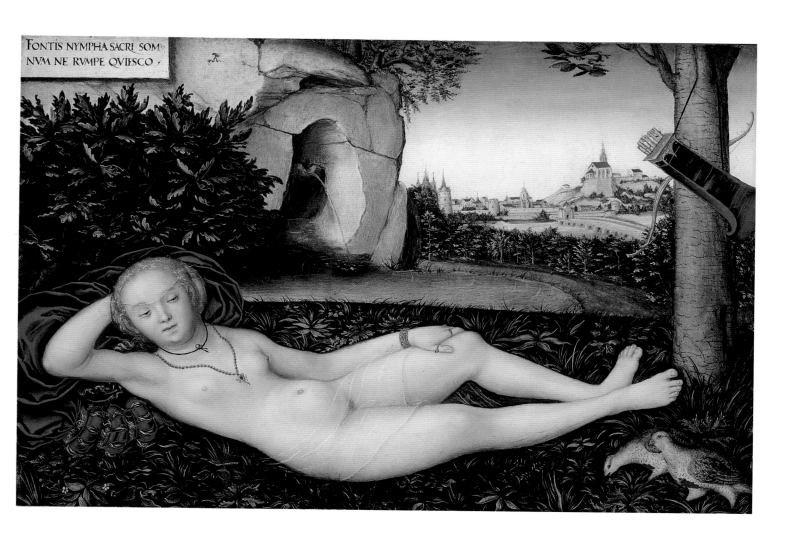

FONTIS NYMPHA SACRI SOM
NVM NE RVMPE QVIESCO ·

Portrait of a Man / Portrait of a Woman

• The identity of this couple is unknown, but the severe and understated elegance of their dress make it likely that they were members of the patrician or merchant class. These are exceptional examples of Cranach's portraiture. Especially interesting are the devices he used to differentiate the two individuals and by implication their roles in society. The man is physically larger and more imposing; his body extends beyond the edges of the painting, and his complexion is somewhat ruddy. In contrast, the woman's face is a pale ivory, and her small figure fits easily within the picture. Although thinly painted, the sitters' features are modeled with exquisite sensitivity. Cranach used cast shadows to create a sense of space around the figures; furthermore, the shadows along the upper edges and along the right side of the man's portrait and the left edge of the woman's portrait suggest the intriguing possibility that the portraits originally hung on either side of a window.

101

102

Lucas Cranach the Elder
(German, 1472–1553)
Portrait of a Man
1522, oil on panel
57.6 × 39.9 (22 ⅝ × 15 ¾)
Samuel H. Kress Collection
1959.9.1

Lucas Cranach the Elder
(German, 1472–1553)
Portrait of a Woman
1522, oil on panel
58 × 39.8 (22 ⅞ × 15 ⅝)
Samuel H. Kress Collection
1959.9.2

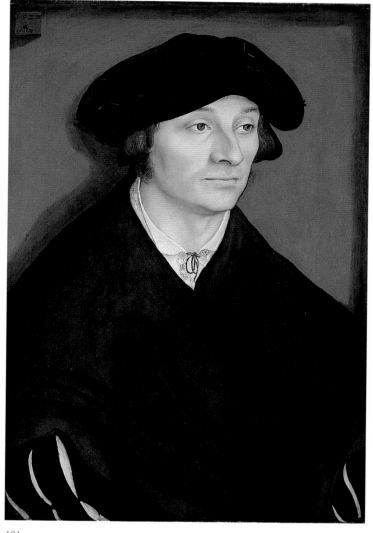

101

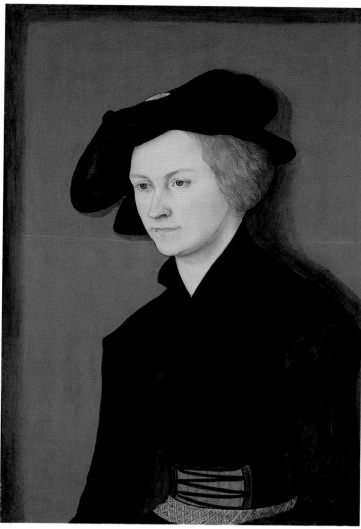

102

The Crucifixion with the Converted Centurion

LUCAS CRANACH THE ELDER

• An eerie stillness permeates this depiction of Christ's death on the cross. The bodies of Christ and the two criminals crucified with him are silhouetted against black clouds, while below bands of yellow, orange, pink, and blue create an unearthly glow. The rocky, barren setting underscores the timeless isolation of the scene. Inscribed at the top of the painting are the words uttered by Christ before his death, "Father, into thy hands I commit my spirit!" At the foot of the cross the centurion, clad in armor and a fashionable hat, acknowledges Christ's divinity with the words, "Truly this was the Son of God!" This anonymous soldier was one of the first Gentiles to recognize Jesus as savior.

Lucas Cranach was a friend of Martin Luther's and among the artists most intimately allied with the Protestant Reformation, although he worked for a wide variety of patrons, including Luther's adversary, Cardinal Albrecht von Brandenburg. The *Crucifixion with the Converted Centurion* belongs to a group of paintings that can be associated with the tenets of Protestantism, specifically Luther's core belief that salvation can be obtained through faith alone. This concept is personified by the centurion, who acknowledges Jesus' divinity and converts to Christianity, and by the "good" thief at the left who has repented and will join Christ in paradise (Luke 23:39–43), in contrast to the "bad" thief at the right who turns away. The fact that the biblical inscriptions are in German rather than Latin is in accord with the Lutheran belief that the Word of God should be accessible to all the people and not just the educated clergy. Although Cranach and his workshop produced a large number of paintings of the Crucifixion over his long career, this is one of the earliest and best of its kind.

103

Lucas Cranach the Elder
(German, 1472–1553)
The Crucifixion with the Converted Centurion
1536, oil on panel
50.8 × 34.6 (20 × 13 ⅝)
Samuel H. Kress Collection
1961.9.69

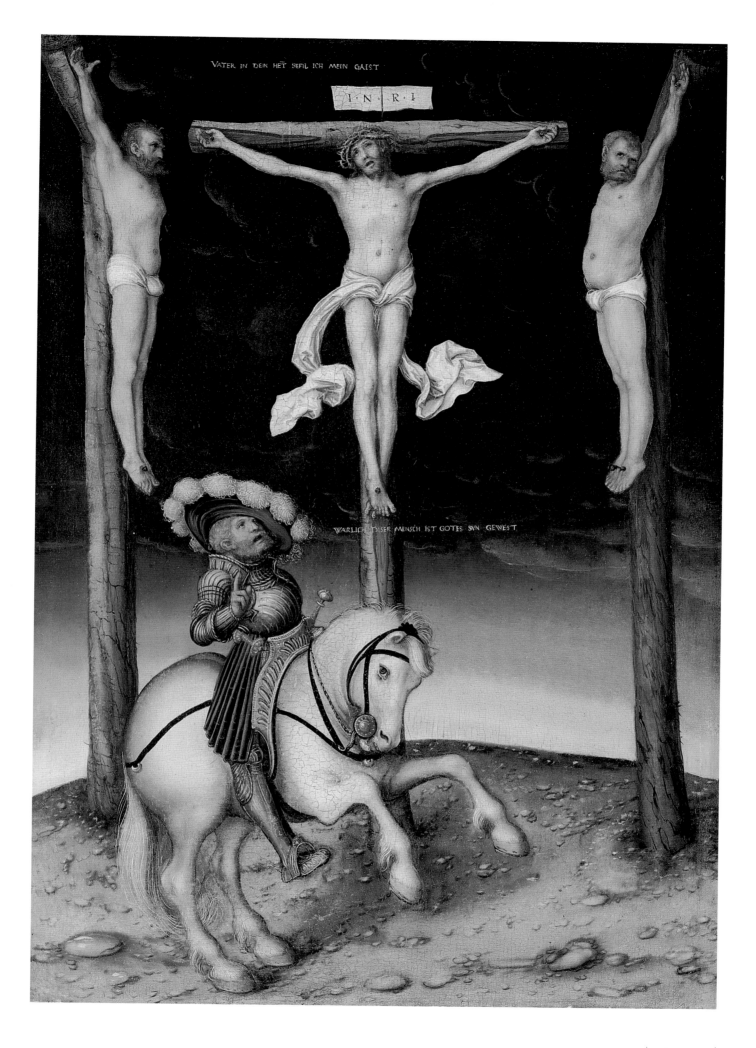

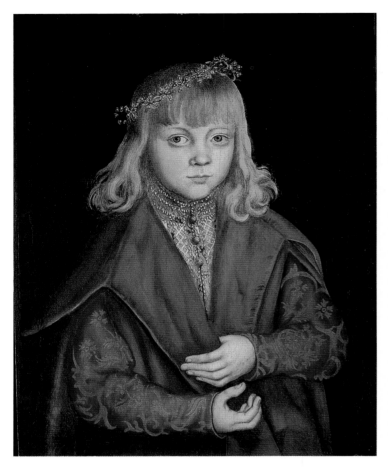

104

105

Lucas Cranach the Elder
(German, 1472–1553)
A Prince of Saxony
c. 1517, oil on panel
43.7 × 34.4 (17 ¼ × 13 ½)
Ralph and Mary Booth Collection
1947.6.1

Lucas Cranach the Elder
(German, 1472–1553)
A Princess of Saxony
c. 1517, oil on panel
43.4 × 34.3 (17 ⅛ × 13 ½)
Ralph and Mary Booth Collection
1947.6.2

106

107

Bernhard Strigel
(German, 1460/1461–1528)
Margarethe Vöhlin, Wife of Hans Roth
1527, oil on panel
43 × 30 (16 ⅞ × 11 ¾)
Ralph and Mary Booth Collection
1947.6.5

Bernhard Strigel
(German, 1460/1461–1528)
Hans Roth
1527, oil on panel
42.6 × 30 (16 ¾ × 11 ¾)
Ralph and Mary Booth Collection
1947.6.4

 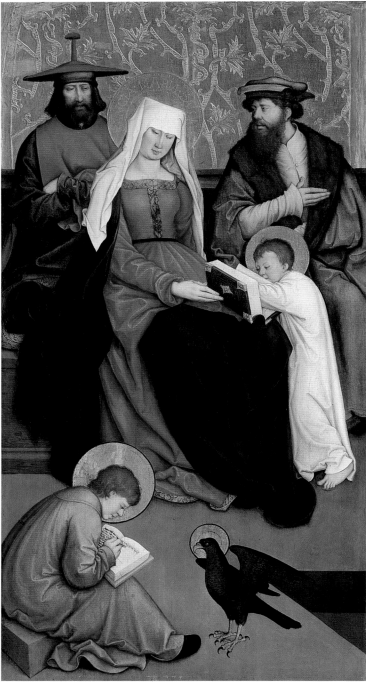

108

109

Bernhard Strigel
(German, 1460/1461–1528)
Saint Mary Cleophas and Her Family
c. 1520/1528, oil on panel
125.5 × 65.8 (49 ⅜ × 25 ⅞)
Samuel H. Kress Collection
1961.9.88

Bernhard Strigel
(German, 1460/1461–1528)
Saint Mary Salome and Her Family
c. 1520/1528, oil on panel
125 × 65.7 (49 ¼ × 25 ⅞)
Samuel H. Kress Collection
1961.9.89

110

Hans Mielich
(German, 1516–1573)
A Member of the Fröschl Family
c. 1539/1540, oil on panel
64.2 × 47 (25 ¼ × 18 ½)
Gift of David Edward Finley
and Margaret Eustis Finley
1984.66.1

Madonna and Child (obverse) / *Lot and His Daughters* (reverse)

ALBRECHT DÜRER

• In late August 1494 an outbreak of plague in Nuremberg provided a reason for Albrecht Dürer to travel to Venice, where he stayed until the spring of 1495. During this time he became acquainted with the city's foremost artists and with the principles of Italian Renaissance art. The *Madonna and Child*, painted not long after his return to Germany, is, in the poses of both mother and child, clearly indebted to the Madonnas of Giovanni Bellini, painted in the late 1480s. It is not surprising to learn that in 1932, before the painting on the reverse was uncovered, the *Madonna and Child* was auctioned in London as a work by Bellini. Netherlandish and German elements are also present, however, such as the placement of the figures in the corner of a room with a window view into a landscape and the accurate rendering of surfaces like the marble walls.

As is typical of Dürer's two-sided paintings, *Lot and His Daughters* on the reverse is done in a much looser style. The combination of this subject with a Madonna and Child is unique, and both were perhaps intended to demonstrate God's redemption of mankind. The coat of arms of the Haller family of Nuremberg is in the lower left corner of the *Madonna and Child*, and the themes were probably chosen by a member of this family. At the lower right the corresponding arms of Haller's wife cannot be indentified, preventing a precise authentication of the painting's original owners.

In its vibrant color, precise draftsmanship, and assimilation of italianate elements this panel is one of the finest of Dürer's paintings in America and also a significant work of his early maturity.

Albrecht Dürer
(German, 1471 – 1528)
Madonna and Child (obverse)
Lot and His Daughters (reverse)
c. 1496/1499, oil on panel
52.4 × 42.2 (20 5/8 × 16 5/8)
Samuel H. Kress Collection
1952.2.16 a – b

obverse

reverse

Portrait of a Clergyman (Johann Dorsch?)

ALBRECHT DÜRER

· Although the black tunic and black cap were appropriate to both academics and ecclesiastics, there are good, albeit circumstantial, reasons for identifying the sitter in this portrait as Johann Dorsch. Dorsch was at various times a member of the Augustinian cloister in Nuremberg, a preacher who sided with the Protestant Reformation, and from 1528 until his death in 1541 the pastor of the reformed church of Saint John in Nuremberg. Since the church was Augustinian before the Reformation and was Dürer's parish church, it is possible that the two men knew each other in the years around 1516 and that this portrait is a record of their friendship. Dürer has captured not only the sitter's heavy jaw and craggy features but also the force of his personality.

Albrecht Dürer
(German, 1471–1528)
Portrait of a Clergyman (Johann Dorsch?)
1516, oil on parchment on fabric
41.7 × 32.7 (16 ⅜ × 12 ⅞)
Samuel H. Kress Collection
1952.2.17

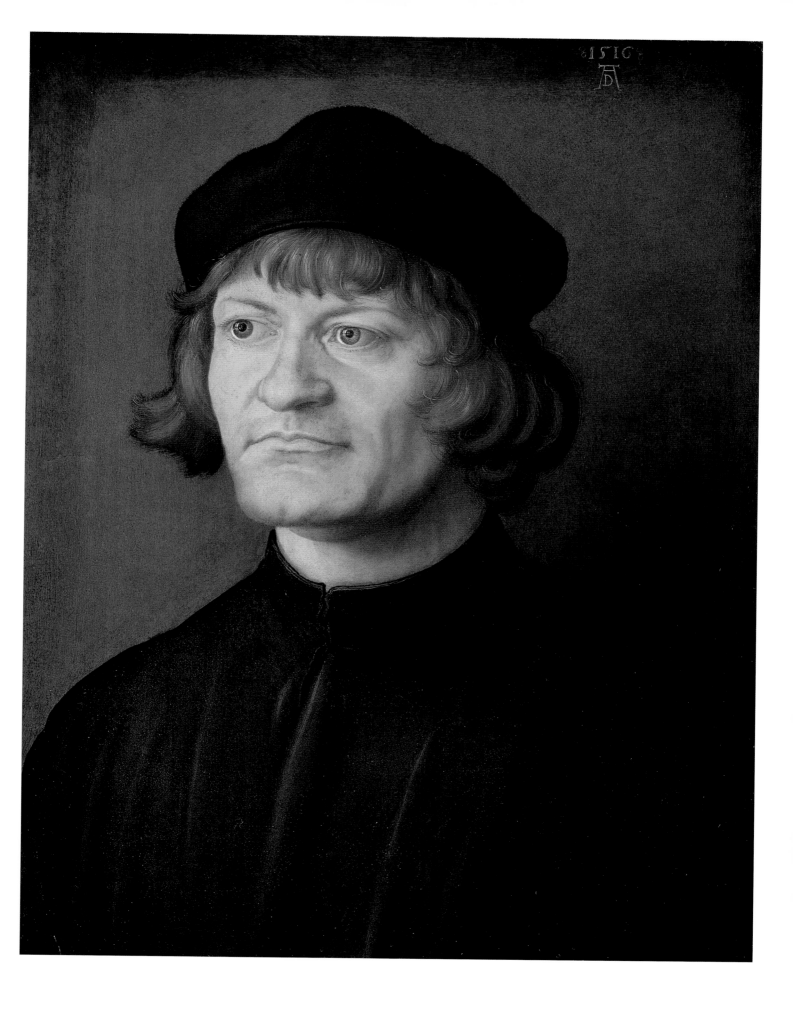

The Small Crucifixion

MATTHIAS GRÜNEWALD

• Matthias Grünewald stands in the top ranks of sixteenth-century German artists, but unlike his contemporaries, such as Dürer and Cranach, he seems not to have had pupils or a large workshop, so his output of only a few more than twenty paintings is relatively small. The only painting by Grünewald in North America is the *Small Crucifixion*, so called beginning in the seventeenth century to distinguish it from the artist's other representations of the theme, including the Isenheim Altarpiece in the Musée d'Unterlinden, Colmar.

Witnessed by the Virgin Mary, John the Evangelist, and Mary Magdalen, Christ's death is depicted here as intensely harrowing in its physicality; his body is discolored and covered with wounds, and its weight is enough to pull down the ends of the cross bar. His hands and feet are twisted into gestures of agony. A major source for Grünewald's imagery was the *Revelations* of the fourteenth-century mystic

Saint Bridget of Sweden, which contained powerfully graphic descriptions of Christ's Crucifixion, such as: "Then his whole body quivered, and his beard sank on his breast....His mouth being open as he expired, his tongue, teeth, and the blood in his mouth could be seen by those looking on...; and his body, now dead, hung heavily, the knees inclining to one side, the feet to the other, on the nails as if on hinges."

Increasing the expressive impact are the harsh color harmonies of blue green, purple, and red, the jagged edges of Christ's loincloth and John's robe, and even the gesture of John's clasped hands, bent awkwardly and painfully at the wrist. It is no wonder that when Grünewald was rediscovered in the early twentieth century, after a period of obscurity, he was extremely popular among the German expressionists.

113

Matthias Grünewald
(German, c. 1475/1480–1528)
The Small Crucifixion
c. 1511/1520, oil on panel
61.3 × 46 (24 ⅛ × 18 ⅛)
Samuel H. Kress Collection
1961.9.19

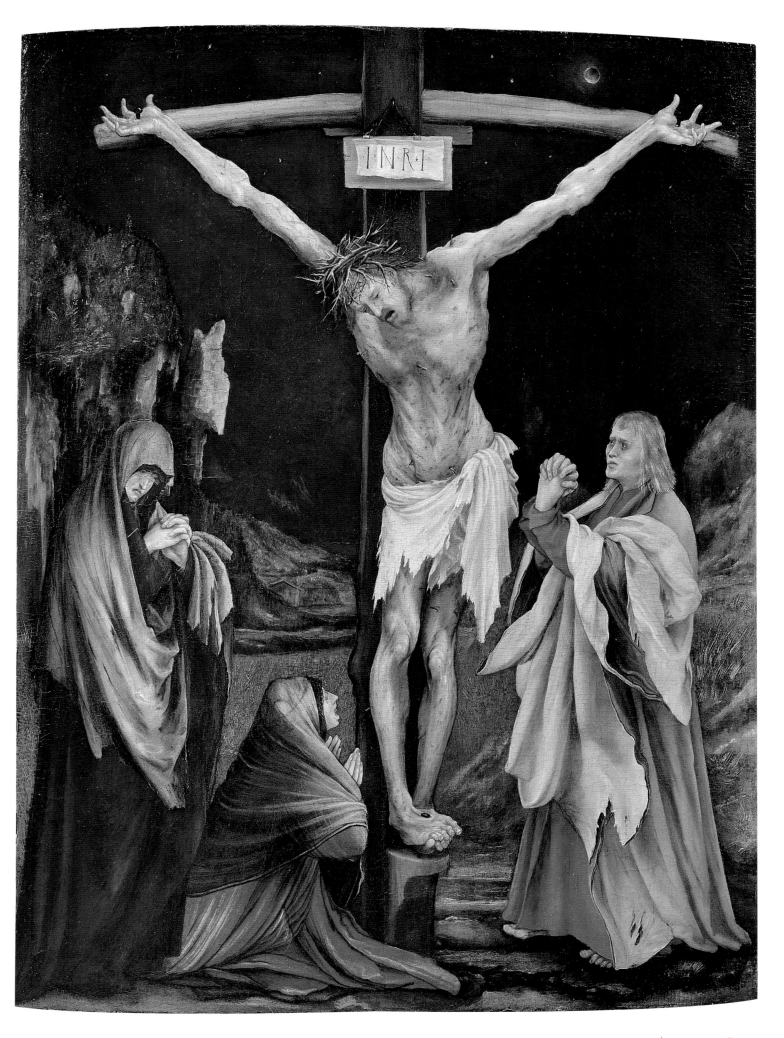

Edward VI as a Child

• It is generally agreed that this painting of Edward VI, only son of Henry VIII and future king of England, was presented as a gift to Henry VIII on 1 January 1539. The king was evidently pleased, for in return he gave Holbein a vessel made of gold. The work is at once a superb portrayal of a young child and an example of political propaganda. Even though he was only about fourteen months old, Edward is shown with the regal bearing of an adult, appearing to look down on the spectator from his position behind a parapet. Although he was frail and often sickly, he is depicted as a sturdy child. This hieratic, iconic image was ultimately intended to flatter Henry VIII and consolidate his authority in the face of growing dissension over his divorce from Catherine of Aragon.

At the bottom of the panel is a Latin inscription by Sir Richard Morison, which reads in part, "Little one, emulate thy father and be the heir of his virtue; the world contains nothing greater. Heaven and earth could scarcely produce a son whose glory would surpass that of such a father." Unfortunately, though he was intelligent and pious, Edward VI did not live long enough to fulfill expectations. Following Henry's death, he was crowned king on 25 February 1547, and he died on 6 July 1553, three months before his sixteenth birthday.

Hans Holbein the Younger
(German, 1497/1498–1543)
Edward VI as a Child
probably 1538, oil on panel
56.8 × 44 (22 ³⁄₈ × 17 ³⁄₈)
Andrew W. Mellon Collection
1937.1.64

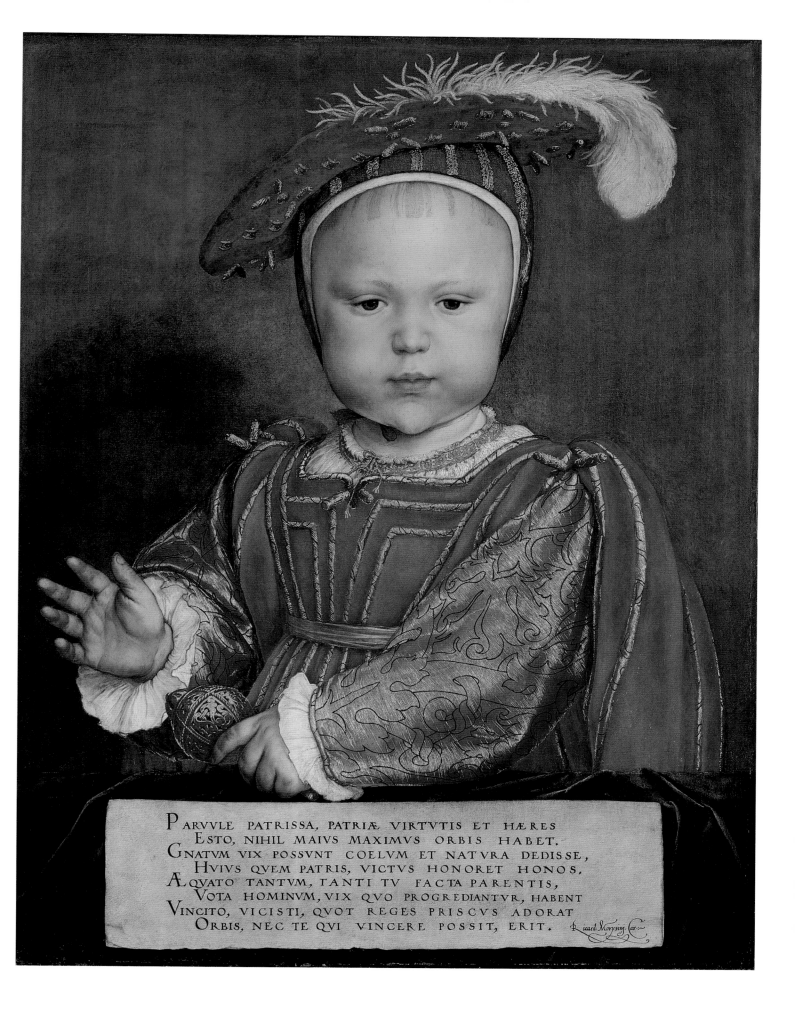

PARVVLE PATRISSA, PATRIÆ VIRTVTIS ET HÆRES
ESTO, NIHIL MAIVS MAXIMVS ORBIS HABET.
GNATVM VIX POSSVNT COELVM ET NATVRA DEDISSE,
HVIVS QVEM PATRIS, VICTVS HONORET HONOS.
ÆQVATO TANTVM, TANTI TV FACTA PARENTIS,
VOTA HOMINVM, VIX QVO PROGREDIANTVR, HABENT
VINCITO, VICISTI, QVOT REGES PRISCVS ADORAT
ORBIS, NEC TE QVI VINCERE POSSIT, ERIT. Ricard: Morysin: Car:—

Sir Brian Tuke

• The inscription at the top of the panel identifies the sitter as Brian Tuke, knight, and gives his age as fifty-seven. Below is a motto, "Droit et Avant," which may be translated as "upright and forward." Blessed with multiple talents, Sir Brian Tuke played an important role in English court and intellectual life. As Governor of the King's Posts, a position he held from 1516 onward, he was effectively Britain's first postmaster general. In 1522 he was French secretary to Henry VIII, and in 1528 the king appointed him treasurer of the royal household and involved him in negotiating a peace treaty with the French. He was also a skilled cryptographer, an eloquent speaker and writer, and a member of the learned group who gathered around Sir Thomas More. Despite his association with More, Tuke prospered at court and was awarded several estates. It was at one of these, Layer Marney, that he died in 1545.

There are glimpses here into Tuke's inner, private life. The inscription on the piece of folded paper at the lower left is from the book of Job (10:20): "Are not the days of my life few?" And Tuke wears a highly unusual cross, which bears the Five Wounds of Christ—that is, the hands and feet of the crucified Christ and a red stone encircled by the crown of thorns that symbolizes the wound in his heart. The Five Wounds were invoked as protection against illness and death and may be associated with the fatalism expressed in the quotation from Job. The date of Tuke's birth is not known, and opinion is divided as to whether the portrait was executed during Holbein's first visit to England from 1526 to 1528 or during the second, which lasted until his death in 1543. Thus although it has not been possible to link Tuke's melancholy expression to a specific event in his life, it is clear that his own mortality was very much in his thoughts.

Hans Holbein the Younger
(German, 1497/1498–1543)
Sir Brian Tuke
c. 1527/1528 or c. 1532/1534,
oil on panel
49.1 × 38.5 (19 ⅜ × 15 ⅛)
Andrew W. Mellon Collection
1937.1.65

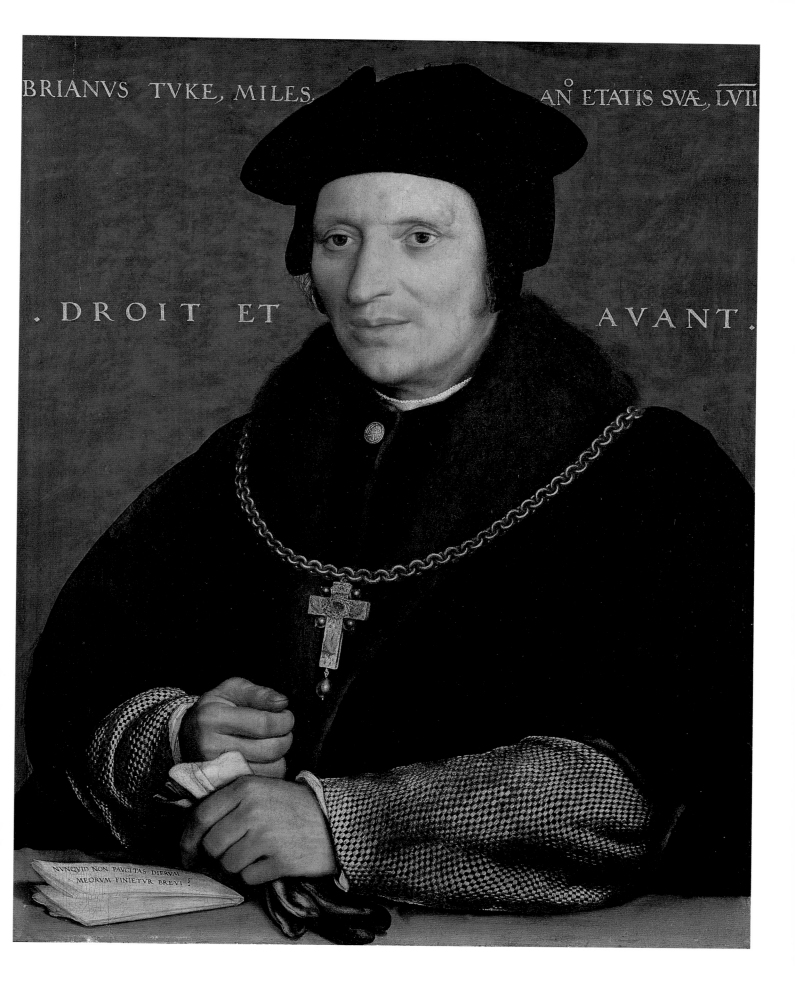

BRIANVS TVKE, MILES,

AN ETATIS SVÆ, LVII

. DROIT ET

AVANT .

NVNQVID NON PAVCITAS DIERVM
MEORVM FINIETVR BREVI ?

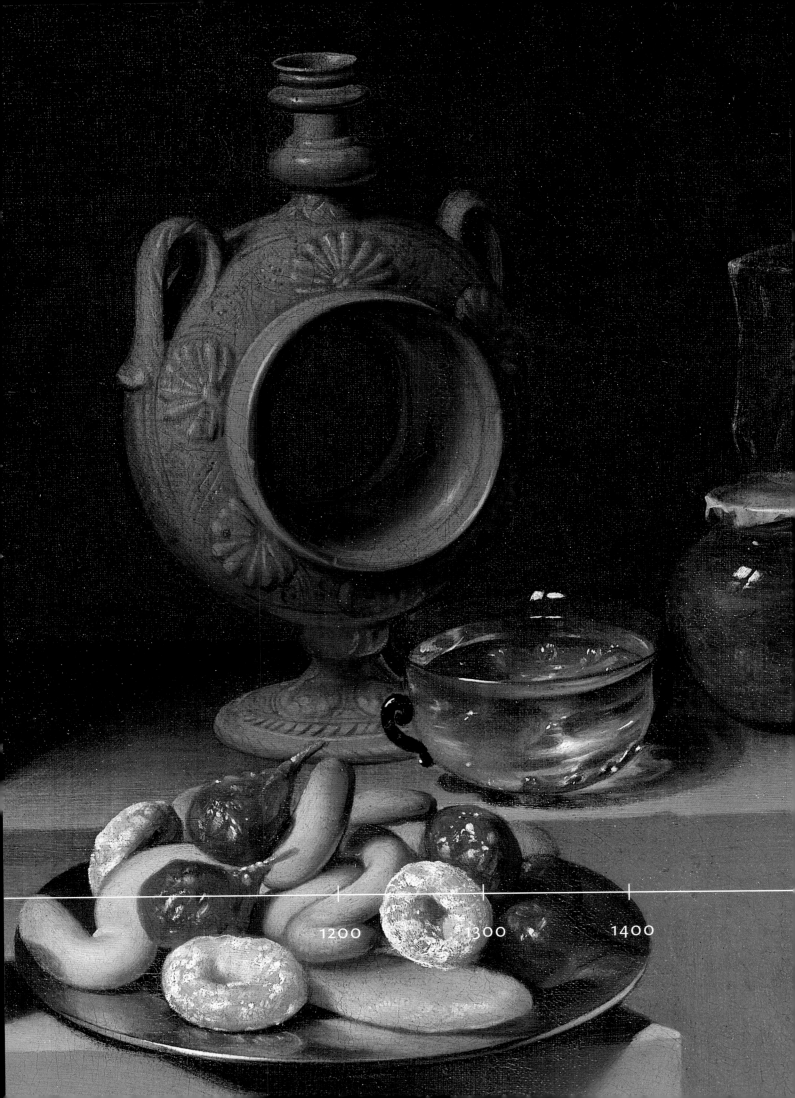

17th century

1500 1600 1700 1800 1900

Still Life with Fruit and Carafe

PENSIONANTE DEL SARACENI

• The unusual name of this artist, Pensionante del Saraceni, calls for an explanation: Italian for "boarder of Saraceni," it was coined by an Italian art historian to apply to a small group of paintings by an unknown artist that were close in style to the works of Carlo Saraceni (1579–1620), one of the many Roman followers of Caravaggio.

Still Life with Fruit and Carafe was for many years attributed to Caravaggio himself and is clearly indebted to the master's still lifes as well as to the arrangements of fruit that are part of his larger compositions. Although those works by Caravaggio date from 1590s, the Pensionante's pictures are usually dated between c. 1610 and c. 1620.

The items shown in this painting are from what may be called a *post pasto*, a display of fruit, nuts, and sweet wine that would have been consumed after dinner. A tempting variety of fruits is depicted. At the left are a cantaloupe and mirobalan plums. On the metal plate in the center are a peach, half a pear, figs, white grapes, a pomegranate, and peaches (or perhaps a summer apple). At the right are cherries,

chestnuts, a slice of watermelon, and a pear. These fruits would have ripened in the late summer, with the exception of the pomegranate and the chestnuts, which become edible in the autumn. The artist has deftly captured the character of each fruit so that one can easily imagine their taste and texture. The Pensionante also distinguishes himself by tending to simplify shapes and by using light to soften forms so that the painting has a tonal unity.

Saraceni is known to have been an ardent Francophile, who wore French clothing and had French pupils. It has therefore been suggested that the Pensionante del Saraceni might have been French, but he could just as easily have been a Fleming studying in Rome, or even an Italian. Despite a lack of knowledge about its author, *Still Life with Fruit and Carafe* is an exceedingly accomplished still life produced in Rome in the early seventeenth century, a picture that links Caravaggio and his immediate followers with still-life artists working at mid-century in Italy and northern Europe.

Pensionante del Saraceni
(Roman, active c. 1610/1620)
Still Life with Fruit and Carafe
c. 1610/1620, oil on canvas
50.4 × 71.6 (19 ⅞ × 28 ⅜)
Samuel H. Kress Collection
1939.1.159

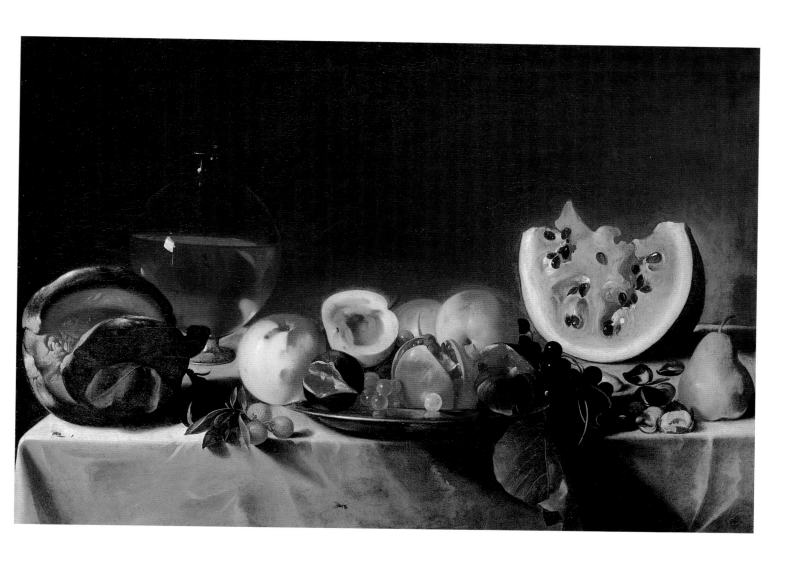

The Martyrdom of Saint Bartholomew

JUSEPE DE RIBERA

• In their attempts to thwart the spread of Protestantism, the theologians of the Counter-Reformation encouraged people to contemplate the lives of martyred saints who had suffered and died for the Christian faith. Artists were enlisted to provide visual confirmation of these events. Saint Bartholomew is an excellent example of what might be called a Counter-Reformation saint. As an apostle of Christ, he was preaching in Asia Minor and Major when, according to legend, he angered King Astrages by refusing to sacrifice to pagan gods and by destroying idols. Astrages ordered Bartholomew flayed alive.

Although Ribera painted numerous versions of the saint's martyrdom, this picture is outstanding for its superior condition, quality of execution, and powerful yet complex emotional and spiritual impact. The figure of Bartholomew, strongly highlighted, is pushed forward, almost into the viewer's space. His right arm has already been raised and bound to a post, while he reaches imploringly toward his torturer with his left. The executioner, holding the knife and whetstone so as to form a cross, appears to pause in his gruesome task, as if moved by the strength of Bartholomew's faith and his rapt, mystical expression. The two witnesses at the left are oblivious to this exchange.

In addition to his name and the date 1634, Ribera also wrote the word "espagnol" on the canvas. Jusepe Ribera was born in Spain, in the town of Jativa near Valencia, but spent most of his life in Italy, traveling to Parma and Rome before settling in Naples, which was ruled by Spanish viceroys and therefore provided him with both Spanish and Italian patrons. While the severe realism and dramatic contrasts of light and shade that characterize the works of Caravaggio and his followers had a decisive influence on Ribera, this was tempered by a study of the harmonious classicism of Raphael and Guido Reni. Typical of Ribera's work in the 1630s, the *Martyrdom of Saint Bartholomew* is notable for the way it modifies Caravaggism in favor of a lighter overall golden tonality and for its varied and lively brushwork.

117

Jusepe de Ribera
(Spanish, 1591–1652)
The Martyrdom of Saint Bartholomew
1634, oil on canvas
104 × 113 (41 × 44 ½)
Gift of the 50th Anniversary
Gift Committee
1990.137.1

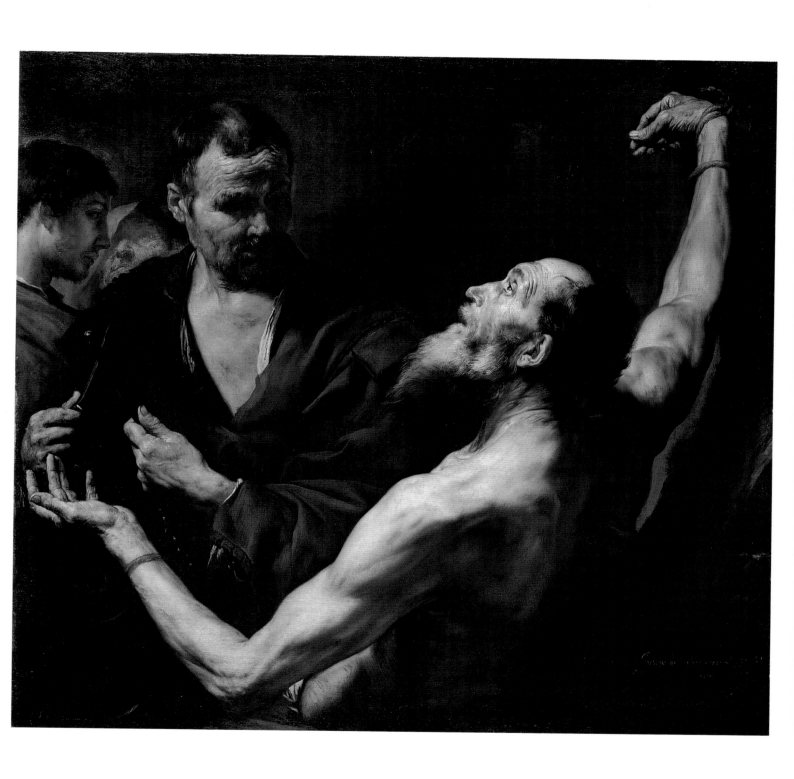

Annibale Carracci
(Bolognese, 1560–1609)
River Landscape
c. 1590, oil on canvas
88.3 × 148.1 (34 ¾ × 58 ¼)
Samuel H. Kress Collection
1952.5.58

119

120

Lodovico Carracci
(Bolognese, 1555–1619)
*The Dream of Saint Catherine
of Alexandria*
c. 1593, oil on canvas
138.8 × 110.5 (54 ⅝ × 43 ½)
Samuel H. Kress Collection
1952.5.59

Domenico Fetti
(Roman, 1589–1623)
The Veil of Veronica
c. 1618/1622, oil on panel
80.6 × 66.3 (31 ¾ × 26 ⅛)
Samuel H. Kress Collection
1952.5.7

The Rebuke of Adam and Eve

DOMENICHINO

• Domenichino's painting is a learned, dramatic, and lucid exposition of an unusual theme, showing God rebuking Adam and Eve after they had eaten the forbidden fruit from the tree of the knowledge of good and evil but before they were expelled from the garden of Eden. This subject is quite rare, and it has been suggested that Domenichino knew of it through late thirteenth-century frescoes in the church of San Paolo fuori le Mura in Rome.

God here is borne aloft by a number of angels, and he gestures accusingly at Adam, who shrugs his shoulders and passes the blame to Eve, who in turn blames the serpent. Domenichino uses a linkage of gestures and postures to convey the narrative with great force and clarity. The grouping of God and the angels is a quotation from Michelangelo's fresco of the *Creation of Adam* from the ceiling of the Sistine Chapel and would have been recognized as such by the contemporary viewer. More arcane is the use of a fig tree for the tree of knowledge instead of the more typical apple tree, but the fig tree plays a role in several early Jewish apocryphal texts, and the Bible states that Adam and Eve covered their nakedness with fig leaves (which are actually rather scratchy). The artist also shows that life in paradise after the Fall became less harmonious; the lions and the lamb still "lie down together," but the lion grows more ferocious and the lamb looks away anxiously.

The kind of erudition and citation of earlier masters seen here is integral to Domenichino's classical training and outlook. Born Domenico Zampieri in Bologna, he studied there at the academy of Agostino and Ludovico Carracci, where he learned to draw from live models and where, because of his short stature, he acquired the nickname Domenichino ("little Domenico"). In 1602 Domenichino moved to Rome and lived for a short time with Agostino's brother Annibale Carracci before moving to Fano and Bologna. In 1621, shortly after the election of a new pope, Domenichino was summoned to Rome to take up the position of papal architect. In 1631 he moved to Naples to paint altarpieces and frescoes for the cathedral, but jealous local artists made his life miserable, and at one point he fled the city for almost a year. Because of a preparatory drawing dated 1626, it is known that the *Rebuke of Adam and Eve* was painted in Rome in happier times. It is not known who commissioned the painting, but it is first recorded in 1714 in the collection of the Colonna family in Rome.

121

Domenichino
(Italian, 1581–1641)
The Rebuke of Adam and Eve
1626, oil on canvas
121.92 × 172.1 (48 × 67 ¾)
Patrons' Permanent Fund
2000.3.1

The Triumph of Galatea

BERNARDO CAVALLINO

• In Greek mythology Galatea was a sea deity or Nereid, one of the numerous offspring of Nereus, a marine god known as the "old man of the sea," and Doris, a sea goddess. Set against a dark and stormy sky, Galatea is here shown seated on a fantastic throne of red coral placed in a giant spiky crab shell pulled by two dolphins. Accompanying her through the waves are tritons, sea creatures who have the upper bodies of men. One triton plays the flute, while another blows into a conch shell. The dusky complexions of the tritons are contrasted to the flawless ivory skin of Galatea, whose name in Greek refers to the whiteness of milk. Documents suggest that this picture was first owned by the Sicilian Don Antonio Ruffo; because Galatea figures in several Sicilian legends and because of her association with Polyphemus, the Cyclops of Sicily, Ruffo may have considered the subject especially desirable.

Very little is known about the life and career of the Neapolitan painter Bernardo Cavallino; only eight pictures bear his name in some form, and it is only lately that his work has been exhibited and studied seriously. Although he was probably first under the sway of the robust naturalism and dark tonalities of Ribera and Caravaggio, he forged a personal style that was appreciably lighter, more colorful, and refined. In the case of the *Triumph of Galatea*, Cavallino borrowed the pose of the sea goddess and other details from Raphael's fresco of the same subject in the Villa Farnesina in Rome. It was not necessary for Cavallino to go to Rome, for Raphael's composition was easily available in an engraving by Marcantonio Raimondi. Most recently several scholars have raised the possibility that the *Triumph of Galatea* represents a collaboration between Cavallino and Artemisia Gentileschi, who moved to Naples around 1640 and remained there until her death in 1652–1653. Setting aside questions of authorship, this is a superlative example of Neapolitan baroque painting in the United States.

Bernardo Cavallino
(Neapolitan, 1616–1656)
The Triumph of Galatea
c. 1650, oil on canvas
148.3 × 203 (58 3/8 × 79 7/8)
Patrons' Permanent Fund
2000.61.1

Orazio Gentileschi
(Florentine, 1563–1639)
The Lute Player
c. 1612/1620, oil on canvas
143.5 × 129 (56 ½ × 50 ¾)
Ailsa Mellon Bruce Fund
1962.8.1

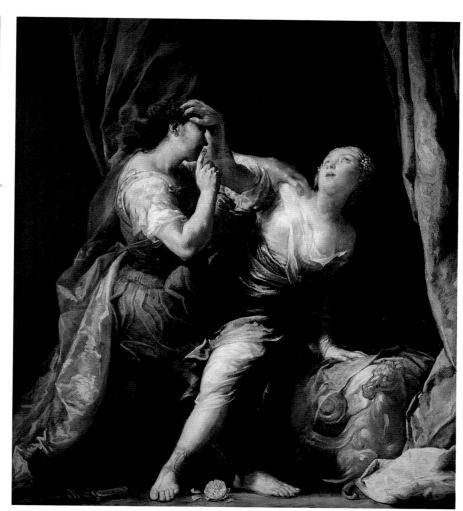

124

Tanzio da Varallo
(Piedmontese, c. 1575–1633)
Saint Sebastian
c. 1620/1630, oil on canvas
117.3 × 93.7 (46 ⅜ × 36 ⅞)
Samuel H. Kress Collection
1939.1.191

125

Bernardo Strozzi
(Genoese-Venetian, 1582–1644)
Bishop Alvise Grimani
1633 or after, oil on canvas
146.7 × 95.1 (57 ¾ × 37 ⅜)
Samuel H. Kress Collection
1961.9.41

126

Giuseppe Maria Crespi
(Bolognese, 1665–1747)
Tarquin and Lucretia
c. 1695/1700, oil on canvas
195 × 171.5 (76 ¾ × 67 ½)
Samuel H. Kress Collection
1952.5.30

Still Life with Sweets and Pottery

JUAN VAN DER HAMEN Y LEÓN

• Beginning in the last decade of the sixteenth century, the ever-increasing importance and popularity of the independent still life seems to have developed simultaneously in Italy, Flanders, Holland, and Spain. Although Juan van Hamen y León died in Madrid when he was only thirty-five, he occupies a central position in the evolution of still-life painting in Spain. Critics are unanimous in ranking the National Gallery of Art's picture as one of the artist's outstanding creations.

An assortment of sweets, earthenware, wooden, and glass containers has been set on stone ledges, or plinths, of various heights. A strong light coming from the left illuminates some of the items fully, while others are cast partially into shadow. The display of sugared donuts, glazed figs, serpentine biscuits, and jars of candied fruits would have especially appealed to Madrid's upper classes. *Pastelerías*, pastry shops that served elaborate desserts, were extremely popular in the early seventeenth century among the aristocracy and the intelligentsia. The painting also testifies to a passion for collecting pottery from foreign lands; the red stoneware jug in the center comes from the Rhineland, while the ewer and bowl with handles at the lower left were imported from Guadalajara, Mexico.

The composition is carefully calibrated and masterfully executed. All of the objects depicted are either round or oval, and these circular shapes are played off against the horizontal and vertical lines of the stone plinths. In addition, the basket of sweets, the red stoneware jug, and the circular wooden boxes define a diagonal that bisects the canvas from corner to corner. The warm reds and browns of the pottery, food, and wood are balanced by the gray stone and the severe black background. Juan van der Hamen's virtuosity is perhaps most evident in his ability to reproduce with uncanny accuracy the individual textures of the many different elements. Particularly striking is the glass finger-bowl next to the red jug, where the artist has expertly captured the complex refraction of light as it passes through glass and water.

127

Juan van der Hamen y León
(Spanish, 1596–1631)
Still Life with Sweets and Pottery
1627, oil on canvas
84.2 × 112.8 (33 ⅛ × 44 ⅜)
Samuel H. Kress Collection
1961.9.75

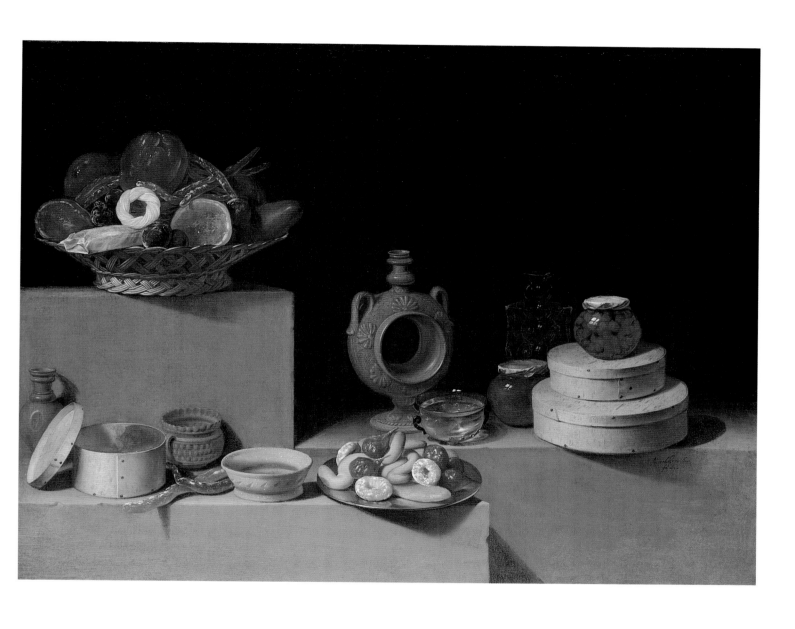

The Return of the Prodigal Son

BARTOLOMÉ ESTEBAN MURILLO

• In 1663 Miguel Mañara became the leader of the Brotherhood of Charity in Seville and embarked on a campaign to expand and refurbish the foundation's building complex. A few years later, probably in 1666, he commissioned two paintings from Juan Valdés Leal and six from Murillo for the church of the Hospital of Charity. As befits the mission of the institution, Murillo's pictures were intended as representations of the acts of mercy set forth in Matthew 25:35–36, and in this regard his *Return of the Prodigal Son* refers to the charitable act of clothing the naked.

The parable of the prodigal son is recounted in the Gospel of Luke (15:11–32), and Murillo here illustrates the moment when the son, having squandered his inheritance, returns to his father barefoot and dressed in rags, pleading for forgiveness. The key components of the narrative are all deftly included: two servants stand at the right, one of whom holds a ring while the other brings forward a tray bearing shoes and fine clothing; the prodigal's disgruntled brother can be glimpsed behind them. At the far left is another reluctant participant, the fatted calf that is led by a young boy and accompanied by the executioner. The little dog that leaps up to greet his long-lost master, not mentioned in the Gospel, is Murillo's own invention. The focal point of the composition is, of course, the father's compassionate acceptance of his repentant son as he at once embraces and supports him.

Murillo's theatrical and sentimental style ensured his success and accorded perfectly with the Counter-Reformation's need for art that conveyed religious doctrines clearly and convincingly. Implicit in Murillo's painting is not only the message that the Church welcomes sinners and penitents back into the fold but also, in contrast to Protestant theology, that good works are a valid way to salvation.

128

Bartolomé Esteban Murillo
(Spanish, 1617–1682)
The Return of the Prodigal Son
1667/1670, oil on canvas
236.3 × 261 (93 × 102 ¾)
Gift of the Avalon Foundation
1948.12.1

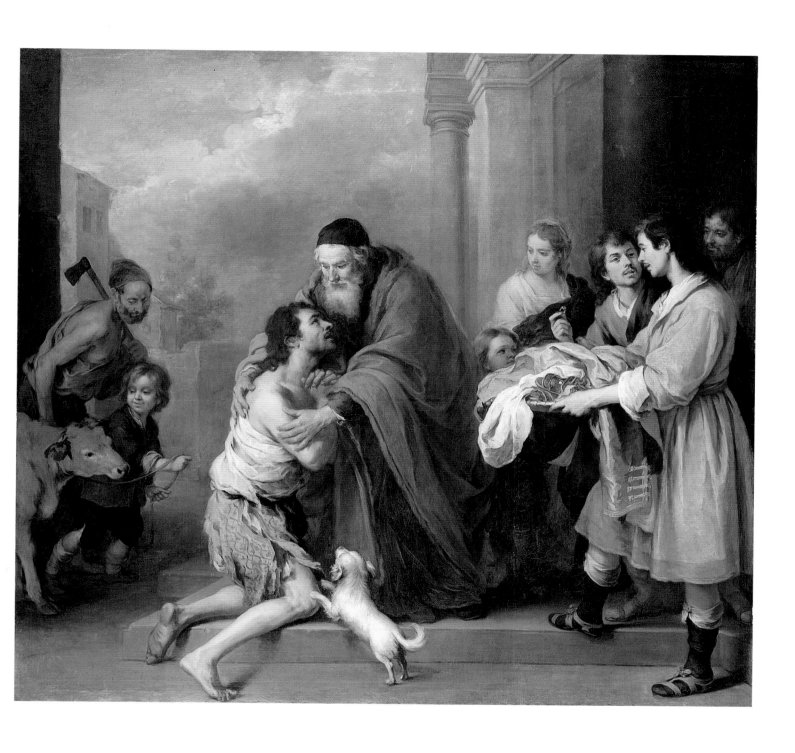

129

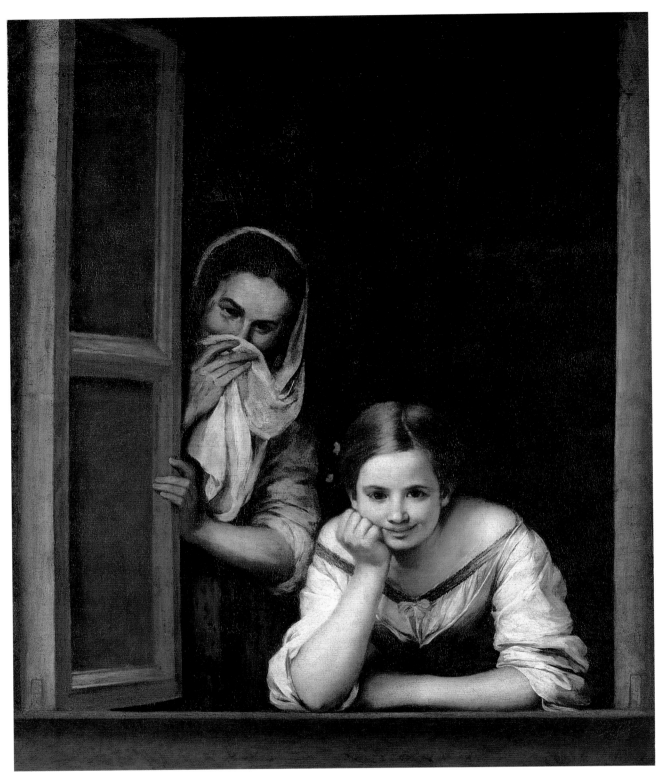

129

Bartolomé Esteban Murillo
(Spanish, 1617–1682)
Two Women at a Window
c. 1655/1660, oil on canvas
125.1 × 104.5 (49 ¼ × 41 ⅛)
Widener Collection
1942.9.46

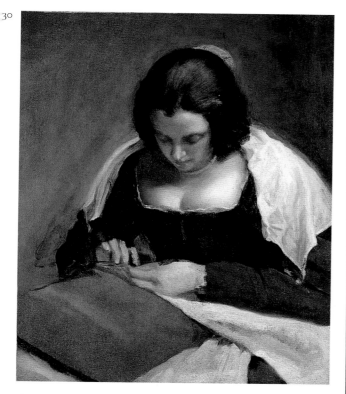

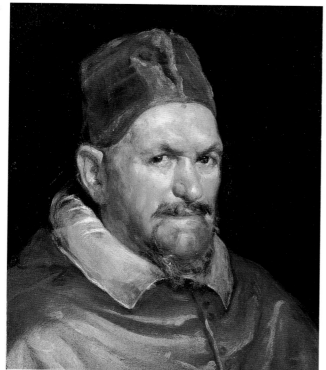

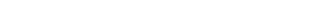

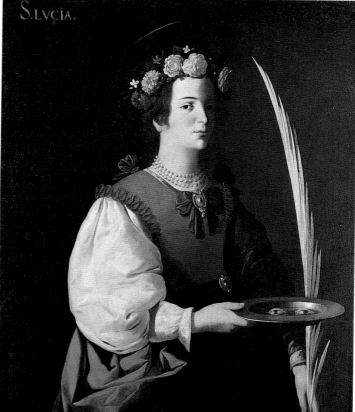

130

Diego Velázquez
(Spanish, 1599–1660)
The Needlewoman
c. 1640/1650, oil on canvas
74 × 60 (29 ⅛ × 23 ⅝)
Andrew W. Mellon Collection
1937.1.81

131

Circle of Diego Velázquez
Pope Innocent X
c. 1650, oil on canvas
49.2 × 41.3 (19 ⅜ × 16 ¼)
Andrew W. Mellon Collection
1937.1.80

132

Francisco de Zurbarán
(Spanish, 1598–1664)
Saint Lucy
c. 1625/1630, oil on canvas
105 × 77 (41 ⅜ × 30 ½)
Chester Dale Collection
1943.7.11

• Omer Talon (1595–1652) was a distinguished jurist who became *premier avocat général* (attorney general) in 1641 during the reign of Louis XIII. The power of the crown was virtually absolute at this time, and ministers — Mazarin in particular — sought to centralize the government at the expense of the parliament of Paris and the nobility. Resistance to royal domination and taxation reached a peak in the revolt known as the Fronde, which lasted from 1648 to 1652. Talon spoke out against the crown's unreasonable seizure of authority and defended the rights and prerogatives of parliament and the people. At the same time he advocated respect, loyalty, and cooperation with the crown. As a lawyer, he was praised for his prudence, eloquence, and erudition.

The inscription on the base of the column at the left indicates that Talon was portrayed in 1649 when he was fifty-four years old. He wears judicial robes, a scarlet gown trimmed in black velvet, and is seated before an expanse of purplish red drapery. He holds a piece of paper in one hand and rests the other on a book, which sits, along with a quill pen and a clock, on a table covered with an Indo-Persian carpet. It is possible that the clock refers to temperance, the column alludes to fortitude, and the partially visible statue at the upper right represents justice, all virtues embodied in Talon.

Philippe de Champaigne was born and trained in Brussels but moved to Paris in 1621 when he was nineteen and quickly found favor at court. Champaigne's portrait of Omer Talon is a splendid marriage of Flemish realism and painterly bravura tempered by French classicism and emphasis on structural clarity. The artist delighted in rendering chips and cracks in the marble as well as the rich textures and slightly discordant colors of the fabrics. With equal precision he captured the stern, authoritative visage of Talon, whose head is placed at the intersection of the ascending triangle of the drapery swag and the descending triangle of his gown. A diagonal of black trim leads up toward his face, and even the quill pen is oriented in his direction. It is likely that Champaigne was uncommonly sympathetic to the austere character of his sitter, for both he and Talon were devout Jansenists, members of an unorthodox, severe, and meditative branch of French Catholicism. Jansenism was viewed as a major impediment to the absolutism of the monarchy, and it is probably a coincidence that in the year this portrait was painted Mazarin led an attempt to destroy its stronghold, the Abbey of Port Royal.

133

Philippe de Champaigne
(French, 1602–1674)
Omer Talon
1649, oil on canvas
225 × 161.6 (88 ½ × 63 ⅝)
Samuel H. Kress Collection
1952.5.35

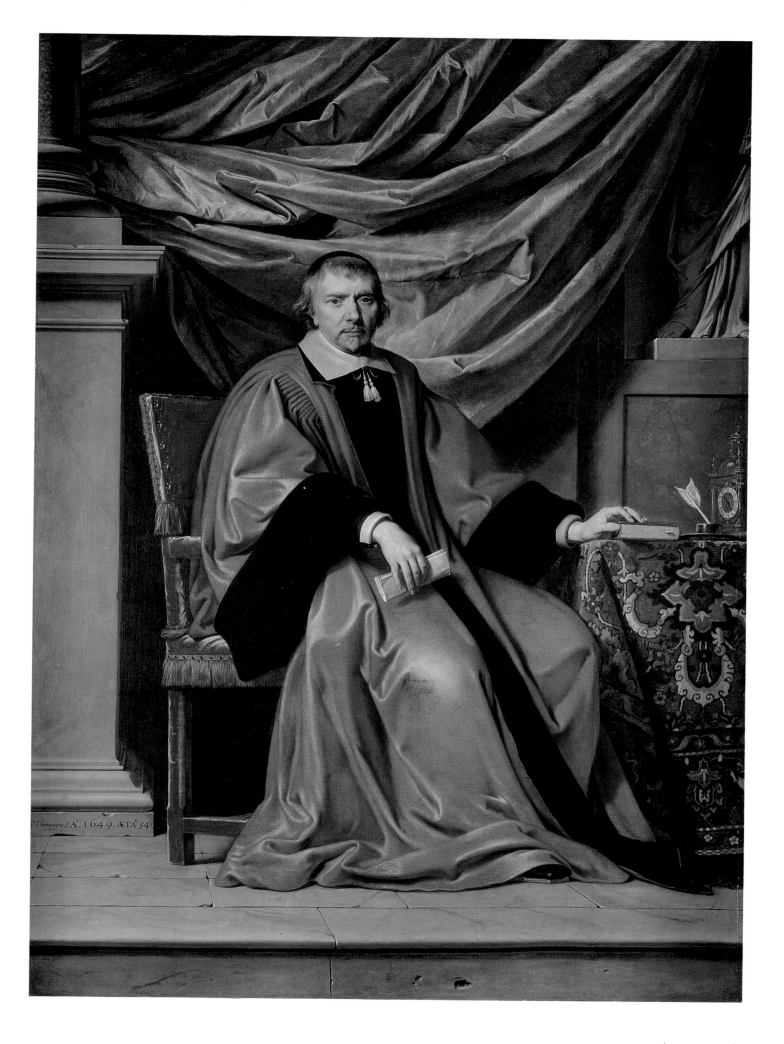

134

135

134

Claude Lorrain
(French, 1600–1682)
Landscape with Merchants
c. 1630, oil on canvas
97.2 × 143.6 (38 1/4 × 56 1/2)
Samuel H. Kress Collection
1952.5.44

135

Sébastien Bourdon
(French, 1616–1671)
The Finding of Moses
probably c. 1650, oil on canvas
119.6 × 172.8 (47 × 68)
Samuel H. Kress Collection
1961.9.65

136	137	138

Claude Lorrain
(French, 1600–1682)
The Judgment of Paris
1645/1646, oil on canvas
112.3 × 149.5 (44 ¼ × 58 ⅞)
Ailsa Mellon Bruce Fund
1969.1.1

Louis Le Nain
(French, 1593–1648)
Landscape with Peasants
c. 1640, oil on canvas
46.5 × 57 (18 ⅜ × 22 ½)
Samuel H. Kress Collection
1946.7.11

Louis Le Nain
(French, 1593–1648)
A French Interior
c. 1645, oil on canvas
55.6 × 64.7 (21 ⅞ × 25 ⅜)
Samuel H. Kress Collection
1952.2.20

The Repentant Magdalen

GEORGES DE LA TOUR

• In a room illuminated by a single candle, Mary Magdalen sits in deep contemplation, her head resting on her hand in a melancholic pose. A profound stillness fills the chamber, with the only suggestion of movement coming from the tip of the flame, which slants as if the Magdalen had just breathed on it. Her fingertips rest against a human skull, and both her hand and the skull are silhouetted by the light. The object of her mediation is not the skull itself but its reflection in a mirror that is depicted at the left. This detail permits the viewer to participate both visually and spiritually in pondering the vanity of worldly things, the brevity of life, and the need for repentance and forgiveness.

After Christ rid her of seven demons (Luke 8:2), Mary Magdalen had become his follower. She was present during the Crucifixion and was the first to see him after his Resurrection. In addition to being mentioned in the Bible, she was the subject of a large body of apocryphal literature, where she was described as a courtesan who, prior to her conversion, dressed in elegant finery and reveled in sensual pleasure. During the Counter-Reformation period Mary Magdalen was especially popular with artists and theologians who extolled her fervent penance, redemption, and nearness to Christ.

Very little is known about Georges de la Tour. He was born in Vic-sur-Seille, a small town in the duchy of Lorraine in northeastern France, not far from the German and Flemish borders. La Tour's teachers have not been identified, and apart from a trip to Paris in 1638 his travels were not recorded, although a trip to Rome is possible. La Tour was quite successful, gaining commissions from the clergy and nobility of Lunéville, where he owned land; from Nancy, the cultural capital of Lorraine; and from Louis XIII and Cardinal Richelieu in Paris.

The earthy realism and dramatic lighting in the paintings of Caravaggio and his followers north and south of the Alps had a decisive impact on La Tour's art. As seen in the *Repentant Magdalen* he forged a highly personal style out of Caravaggio's tenebrism. Shapes are simplified and details suppressed, while the effects of light are rendered with exquisite subtlety. Like Vermeer, La Tour achieved a nearly abstract and silent visual poetry. Also like Vermeer, he and his work were rediscovered in modern times after a period of obscurity.

Georges de La Tour
(French, 1593–1652)
The Repentant Magdalen
c. 1640, oil on canvas
113 × 92.7 (44 ½ × 36 ½)
Ailsa Mellon Bruce Fund
1974.52.1

The Baptism of Christ

NICOLAS POUSSIN

• It is not without irony that one of the most influential French painters spent virtually all of his career in Italy. Poussin was born in Les Andelys in Normandy, and after training there and in Paris, he traveled to Rome in 1624 and studied life drawing under Domenichino and Andrea Sacchi. The artist received few public commissions; instead, his paintings were sold to private collectors in Rome and, later, in France. In 1632 Poussin became a member of the Accademia di San Luca, and in 1635–1636 he painted a series of bacchanals for the French minister, Cardinal Richelieu. In 1640 he returned to France to work for Louis XIII, but he was unhappy working with numerous assistants on large-scale decorative projects in the royal residences, so in 1642 he went back to Rome, where he stayed for the rest of his life.

Sometime around 1635/1636 Cassiano dal Pozzo commissioned from Poussin a series of pictures devoted to the Seven Sacraments. Among the artist's most powerful patrons and friends, Pozzo was a learned antiquarian and the secretary to Cardinal Barberini. The rare subject of the Seven Sacraments reflects Pozzo's interest in the early history of the Church in Rome. Poussin's *Baptism of Christ* was not yet finished when he left Rome in 1640, so he completed the painting in France in 1642 and shipped it to Pozzo.

The biblical narrative is illustrated here with Poussin's characteristic clarity and seriousness. John the Baptist, in a brilliant red robe at the right, baptizes Christ, assisted by two angels, one of whom holds Christ's outer garment while the other daintily keeps his robe out of the River Jordan. Directly over Christ's head is the dove of the Holy Spirit. In the center is a group of five men and a boy who react in different ways to the event. The kneeling man and one in the background look upward in amazement, while another points to the sky, indicating that, though unseen, God has proclaimed from above, "This is my beloved Son, with whom I am well pleased" (Matthew 3:17). Finally, at the far left several neophytes disrobe as they prepare for baptism.

The figures are arrayed in a friezelike procession across the surface, and their postures and gestures are carefully linked and designed to move the spectator's gaze inevitably toward Christ's baptism at the right. Poussin's absorption of Renaissance art can be seen here in the seated figure at the far left, whose pose was inspired by an engraving after a lost Michelangelo cartoon, and in the figure pulling a white robe over his head, who was borrowed from Raphael's *Baptism* fresco in the Vatican. One painting by Poussin, *Penance*, was destroyed by fire in 1816, while the other five paintings in the series belong to the duke of Rutland, Belvoir Castle, Leicestershire.

Nicolas Poussin
(French, 1594–1665)
The Baptism of Christ
1641/1642, oil on canvas
95.5 × 121 (37 ⅝ × 47 ⅝)
Samuel H. Kress Collection
1946.7.14

Soldiers Playing Cards and Dice (The Cheats)

VALENTIN DE BOULOGNE

• In this painting an elegantly dressed young man plays a game of cards with a rough, unkempt soldier in the foreground. As he scrutinizes his cards, he is unaware that the soldier standing behind him is signaling the hand to his accomplice. Meanwhile two other men play dice. The man at the right, wearing an odd combination of a satin shirt and neck armor, is probably a soldier or mercenary. His opponent, whose shirt has slipped off his shoulder, gestures angrily, and a violent altercation seems imminent.

Although secular images of people playing cards or chess began to appear in the sixteenth century, it was Caravaggio who turned this into a new subject category: soldiers gambling and cheating cards. In addition to their moralizing or even comic overtones, the paintings by Caravaggio and his close follower Bartolomeo Manfredi had a basis in fact. Among the riffraff found in the alleys and taverns of Rome in the late sixteenth century were armed mercenaries, who sought work with the nobility but were often unemployed or unpaid, and who, like the men in this picture, dressed in ill-matched, pieced-together uniforms.

Valentin de Boulogne, as his name indicates, came from the town of Boulogne in Picardy. His father was an artist, but almost nothing is known about his life in France. Valentin is not documented in Rome until 1620 but may have actually arrived some years earlier. Although Caravaggio had died in 1610, his influence was very much alive in the works of Manfredi and a group of Dutch, Flemish, and French artists living in the neighborhood around the Piazza del Popolo, where Valentin took up residence. As is evident here, Valentin embraced not only Caravaggio's subject matter but also his dramatic illumination and contrasts of light and shadow. In addition to genre pieces, Valentin painted religious subjects as well, and thanks to patrons such as Cardinal Barberini, he garnered both public and private commissions. Valentin de Boulogne died in 1632, when he was likely in his early forties.

Valentin de Boulogne
(French, c. 1591–1632)
Soldiers Playing Cards and Dice (The Cheats)
c. 1620/1622, oil on canvas
121 × 152 (47 ⅝ × 59 ⅞)
Patrons' Permanent Fund
1998.104.1

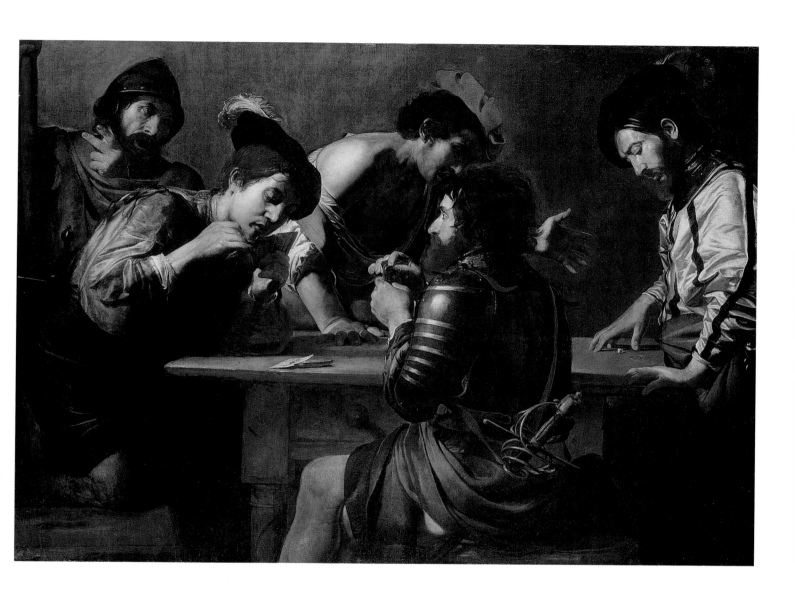

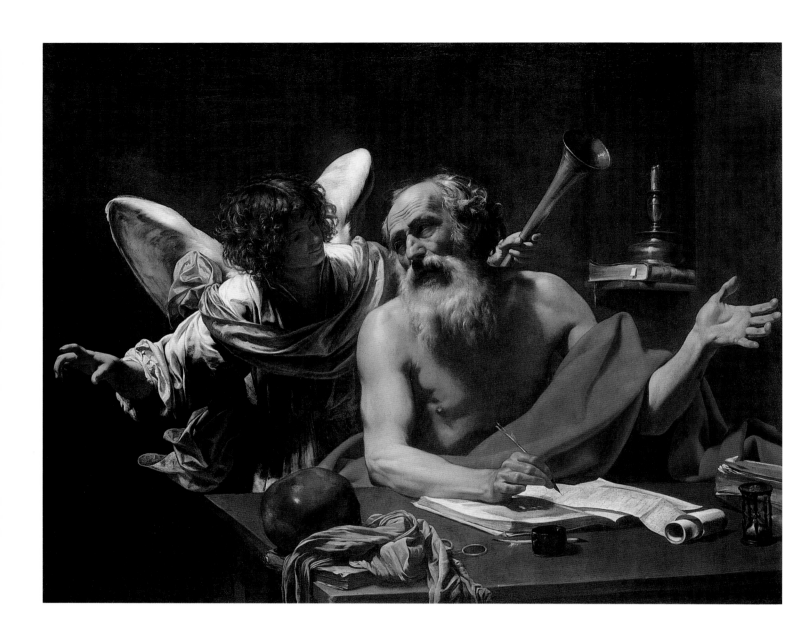

142

Simon Vouet
(French, 1590–1649)
Saint Jerome and the Angel
c. 1625, oil on canvas
144.8 × 179.8 (57 × 70 ¾)
Samuel H. Kress Collection
1961.9.52

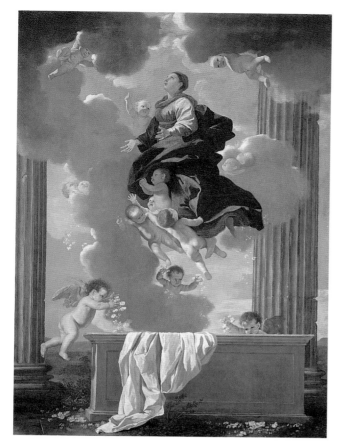

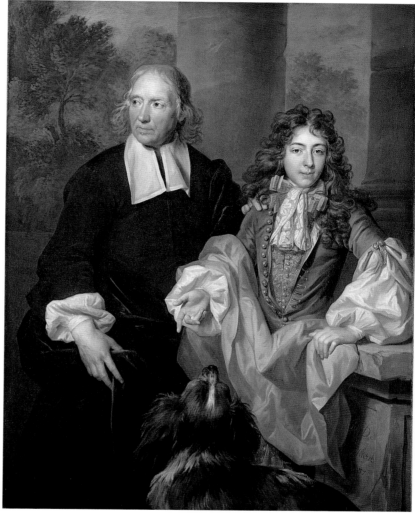

143

144

Nicolas Poussin
(French, 1594–1665)
The Assumption of the Virgin
c. 1626, oil on canvas
134.4 × 98.1 (52 ⅞ × 38 ⅝)
Ailsa Mellon Bruce Fund
1963.5.1

Nicolas de Largillière
(French, 1656–1746)
A Young Man with His Tutor
1685, oil on canvas
146 × 114.8 (57 ½ × 45 ⅛)
Samuel H. Kress Collection
1961.9.26

The Maas at Dordrecht

AELBERT CUYP

• Situated at the confluence of three major rivers—the Maas, the Rhine, and the Merwede—Dordrecht was a well-established mercantile center and transportation hub. Its harbor was deep enough to admit seagoing vessels, and the numerous waterways provided routes inland. Cuyp was born in Dordrecht to a family of artists and artisans. He spent essentially all of his life in the city and knew it and its surroundings intimately.

Here the city is viewed across the Maas from the north. At the far left one can see the pointed tower of the port building, and to the right of it, the square unfinished tower of the Grote Kerk. An exceptionally large number of ships has gathered on the river, and although it cannot be established with certainty, it is likely that the painting depicts an actual event. In July 1646 more than 30,000 Dutch soldiers and a vast fleet of ships amassed in Dordrecht in preparation for an excursion into the southern Netherlands. The prominent ship in the right foreground is a *pleyt*, designed for sailing in

shallow waters. Next to it is a rowboat that probably bears officials from the city of Dordrecht, for one of the men standing wears a sash of red and white, the city's colors. Typical of Cuyp are the extraordinary light effects. It is early morning, and the entire painting is suffused with limpid golden light that lends a soft glow to the ships' sails. There is a poetic yet palpable contrast and equilibrium created between the sailing vessels, becalmed yet poised to depart, and the massive clouds that promise fresh winds.

Cuyp has always been cherished by the English, and by 1804 his *Maas at Dordrecht* was in England, where it was exhibited often. Among those who fell under its spell was Joseph Mallord William Turner, who in 1818 made a free adaptation of the picture that is now in the Yale Center for British Art in New Haven.

Aelbert Cuyp
(Dutch, 1620–1691)
The Maas at Dordrecht
c. 1650, oil on canvas
114.9 × 170.2 (45 ¼ × 67)
Andrew W. Mellon Collection
1940.2.1

Portrait of an Elderly Lady

FRANS HALS

• The inscription on the wall indicates that in 1633 this unknown woman was sixty years old. Her ample bulk settled comfortably in a wooden chair, she holds a small book, perhaps a prayer book or a Bible, in one hand and maintains a firm grasp on the arm of the chair with the other. Her sober but expensive costume places her among the prosperous middle class.

This picture reveals fully why Hals is considered one of the supremely gifted portraitists of the seventeenth century and one of the preeminent painters of any era. The viewer is brought into a direct, immediate encounter with the woman's spry, energetic personality, and it is easy to imagine her smile turning into speech or laughter. Hals has indeed created a "speaking likeness." A virtuoso with a brush, Hals used broad, unblended strokes of black and white to capture the different textures of the black dress while at the same time rendering with great precision the folds, patterns, and even the translucency of the lace cuffs, cap, and ruff. The hand holding the arm of the chair is a small masterpiece, painted with unhesitating sureness and an economy of brushwork. From

the position of the figure facing left, it is almost certain that a portrait of her husband was originally pendant to this work, and although not all authorities agree, the most likely candidate is the *Portrait of a Man* in the Frick Collection, New York.

Following the fall of Antwerp to the Spanish in 1585, Hals' parents emigrated to Haarlem. Hals joined the painters' guild in 1610 and remained in Haarlem for the rest of his long career. He was primarily a portraitist but also painted genre scenes and a few religious works. Although reports of his alcoholism and dissolute ways are for the most part unfounded, it is true that he was often in debt to local merchants and at the end of his life received financial assistance from the city's aldermen. Hals was almost completely unknown until the 1860s when his paintings were rediscovered by the French critic Théophile Thoré and artists such as Gustav Courbet and Edouard Manet.

Frans Hals
(Dutch, c. 1582/1583–1666)
Portrait of an Elderly Lady
1633, oil on canvas
102.5 × 86.9 (40 ⅜ × 34 ¼)
Andrew W. Mellon Collection
1937.1.67

ÆTAT SVÆ 60
ANº 1633

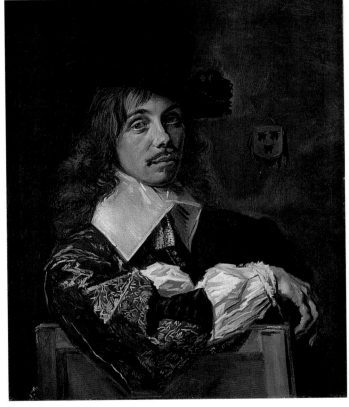

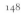

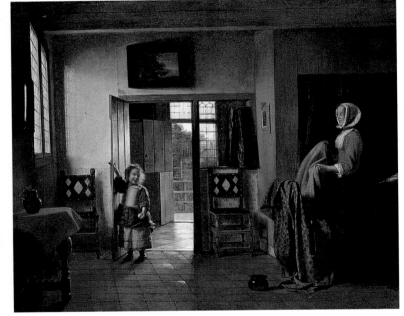

147

Jan van Goyen
(Dutch, 1596–1656)
View of Dordrecht from the Dordtse Kil
1644, oil on panel
64.7 × 95.9 (25 × 37 ¾)
Ailsa Mellon Bruce Fund
1978.11.1

148

Frans Hals
(Dutch, c. 1582/1583–1666)
Willem Coymans
1645, oil on canvas
77 × 64 (30 ¼ × 25)
Andrew W. Mellon Collection
1937.1.69

149

Pieter de Hooch
(Dutch, 1629–1684)
The Bedroom
1658/1660, oil on canvas
51 × 60 (20 × 23 ½)
Widener Collection
1942.9.33

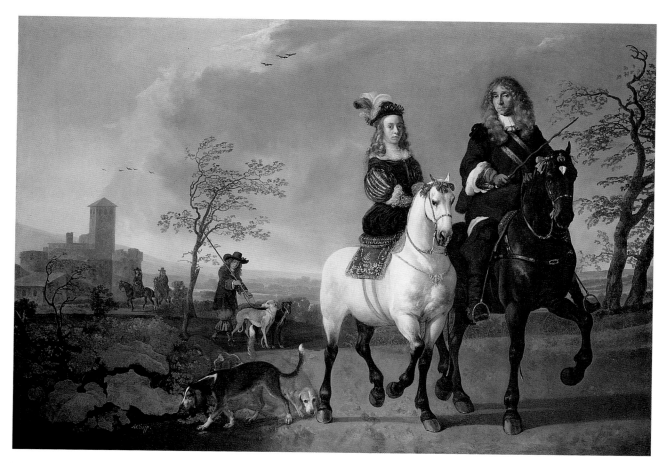

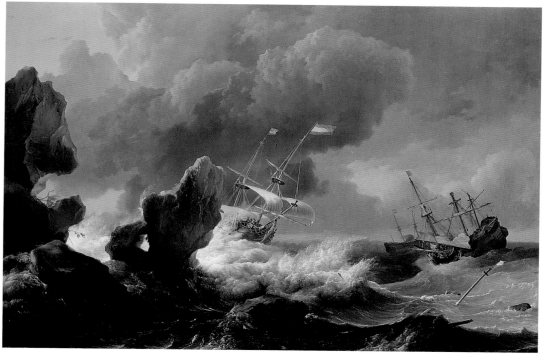

150

151

Aelbert Cuyp
(Dutch, 1620–1691)
Lady and Gentleman on Horseback
c. 1655, reworked 1660/1665, oil on canvas
123 × 172 (48 ½ × 67 ¾)
Widener Collection
1942.9.15

Ludolf Backhuysen
(Dutch, 1631–1708)
Ships in Distress off a Rocky Coast
1667, oil on canvas
114.3 × 167.3 (45 × 65 ⅞)
Ailsa Mellon Bruce Fund
1985.29.1

Vase of Flowers

JAN DAVIDSZ DE HEEM

• It was in the seventeenth century that still life came into its own throughout Europe, but nowhere was it more highly prized that in Flanders and the Netherlands. Of the artists who specialized in still-life painting, de Heem was unusually accomplished. He had worked in Utrecht, Leiden, and Antwerp and was knowledgeable about both Dutch and Flemish approaches to the genre. A work of his maturity, *Vase of Flowers* brings together a rich variety of plant and animal life. Among the many flowers are rare and expensive striped tulips, an unusual white poppy fringed in red, roses, hyacinth, violet, and morning glory, to name a few. There are also edible plants: peas in a pod and stalks of wheat. This arrangement teems with animal and insect life as well: in addition to several butterflies one can find at the lower left a snail, a lizard, and a spider. Every item is painstakingly and beautifully portrayed, and what appears to be random profusion is actually carefully organized in an oval shape.

Although many still lifes are simply displays of the good and precious things of this world, others, including de Heem's *Vase of Flowers*, have moralizing meanings. Cut flowers symbolize the evanescent, transitory nature of human existence, recalling the words of Job (14:1−2), "Man that is born of woman is of few days and full of trouble. He comes forth like a flower, and withers." The tulip at the far right is past its prime, and while the large white poppy is still upright, the red poppy has fallen over, both associated with sleep and death. The insects that have come to feed on the plants will hasten the process of decay. Religious meaning is perhaps most evident in the stalks of wheat, whose grains must enter the earth to be regenerated, and which calls to mind the bread of the Eucharist. It is even possible to find a cross in the mullions of the window (of the artist's studio?) reflected in the glass vase.

152

Jan Davidsz de Heem
(Dutch, 1606−1683/1684)
Vase of Flowers
c. 1660, oil on canvas
69.6 × 56.5 (27 ³/₈ × 22 ¹/₄)
Andrew W. Mellon Fund
1961.6.1

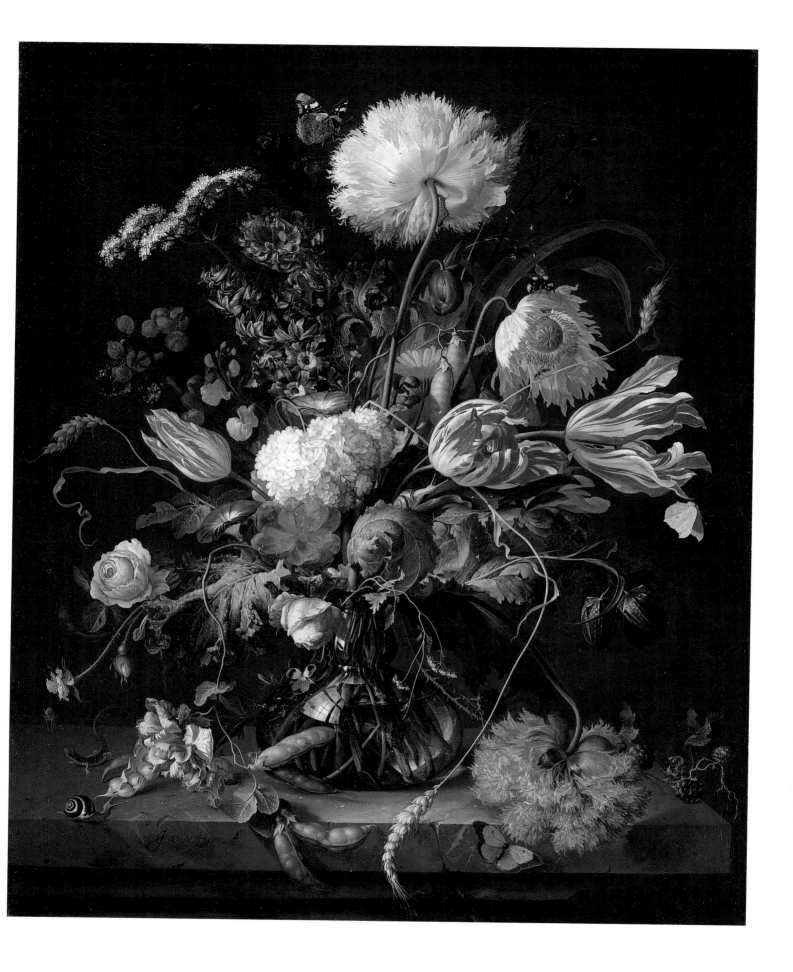

Banquet Piece with Mince Pie

WILLEM CLAESZ HEDA

• One of several types of still life, the banquet piece focused on the display of costly and sumptuous food and tableware. In this painting the repast has already taken place. The main course would have been the mince pie at the right. Made with meat, raisins, currants, and spices, it was an expensive dish reserved for special occasions. Oysters were considered an aphrodisiac and emblem of sensual delight, and empty shells indicate that a number were consumed. They would have been flavored with vinegar from the Venetian-style glass cruet. Next to the cruet is a mound of salt in a silver receptacle, while the pepper is contained in the narrow paper cone made from the page of an almanac resting on the metal plate at the far right. Still remaining on the table are green olives, a peeled lemon, a roll, and half a glass of brown beer.

Heda was especially skilled at reproducing the distinctive textures and sheen of the pewter jug, overturned silver tazza, tall gilt bronze covered goblet, and brass candlestick as well as the different kinds of glass. He organized the composition with exceptional care, using the lemon peel, knife handle, and pewter plates that project over the edge of the table to create visual and spatial pathways to the objects on the table. Heda, who spent his career in Haarlem, was a master of what is called monochrome still life. As seen here, color is greatly restricted and modified by the predominantly brown and grayish brown tonality. The only jarring notes in this display of wealth and abundance are provided by the extinguished candle at the left and the broken wine glass at the right, reminders of the transience and fragility of life's pleasures.

153

Willem Claesz Heda
(Dutch, 1593/1594–1680)
Banquet Piece with Mince Pie
1635, oil on canvas
106.7 × 111.1 (42 × 43 ¾)
Patrons' Permanent Fund
1991.87.1

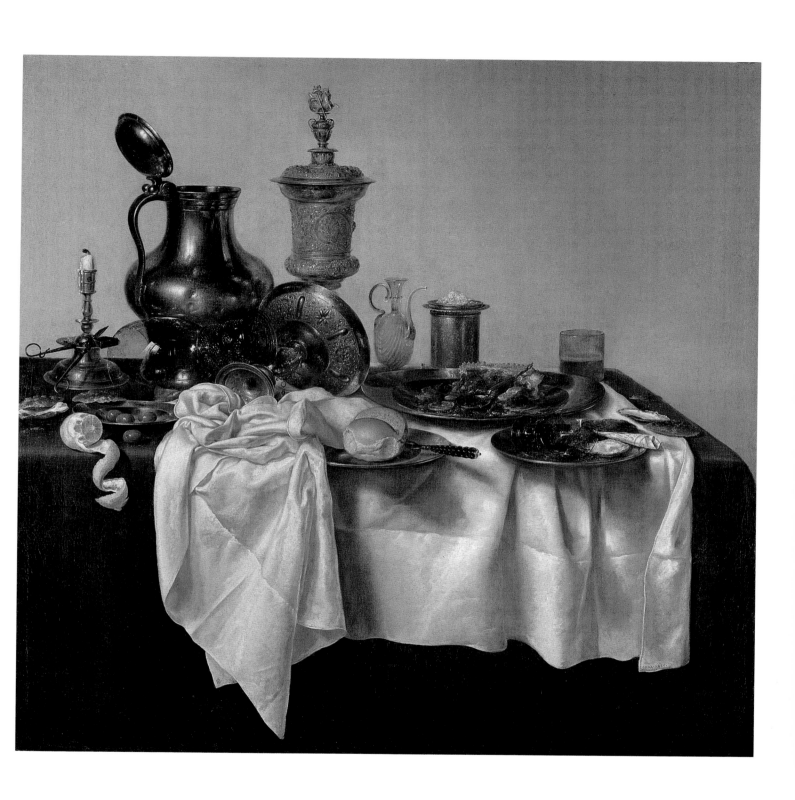

Self-Portrait

JUDITH LEYSTER

• A figure of singular importance for seventeenth-century Dutch painting, Judith Leyster was born in Haarlem. Leyster, which means "lodestar" in Dutch, was the name of her father's brewery, which was transformed into a family name. Recognition of her talent came early. She is first mentioned in 1628 when she was only nineteen, but details of her early training are unknown. She was certainly influenced by both Frans Hals and his brother Dirck, but no documents exist to prove that she studied with either. In 1633 she became a master in the Haarlem Guild of Saint Luke—the first woman to produce a body of known works—and in 1635 she had three pupils. When one of these left to work for Frans Hals, Leyster successfully petitioned the guild to demand recompense from the student's mother. In 1636 Leyster married another painter, Jan Miense Molenaer, and although she doubtless helped run the atelier, she painted very little between her marriage and her death in 1660.

In her *Self-Portrait* Leyster turns to face the viewer with a smile on her open, youthful face, as if she had just been interrupted in her work. With her arm resting on the back of her chair, she leans back, striking a relaxed, informal pose that owes much to the portrait innovations of Hals, as do the loose, seemingly rapid and assured brush strokes. In one hand Leyster holds a fine-tipped brush, and in the other a palette, white rag, and several other brushes. She is not, however, dressed for work but is attired elegantly and formally in a black and purplish red dress with a wide starched collar. In this she is following the tradition of self-portraiture in which artists represent themselves as the social equals of their patrons. On the easel is an unfinished depiction of a violinist, taken from a larger composition, the *Merry Company*, a scene of people drinking and singing. Perhaps best known for the lively, good-humored genre scenes such as that, she also painted still lifes and portraits.

Judith Leyster
(Dutch, 1609–1660)
Self-Portrait
c. 1630, oil on canvas
74.61 × 65.09 (29 3/8 × 25 5/8)
Gift of Mr. and Mrs. Robert Woods Bliss
1949.6.1

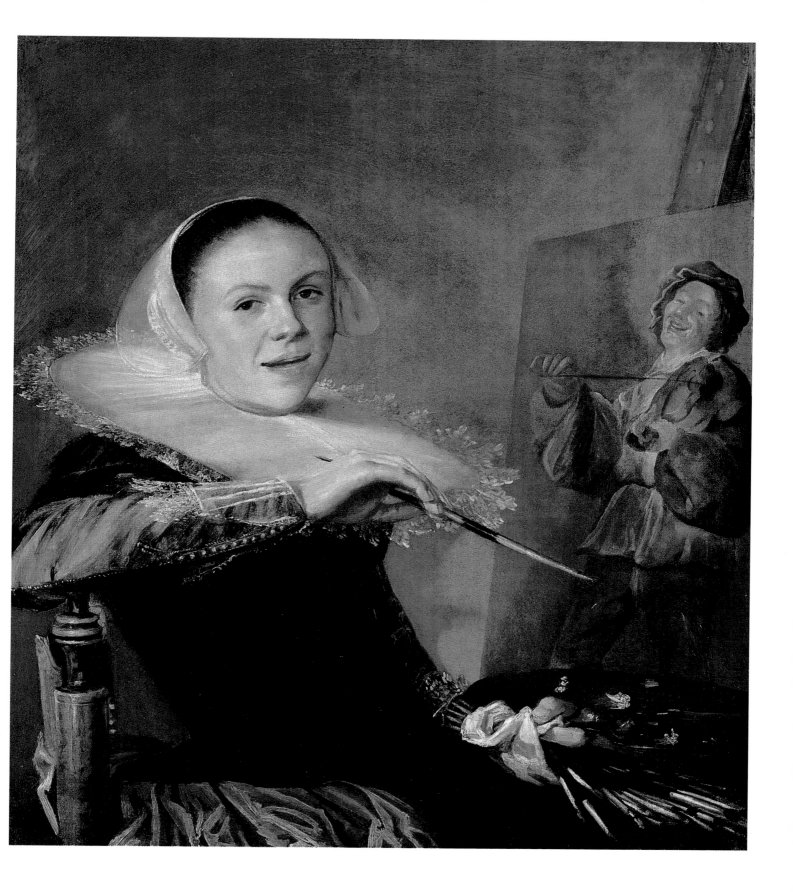

Moonlit Landscape with Bridge

AERT VAN DER NEER

• The haunting glow of a full moon, its light diffused in a cloud-filled sky, illuminates this landscape. The clouds are particularly dramatic, ranging from dark gray to an almost fiery red. In the river below, a second focal point of light is provided by the reflection of the moon in the water. A modest footbridge passes over the waterway, connecting a group of houses on the left with a small bosk on the right. Adjusting to the semidarkness, one finds a man, a woman, and a dog crossing the bridge at the right, and warm light at the far right picks out an elegant couple standing in front of a portico that is part of a high wall. The stone wall and gate are typical of those protecting the country houses of patrician families.

Although certain aspects of the buildings and the setting recall Amsterdam and its environs, the scene is imaginary and is merely a vehicle for the real subject: van der Neer's exploration of atmospheric effects. Earth and sky, man and nature, and even country and city are united by the moonlight that saturates the landscape.

Van der Neer was interested in all manner of atmospheric and meteorological effects, including rainbows, snowstorms, and winter scenes, and he is the most accomplished Dutch artist to paint nocturnal landscapes. In the seventeenth century both the German artist Adam Elsheimer and the Flemish painter Peter Paul Rubens produced night scenes, but it is not clear to what extent van der Neer might have been aware of their work.

The absence of religious or noble patronage in the Dutch Republic created a free market economy in which not all artists were able to make a living, and Aert van der Neer, who was active in Amsterdam, had to run a tavern to augment his income from selling his paintings. That venture failed, however, and he was forced to declare bankruptcy, spending his final years in poverty. Now he is celebrated as among the most sensitive and innovative of Dutch landscape artists.

155

Aert van der Neer
(Dutch, 1603/1604–1677)
Moonlit Landscape with Bridge
probably 1648/1650, oil on panel
78.4 × 110.2 (30 7/8 × 43 3/8)
Patrons' Permanent Fund
1990.6.1

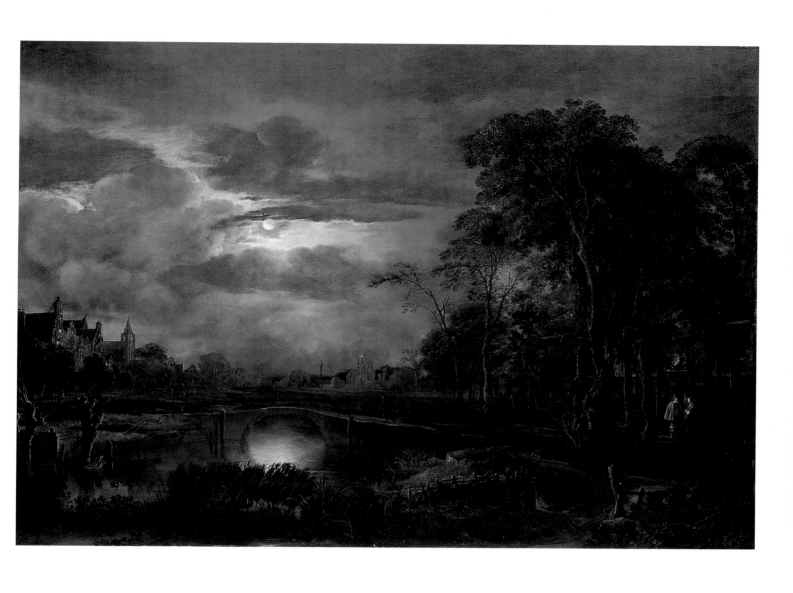

Self-Portrait

REMBRANDT VAN RIJN

• Rembrandt is one of the towering figures in the history of Western art. Among his contemporaries he is unique in the number of self-portraits he produced. From youth to old age, he chronicled his changing appearance in forty paintings, thirty-one etchings, and many drawings. The National Gallery of Art's *Self-Portrait*, dated 1659, was painted when the artist was fifty-three years old. He is dressed rather simply in a black beret and a dark brown jacket, though there appears to be a fur cloak draped over his right arm. He is seated with his hands folded and has turned his head to regard the viewer with a riveting gaze. As if illuminated by a spotlight, the face is the brightest area of the canvas, and Rembrandt has unsparingly recorded the wrinkles around his eyes, the furrowed brow, the wispy gray hair, and the slightly sagging flesh that comes with age.

In 1656 Rembrandt was forced into bankruptcy, and in 1657 and 1658 his possessions were auctioned off and he had to move out of the large house he had purchased in 1639 (which was one cause of his financial problems). One must avoid the overly romantic notion that Rembrandt painted this self-portrait merely as a commentary on his difficult life. Nonetheless, it is interesting and perhaps revealing that he modeled the pose and the direct gaze on Raphael's portrait of the nobleman Balthasar Castiglione (Musée du Louvre, Paris), which had come up for auction in Amsterdam in 1639. Although an exact interpretation of Rembrandt's expression may be elusive, there is an ineffable depth of feeling and human experience in this portrait.

The emotional richness of this *Self-Portrait* is paralleled by the range and diversity of Rembrandt's formidable technique. In contrast to areas such as the hands that are thinly painted, the face is a complex mixture of short strokes of thick paint, wet-in-wet brushwork, and softening, transitional shadows and halftones that were applied after the initial paint layers had dried. In the hair Rembrandt used fine individual strokes and incised the paint with the tip of the brush handle to achieve the effects he desired.

156

Rembrandt van Rijn
(Dutch, 1606–1669)
Self-Portrait
1659, oil on canvas
84.5 × 66 (33 ¼ × 26)
Andrew W. Mellon Collection
1937.1.72

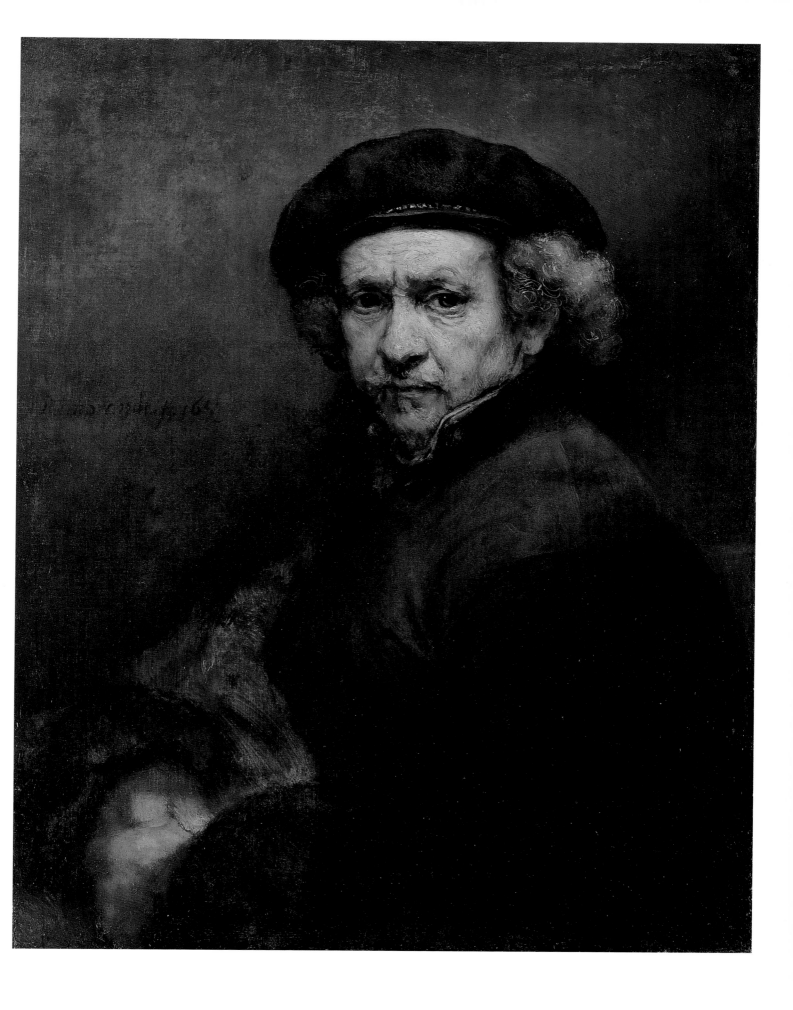

Lucretia

REMBRANDT VAN RIJN

• As told by Livy in his history of Rome, the story of Lucretia is said to have taken place in the sixth century BC during the reign of the tyrant Tarquinius Superbus. Angered and aroused by Lucretia's virtue, the ruler's son Sextus Tarquinius raped her. The following day she told her husband and father what had taken place, and although she felt that only her body, not her mind or heart, had been violated, she did not want to provide an excuse for unchaste women to escape punishment. Before anyone could stop her, Lucretia took a knife from her clothing, stabbed herself in the heart, and died. Vowing revenge, her family and friends displayed her body in the marketplace. The ensuing outrage by the citizens of Rome brought about the expulsion of the tyrant and his son and the establishment of a republican government. From the Renaissance on, Lucretia was an emblem of chastity, choosing death over dishonor, and in the larger political sense she stood for freedom from tyranny.

Rembrandt chose to depict the awful moment just before Lucretia's suicide. With searing insight into the human condition, the artist depicts a woman, anguished and tormented by a moment of doubt, even as she realizes what must be done. Of no little significance is the fact that Rembrandt has given Lucretia the features of his companion, Hendrickje Stoffels, as she looked in the 1650s. Even though they had a daughter, Cornelia, Hendrickje and Rembrandt never married, and in 1654 Hendrickje was publicly rebuked by the Dutch Reformed Church for "living in sin" with the artist. Hendrickje died in 1663, the year before this painting, and it is quite likely that Rembrandt equated Hendrickje's suffering and humiliation with that of Lucretia.

The figure of Lucretia is shown emerging from the darkness with light almost seeming to emanate from her body. The lightest area is her chest, which in the next moment will receive the dagger's thrust. Rembrandt's handling of paint is extraordinarily varied: a palette knife was used to render her left sleeve and parts of her dress, while both wet-in-wet brushwork and scumbling with a dry brush and a skein of highlights in impasto plays over the surface. As with the late works of other great artists, such as Titian, Michelangelo, and Beethoven, Rembrandt in his last years achieved a highly personal and expressive fusion of style and technique that borders on the abstract.

Rembrandt van Rijn
(Dutch, 1606–1669)
Lucretia
1664, oil on canvas
120 × 101 (47 ¼ × 39 ¼)
Andrew W. Mellon Collection
1937.1.76

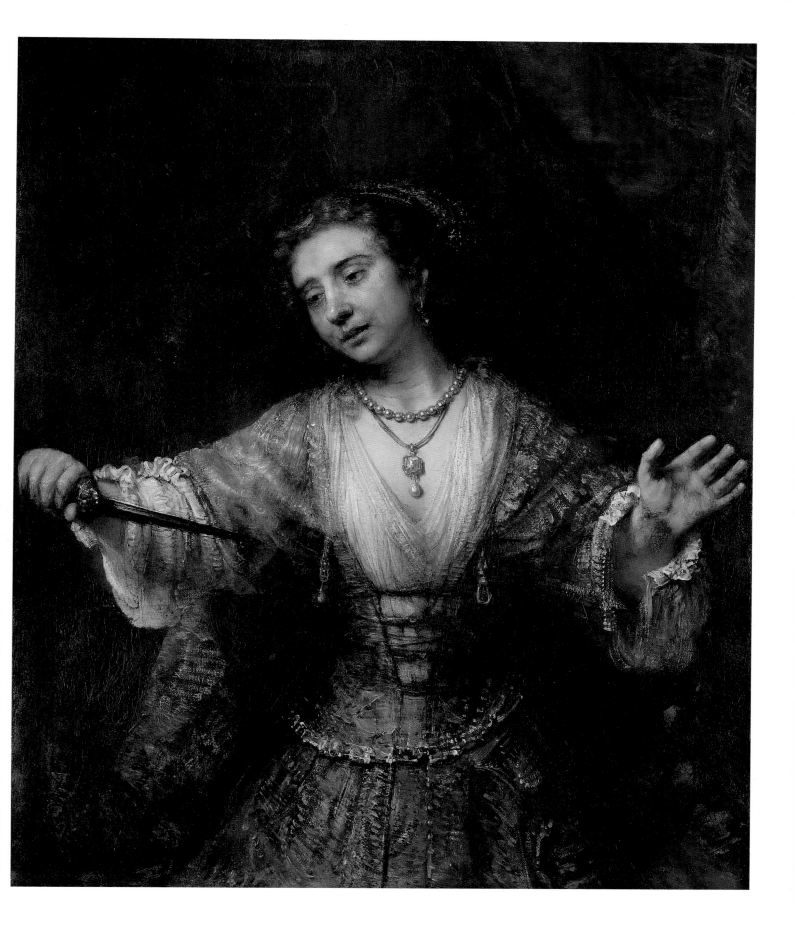

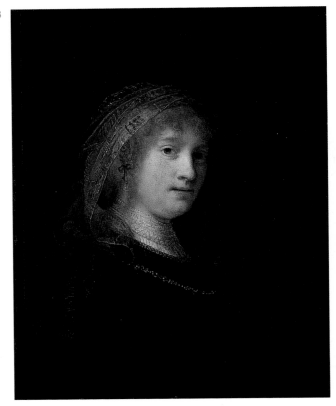

159

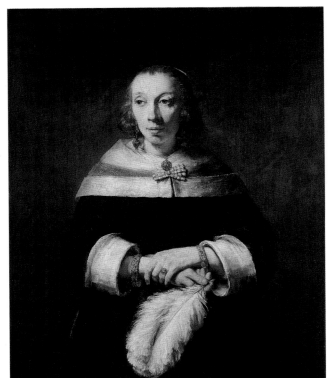

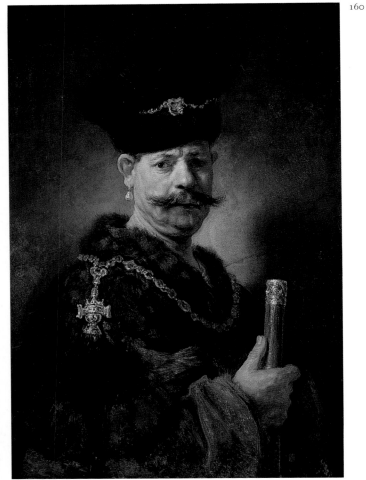

158

Rembrandt van Rijn
(Dutch, 1606–1669)
Saskia van Uylenburgh,
the Wife of the Artist
probably begun 1634/1635 and
completed 1638/1640, oil on panel
60.5 × 49 (23 ¾ × 19 ¼)
Widener Collection
1942.9.71

159

Rembrandt van Rijn
(Dutch, 1606–1669)
Portrait of a Lady with
an Ostrich-Feather Fan
c. 1658/1660, oil on canvas
transferred to canvas
99.5 × 83 (39 ¼ × 32 ⅝)
Widener Collection
1942.9.68

160

Rembrandt van Rijn
(Dutch, 1606–1669)
A Polish Nobleman
1637, oil on panel
96.8 × 66 (38 ⅛ × 26)
Andrew W. Mellon Collection
1937.1.78

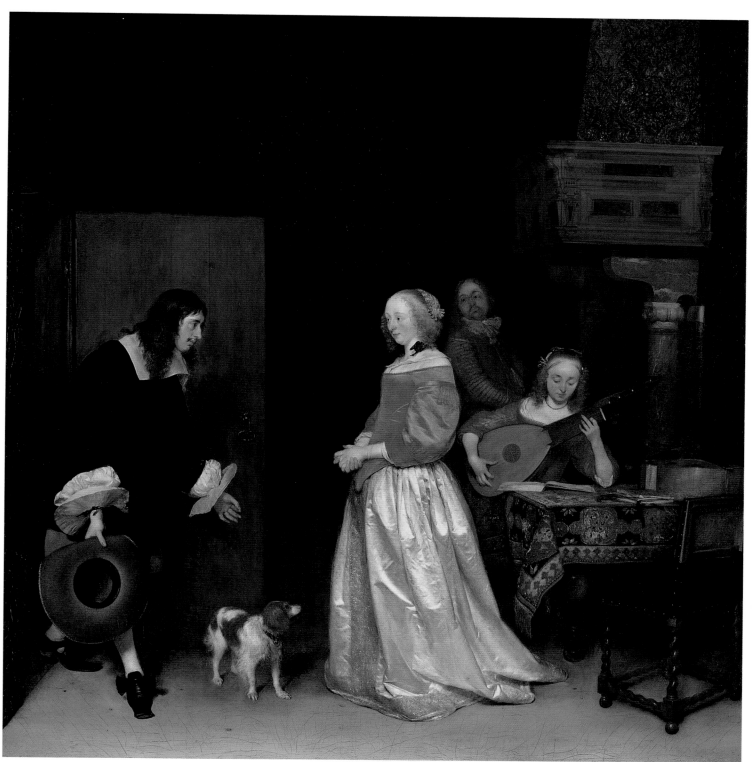

161

Gerard ter Borch II
(Dutch, 1617–1681)
The Suitor's Visit
c. 1658, oil on canvas
80 × 75 (31 ½ × 29 ½)
Andrew W. Mellon Collection
1937.1.58

Forest Scene

JACOB VAN RUISDAEL

• The strength of Jacob van Ruisdael rests simultaneously on his ability to observe and transcribe the colors and textures of earth, trees, and plants in a convincing manner and on his broader vision of the emotional power inherent in the natural world. Both qualities are fully apparent in this *Forest Scene*, where in the foreground a torrent of water rushes over rocks and large birch trees that have died, broken, and fallen over, their bark a deathly white. Backlit by a cloudy sky, the dark forest appears especially dense and impenetrable. There are a few signs of human habitation: in the middle ground one can pick out a man and a woman and several grazing sheep, but they are all but absorbed into the surrounding woods. There is a sense that, however somber, decay is an essential part of the natural order of things; the fallen trees will become part of the forest and be replaced by saplings and young plants.

Born in Haarlem, Ruisdael entered the painters' guild in that city in 1648. Both his father and his uncle Salomon van Ruisdael were painters, and one assumes they were among his first teachers. After traveling in the Lower Rhine in the 1650s, Jacob van Ruisdael settled in Amsterdam in 1656 and spent the rest of his life there. He was successful and influenced a number of artists, notably Meindert Hobbema and Jan van Kessel. In the early nineteenth century there was a strong interest in Ruisdael among landscape artists who also wished to capture the heroic grandeur of the natural world.

Jacob van Ruisdael
(Dutch, c. 1628/1629–1682)
Forest Scene
c. 1655, oil on canvas
105.5 × 123.4 (41 ⅝ × 52 ⅛)
Widener Collection
1942.9.80

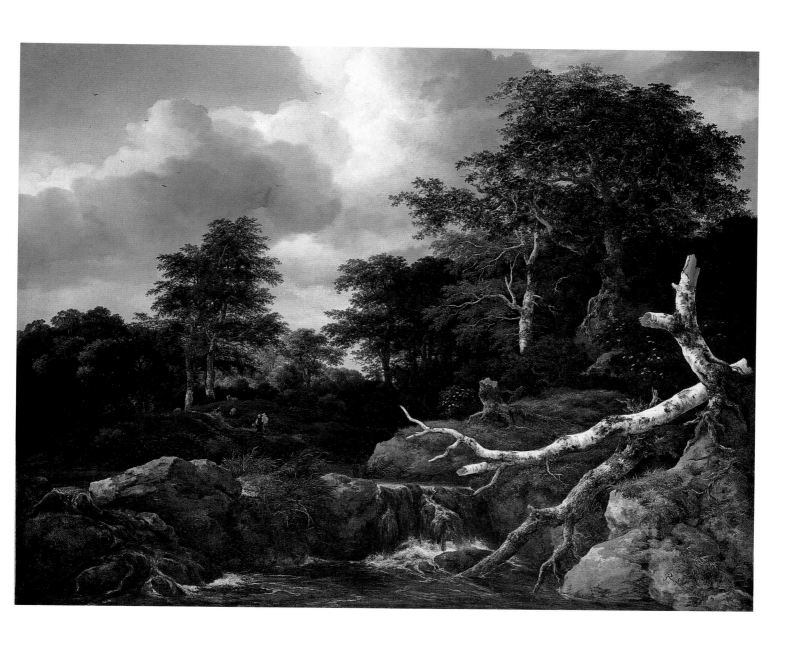

Woman Holding a Balance

JOHANNES VERMEER

• In this thought-provoking image, a young woman stands in front of a table on which are arrayed gold coins, pearls, and a gold chain. She looks pensively at the balance she holds; the pans are empty, and it would seem that she is checking their accuracy before weighing the treasures before her. A painting hangs on the wall behind her, and even though it is partially obscured it is clearly a depiction of the Last Judgment. There is an immediate and obvious parallel between the moment when Christ comes to judge men's souls and the weighing of worldly goods. This juxtaposition of religious and secular themes has been interpreted in different ways. For a time it was thought that the painting was an allegory of vanity, a warning against choosing gold over salvation. Recently, a more positive interpretation has been proposed: that in her serene meditation the woman represents the need to live a life of moderation and balanced judgment. Accordingly, the mirror hanging on the wall at the left represents self-knowledge, and self-awareness means judging and taking responsibility for one's actions.

Woman with a Balance testifies to Vermeer's exquisite technique and perfectly calibrated control over light, color, and space. Sunlight from the window at the left directly illuminates the tabletop and the woman, especially the brilliant white fur of her morning jacket; but a softer, indirect light, reflecting off the wall, also fills the room. Small details, such as the hole high in the plaster wall and the nail next to it, are superbly observed. The overall composition is also carefully organized; note, for example, how the hand holding the balance is positioned at the corner of the picture frame enclosing the Last Judgment and how this is also the center of Vermeer's painting. All these elements come together to create a moment frozen in time, filled with an uncanny stillness and silence.

Johannes Vermeer
(Dutch, 1632–1675)
Woman Holding a Balance
c. 1664, oil on canvas
39.7 × 35.5 (15 7/8 × 14)
Widener Collection
1942.9.97

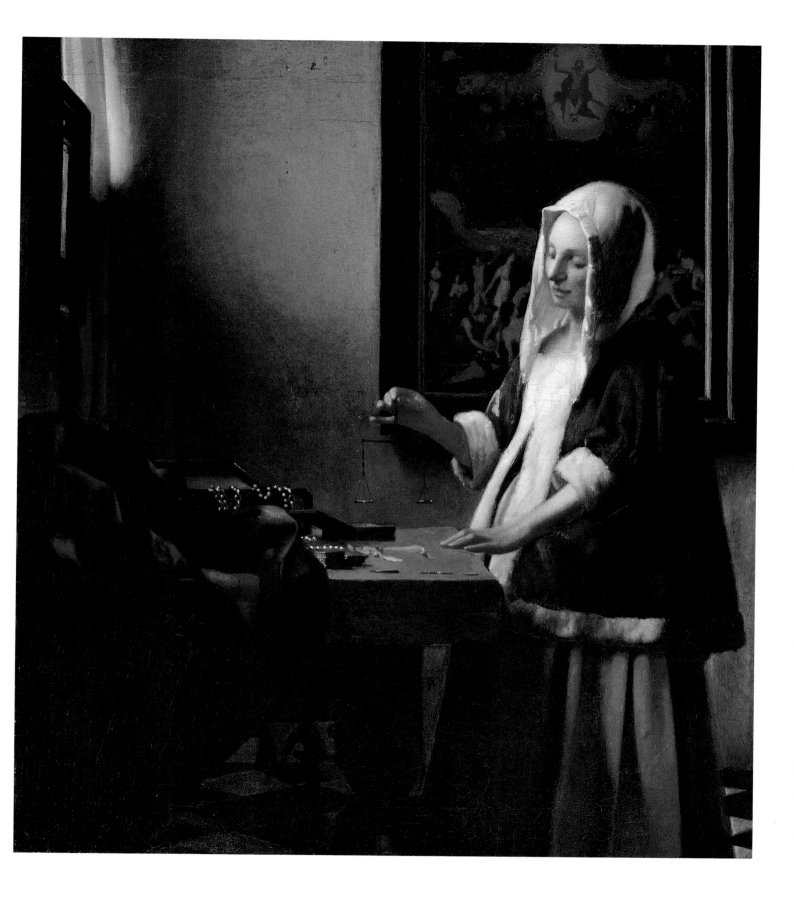

Girl with the Red Hat

• Among Vermeer's works this small painting is unusual in two regards: it is his only surviving picture on panel, and in contrast to the self-contained isolation of most of his figures, the subject here makes eye contact with the viewer. Seated before a tapestry and wearing a blue dress and a wide-brimmed hat of brilliant red, a captivating young woman looks over her shoulder to meet our gaze. There is a momentary quality to her casual pose, with her arm resting on the back of a chair and her moist, slightly parted lips, as if she had just become aware of being observed.

This is probably not a true portrait, but a *tronie*, a study of expression and exotic costume; such extravagant hats were popular with Dutch artists. Vermeer's painterly skill, however, transcends the category. The shadows in the girl's face, for example, are greenish in tone, rather than red, and small dots or highlights of color on the lips, the tip of the nose, the eye, and the pearl earring enliven the surface. Most interesting are the lion-head finials of the chair; their unfocused, diffused appearance and scattered highlights suggest that Vermeer had studied the effects produced by optical devices such as the camera obscura. The many adjustments in the finials indicate that he did not actually project an image onto the panel.

Knowledge of Vermeer's life and career is incomplete. Born in Delft, he became a master in the painters' guild there in 1653, but there is no record of who his teachers were. Following his father's death he took over the operation of an inn and a business buying and selling pictures. Raised as a Protestant, he seems to have converted to Catholicism after marrying Catharina Bolnes. Probably because of difficulties with his art dealership, Vermeer was heavily in debt when he died, and it was necessary for his wife to declare bankruptcy and auction off much of the estate. Only about thirty-five paintings by Vermeer exist, and he was not well known outside of Delft until the late nineteenth century when he was praised by the French critic Théophile Thoré. Since then Vermeer has become one of the most famous and beloved of Dutch artists.

Johannes Vermeer
(Dutch, 1632–1675)
Girl with the Red Hat
c. 1665/1666, oil on panel
22.8 × 18 (9 × 7 ⅛)
Andrew W. Mellon Collection
1937.1.53

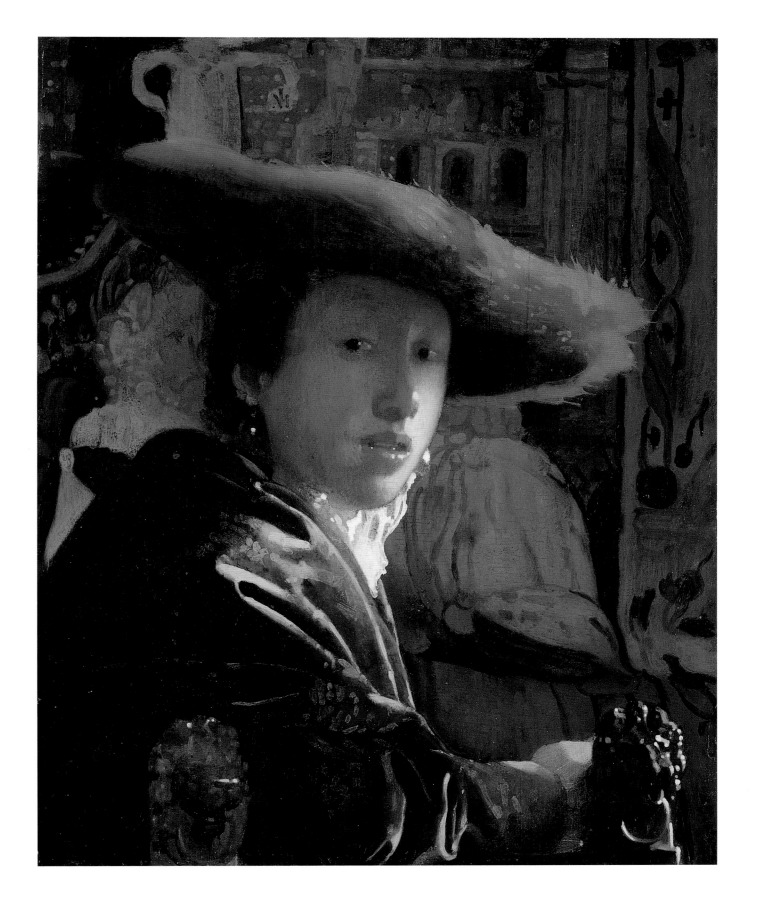

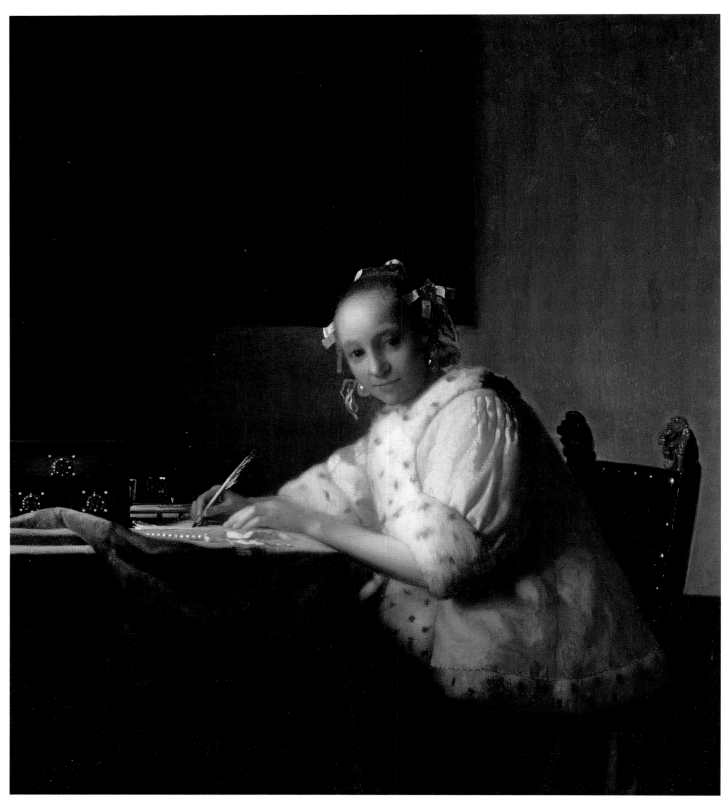

Johannes Vermeer
(Dutch, 1632–1675)
A Lady Writing
c. 1665, oil on canvas
45 × 39.9 (17 ¾ × 15 ¾)
Gift of Harry Waldron Havemeyer
and Horace Havemeyer, Jr., in memory
of their father, Horace Havemeyer
1962.10.1

166

167

168

166

Pieter Jansz Saenredam
(Dutch, 1597–1665)
Cathedral of Saint John at 's-Hertogenbosch
1646, oil on panel
128.9 × 87 (50 ⅞ × 34 ¼)
Samuel H. Kress Collection
1961.9.33

167

Simon de Vlieger
(Dutch, 1600/1601–1653)
Estuary at Dawn
c. 1640/1645, oil on panel
36.83 × 58.42 (14 ½ × 23)
Patrons' Permanent Fund and Gift
in memory of Kathrine Dulin Folger
1997.101.1

168

Jan Steen
(Dutch, 1625/1626–1679)
The Dancing Couple
1663, oil on canvas
102.5 × 142.5 (40 ⅜ × 56 ⅛)
Widener Collection
1942.9.81

169

Meindert Hobbema
(Dutch, 1638–1709)
A Wooded Landscape
1663, oil on canvas
94.7 × 130.5 (37 ³⁄₈ × 51 ³⁄₈)
Andrew W. Mellon Collection
1937.1.61

170

Johannes Cornelisz Verspronck
(Dutch, 1606/1609–1662)
Andries Stilte as a Standard Bearer
1640, oil on canvas
101.6 × 76.2 (40 × 30)
Patrons' Permanent Fund
1998.13.1

171

Jan van Huysum
(Dutch, 1682–1749)
Still Life with Flowers and Fruit
c. 1715, oil on panel
79.04 × 59.09 (31 ¹⁄₈ × 23 ¹⁄₄)
Patrons' Permanent Fund and
Gift of Philip and Lizanne Cunningham
1996.80.1

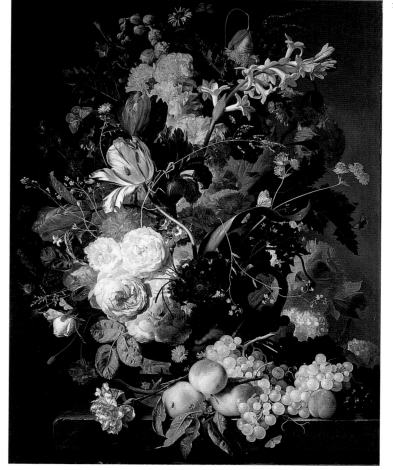

171

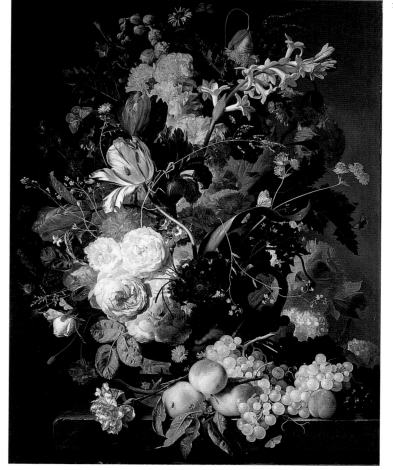

171

DUTCH SCHOOL | 17th Century | 213

Bouquet of Flowers in a Glass Vase

AMBROSIUS BOSSCHAERT THE ELDER

• The rapid emergence of the floral still life as an independent genre in the Netherlands in the late sixteenth and early seventeenth centuries was due to a number of factors. For one thing, increased exploration in the Near East and the New World meant increased importation of exotic blossoms. Moreover, scientific naturalism and the tradition of botanical illustration went hand in hand with the belief that all nature was a reflection of God's glory and even the smallest insect or most humble plant was worthy of study.

Ambrosius Bosschaert belonged to the first generation of floral still-life specialists. Born in Antwerp, he moved for religious reasons to Middelburg, the capital of Zeeland and site of several important botanical gardens. Bosschaert prospered in Middelburg. In 1604 he married Maria van der Ast, whose younger brothers Hans and Balthasar became his students. His three sons, Ambrosius the Younger, Johannes, and Abraham, were also still-life painters. Bosschaert moved to Amsterdam in 1614, then to Bergen op Zoom, Utrecht, and finally, in 1619, to Breda.

Bouquet of Flowers in a Glass Vase presents a glorious profusion of blossoms in a balanced arrangement that forms an oval. Among the many kinds of flowers, Bosschaert has included a purplish red and white striped tulip at the top, with a yellow iris next to it on which perches a blue dragonfly; in the center are a white rose, grape hyacinth, and forget-me-not; at the left are a blue and white striped columbine and a pink rose, and next to it lily of the valley and a yellow poppy anemone. Resting on the ledge to the left of the vase is a wild violet, and to the right is a cyclamen with a Red Admiral butterfly on its stem. These flowers could not have all bloomed at the same time, and because several of them recur in other paintings, it is evident that for some specimens Bosschaert worked from drawings kept in his studio. Using a copper plate as the support, the artist achieved soft, velvety textures with barely discernible brushwork.

At the lower left edge of the ledge is the artist's monogram and the date 1621, the year of his death. The picture is made more poignant by the inscription, in French, that appears to be attached to the front of the ledge; it may be translated, "It is the angelic hand of the great painter of flowers, Ambrosius, renowned even to the banks of death." The inscription was possibly added by a collector attached to the court of the prince of Orange in The Hague, where French was often spoken.

Ambrosius Bosschaert the Elder
(Dutch, 1573–1621)
Bouquet of Flowers in a Glass Vase
1621, oil on copper
31.6 × 21.6 (12 3/8 × 8 1/2)
Patrons' Permanent Fund and
New Century Fund
1996.35.1

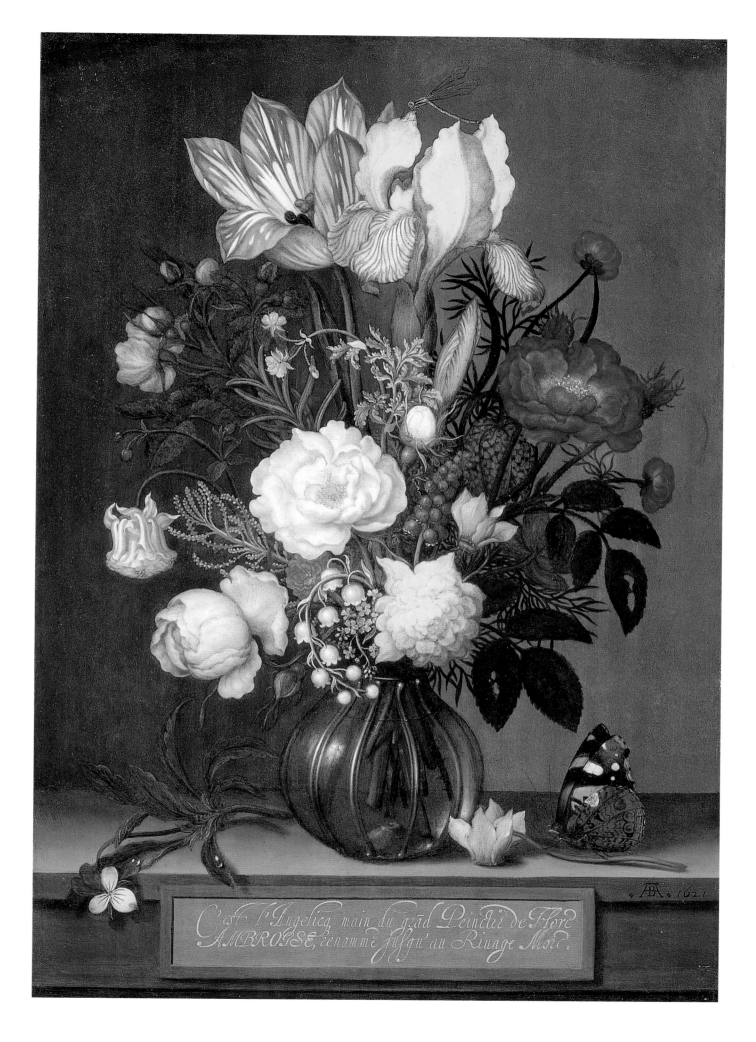

C'est l'Angelica main du grand Peinctre de Flore
AMBROISE, ce nommé jusqu' au Riuage Mort.

The Fall of Man

HENDRIK GOLTZIUS

• Goltzius' artistic career can aptly be described as protean. Born and trained in the Lower Rhine, he followed his teacher to Haarlem in 1577 and together with Karel van Mander and Cornelis Cornelisz. van Haarlem practiced an overwrought late mannerist style based on the work of Bartholomäus Spranger. He went to Italy in 1590-1591, visiting Rome, Naples, Venice, and Florence, where he studied antique art and Renaissance painting, an experience that profoundly affected his style. He made numerous drawings after classical sculpture before returning to Haarlem the following year.

Goltzius was famous as a virtuoso draftsman and engraver, and among his many talents he had the ability to emulate the engraving styles of other artists, including Albrecht Dürer and Lucas van Leyden. In 1600, for reasons that are not fully known, Goltzius suddenly abandoned printmaking and began to paint religious and mythological subjects in a classicizing style that also incorporated the careful observation of nature.

Fall of Man, painted the year before the artist's death, presents a moralizing commentary on the consequences for mankind of temptation and lust, even as it displays a sensuous, physically attractive couple. Naked except for a strategically placed ivy vine, Adam and Eve recline under an apple tree that contains a serpent with a woman's head. Eve has already taken a bite from an apple and looks seductively at Adam, who longingly returns her gaze. Their silken, flawless skin has a reddish glow that testifies to Goltzius' admiration for Venetian painting. Adam's pose is derived from Goltzius' drawing made in Rome in 1591 of the antique statue of a river god. The pair of goats in the background are traditional symbols of lasciviousness and refers to Adam and Eve's carnal relationship. In contrast, the elephant in the distance was considered a chaste and pious animal, who was afraid of snakes. Accordingly it has turned its back on the proceedings. The cat in the foreground may be a symbol of Eve's cunning and deception, but the wonderfully portrayed creature gazes outward with a worried and knowing look that reminds the viewer that mankind's troubles are just beginning.

173

Hendrik Goltzius
(Dutch, 1558–1617)
The Fall of Man
1616, oil on canvas
104.5 × 138.4 (41 1/8 × 54 1/2)
Patrons' Permanent Fund
1996.34.1

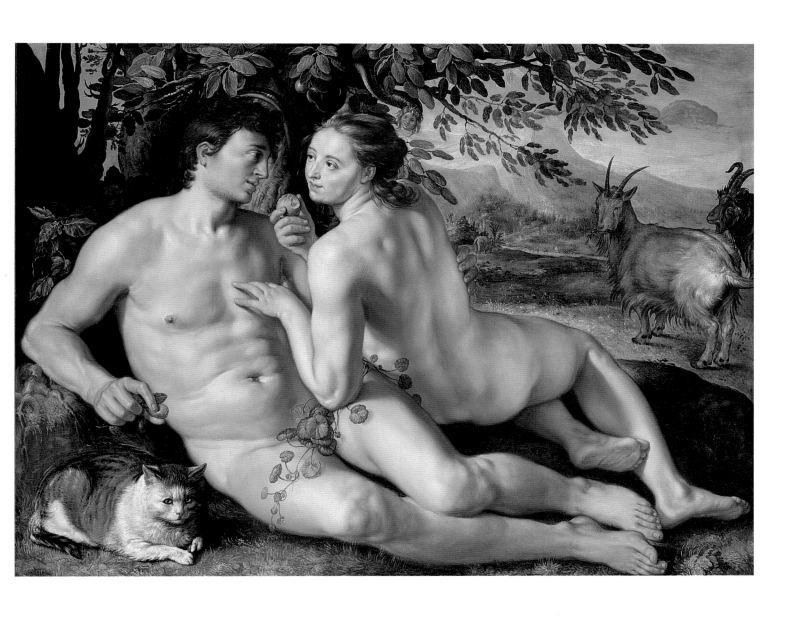

Queen Henrietta Maria with Sir Jeffrey Hudson

SIR ANTHONY VAN DYCK

• This superlative portrait can be dated to 1633, a year after Van Dyck moved from Flanders to England to work at the court of Charles I. Henrietta Maria was the daughter of Henry IV and Marie de' Medici, and while still in her teens she was married to Charles by proxy. The union strengthened the alliance between France and England, which in turn helped ensure Charles' peaceful reign, despite some misgivings on the British side about the queen's Catholicism.

Henrietta Maria is shown here dressed to go hunting in a broad-brimmed black hat and a shimmering, brilliantly rendered blue satin dress trimmed in gold. Her crown, barely noticeable, is at the right, set against a swag of golden drapery. Accompanying the queen is a dwarf, Sir Jeffrey Hudson, here about thirty-six years old and less than four feet tall. Sir Jeffrey made his appearance at court by popping out of a pie and quickly became a favored companion of Henrietta Maria. His exploits, which included fighting (and winning) a duel and being captured by pirates, were avidly repeated. A further indication of the queen's taste for the unusual and the exotic is the monkey, who may be identified as Pug and was beloved by Sir Jeffrey. Henrietta Maria's act of calming the beast may have deeper meaning,

for the monkey was often a symbol of unbridled eroticism, but is here restrained by the force and virtue of the queen. The potted orange tree at the upper left may be seen as a reflection of the queen's love of plants and gardens, but since the orange tree also symbolizes purity and chastity, it may allude to the Virgin Mary, who was claimed by Henrietta as her patron and protector.

Van Dyck relied on a number of devices to impress the viewer with the queen's magnificence. The low viewpoint increases her stature, as do the verticals of the column and drapery at the right and even the diminutive Sir Jeffrey. The artist was not above flattering his sitters; Henrietta Maria was in actuality short and far from beautiful. When one of Charles I's nieces finally met her, she was taken aback to find the woman who was "so beautiful in her picture, a little woman with long lean arms, crooked shoulders, and teeth protruding from her mouth like guns from a fort."

174

Sir Anthony van Dyck
(Flemish, 1599–1641)
*Queen Henrietta Maria
with Sir Jeffrey Hudson*
1633, oil on canvas
219.1 × 134.8 (86 ¼ × 53 ⅛)
Samuel H. Kress Collection
1952.5.39

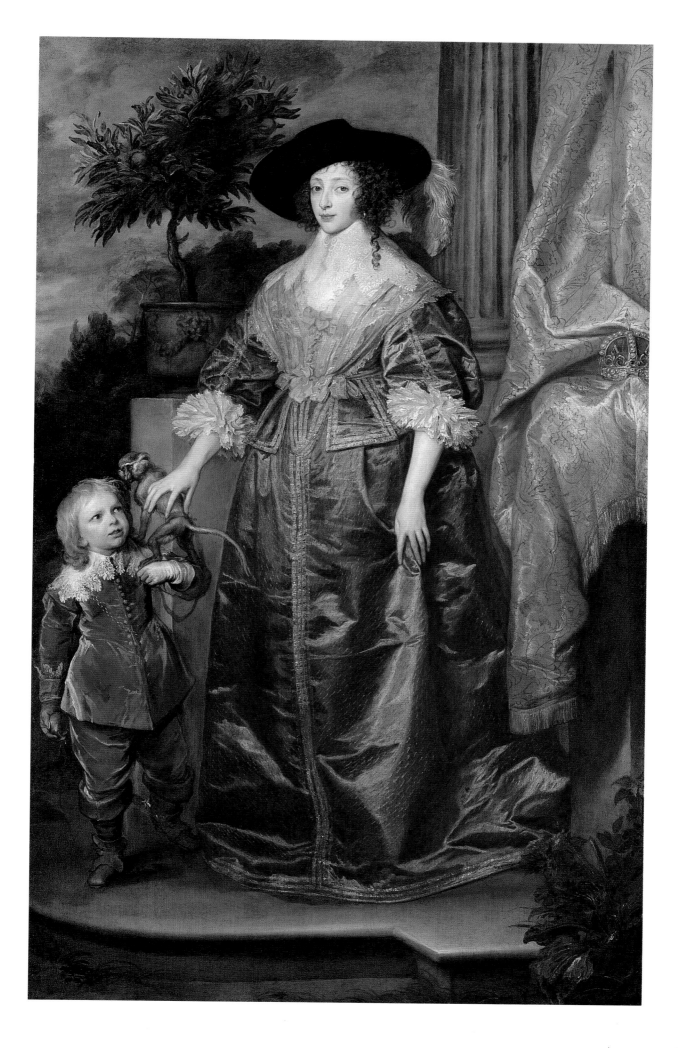

Daniel in the Lions' Den

SIR PETER PAUL RUBENS

• If one wanted to emulate an artist's life, it would be hard to make a better choice than that of Peter Paul Rubens. Possessed of seemingly boundless energy and organizational skills, learned and well traveled, he was, in addition to being an artist, a diplomat and linguist as well as an antiquarian and collector.

In 1618 Rubens was in the middle of negotiating with Sir Dudley Carleton, a British diplomat, for a number of antique marble statues that Sir Dudley had acquired in Venice, his previous post. In a letter dated 28 April 1618, Rubens offered by way of exchange a number of his own paintings, including "Daniel amidst many lions, which are taken from life. Original, the whole by my hand." The second sentence is especially noteworthy, because Rubens often enlisted and acknowledged the use of assistants in creating his pictures. The transaction was successful for both parties: Sir Dudley got the painting, and sometime before his death gave it to King Charles I of England. *Daniel in the Lions' Den* next entered the collection of the Scottish dukes of Hamilton, where it remained until the early twentieth century, passing to the Viscount Cowdray and descendents before being acquired by the National Gallery of Art. The painting's history is known from the time it left Rubens' studio. Such comprehensiveness is rare.

Rubens illustrated a decisive moment from the sixth chapter of the Old Testament book of Daniel. Because Daniel chose to worship God rather than the Persian king Darius, he was thrown into a den of lions. The next morning, when the stone covering the entrance was removed, Daniel was found unharmed, protected by his faith. He is seen here thanking God for his deliverance. Theologically, this scene prefigures Christ's triumph over death and escape from the sepulcher.

The painting's large size invites the viewer into the same space as Daniel, and the nearly life-size lions heighten the emotional impact of the scene. The light from the overhead opening and the red cloak focus primary attention on Daniel, but the superbly rendered lions in a variety of poses and expressions command nearly equal attention and confirm Rubens as a masterful portrayer of animals. He made a number of drawings of lions that inhabited the royal menagerie in Brussels. The pose of the lioness at the far right, however, is probably based on a sixteenth-century Paduan bronze statuette, and Daniel's pose, also on an Italian prototype. *Daniel in the Lions' Den* is a skillful blend of realistic observation and theatrical artifice animated throughout by Rubens' fluent, vibrant brushwork.

175

Sir Peter Paul Rubens
(Flemish, 1577–1640)
Daniel in the Lions' Den
c. 1613/1615, oil on canvas
224.3 × 330.4 (88 ¼ × 130)
Ailsa Mellon Bruce Fund
1965.13.1

The Meeting of Abraham and Melchizedek

SIR PETER PAUL RUBENS

• On several occasions Rubens was asked to create designs for tapestries. The largest and most complicated of these, known as the *Triumph of the Eucharist,* was commissioned by the Infante Isabella, governess of the southern Netherlands. Following Rubens' models, the tapestries were woven in Brussels and presented by Isabella to the convent of the Poor Clares, the Descalzas Reales, in Madrid, where they remain to this day. Isabella had strong ties to the institution, having spent time in the convent as a girl; and after the death in 1621 of her husband, Archduke Albert, she wore the habit of the Poor Clares. Rubens took pains with the commission, first making painted sketches, and then more detailed models, or *modelli,* that served as the basis for the full-size cartoons, produced by assistants, that were given to the weavers. In the case of the *Meeting of Abraham and Melchizedek,* the National Gallery of Art's panel is the final *modello* from which the cartoon was made.

As recounted in the fourteenth chapter of Genesis, the Hebrew patriarch Abraham was returning home after a major victory, which included the rescue of his nephew Lot, when he was met by Melchizedek, who was both king of Salem and a high priest. Melchizedek blessed Abraham and presented him with gifts of bread and wine. This Old Testament story was always viewed as a prefiguration of the Eucharist, the bread and wine used in Communion, but it acquired popularity during the Counter-Reformation.

In a brilliant and one might say typically baroque conceit, Rubens envisioned this scene and others in the series as a tapestry within a tapestry. Three putti unfurl the illusionistic tapestry that is attached by a garland to a classical entablature and sturdy Tuscan columns. *The Meeting of Abraham and Melchizedek* is also a showcase for the power and vigor of Rubens' brushwork, which magically captures the gleam of metal in the armor of Abraham and his soldiers at the left, the rich textures of Melchizedek's ermine-trimmed gold robe, and the muscular, pliant flesh of the men at the lower right who deliver the wine in ornate gold and silver flagons.

Sir Peter Paul Rubens
(Flemish, 1577–1640)
*The Meeting of Abraham
and Melchizedek*
c. 1625, oil on panel
66 × 82.5 (26 × 32 ½)
Gift of Syma Busiel
1958.4.1

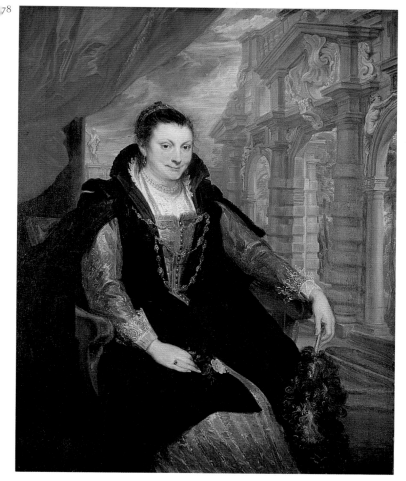

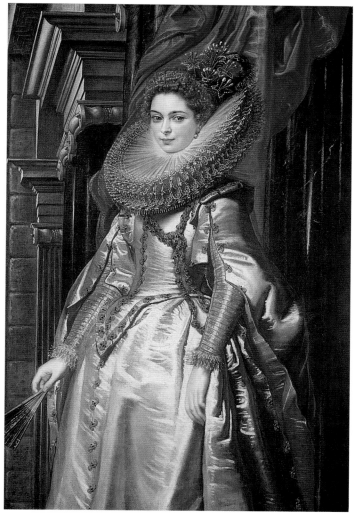

177

178

179

Sir Anthony van Dyck
(Flemish, 1599–1641)
Marchesa Elena Grimaldi,
Wife of Marchese Nicola Cattaneo
1623, oil on canvas
246.4 × 172.7 (97 × 68)
Widener Collection
1942.9.92

Sir Anthony van Dyck
(Flemish, 1599–1641)
Isabella Brant
1621, oil on canvas
153 × 120 (60 ¼ × 47 ¼)
Andrew W. Mellon Collection
1937.1.47

Sir Peter Paul Rubens
(Flemish, 1577–1640)
Marchesa Brigida Spinola Doria
1606, oil on canvas
152.5 × 99 (60 × 39)
Samuel H. Kress Collection
1961.9.60

Banquet Piece with Oysters, Fruit, and Wine

OSIAS BEERT THE ELDER

• Beginning with an invitation to eleven of the most succulent oysters ever painted, this painting celebrates a world of elegance and tasteful refinement. In the right foreground a blue-and-white bowl from the Ming dynasty (Wan-Li period) is filled with slices of cake and pastries decorated with tiny squares of gold leaf. Both the Chinese porcelain and the seashells beside it are exotic, costly imports from distant lands. In the center of the composition a ceramic tazza, Italian in style but probably produced locally, is filled with sweets, including candied almonds. In the seventeenth century sugar was a luxury item, affordable only by the upper classes. Behind the plate of oysters is another Ming dynasty bowl containing raisins, almonds, and figs, all of which were imported, topped by a confection probably made of sugar, grape juice, and chopped nuts. At the right rear is a dish of chestnuts, a delicacy in northern Europe, and next to it a round wooden box containing what has been identified as a kind of fruit jelly, perhaps quince. Delicate glass vessels of red and white wine complete this sumptuous display,

though, as with the tazza, it is likely that the *façon de Venise* glass and carafe were made by Flemish artisans. In order to allow the viewer to examine and enjoy each object, Beert adopted a high viewpoint and presented them in a clear light against a nearly monochrome background.

Not much is known about Osias Beert the Elder. Apprenticed to a local artist, he became a master in the Antwerp Guild of Saint Luke in 1602 and died in Antwerp in 1623. In addition to painting, he was a cork merchant. Beert specialized in the type of still life seen here, and many of the objects in the National Gallery of Art's panel appear in other works by him. Because none of his pictures is dated, matters of exact chronology and stylistic development remain conjectural.

Osias Beert the Elder
(Flemish, active 1596–1623)
Banquet Piece with Oysters, Fruit, and Wine
c. 1610/1620, oil on panel
52.5 × 73.3 (20 5/8 × 28 7/8)
Patrons' Permanent Fund
1995.32.1

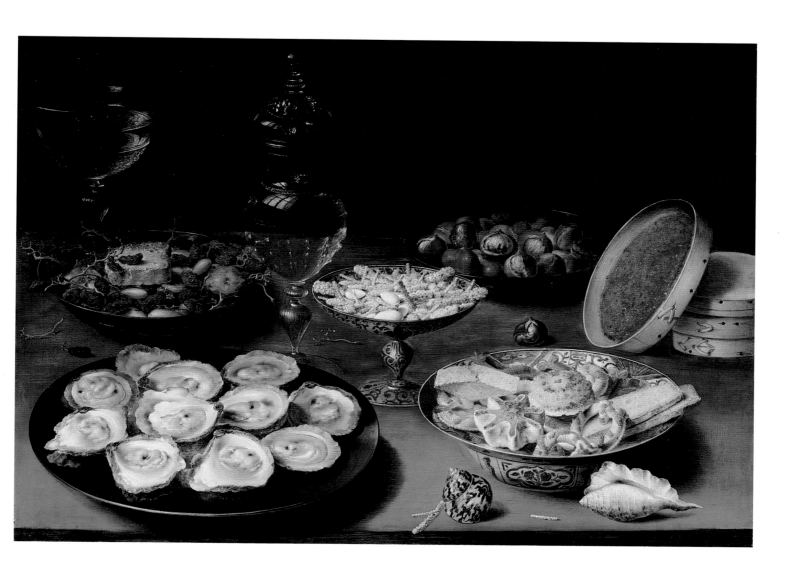

River Landscape

JAN BRUEGHEL THE ELDER

• Rivers are vital arteries of transportation and commerce, and although the setting is imaginary, this painting faithfully records the busy life on a large river and its smaller tributary. In the left foreground a ferryman hands an infant to its father. A group of well-dressed people has either just arrived or is waiting to depart. On the water two boats laden with people, horses, and cattle approach the landing. Further activity occurs in the middle distance, where a village occupies the land at the juncture of the two rivers.

Brueghel painted this scene directly on a copper plate, a support that had been used in the late sixteenth century but became increasingly popular in the course of the seventeenth century. The smooth surface allowed him to work with the extraordinary delicacy, fluency, and precision of a miniaturist. Despite its small size, River Landscape is a work of considerable complexity. At the right, changes in the color of the water, from green to white to blue and finally to white, enhance the effects of the river's recession into space. Counterbalancing the distant view are the dark masses of trees on the left. The patch of sunlit water at the right marks the beginning of a strong diagonal that carries the eye to the space between the trees and the village church in the distance.

Jan Brueghel the Elder was the son of the famous painter Pieter Bruegel the Elder, who died the year after Jan was born. Following a trip to Italy, which included stays in Naples and Rome, Brueghel returned to settle in Antwerp where he entered the painters' guild in 1597. By 1608 he had been appointed court painter to Albert and Isabella, governors of the southern Netherlands, a position he held until his death. Nicknamed Velvet Brueghel, that artist was famed not only for his landscapes and river views, but also for a wide range of other subjects, including floral still lifes and religious and mythological scenes.

Jan Brueghel the Elder
(Flemish, 1568–1625)
River Landscape
1607, oil on copper
20.7 × 32.1 (8 1/8 × 12 5/8)
Patrons' Permanent Fund
and Nell and Robert
Weidenhammer Fund
2000.4.1

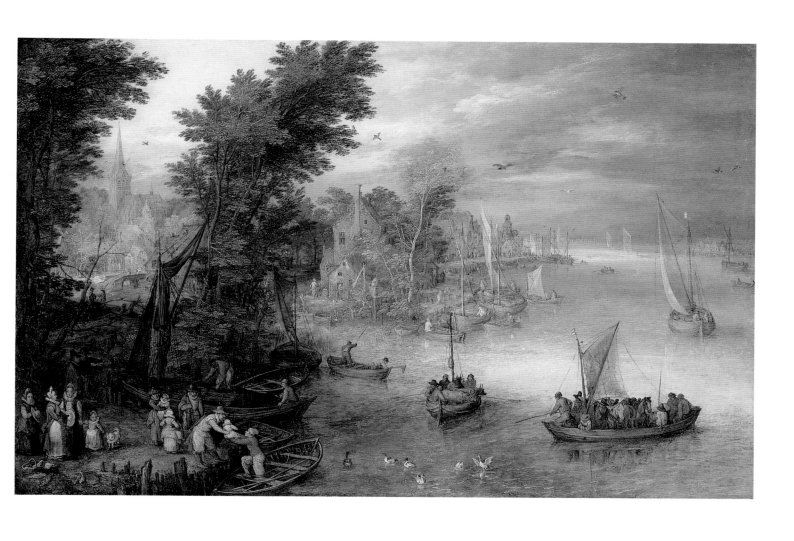

Jan Brueghel the Elder
(Flemish, 1568–1625)
A Basket of Mixed Flowers
and a Vase of Flowers
1615, oil on panel
54.9 × 89.9 (21 ⅝ × 35 ⅜)
Collection of Mrs. Paul Mellon,
in Honor of the 50th Anniversary
of the National Gallery of Art
1992.51.7

183

Adriaen Brouwer
(Flemish, 1605/1606–1638)
Youth Making a Face
c. 1632–1635, oil on panel
13.7 × 10.5 (5 3/8 × 4 1/8)
New Century Fund
1994.46.1

184

David Teniers II
(Flemish, 1610–1690)
Peasants Celebrating Twelfth Night
1635, oil on panel
47.2 × 69.9 (18 5/8 × 27 1/2)
Ailsa Mellon Bruce Fund
1972.10.1

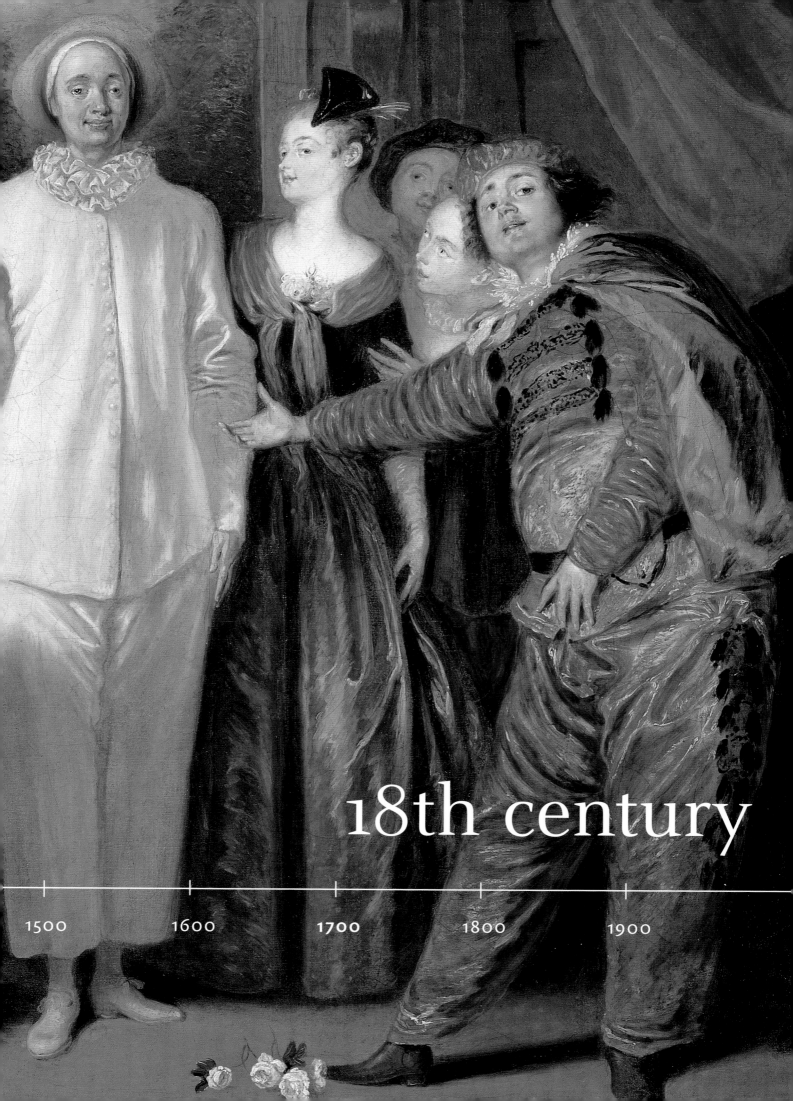

18th century

1500 1600 1700 1800 1900

The Fortress of Königstein

BERNARDO BELLOTTO

• Sometime around 1735 Bellotto began his apprenticeship with his uncle, the famous Venetian view painter Antonio Canaletto. So completely did he absorb Canaletto's style that even today it is not easy to distinguish master from pupil in pictures from this period. In 1747, after several years spent traveling and working in Italy, Bellotto was called to Dresden where he became court painter to Augustus III, king of Poland and elector of Saxony. He produced panoramic views of Dresden and other cities for Augustus. Then in 1756 Augustus asked Bellotto to make five large paintings of the fortress of Königstein: three exterior views and two views of the interior courtyards. But in August 1756 Frederick the Great invaded Saxony, starting the Seven Years' War, and Augustus fled Königstein for Warsaw. When Dresden was taken over by the Prussians in 1758, Bellotto moved to Vienna. The five paintings of Königstein somehow made their way to England: two are in a private collection; two are in the City Art Gallery, Manchester; and the fifth was acquired by the National Gallery of Art in 1993.

Here seen from the northwest, the castle of Königstein sits atop a massive rock formation that looms over the Elbe River valley; it had served as a defensible refuge since the thirteenth century. Under the Saxon electors Königstein was turned into a fortress complex that also contained archives and a treasury (in the twentieth century it housed prisoners of war). The broad panorama portrayed in this painting also includes the Lilienstein, a sandstone formation that rises abruptly from the hills in the distance at the left. At the right are the various roads and paths that lead to the castle, seen from a high viewpoint, as if on a map. Silhouetted against the blue sky high above the horizon, the fortress itself is imbued with a majestic, forbidding presence. The peasants and their livestock in the foreground lessen the severity of the scene and also serve as a reminder that the castle offered protection and sanctuary for the region's inhabitants. The combination of topographical accuracy, precisely rendered details, and vivid atmospheric effects creates an astonishing optical realism that makes this one of the most emotionally affecting view paintings of the eighteenth century.

Bernardo Bellotto
(Venetian, 1722–1780)
The Fortress of Königstein
1756–1758, oil on canvas
133 × 235.7 (52 ½ × 92 ¾)
Patrons' Permanent Fund
1993.8.1

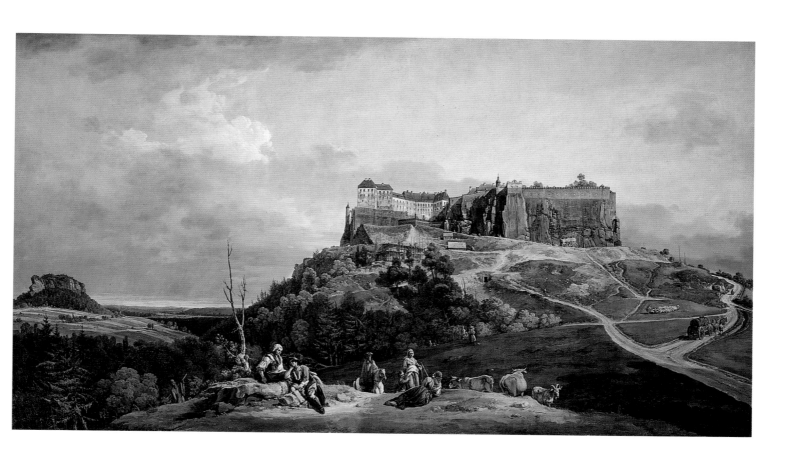

The Porta Portello, Padua

CANALETTO

• Canaletto's fame rests justly on his depictions of Venice, which were prized by foreign visitors to the city, especially the British. He is also known, perhaps to a lesser degree, for the views of English sites that he produced during two separate visits to that country. Less familiar but if anything more appealing are the subjects that are off the beaten track.

In 1740/1741 Canaletto departed Venice for the mainland, and traveling along the Brenta Canal, he went at least as far as Padua. The drawings he made in the course of his journey became the source material for paintings produced in the studio. The present work shows an area on the outskirts of Padua. At the center of the composition is the Porta Portello, constructed in 1518–1519, which was and still is a major thoroughfare leading east to Venice. It is on the south bank of the Piovego, a tributary of the river that joins with the waterway between Venice and Padua. Looking beyond the Porta Portello toward the northwest, one sees the skyline of Padua and the church and campanile of Santa Maria del Carmine. Throughout the painting there are indications of human activity and commerce, yet they are subordinated to the architecture. The scene has changed relatively little over time—though the colonnaded building at the right is gone, and the Porta Portello itself was replaced in the late eighteenth century—thus a comparison between reality and Canaletto's painting reveals that the artist took a few liberties, including reducing the numbers of piers that support the bridge from three to two.

A number of factors help to give Canaletto's cityscape a relaxed, intimate character. The horizontal composition creates a feeling of stability and peacefulness, and, except for the sky, the color scheme is limited to varying tones of green, brown, and white. Landscape and buildings are bathed in a soft light, and one can almost feel the warmth of the sun on the stones and bricks and sense their different textures. Although all objects, whether near or far, are presented with nearly equal clarity and no atmospheric blurring, Canaletto's mastery is clearly evident.

Canaletto
(Venetian, 1697–1768)
The Porta Portello, Padua
c. 1741/1742, oil on canvas
62 × 109 (24 3/8 × 42 7/8)
Samuel H. Kress Collection
1961.9.53

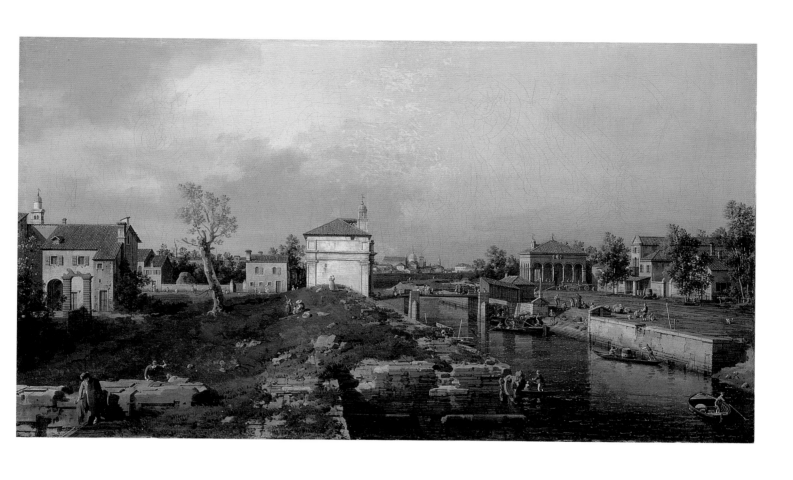

187

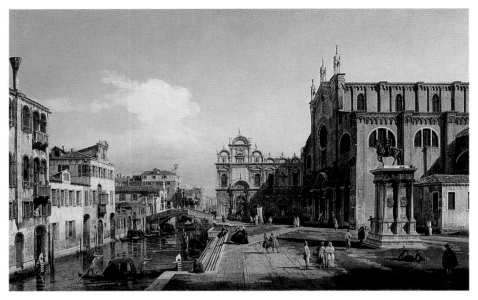

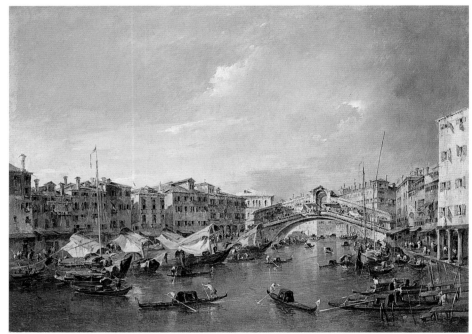

187

Donato Creti
(Bolognese, 1671–1749)
Alexander the Great
Threatened by His Father
probably 1700/1705, oil on canvas
129.7 × 97 (51 × 37 ⅛)
Samuel H. Kress Collection
1961.9.6

188

Bernardo Bellotto
(Venetian, 1722–1780)
The Campo di SS. Giovanni e Paolo, Venice
1743/1747, oil on canvas
70.8 × 111 (27 ⅞ × 43 ⅞)
Widener Collection
1942.9.7

189

Francesco Guardi
(Venetian, 1712–1793)
Grand Canal with the Rialto Bridge, Venice
probably c. 1780, oil on canvas
68.5 × 91.5 (27 × 36)
Widener Collection
1942.9.27

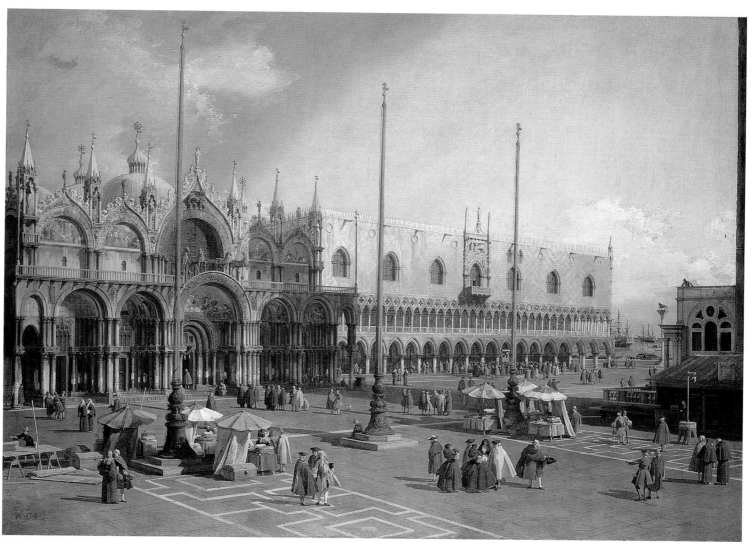

190

Canaletto
(Venetian, 1697–1768)
The Square of Saint Mark's, Venice
1742/1744, oil on canvas
114.6 × 153 (45 ⅛ × 60 ¼)
Gift of Mrs. Barbara Hutton
1945.15.3

Temporary Tribune in the Campo San Zanipolo, Venice

FRANCESCO GUARDI

• Pope Pius IV visited Venice from 15 to 19 May 1782 on his return to Rome from Vienna. Then on 21 May Pietro Edwards, inspector of fine arts for the republic, contracted with Guardi for four paintings that would record key aspects of the pope's visit. The fourth picture, now in the Ashmolean Museum, Oxford, depicts the papal benediction on the city of Venice. Originally the blessing was to take place from the Loggia of San Marco, but the merchants who occupied the Piazza San Marco objected, and the event was moved to the Campo San Zanipolo, which was smaller but close to the pope's lodging in a monastery that was part of the church of Santi Giovanni e Paolo. The theme was evidently popular and engendered a number of independent paintings by Guardi.

In contrast to the more expansive view of the Oxford painting, the artist here has created a close-up of the Campo San Zanipolo ("Zanipolo" means "Giovanni e Paolo" in the Venetian dialect). Directly ahead is the Scuola di San Marco, and in front of it, the staircases and loggia of the temporary tribune that was constructed in two days (see no. 188). At the right a portion of the church of Santi Giovanni e Paolo is visible. Pietro Edwards was evidently concerned about Guardi's reputation for fanciful invention, for the contract stipulated that the artist make accurate studies of the sites, and in fact a number of drawings have survived.

This painting exhibits all the hallmarks of Guardi's mature style: dramatic contrasts of sunlight and shadow, strong atmospheric effects (one senses the wind that sends gray and white clouds scuttling across the sky), and bravura brushwork. There is also a solid compositional structure; note how the two lines of figures in the foreground define diagonals that lead to the base of the tribune and how touches of white carry the eye up the staircases to the loggia. Larger diagonals—the edge of the shadow at the right and the cloud at the upper left—are played off against the vertical elements in the façade of the Scuola di San Marco.

191

Francesco Guardi
(Venetian, 1712–1793)
*Temporary Tribune in the
Campo San Zanipolo, Venice*
1782 or after, oil on canvas
37.5 × 31.5 (14 ¾ × 12 ⅜)
Samuel H. Kress Collection
1939.1.129

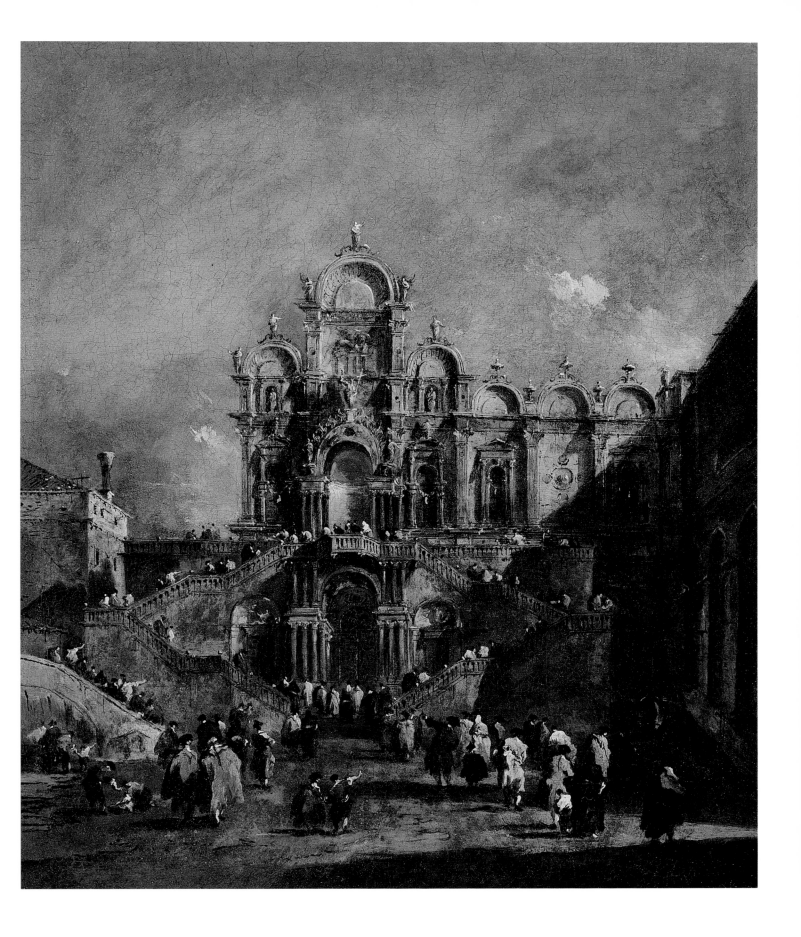

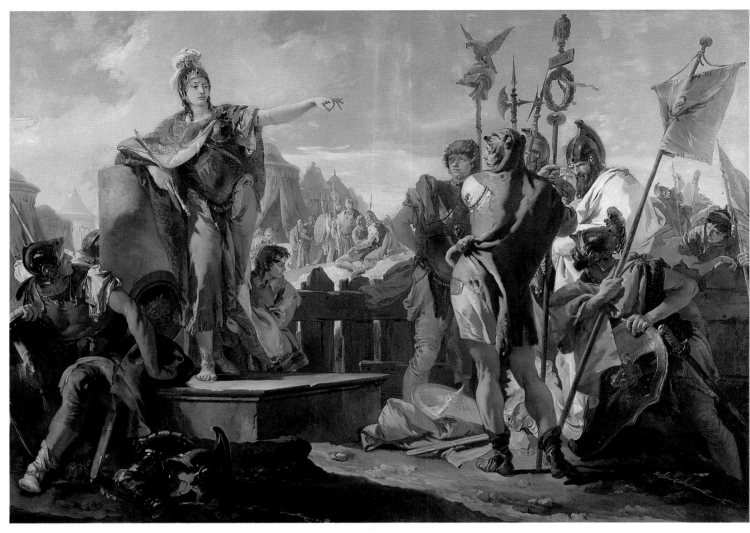

Giovanni Battista Tiepolo
(Venetian, 1696–1770)
Queen Zenobia Addressing Her Soldiers
1725/1730, oil on canvas
261.4 × 365.8 (102 ⅞ × 144)
Samuel H. Kress Collection
1961.9.42

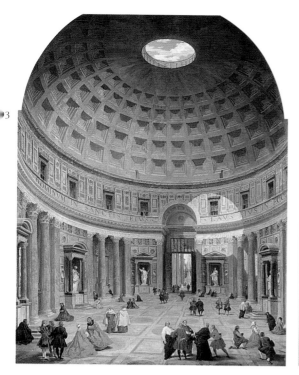

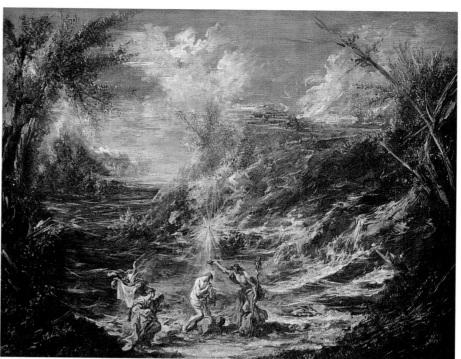

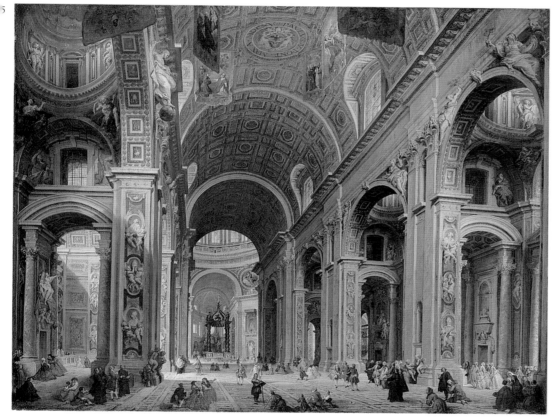

Memorial to Admiral Sir Clowdisley Shovell

SEBASTIANO RICCI AND MARCO RICCI

• Owen McSwiny was an Irish impresario who had worked for the London theater but fell into bankruptcy and moved to Italy to escape his creditors. Ever the entrepreneur, McSwiny engaged Italian artists to paint a series of "monuments" or memorials to British "worthies," with special emphasis on those who had helped put King William III on the throne in 1688. The series was to comprise twenty-four paintings (only twenty are known), and McSwiny planned to make extra money selling subscriptions for reproductive engravings after the paintings.

The *Memorial to Admiral Sir Clowdisley Shovell* was commissioned by McSwiny from Sebastiano Ricci and his nephew Marco Ricci for Charles Lennox, second duke of Richmond. Along with a number of other "monuments," it was originally intended to decorate the dining room of Goodwood, the duke's country house in Sussex. Sir Clowdisley Shovell was among those who allowed the prince of Orange, the future William III, to land in England. More important, he was an accomplished officer who rose to the position of commander in chief of the Fleet, battled the French, the Dutch, and Barberry pirates, then participated in the capture of Gibraltar in 1704. Shovell's death by drowning three years later was widely reported and mourned.

Shovell himself is not represented in the fountain that serves as his monument; rather, the seated figure at the top is a personification of Naval Victory whose hand rests on a "rostral column," bearing rostra or beaks from the bows of captured ships. The theme of triumph at sea is further present in the middle section of the fountain, with the relief of Neptune brandishing a trident and riding the waves. A diverse group has come to pay homage to Shovell: in the left foreground are the slaves freed from the Barberry pirates; and the two exotically dressed figures in the center may refer to Shovell's early exploits in Turkey and the Mediterranean.

Although McSwiny provided the general directive regarding subject matter, the full significance of many details is either unknown or confusing. He probably allowed the artists a certain amount of creative license. In this case Marco Ricci was responsible for the landscape, the rather fanciful collection of antique ruins, and the fountain, while his uncle painted the figures. Sebastiano and Marco had often collaborated on projects in Europe, and both had visited England and were known to British patrons. Their colorful, decorative style and love of ruins, as seen here, were both key elements in the developing rococo style.

Sebastiano Ricci and Marco Ricci
(Venetian, 1659–1734; Venetian, 1676–1729)
Memorial to Admiral Sir Clowdisley Shovell
1725, oil on canvas
222.1 × 158.8 (87 1/8 × 62 1/2)
Samuel H. Kress Collection
1961.9.58

Apollo Pursuing Daphne

GIOVANNI BATTISTA TIEPOLO

• Tiepolo was endowed with a special genius for integrating large-scale frescoes into complex decorative interiors. He was born in Venice, but commissions from princes and prelates took him all over Europe. His decoration for the archbishop's palace in Udine, completed in 1729, brought him immediate fame, followed by ten years of projects in northern Italy. Tiepolo was also employed in Germany, in Dresden, and then from 1750 to 1753 in Würzburg, where he produced for the prince bishop what is probably his most famous work: the fresco of *Olympus and the Four Continents* in the grand staircase of the archepiscopal palace. In 1761 he was summoned to Madrid by King Charles III of Spain to provide paintings and frescoes for the recently completed royal palace, and it was in Madrid that Tiepolo died.

As evident in the present work, the artist was equally adept at painting on a smaller scale. The story of Apollo and Daphne, a favorite of artists since the Renaissance, is told in Ovid's *Metamorphoses*: in revenge for Apollo's teasing, Cupid shoots him with a golden arrow that causes him to fall in love with Daphne, a beautiful virgin nymph. Cupid has also struck Daphne with a lead-tipped arrow that causes her to reject Apollo's advances and plead with her father, the river god, Peneus, for help. Tiepolo depicted the moment of transformation: as Apollo runs forward, Daphne is changed into a laurel tree, with one leg becoming a tree trunk and her hands sprouting branches. Apollo took the laurel as his personal emblem, and somewhat anachronistically Tiepolo shows him already wearing a laurel wreath on his head.

The composition is masterful in its use of thrusting diagonals to convey the animation and urgency of the moment. Daphne appears to be forced backward by the energy generated by Apollo but is bolstered by the counterbalancing diagonal of Peneus' body. It is quite likely that *Apollo Pursuing Daphne* was originally paired with *Venus and Vulcan* (Philadelphia Museum of Art) and that both were *sopraporte*, that is, hung over doorways.

197

Giovanni Battista Tiepolo
(Venetian, 1696–1770)
Apollo Pursuing Daphne
c. 1755/1760, oil on canvas
68.5 × 87 (27 × 34 ¼)
Samuel H. Kress Collection
1952.5.78

The House of Cards

JEAN SIMÉON CHARDIN

• A young boy sits at a gaming table and builds a structure out of playing cards that have been folded in half lengthwise. To prevent their being marked, the backs of the cards are blank. Motionless and silent, the lad is completely absorbed in his task and oblivious to being observed. A major aspect of the composition is the triangle defined by the boy's arms, leading to cards across the base, his body on one side, and the invisible yet palpable line of sight from his downcast eyes to the cards. The open drawer in the table appears to project forward into the viewer's space and functions simultaneously as a barrier and as a gateway into the picture. The white card in the drawer directs attention to the cards on the table and in the boy's hand as well as to his white collar. The face card in the drawer—the knave (jack) of hearts—tilts at the same angle as one of the cards in the boy's hand and also the position in which he holds his body.

The same care and calculation are evident in Chardin's painting technique. The artist is known to have worked very slowly and built up what might be called a "dry" impasto using layers of thick paint augmented with glazes and scumbles; this is most visible in the boy's face. The result is an optical realism that is neither labored nor fussy and indeed all the more powerful for not being overly detailed.

Without belaboring the point, the picture's meaning is implicit in the title "house of cards": the accomplishments of youth are fragile and can collapse suddenly and without warning. This canvas was painted a few years before it was exhibited in the Salon of 1737. It entered the collection of Catherine II, empress of Russia, by 1774 and remained in the Imperial Hermitage Gallery in St. Petersburg until it was purchased by Andrew W. Mellon in 1931.

Chardin was born in Paris and served a traditional apprenticeship with Pierre-Jacques Cazes. On 25 September 1728, at age twenty-nine, he was accepted by the Académie Royale de Peinture et de Sculpture and enrolled on the same day. At first Chardin specialized in still life, painting animals, fruit, kitchen utensils, and other household objects. By 1733 he had turned to genre subjects and scenes of domestic life, which had a higher status and were often copied in engravings. He returned to still life beginning in 1748. When his eyesight started to fail in his last years, he, like Edgar Degas, often turned to pastel. Throughout his long and successful career he was closely associated with the Académie Royale. In 1755 he became the institution's treasurer and was assigned the diplomatically challenging task of hanging the Salon exhibitions, which he did until 1744.

Jean Siméon Chardin
(French, 1699–1779)
The House of Cards
c. 1735, oil on canvas
82.2 × 66 (32 3/8 × 26)
Andrew W. Mellon Collection
1937.1.90

199

200

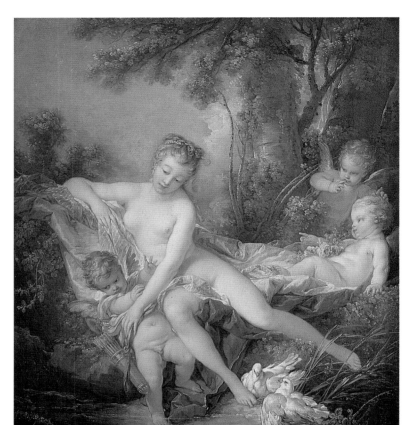

199

Jean Siméon Chardin
(French, 1699–1779)
The Kitchen Maid
1738, oil on canvas
46.2 × 37.5 (18 ⅛ × 14 ¾)
Samuel H. Kress Collection
1952.5.38

200

Jean Siméon Chardin
(French, 1699–1779)
Still Life with Game
c. 1760/1765, oil on canvas
49.6 × 59.4 (19 ½ × 23 ⅜)
Samuel H. Kress Collection
1952.5.36

201

François Boucher
(French, 1703–1770)
Venus Consoling Love
1751, oil on canvas
107 × 84.8 (42 ⅛ × 33 ⅜)
Chester Dale Collection
1943.7.2

202

François-Hubert Drouais
(French, 1727–1775)
Group Portrait
1756, oil on canvas
243.8 × 194.6 (96 × 76 ⅝)
Samuel H. Kress Collection
1946.7.4

Blindman's Buff / The Swing

JEAN-HONORÉ FRAGONARD

• It seems somehow apt that Fragonard, a supremely gifted rococo era painter, was born in Grasse, a center for the manufacture of perfume. At the age of eighteen he came to Paris, where he studied with François Boucher and briefly with Jean Siméon Chardin. Although he won the Prix de Rome in 1752, Fragonard elected to postpone his journey to Italy until 1756. He stayed primarily in Rome, but in 1759 he traveled to southern Italy. Fragonard returned to Paris in 1761 and, with the exception of a second trip to Italy in 1773, remained there for the rest of his life.

Although the original owner of the National Gallery of Art's paintings is not known, it is most likely that *Blindman's Buff* and *The Swing* were part of the interior decoration of a house in Paris and were executed not long after Fragonard's second Italian sojourn. In these large paintings, which might derive from the tradition of *fêtes galantes*, Fragonard created a world of trees and foliage that are larger than life, billowing clouds shaded in lavender, a landscape of grandeur filled with sunlight and warm breezes that is deliciously hospitable to the carefree young people who have gathered to socialize and play games. Especially in *Blindman's Buff* the majestic cypresses, waterfall, fountain with vestal virgins, and statue of Minerva at the upper right recall the famous gardens of the Villa d'Este at Tivoli, outside of Rome. In the companion piece the landscape is more open and includes views of distant hills and mountains at the right, while a young woman uses a telescope to explore the countryside. The motif of a girl on a swing was used on several occasions by Fragonard, Antoine Watteau, and others; it may be understood as a symbol of the fickleness or romantic inconstancy of women. Both here and in *Blindman's Buff*, the mood is playful and lighthearted, more amorous than erotic. Indeed, the most serious event depicted is the charming vignette at the lower left of a small white dog being rescued from a pool.

These idyllic moments and the aristocracy who enjoyed them were all but swept away by the French Revolution. Fragonard survived, but he no longer had his usual patrons. His efforts to paint in a new, more serious manner were not successful, and he died in poverty.

203

Jean-Honoré Fragonard
(French, 1732–1806)
Blindman's Buff
probably c. 1765, oil on canvas
216.2 × 197.8 (85 1/8 × 77 7/8)
Samuel H. Kress Collection
1961.9.16

204

Jean-Honoré Fragonard
(French, 1732–1806)
The Swing
probably c. 1765, oil on canvas
215.9 × 185.5 (85 × 73)
Samuel H. Kress Collection
1961.9.17

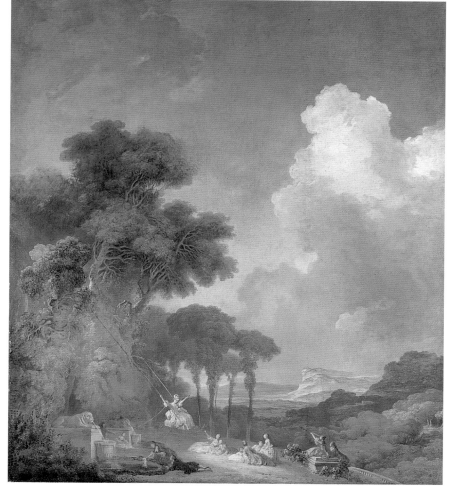

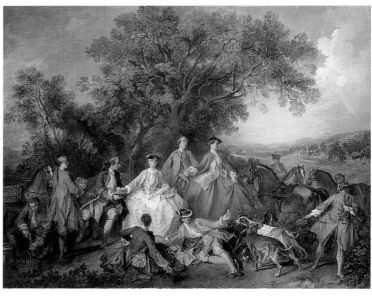

205

206

Nicolas Lancret
(French, 1690–1743)
La Camargo Dancing
c. 1730, oil on canvas
76.2 × 106.7 (30 × 42)
Andrew W. Mellon Collection
1937.1.89

Nicolas Lancret
(French, 1690–1743)
The Picnic after the Hunt
probably c. 1740, oil on canvas
61.5 × 74.8 (24 1/8 × 29 3/8)
Samuel H. Kress Collection
1952.2.22

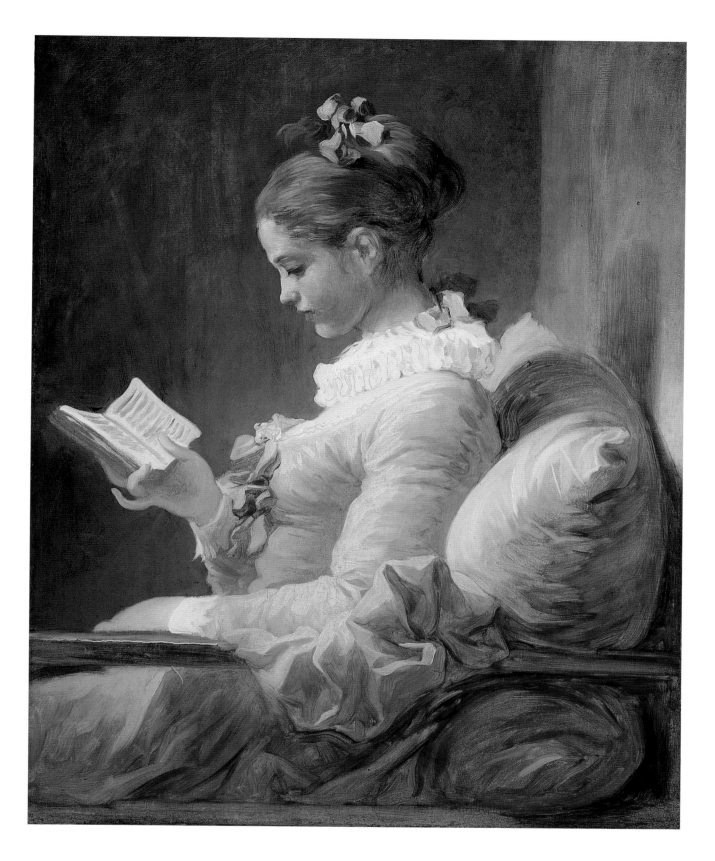

207

Jean-Honoré Fragonard
(French, 1732–1806)
A Young Girl Reading
c. 1776, oil on canvas
81.1 × 64.8 (32 × 25 ½)
Gift of Mrs. Mellon Bruce in memory
of her father, Andrew W. Mellon
1961.16.1

Ange-Laurent de Lalive de Jully

JEAN-BAPTISTE GREUZE

• *Amator* (Latin for "lover") is at the root of the word "amateur," and Ange-Laurent de Lalive de Jully (1725–1779) was an amateur in the best sense of the word. He was not a professional musician but played the harp for pleasure. In fact it was not necessary for him to work at all, for he came from a wealthy family and inherited his father's fortune in 1757. In 1756 he purchased the position of *introducteur des ambassadeurs* at court, the equivalent of chief of protocol, and was on friendly terms with such figures as Madame de Pompadour.

In Greuze's painting Lalive de Jully is shown in his Paris home, dressed informally yet elegantly in a white silk robe, scarf, and plum-colored britches. He turns from his playing to welcome his visitor. Music was only one of his passions. He was also a draftsman and printmaker as well as a collector. He amassed a large number of French, Italian, and Flemish paintings and opened his home to anyone who expressed an interest in seeing them. In 1754 he was elected an honorary member of the Académie Royale de Peinture et de Sculpture, and the portfolio, roll of paper, and sculpture at the right allude to his activity as artist and collector.

What are probably Lalive de Jully's most valuable acquisitions are the chair on which he sits and the writing table that can be glimpsed through the harp strings. He owned what are perhaps the earliest known pieces of neoclassical furniture, commissioned from Louis Joseph Le Lorrain. Made of ebony veneer and fitted with gilt bronze mounts, the severe rectilinear style and use of classical motifs "à la grecque" were inspired in part by the archeological discoveries at Herculaneum and Pompeii and provided a stark contrast to the curves and arabesques of the rococo style. Virtually all of the furniture has disappeared, except the writing table and accompanying filing cabinet, which are to be found in the Musée Condé, Chantilly.

Lalive de Jully was also a pioneer in recognizing Greuze's talent and was instrumental in getting the artist admitted to the Académie Royale in 1755. This portrait, acclaimed as one of Greuze's finest, was shown in the Salon of 1759 and captures the character of the man described by a contemporary, Baron de Grimm, as "a pleasant man who was widely liked. He was not a man particularly brilliant or profound, but he was gentle and agreeable; he was rich, however, and had an engaging appearance."

Jean-Baptiste Greuze
(French, 1725–1805)
Ange-Laurent de Lalive de Jully
probably 1759, oil on canvas
117 × 88.5 (46 × 34 ⅞)
Samuel H. Kress Collection
1946.7.8

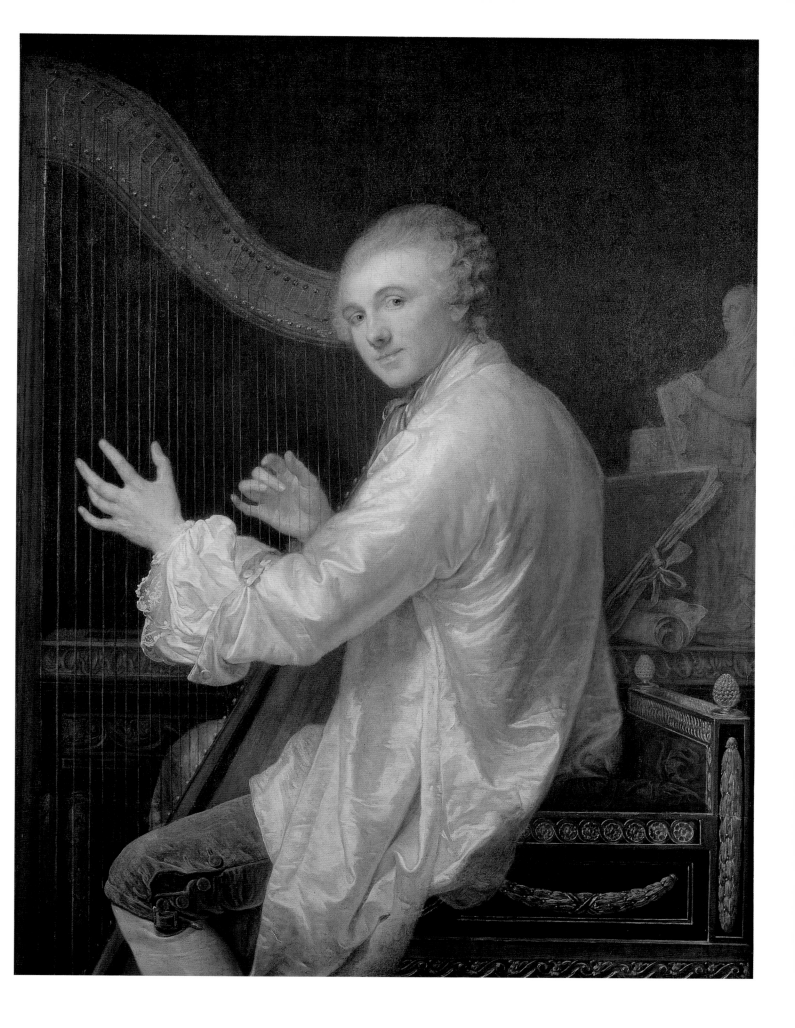

The Shipwreck

CLAUDE-JOSEPH VERNET

• An important landscape and marine painter of the late eighteenth century, Claude-Joseph Vernet was born and first studied in Provence. In 1734, at the age of twenty, he moved to Rome, where he soon established a successful practice that included Italian, French, and a large number of British clients. In 1753 Vernet returned to France, bringing with him sketches of the countryside and coastal areas from Rome to Naples. Although he could make topographically accurate pictures, he seemed to have particularly relished the challenge of producing imaginary scenes.

In 1771 Vernet was commissioned by Lord Arundell to paint a pair of marines, *The Shipwreck* and *Moonlight*, which were completed the following year. They remained in Wardour Castle, in the Arundell collection until 1952, at which time *Moonlight* disappeared; its location remains unknown. *Moonlight*, a calm, moonlit harbor scene, stood in deliberate contrast to the high-pitched emotionalism of *The Shipwreck*. Here the drama is nearly operatic, as man struggles to survive nature's fury. The jagged bolt of lightning in the background signals both the majesty and the danger of the storm.

In the foreground the heavy seas and crashing waves have forced a ship to founder. While enduring a howling wind, the passengers and crew cling to the rigging or attempt to reach land by sliding down the ropes secured by those already on shore. Vernet's technique is more than equal to the task of depicting the storm-wracked landscape as well as the wide range of human emotions, including fear, exhaustion, and elation at survival.

Vernet's pairing of *The Shipwreck* and *Moonlight* reflects late eighteenth-century notions about the aesthetic categories called the sublime and the beautiful. As defined by the Englishman Edmund Burke in a book published in 1757 and translated into French in 1765, the sublime included the awe and terror elicited by the raw power of nature, while the beautiful was associated with calm and restful compositions. These sensations were to be experienced in contrast to and in association with one another. Burke's ideas influenced artists and intellectuals in Europe and Britain.

Claude-Joseph Vernet
(French, 1714–1789)
The Shipwreck
1772, oil on canvas
113.5 × 162.9 (44 5/8 × 64 1/8)
Patrons' Permanent Fund
and Chester Dale Fund
2000.22.1

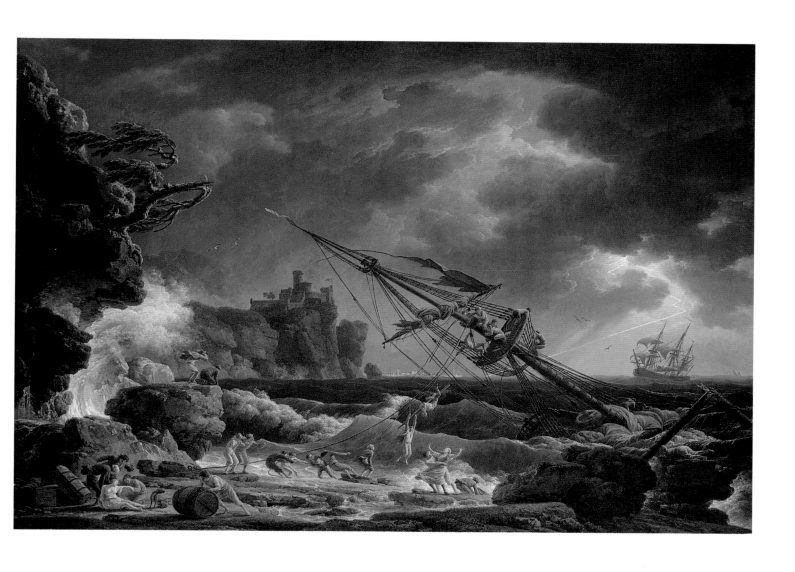

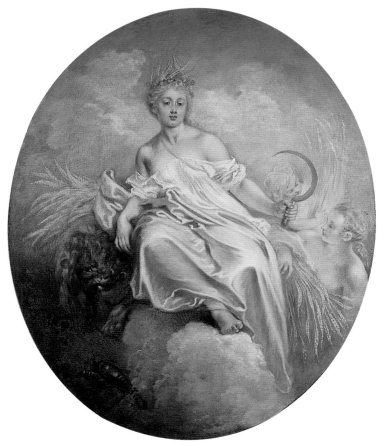

210

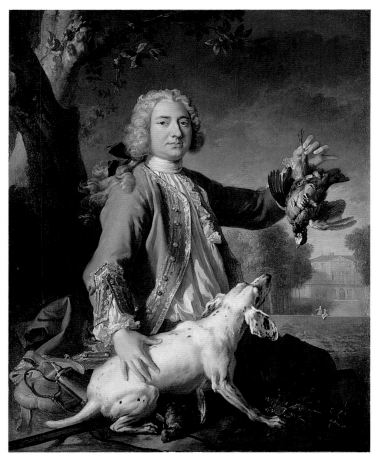

210

Antoine Watteau
(French, 1684–1721)
Ceres (Summer)
1715/1716, oil on canvas
141.6 × 116 (55 ¾ × 45 ⅝)
Samuel H. Kress Collection
1961.9.50

211

Jean-Baptiste Oudry
(French, 1686–1755)
The Marquis de Beringhen
1722, oil on canvas
147 × 113.98 (57 ⅞ × 44 ⅞)
Eugene L. and Marie-Louise
Garbaty Fund, Patrons' Permanent
Fund, and Chester Dale Fund
1994.14.1

212

Pierre-Henri de Valenciennes
(French, 1750–1819)
*Study of Clouds over
the Roman Campagna*
c. 1787, oil on paper on cardboard
19 × 32.1 (7 ½ × 12 ⅝)
Given in honor of Gaillard F.
Ravenel II by his friends
1997.23.1

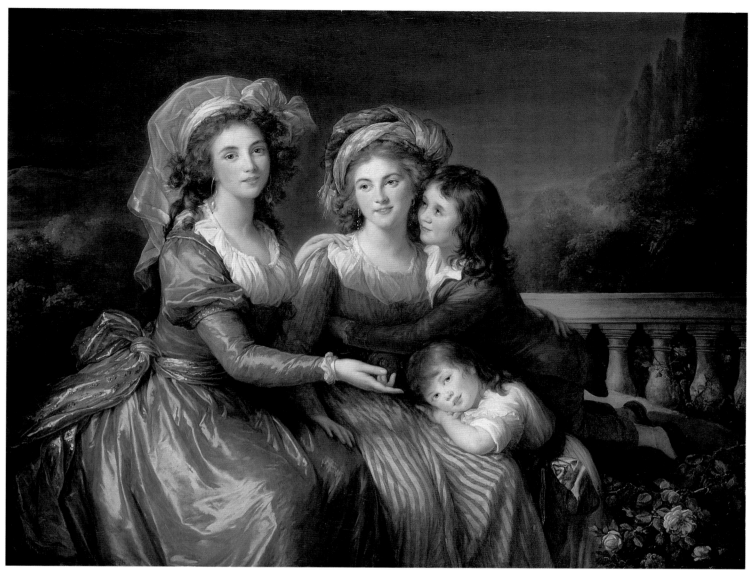

Elisabeth Vigée-LeBrun
(French, 1755–1842)
*The Marquise de Pezé and the Marquise
de Rouget with Her Two Children*
1787, oil on canvas
123.4 × 155.9 (48 ⅝ × 61 ⅜)
Gift of the Bay Foundation in memory
of Josephine Bay Paul and
Ambassador Charles Ulrick Bay
1964.11.1

Italian Comedians

ANTOINE WATTEAU

• Since its inception in the mid-sixteenth century the commedia dell'arte, known in France as the Comédie Italienne, consisted of a troupe of actors who took on the roles of stock characters easily identified by their costumes or masks. The plays allowed considerable leeway for improvisation, satire, and the insertion of topical references. In 1697 the troupe in Paris was banished after offending a member of the nobility, and it was not allowed to return until 1716, after the death of Louis XIV.

Watteau's painting appears to show the performers taking a curtain call, although neither the play nor specific actors can be identified. In the center, dressed in white satin, Pierrot is presented to the audience. Shy and bumbling, Pierrot is perpetually unsuccessful in his efforts to win the love of the beautiful Flaminia, who stands next to him. Other characters include, at the right, Scaramouche, in gold and black, who gestures grandly toward Pierrot, and further right, the doctor, an old man in black leaning on a cane. At the far left Mezzetin appears to be infatuated with Sylvia, the ingénue, while Scapin plays the guitar. Almost hidden behind Scapin is Harlequin, in either black-face or a mask and wearing his distinctive diamond-patterned costume. In the foreground a jester with a garland of roses and a bauble delights some children.

Born in Valenciennes on the border with Flanders, Watteau developed a lush painterly technique that reflects the decisive influence of Peter Paul Rubens, as seen here in the resplendent textures and shimmering highlights that play over the silks and satins. Watteau moved to Paris in 1702 and became a member of the Académie Royale de Peinture et de Sculpture in 1712. Throughout his career Watteau was involved in the theater and was sensitive to the contrast between the illusion of the stage and the reality of the sadness that lay behind the actor's smile. Thus, while the rest of the ensemble remains in character, Pierrot reveals an awkward but palpable humanity, tinged with a faint melancholy.

The *Italian Comedians* was painted for Dr. Richard Meade, a renowned British physician and avid collector. In 1719–1920 Watteau lived in London, where he was treated, probably for tuberculosis, by Dr. Meade. Unfortunately, the treatment was of no avail, and Watteau died in Paris in 1721 at the tragically young age of thirty-seven.

Antoine Watteau
(French, 1684–1721)
Italian Comedians
probably 1720, oil on canvas
63.8 × 76.2 (25 ⅛ × 30)
Samuel H. Kress Collection
1946.7.9

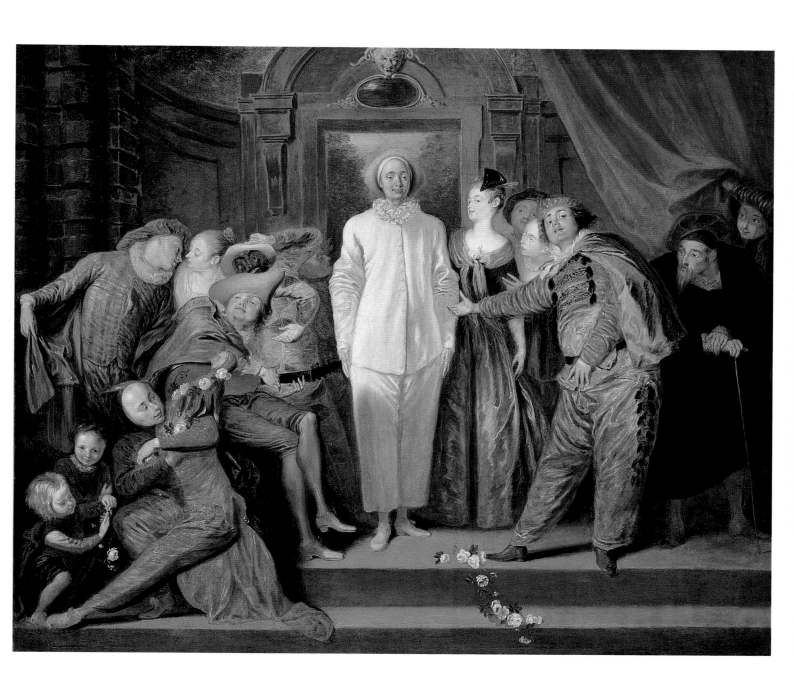

The Marquesa de Pontejos

FRANCISCO DE GOYA

• In 1786, when she was twenty-four years old, Doña Maria Ana de Pontejos y Sandoval married Francisco de Moñino y Redondo, ambassador to Portugal and brother of the court of Floridablanca, prime minister to King Charles III. Maria Ana was the only daughter of a very wealthy family and like her husband moved in the highest levels of society. It is likely that Goya was commissioned to paint this full-length portrait on the occasion of her engagement. The carnation she holds is a traditional symbol of betrothal, and the pug sporting a bow and bells on his collar could refer to fidelity.

Her extravagant dress, which includes a filmy, gathered tulle overskirt trimmed with pink roses and white satin ribbons, and her elaborate hairdo reflect the dominant influence of French fashion. The painfully narrow waist was in vogue among Spanish noblewomen. The rather amorphous outdoor setting coupled with the large straw hat of a type found in Gainsborough's portraits create a pastoral mood, echoing the French predilection for depicting women as well-dressed shepherdesses. Frivolity is effectively dampened by the marquesa's erect posture and serious demeanor. In this, Goya may have wanted to recall something of the dignity and truthfulness of Spanish court portraiture of the seventeenth century, especially that of Diego Velázquez, who often played off notes of pinks and rose against tonalities of glistening silver.

On the eve of her marriage the marquesa de Pontejos could not have known that her life would be far from settled or happy. Her brother-in-law's fall from favor caused Maria Ana and Francisco to be exiled from court briefly and was followed by Francisco's death in 1808. She would marry and be widowed a second time, and her third husband's political views forced the couple to leave in 1822 and live in Paris. They were not able to return to Spain until 1833, only a year before Maria Ana's death.

Francisco de Goya
(Spanish, 1746–1828)
The Marquesa de Pontejos
c. 1786, oil on canvas
210.3 × 127 (82 ¾ × 50)
Andrew W. Mellon Collection
1937.1.85

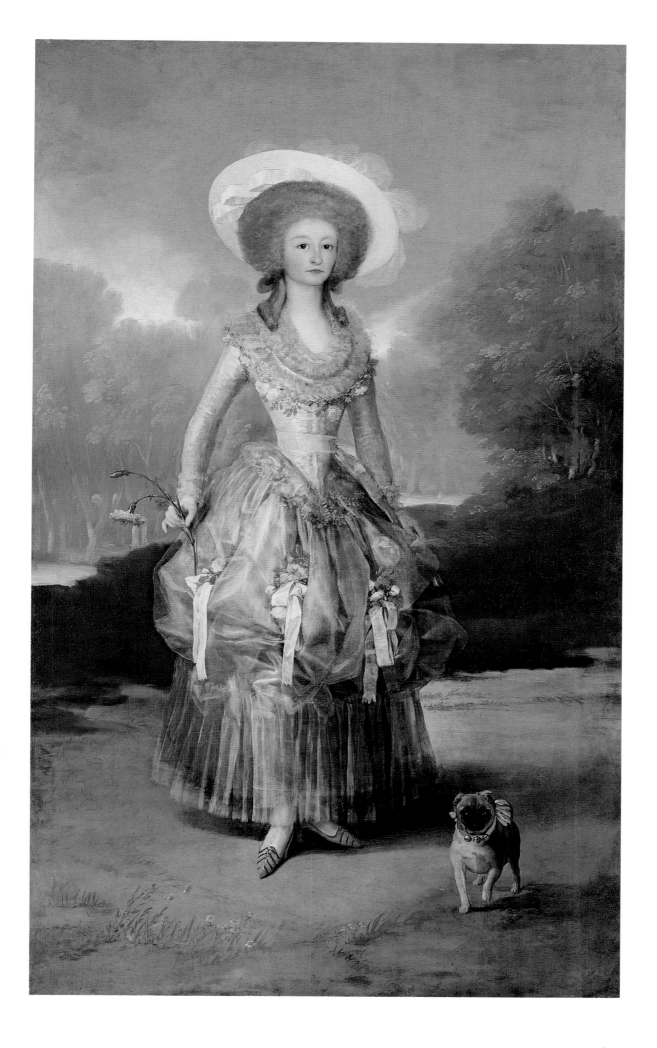

Señora Sabasa García

FRANCISCO DE GOYA

• This hauntingly beautiful portrait depicts Maria García de Castro, known to her friends as Sabasa García. Born in 1790, she was in her late teens or early twenties when Goya painted this likeness. The exact occasion or circumstances of the commission are unknown, but in 1806 Goya painted a portrait of her uncle, Evaristo Pérez de Castro, a prominent politician and diplomat (Musée du Louvre, Paris), who most likely introduced the artist to Sabasa García.

The extraordinary impact of the painting derives from several factors. First, there is its simplicity. Set against a black background, Sabasa García wears a transparent veil, a shawl, and long fingerless gloves. No prop, jewelry, or elaborate costume detracts from contemplation of this attractive young woman. Attention is drawn immediately to her face, the brightest area of the painting, where deep brown eyes, contrasting with her fair complexion, return the viewer's gaze with intensity and unflinching directness. Her oval face is played off against the almond-shaped opening created by her veil. Second, Goya allowed Sabasa García's body language to express a strong character, for her erect carriage suggests pride and self-contained reserve. Lastly, the picture testifies to Goya's virtuoso technique. He used thick creamy paint to describe her face and numerous glazes to define the detailed ringlets in her hair. Gossamer touches of white paint suggest the transparent veil. Perhaps most striking is the shawl, where broad strokes of ocher, shades of brown, and black give the fabric a convincing tactile quality. He brought together diverse technical means and controlled them with thoughtfulness and sensitivity to produce an unforgettable image of feminine beauty.

Not much is known about Sabasa García's life. In 1820 she married Juan Peñuelas, a wealthy landowner, and as a member of Spain's upper class she presumably lived a privileged and comfortable life. She seems to have cherished Goya's portrait, for it remained in her possession until her death.

Francisco de Goya
(Spanish, 1746–1828)
Señora Sabasa García
c. 1806/1811, oil on canvas
71 × 58 (28 × 22 ⅞)
Andrew W. Mellon Collection
1937.1.88

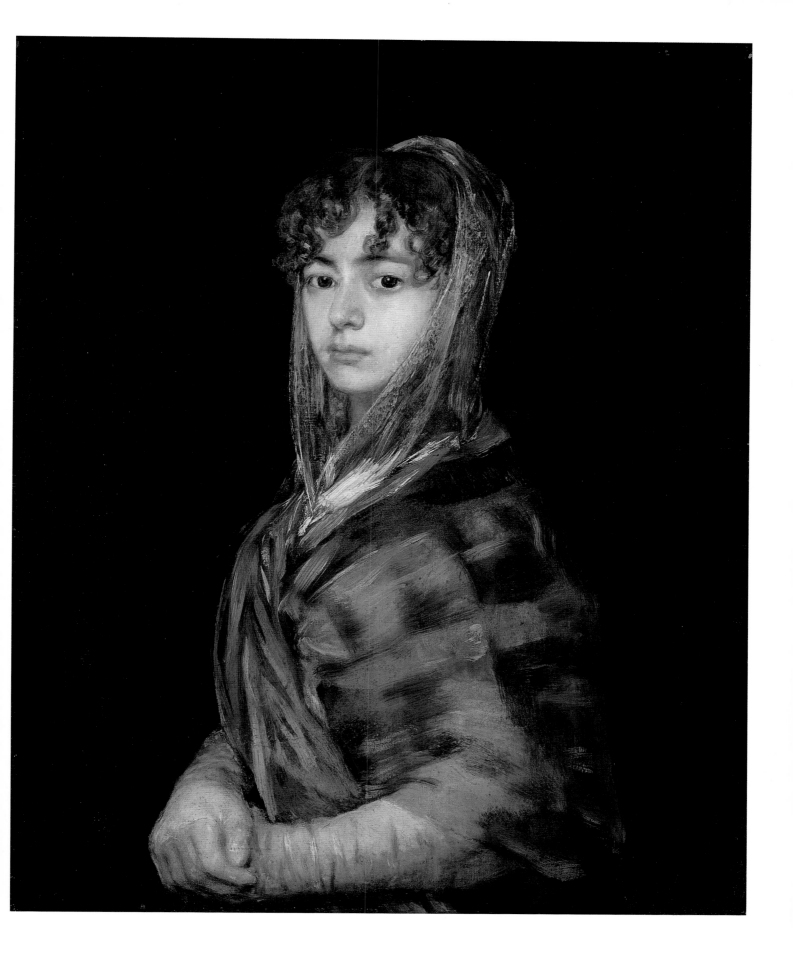

Bartolomé Sureda y Miserol / Thérèse Louise de Sureda

FRANCISCO DE GOYA

• Artist, engineer, and administrator, Bartolomé Sureda y Miserol (1769–1850) was a figure of considerable importance to Spain's economic well being. Born in Palma de Mallorca and first trained as an artist, Sureda moved to Madrid, where his talents as a draftsman attracted the attention of the engineer Agustín de Betancourt. The two men spent the years from 1793 to 1796 in England studying manufacturing techniques and machinery. In 1800 Sureda was sent to France to examine the factories that made cotton, porcelain, and ceramics. It was there that he married Thérèse Louise Chapronde Saint Amand. The two probably met through her childhood friend, Abraham-Louis Bréguet, a famous designer of watches and scientific instruments.

On Sureda's return to Madrid in 1803, he started working at Buen Retiro Royal Porcelain Factory and quickly rose to a position of authority. After the factory was partially destroyed in the Napoleonic invasion of 1808, Sureda and his wife fled to France, where they remained until 1814. Returning to Spain, he directed in succession the royal factories that manufactured textiles, ceramics, and glass and was praised for introducing modern equipment and improving product quality. Retiring in 1829, Sureda returned to Palma de Mallorca and to his original avocation, painting landscapes and religious subjects.

Goya probably painted the portraits of Bartolomé and Thérèse Louise de Sureda in 1803/1804 just after their arrival in France. The two men were friends, and Sureda had taught Goya a method for making aquatints he had learned in England. Shown leaning against a plinth and holding a tall hat lined in brilliant red, Sureda's informal pose is based on eighteenth-century British portraits that Goya knew through mezzotint reproductions. The influence of contemporary French fashion is evident in both paintings. Not only Sureda's tight-fitting coat with wide lapels, waistcoat, and cravat but also his disheveled looking hairstyle is French. The portrait of Thérèse Louise ranks among Goya's finest depictions of women. In contrast to her husband's relaxed pose, Thérèse Louise sits erect and alert, looking directly at the viewer with large brown eyes and an expression of disdainful pride. The carefully arranged curls on her forehead, the brilliantly rendered blue-red *couleur changeant* silk dress, and the sphinx that adorns the arm of the chair (a souvenir of Napolean's Egyptian campaign) are all manifestations of the Empire style.

217

Francisco de Goya
(Spanish, 1746–1828)
Bartolomé Sureda y Miserol
c. 1803/1804, oil on canvas
119.7 × 79.3 (47 ⅛ × 31 ¼)
Gift of Mr. and Mrs. P.H.B. Frelinghuysen
in memory of her father and mother,
Mr. and Mrs. H. O. Havemeyer
1941.10.1

218

Francisco de Goya
(Spanish, 1746–1828)
Thérèse Louise de Sureda
c. 1803/1804, oil on canvas
119.7 × 79.4 (47 ⅛ × 31 ¼)
Gift of Mr. and Mrs. P.H.B. Frelinghuysen
in memory of her father and mother,
Mr. and Mrs. H.O. Havemeyer
1942.3.1

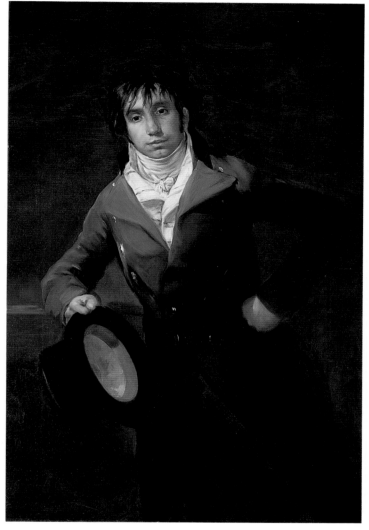

217

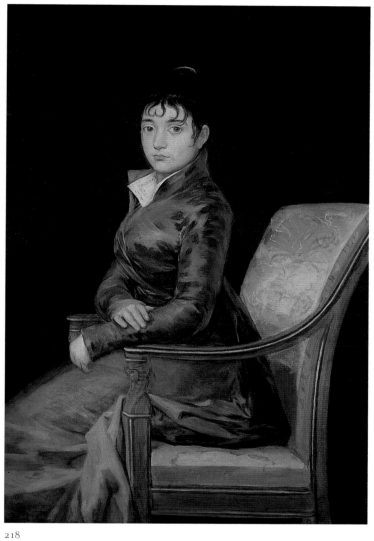

218

Still Life with Figs and Bread

LUIS MELÉNDEZ

• This painting amply demonstrates Meléndez's gifts as a still-life painter. The artist fashioned a work of compelling visual interest out of humble foodstuffs and kitchen equipment. As is typical for him, the subjects are strongly lit from the left and placed close to the picture plane so that they can be scrutinized. A bone-handled knife that juts into the viewer's space provides entry into the painting, where one finds a loaf of crusty bread depicted with exceptional fidelity and clarity, its rough texture juxtaposed with the glistening surfaces of the green, red, and purple figs. Similarly, a shiny glass flask is deliberately placed next to a deeply grained wooden cask. The object at the rear is made of cork bound by a wooden stave, and it holds what appears to be a long-necked copper container. What seems to be ice or snow on the top suggests that this is a cooler. Each object is endowed with solidity, and its texture rendered with such accuracy that one knows immediately how it would feel to the touch. In addition, virtually all of the components are round or circular, with their curves creating a unified composition.

Luis Meléndez came from a family of artists: both his father, Francisco, and his uncle, Miguel, were painters. In 1745 Luis was admitted to the Royal Academy of Fine Arts in Madrid, founded the year before, but because of his father's criticism of the institution both were dismissed. Luis then moved to Italy, settling in Naples, which was under Spanish rule. In 1753 he was called back to Madrid by his father to assist in painting the illuminations in choir books for the royal palace. He began to specialize in still-life painting in 1759 and continued until 1774. In addition to private commissions, forty-five of his still lifes, apparently ordered by Charles III, originally decorated the royal summer palace at Aránjuez, outside Madrid. Very little is known of Meléndez's activity after 1774, but he formally declared poverty in June 1780 and died on 11 July.

Luis Meléndez
(Spanish, 1716–1780)
Still Life with Figs and Bread
1760s, oil on canvas
47.6 × 34 (18 ¾ × 13 ⅜)
Patrons' Permanent Fund
2000.6.1

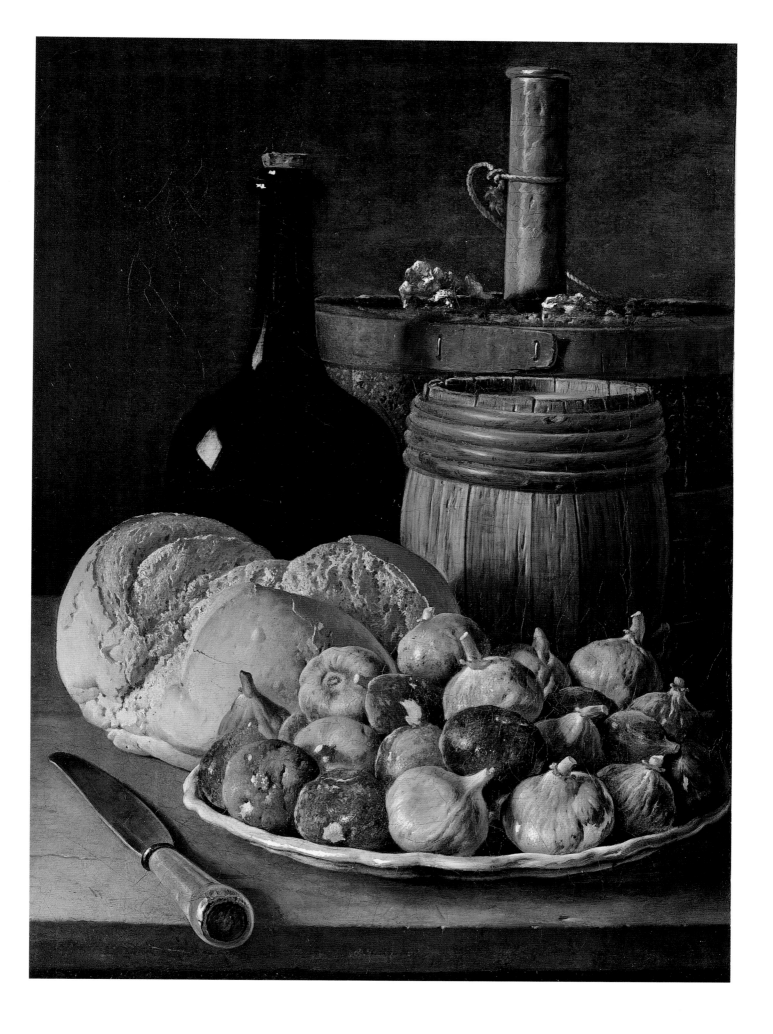

Oedipus Cursing His Son, Polynices

HENRY FUSELI

• Depicted here is a scene from Sophocles' play *Oedipus at Colonus*. After realizing that he has married his own mother, Jocasta, Oedipus blinds himself and is banished from the city of Thebes. His daughter Antigone leads him to Colonus, a sacred wood near Athens, where he is visited by his son Polynices, who wants his father's blessing in his attempt to regain control of Thebes ruled by his brother Eteodes. Infuriated by the request, Oedipus pronounces a malediction on Polynices and his brother Eteodes: "May you never defeat your motherland; may you never return alive to Argus; may you in dying kill your banisher, and, killing, die by him who shares your blood. This is my prayer."

In keeping with the tragedy and the histrionics of the moment, the taut, expressionistic figures in this painting are surrounded by a pervading darkness, emerging only partially, as if caught in a spotlight. The sightless Oedipus points an accusing finger at Polynices, as his son turns away, rejecting the curse. Their gestures are at once antagonistic yet interconnected. Between them is Antigone who attempts to restrain her father. At the lower left a despondent Ismene, the second daughter, rests her head on Oedipus' knee.

Fuseli, born in Zurich and educated in Switzerland, was multilingual and well read in the areas of classical philology, theology, philosophy, and literature, turning often for inspiration to the writings of Shakespeare, Dante, and Milton. In 1770, at the urging of Sir Joshua Reynolds, he made the obligatory trip to Italy, where it was the *terribilità* of Michelangelo that struck him most forcibly, as can be seen here in the powerful figure of Oedipus. Returning to Rome in 1780, Fuseli went on to become a member of the Royal Academy of Arts and a professor of painting. He was a popular and influential teacher who encouraged the use of literature as a source of subjects for visual artists.

In his fascination with the darker, agonized, and passionate side of human existence, Fuseli represents an aspect of eighteenth-century romanticism that is the antithesis of the optimistic, rational, and scientific outlook of contemporaries such as Reynolds, Thomas Gainsborough, or George Stubbs. Particularly in his late works Fuseli dealt with erotic and demonic themes, and his psychological expression was to have a decisive influence upon artists like Edvard Munch.

Henry Fuseli
(British, 1741–1825)
Oedipus Cursing His Son, Polynices
1786, oil on canvas
149.8 × 165.4 (59 × 65 ⅛)
Paul Mellon Collection
1983.1.41

Mrs. Richard Brinsley Sheridan

THOMAS GAINSBOROUGH

• In 1759 Gainsborough moved from Ipswich to the fashionable resort city of Bath, where he quickly met with resounding success. A lover of music and the theater, and an amateur musician himself, Gainsborough was well acquainted with the composer and choirmaster of Bath, Thomas Linley, and his musically gifted family. Thomas' most famous daughter, Elizabeth, was celebrated both for her beauty and for her ravishing soprano voice. As a contemporary wrote, "The whole town seems distracted by her. Every other diversion is forsaken; Miss Linley alone engrosses all eyes, ears, hearts." In 1773, when she was nineteen years old, Elizabeth married the brilliant wit, politician, and playwright Richard Brinsley Sheridan. It is said that Sheridan used their courtship, which included eloping to France to escape another suitor, as the basis for his play *The Rivals*. After marriage Mrs. Sheridan ceased concertizing, perhaps judging it incompatible with her husband's burgeoning political career.

Gainsborough, having known Elizabeth since childhood, portrayed her on several occasions. This picture, which shows her at age thirty-one, is a superb example of his wizardry with a brush. A flurry of rapid, gossamer strokes animates the entire picture surface, yet her solidly modeled face and wistful expression remain the focal point. Mrs. Sheridan is not just posed against a landscape, she is to a remarkable degree consonant with her surroundings. For example, there is essentially no difference in color or texture between her windswept hair and the foliage that frames her head. Gainsborough's romantic fusion of sitter and setting accords with Mrs. Sheridan's own feelings; she much preferred life in the country to the bustle of London.

Impetuous and intuitive, Gainsborough was the opposite of the calm and calculating Sir Joshua Reynolds. Unlike his contemporary, Gainsborough rarely made preparatory drawings or compositional sketches, preferring to compose and paint *a la prima*, directly on the canvas. Both men were founding members of the Royal Academy of Arts, and although the praise may have been grudging, Reynolds appreciated Gainsborough's unique talent.

Thomas Gainsborough
(British, 1727–1788)
Mrs. Richard Brinsley Sheridan
1785–1787, oil on canvas
220 × 154 (86 ⅝ × 60 ⅝)
Andrew W. Mellon Collection
1937.1.92

222

Thomas Gainsborough
(British, 1727–1788)
Mountain Landscape with Bridge
c. 1783/1784, oil on canvas
113 × 133.4 (44 ½ × 52 ½)
Andrew W. Mellon Collection
1937.1.107

223

Sir Henry Raeburn
(British, 1756–1823)
John Johnstone, Betty Johnstone,
and Miss Wedderburn
c. 1790/1795, oil on canvas
101.5 × 120 (40 × 47 ¼)
Gift of Mrs. Robert W. Schuette
1945.10.3

224

Sir Henry Raeburn
(British, 1756–1823)
Miss Eleanor Urquhart
c. 1793, oil on canvas
75 × 62 (29 ½ × 24 ⅜)
Andrew W. Mellon Collection
1937.1.101

Lady Elizabeth Delmé and Her Children

SIR JOSHUA REYNOLDS

• Sir Joshua Reynolds is a pivotal figure in the history of British art. Born in Plympton, Devon, he was apprenticed for several years to a painter in London, but his real education took place in Italy, where from 1750 to 1752 he resided primarily in Rome but also visited Naples, Florence, and Venice. In addition to studying antique statuary, Reynolds was particularly impressed by Raphael, Michelangelo, and the painters of Venice. Returning to London, he became the most sought-after and best-paid artist of his day.

As the first president of the Royal Academy of Arts, founded in 1768, Reynolds delivered an annual lecture that set forth his ideas about theory and practice and the education of artists. What he called the "Great Style" favored the general over the particular, and he advocated borrowing poses and compositions from the old master painters and classical sculptors. Reynolds, however, was not stifling or doctrinaire, and he believed that once students had acquired a solid foundation through hard work and study they should be free to pursue their own way.

The primary subject of this painting, Lady Elizabeth Howard, descended from one of the grand aristocratic families in Britain and married the wealthy and landed Peter Delmé in 1769. From 1774 to 1789 Delmé was member of Parliament for Morpeth, a position obtained through the influence of his wife's family. Commissioned by Delmé, this portrait shows

Lady Elizabeth with the two eldest of their five children; next to her is John, born in 1772, and Emilius Henry, born two years later. The artist's appointment books indicate that Lady Elizabeth posed for Reynolds several times in April and June of 1777 and that there were separate sittings for the children.

Reynolds practiced what he preached. The triangular figure grouping here owes much to the Italian Renaissance — especially the Madonnas by Raphael — while the large expanse of rose-colored fabric, which exists independently of Lady Elizabeth's dress, recalls the swags of drapery found in Italian baroque paintings or the portraits of Anthony van Dyck. The figures are set against a stand of massive beech trees, part of a wooded park that could derive from the landscapes of Titian. Reynolds manages the difficult task of endowing the family group with nobility and dignity without sacrificing their humanity. With her hair piled high, Lady Elizabeth is at once a fashionable, idealized woman and a mother who tenderly embraces her children. Reynolds loved children and found them naturally graceful, yet he also felt the need to depict John in the self-assured masculine posture of an adult. As he gazes off into the distance, his brother clings to him, and the family terrier looks upat him adoringly.

225

Sir Joshua Reynolds
(British, 1723–1792)
Lady Elizabeth Delmé and Her Children
1777–1779, oil on canvas
239.2 × 147.8 (94 ⅛ × 58 ⅛)
Andrew W. Mellon Collection
1937.1.95

226

Sir Joshua Reynolds
(British, 1723–1792)
Lady Caroline Howard
1778, oil on canvas
143 × 113 (56 ¼ × 44 ½)
Andrew W. Mellon Collection
1937.1.106

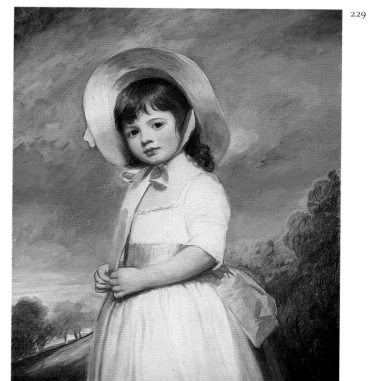

229

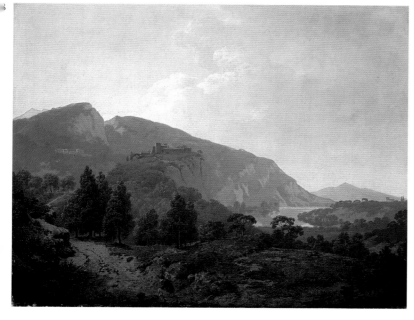

227

George Stubbs
(British, 1724–1806)
White Poodle in a Punt
c. 1780, oil on canvas
127 × 101.5 (50 × 40)
Paul Mellon Collection
1999.80.22

228

Joseph Wright
(British, 1734–1797)
Italian Landscape
1790, oil on canvas
103.5 × 130.4 (40 ¾ × 51 ⅜)
Paul Mellon Collection
1983.1.47

229

George Romney
(British, 1734–1802)
Miss Juliana Willoughby
1781–1783, oil on canvas
92.1 × 71.5 (36 ¼ × 28 ⅛)
Andrew W. Mellon Collection
1937.1.104

Captain Samuel Sharpe Pocklington with His Wife, Pleasance, and possibly His Sister, Frances

GEORGE STUBBS

• This is a fine example of a "conversation piece," an informal group portrait, usually of members of the same family, that was popular in England in the eighteenth century. It is also a marriage portrait, for the woman who is playfully offering the horse a small bouquet of flowers is dressed in a white wedding gown. She is Pleasance Pykarell, who changed her name to Pocklington when she inherited the estate of her cousin, Robert Pocklington. When Pleasance married Samuel Sharpe in 1769, he also took the name Pocklington. He is shown standing next to his horse and wearing the uniform of the Third Regiment of Foot Guards, later known as the Scots Guards. The woman at the far left has been tentatively identified as Samuel's sister, Frances. Rather than depicting a specific location, the dark mass of foliage and the misty lake serve simply as a backdrop that effectively focuses attention on the figures, whose poses do appear somewhat awkward and contrived. It is, interestingly, the splendidly rendered horse that serves as the compositional link between the members of the Pocklington family.

Born in Liverpool, Stubbs served only a few weeks of apprenticeship and apparently was self-taught as an artist. In 1754 he went to Rome, and contrary to the experiences of others, what he saw convinced him that nature was superior to art, even the creations of the Greeks and Romans. Equal parts scientist and artist, Stubbs was fascinated by human and equine anatomy. His most notable publication, *The Anatomy of the Horse*, published in 1766, was based on drawings and dissections made by Stubbs, who engraved the painting plates himself when he could not find a suitable engraver.

Stubbs was an incomparable painter of animals and was especially renowned during his lifetime for his representations of horses, creatures that played an essential part in the aristocratic life of England. The impact of his paintings rests on Stubbs' knowledge of anatomy, his precise observation of individual characteristics, and his refusal to anthropomorphize the creatures he depicted. Ironically, Stubbs' skill caused him to be thought of as a mere "horse painter," and he never attained full membership in the Royal Academy of Arts. Full recognition of his genius had to wait until relatively recently.

230

George Stubbs
(British, 1724–1806)
*Captain Samuel Sharpe Pocklington
with His Wife, Pleasance,
and possibly His Sister, Frances*
1769, oil on canvas
100.2 × 126.6 (39 ½ × 49 ⅞)
Gift of Mrs. Charles S. Carstairs
in memory of her husband,
Charles Stewart Carstairs
1952.9.4

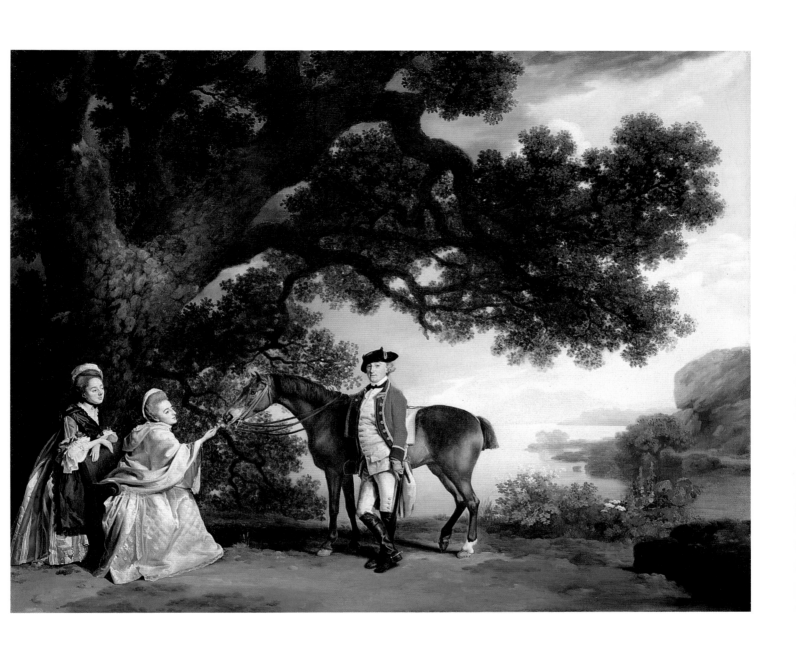

The Corinthian Maid

JOSEPH WRIGHT

• The best-known story explaining the invention of portraits modeled in clay is found in the *Natural History* of the Roman author Pliny. The daughter of a Corinthian potter was in love with a young man who was about to leave the city. In an attempt to preserve his features, she carefully incised on a wall the outline of his face formed by a cast shadow. Her father used clay to make from the profile a relief, which he then fired in his pottery kiln. Another ancient author, Athenagoras, added that the lad was asleep, which suggested, as seen here, that the event took place at night. For Wright the immediate literary source was a poem written by his friend William Hayley and published in 1778. In retelling the legend, Hayley also mentioned the sleeping youth.

Wright painted the *Corinthian Maid* for Josiah Wedgwood, and the subject was particularly appropriate for the famous potter and designer whose works, often in low relief, contributed to the establishment of the neoclassical style in England. The painting took several years to complete, in part because Wright was busy with other projects but also because he was in continuous discussion with Wedgwood and made changes in response to these conversations.

The painting is neoclassic in style: surfaces are smoothly finished, shapes are carefully delineated, the color scheme is restricted to warm browns and oranges enlivened by the touches of dark blue and purple, and the furnishings of the room are sparse. Even the greyhound, perhaps a symbol of fidelity, is rather neoclassic in appearance. The pose of the sleeping youth is derived from an antique relief of Endymion that Wright sketched in Rome in 1774.

Throughout his career the artist was fascinated by the effects of artificial illumination, especially candlelight. The room shown here is lit by a lamp hidden behind a curtain at the upper left, while at the far right a bright patch of moonlight is visible through a window. Apparently feeling no desire to live in London, Wright spent most of his career in Derby, the city of his birth. His works encompass a wide range of subjects, including not only portraits and landscapes but also depictions of experiments and mechanical devices. He was well acquainted with scientists and engineers during what might be called the dawn of the Industrial Revolution.

Joseph Wright
(British, 1734–1797)
The Corinthian Maid
1782–1784, oil on canvas
106.3 × 130.8 (41 ⅞ × 51 ½)
Paul Mellon Collection
1983.1.46

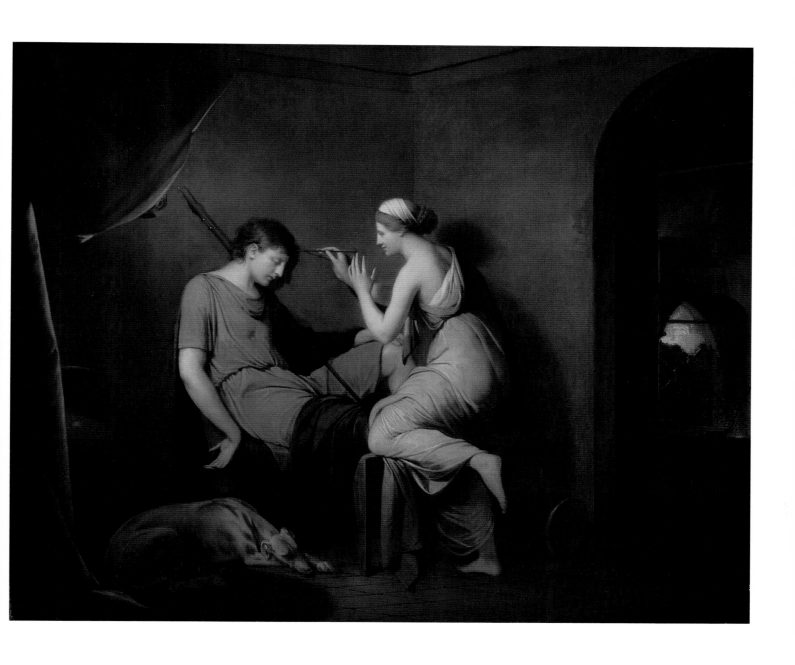

The Copley Family

JOHN SINGLETON COPLEY

• Copley was born in Boston and received his only formal training from his stepfather, Peter Pelham, an English engraver and portraitist. In the course of teaching himself art, he studied prints, mainly English, and the paintings of his American contemporaries. Hardworking, ambitious, and talented, he soon became the foremost portraitist in the colonies. When his *Boy with a Squirrel* (Museum of Fine Arts, Boston), 1765, was exhibited in London, it attracted favorable comments, but the criticism made Copley aware of his deficiencies.

In 1774 Copley left Boston for London, both to further his education and to escape the growing political unrest and antagonism toward the British. He soon left London for Italy and France, where he spent more than a year studying art. In 1775 he returned to London, and by May he was joined by his wife and children, who had remained in Boston up to that time. This large group portrait may be seen as a celebration of the reunion of the artist with his family. Copley at the upper left, holding several sheets of paper, turns to face the viewer. Directly below, his father-in-law, Richard Clarke, holds the youngest child, Susanna (Clarke was among the merchants whose goods were thrown into the harbor during the Boston Tea Party). At the right the artist's wife, Susanna, embraces John Jr., as Mary snuggles up next to her mother. Unlike the other squirming children the eldest child, Elizabeth, stands in the center of the group looking poised yet somewhat wary.

Exhibited at the Royal Academy of Arts in 1777, the *Copley Family* marks a critical moment in the artist's career. The painting contains the wonderfully rendered fabrics and incisive portraiture that established Copley's success in America; Richard Clarke's stern countenance is particularly arresting. Equally evident is the increased sophistication in both technique and style that resulted from Copley's first-hand experience of European and English art. The tender pose of Susanna and her son was inspired by the Madonnas of Raphael and others that Copley saw in Italy. It is also clear that he looked carefully at family portraits by Rubens and Van Dyck for hints on how to arrange multiple-figure compositions. The setting owes something to the conventions of grand manner portraiture, although the juxtaposition of carpeted foreground with the background vista of water and hills is at once ambiguous and unconvincing. Whether he knew it at this moment or not, Copley was destined to remain in England for the rest of his life, where a cosmopolitan environment and greater opportunities for patronage could keep pace with his ambitions.

John Singleton Copley
(American, 1738–1815)
The Copley Family
1776/1777, oil on canvas
184.1 × 229.2 (72 ½ × 90 ¼)
Andrew W. Mellon Fund
1961.7.1

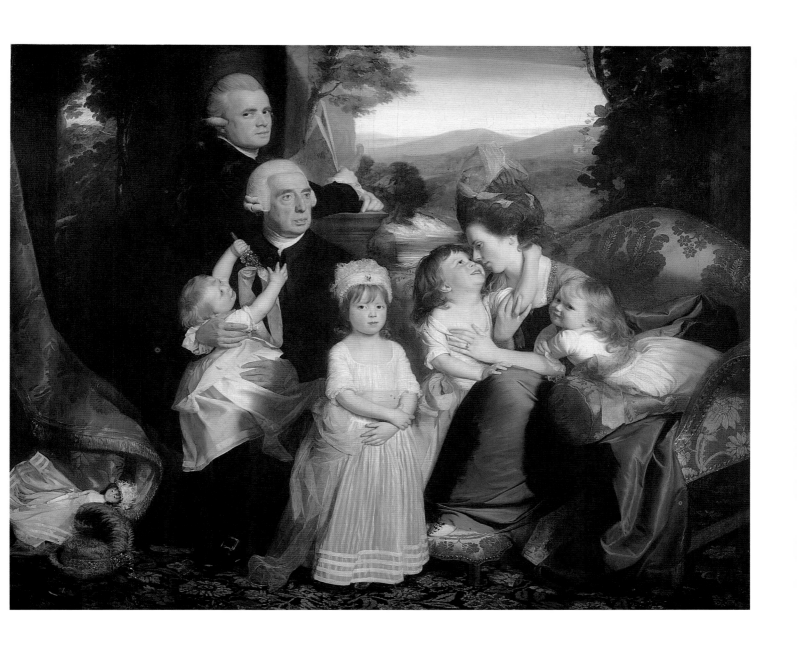

Watson and the Shark

JOHN SINGLETON COPLEY

• This monumental canvas depicts a horrific event in the life of Brook Watson, which occurred in 1749 when he was fourteen years old. An orphan born in England, Watson was sent to Boston, where, thanks to a relative, he found work on a merchant vessel. One day while swimming in the harbor of Havana, he was attacked by a shark, but after having his right foot bitten off, he was rescued by his shipmates. He survived, although his leg was amputated below the knee and replaced by a wooden prosthesis. His subsequent life sounds like a Horatio Alger novel: he became a very successful merchant in Canada and in England, where he was elected to Parliament, became a director of the Bank of England, and in 1796–1797 he was the lord mayor of London. Commissioned by Watson, Copley's painting was exhibited at the Royal Academy of Arts in 1778; it was a huge critical and popular success that launched the artist's career in England.

Taking a cue from his fellow expatriate Benjamin West, Copley gave this relatively recent event the large format, seriousness, and complexity usually accorded to ancient or biblical history. He captured a moment of high drama; just as the shark was about to make a third and certainly fatal pass, it was driven away by a crewman with a boathook. To enhance the scene's realism, Copley based his view of the Cuban harbor on prints and drawings of the site, but he had never seen a shark, and this creature is ferocious but fanciful. On the other hand, the vividly characterized black sailor is painted from life, and his presence may have been requested by Watson.

For the figural groupings of the crewmen in the boat Copley turned to representations of similar themes in Renaissance and baroque art. The poses of the two men reaching for Watson recall those of the figures in both Rubens' and Raphael's *Miraculous Draft of Fishes*, both of which were available in engravings. The pose of Watson is like that of the possessed boy in Raphael's *Transfiguration*, which Copley could have seen in Rome.

Artist and patron probably discussed the underlying themes of the painting: triumph over adversity; and salvation. The subject of trial by hardship followed by redemption was popular in eighteenth-century literature, and the painting would have reminded viewers of the story of Jonah and the whale. At his death in 1807, Watson bequeathed *Watson and the Shark* to Christ's Hospital, London, an institution for orphans, doubtless intending his own triumph over adversity to serve as an inspiration to others.

233

John Singleton Copley
(American, 1738–1815)
Watson and the Shark
1778, oil on canvas
182.1 × 229.7 (71 ¾ × 90 ½)
Ferdinand Lammot Belin Fund
1963.6.1

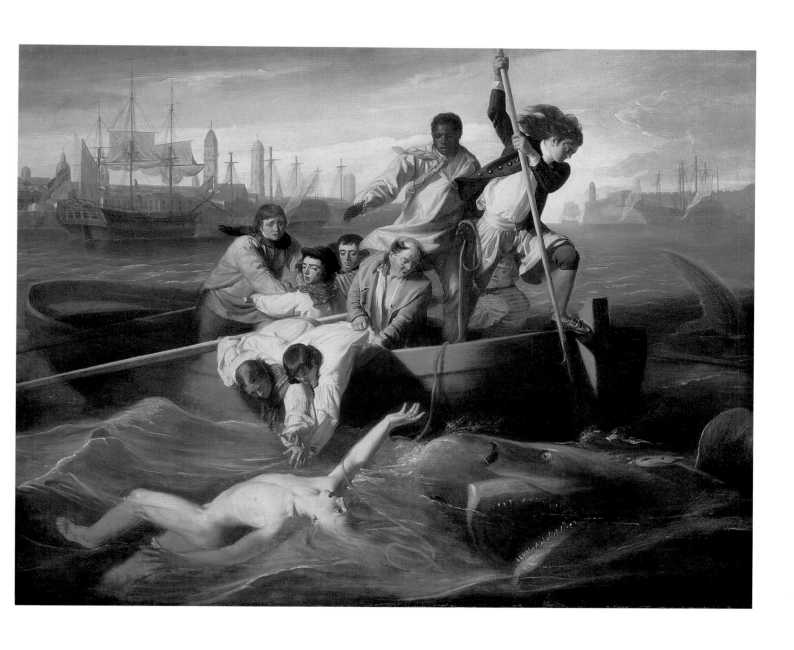

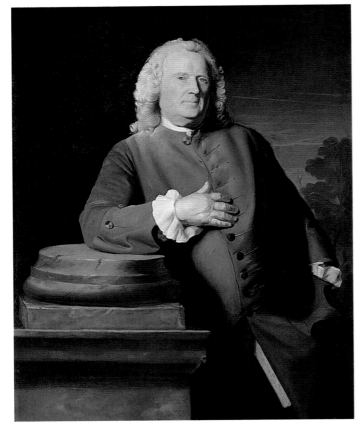

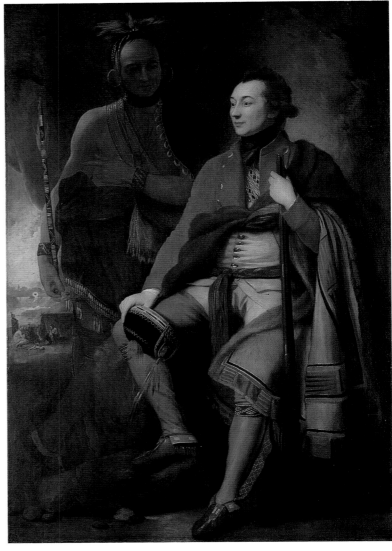

234

235

John Singleton Copley
(American, 1738–1815)
Epes Sargent
c. 1760, oil on canvas
126.6 × 101.7 (49 ⅞ × 40)
Gift of the Avalon Foundation
1959.4.1

Benjamin West
(American, 1738–1820)
*Colonel Guy Johnson and
Karonghyontye (Captain David Hill)*
1776, oil on canvas
202 × 138 (79 ½ × 54 ⅜)
Andrew W. Mellon Collection
1940.1.10

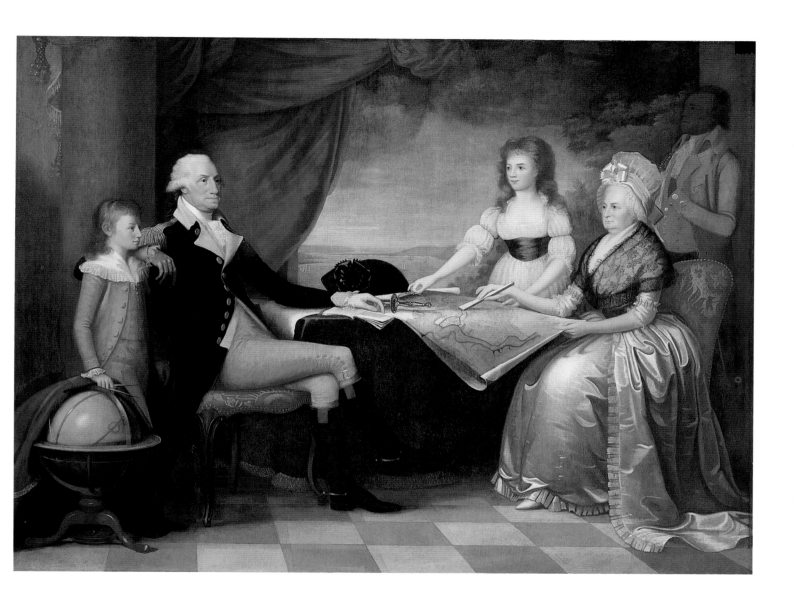

236

Edward Savage
(American, 1761–1817)
The Washington Family
1789–1796, oil on canvas
213.6 × 284.2 (84 ¾ × 111 ⅞)
Andrew W. Mellon Collection
1940.1.2

237

237

Charles Willson Peale
(American, 1741–1827)
Benjamin and Eleanor Ridgely Laming
1788, oil on canvas
106 × 152.5 (42 × 60)
Gift of Morris Schapiro
1966.10.1

238

Gilbert Stuart
(American, 1755–1828)
Catherine Brass Yates (Mrs. Richard Yates)
1793/1794, oil on canvas
76.2 × 63.5 (30 × 25)
Andrew W. Mellon Collection
1940.1.4

239

Gilbert Stuart
(American, 1755–1828)
George Washington (Vaughan Portrait)
1795, oil on canvas
73 × 60.5 (28 ¾ × 23 ¾)
Andrew W. Mellon Collection
1942.8.27

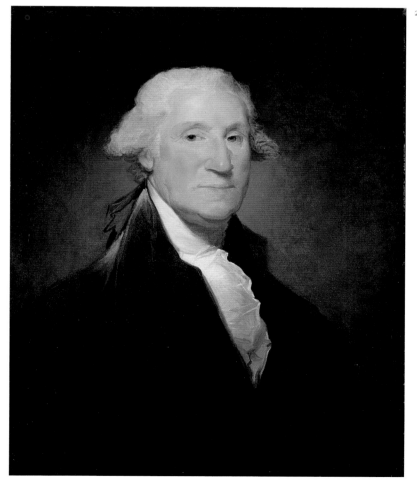

The Skater (Portrait of William Grant)

GILBERT STUART

• The son of a Scottish immigrant, Stuart was born and received his first training in Rhode Island. In 1774 he left for London, where he was a student and assistant to the American expatriate Benjamin West for five years. In 1782 his *Skater* was shown at the Royal Academy of Arts, and as Stuart later said, he was "suddenly lifted into fame by the exhibition of a single picture." By presenting the sitter, William Grant, in full length and in the act of skating, Stuart had created a totally new composition that was still within the grand manner tradition of British portraiture.

The inspiration for the image occurred when William Grant of Congalton, Scotland, arrived for his first sitting in West's studio and remarked that the cold weather was better suited to skating than to having one's portrait painted. Stuart, who was an excellent skater, suggested that they both take to the ice on the Serpentine, a popular spot in Hyde Park, and when a dangerous crack appeared in the ice, they departed, with Grant holding onto Stuart's coattails. Returning to the studio, Stuart was struck with the idea of depicting Grant skating.

Whatever deficiencies Grant may have had in reality have been banished from Stuart's portrait; he appears masterfully poised and in complete control as he executes a graceful curve. Dressed almost entirely in black, his skates are designed for making figures rather than for speed, and his folded arms correspond to the posture recommended in skating manuals of the period. The rest of his pose, however, is taken from the classical statue known as the Apollo Belvedere, a cast of which stood in West's studio. The setting is the Serpentine, and other skaters can be seen at the left, while farther back are the towers of Westminster Abbey. Attention is focused on the sitter's face, which is solidly modeled, while the rest of the picture is quite loosely painted, in keeping with contemporary practice.

As a result of the success of his *Skater*, Stuart was able to set up an independent practice, first in London and then in Dublin. In 1793 he returned to America, where he quickly became the portraitist of choice for the politically and socially prominent. His clientele included five presidents, and one of his several portraits of George Washington was reproduced on the dollar bill, thus becoming a national icon.

Gilbert Stuart
(American, 1755–1828)
The Skater (Portrait of William Grant)
1782, oil on canvas
245.5 × 147.4 (96 ¼ × 58)
Andrew W. Mellon Collection
1950.18.1

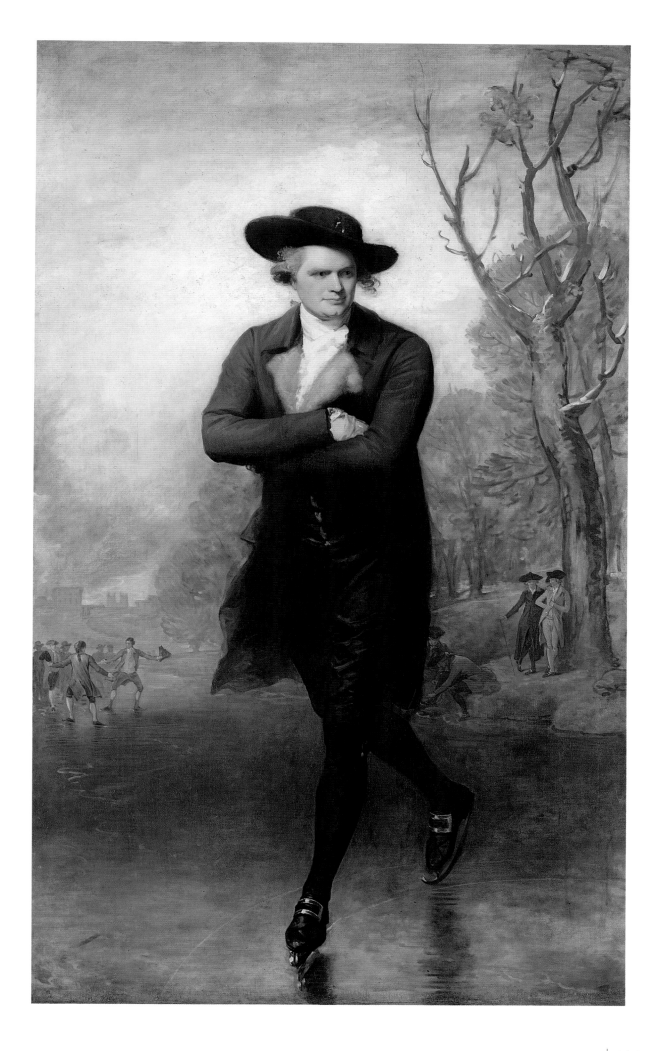

The Expulsion of Adam and Eve from Paradise

BENJAMIN WEST

• Born near Philadelphia, Benjamin West occupies a pivotal position in the history of painting in Britain and America. West's early portraits differed little from those of his American contemporaries. In 1760, however, he traveled to Italy, where he spent three years studying in Rome, Florence, and Venice before moving to London, where he would spend the rest of his life. In England West was primarily a painter of historical and religious subjects, which allowed him to call on his experience of Italian Renaissance and baroque art. His painting of 1770, the *Death of General Wolfe* (National Gallery of Canada, Ottawa), revolutionized history painting in Britain because it illustrated a contemporary event—the death of an English officer in Canada—with figures dressed in modern, not classical, garb, As an advisor and teacher to many American artists such as Gilbert Stuart and Thomas Sully, who came to England to study, West played a vital role in their development, sending them back to America with greater technical knowledge and a more cosmopolitan outlook.

In 1779 West was commissioned by King George III to paint an extensive cycle of more than thirty pictures for a royal chapel in Windsor Castle dealing with the subject of "revealed religion": that is, how God's intentions for mankind have been disclosed through biblical prophecies. The ambitious project dragged on for more than twenty years before being abandoned by the king. *The Expulsion of Adam and Eve from Paradise* is one of the surviving works. For the most part West followed the account in the book of Genesis, including details such as the garments of skins that God made for Adam and Eve to cover their nakedness, or the thistle that refers to Adam's future toil on the earth. Instead of a flaming sword, a shaft of light pierces the stormy sky.

It has also been noted that West included elements from John Milton's epic poem *Paradise Lost*, in particular the eagle attacking a heron in midair and a lion pursuing two horses below, indications of the troubling changes in paradise. In Milton's poem the archangel Michael predicts mankind's future redemption, and Anglican theologians also saw the expulsion from paradise as the first "revealed" prophecy of man's fate. Exhibited at the Royal Academy of Arts in 1791, the *Expulsion* was generally well received, and its theatrical emotionalism fit well with current notions of the "pathetic" and the "sublime." It is not recorded whether viewers noticed that Adam's gesture of covering his eyes was taken from Massaccio's fresco of 1425 in the Brancacci chapel in Florence, but they certainly would have responded to it as a powerful indicator of his shame and despair.

Benjamin West
(American, 1738–1820)
The Expulsion of Adam and Eve from Paradise
1791, oil on canvas
186.8 × 278.1 (73 ½ × 109 ½)
Avalon Fund and Patrons' Permanent Fund
1989.12.1

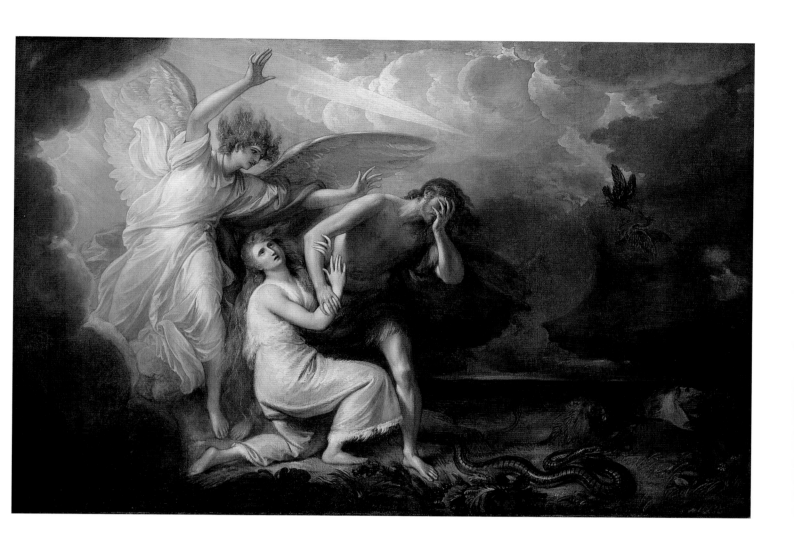

19th century

1200 1300 1400

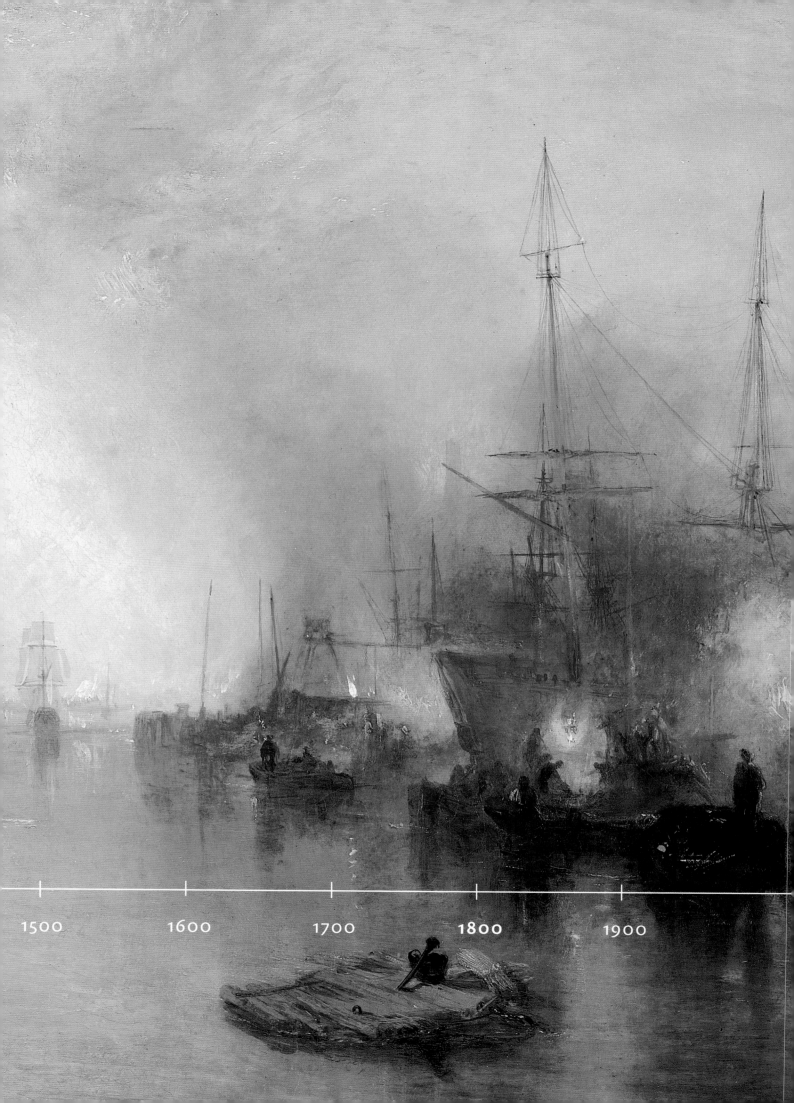

1500 1600 1700 1800 1900

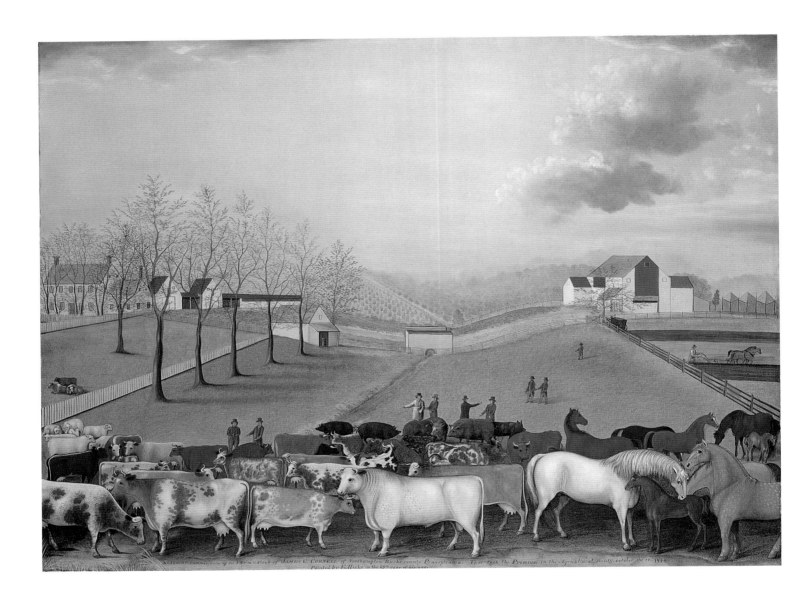

242

Edward Hicks
(American, 1780–1849)
The Cornell Farm
1848, oil on canvas
93.3 × 124.4 (36 ¾ × 49)
Gift of Edgar William and
Bernice Chrysler Garbisch
1964.23.4

243

Joshua Johnson
(American, born c. 1763,
active 1796/1824)
The Westwood Children
c. 1807, oil on canvas
104.5 × 117 (41 ⅛ × 46)
Gift of Edgar William and
Bernice Chrysler Garbisch
1959.11.1

Lake Lucerne

ALBERT BIERSTADT

• *Lake Lucerne* marks Bierstadt's coming of age as an artist; it is at once a summation and the foundation of his later success. His parents came to America from Prussia when he was two and settled in New Bedford, Massachusetts, where Bierstadt, receiving minimal instruction, largely taught himself to paint. In the mid-nineteenth century most American artists who wanted to further their education went abroad, either to London or to Düsseldorf. Bierstadt departed for Düsseldorf in 1853 and spent three years learning his craft. His teachers included two Americans: Emanuel Leutze, best known today for *Washington Crossing the Delaware*, and Worthington Wittredge.

In 1856 Bierstadt took a trip through Germany, Switzerland, and Italy in the company of Wittredge and other artists, and in July they spent several weeks in a picturesque region in the vicinity of Lake Lucerne. Adopting an approach that he would continue to use throughout his career, Bierstadt made many sketches on the spot, and these, rather than a single preparatory drawing, served as the basis for the finished painting, which was composed in the studio. Following his return to New Bedford in 1857, Bierstadt began to work on *Lake Lucerne*, completing and exhibiting it to thunderous acclaim in New Bedford and Boston the following year.

Measuring six by ten feet, this panoramic landscape depicts the village of Brunnen at the left and the glacial blue green lake beyond that is bordered by the towering peaks of Ematten, Oberbauren, Uri-Rotstock, and, at the distant left, St. Gotthard. Although comparison with photographs of the site indicates that Bierstadt's rendering was topographically accurate for the most part, it is also clear that the artist was not above altering reality if it would enhance the drama and grandeur of the scene. He regulated progress through the pictorial space by alternating a light foreground with a dark line of trees and shadows before offering a sunlit middle distance. Notes of human activity are supplied by the gypsy encampment in the shadows at the left and the religious procession heading toward the church at the right.

Bierstadt returned from Europe equipped with both the technical prowess and the breadth of vision needed to imbue *Lake Lucerne* with epic majesty. In the spring of 1858 he traveled for the first time to the Rocky Mountains to experience the "American Alps." The great Western landscapes that he painted in ensuing years ensured his fame, but many are based on the compositional model that he first created in *Lake Lucerne*.

Albert Bierstadt
(American, 1830–1902)
Lake Lucerne
1858, oil on canvas
182.9 × 304.8 (72 × 120)
Gift of Richard M. Scaife and
Margaret R. Battle, in Honor
of the 50th Anniversary of
the National Gallery of Art
1990.50.1

A Friendly Call

WILLIAM MERRITT CHASE

· Filled with sunlight, this picture presents the studio that was part of Chase's house at Shinnecock, near Southampton, on eastern Long Island. Chase and his family spent their summers here, and he taught at the local art school from 1891 until 1902. His wife, Alise Gerson Chase, is shown at the right wearing a yellow and white dress. The anonymous visitor is clad in white, her face obscured by a veil, and she carries a parasol as further protection against the sun. It is possible that the caller has just arrived and, following the dictates of Victorian etiquette, is waiting for an invitation before removing her bonnet. For a successful artist in the late nineteenth century, the studio was more than just a place to work. As seen here, the displays of prints, watercolors, and paintings, the rich fabrics, and large ornately framed mirror all speak to Chase's elegant tastes as well as his prosperity.

In 1872, following his initial training in Indianapolis and New York, Chase was offered a chance to study abroad. His reply, "My God, I'd rather go to Europe than to heaven," nicely expresses the allure of the Continent for many Americans. In Munich he acquired technical skills, while travel through Europe brought him into contact with the impressionists and with the idea that the role of the modern artist was to portray modern life. The contemporary domestic scene of *A Friendly Call* accords with this notion.

The picture is an outstanding example of Chase's facility with a brush, his delight in the physical manipulation of paint to capture the play of light and color. The composition is carefully constructed, with the rigorous but essentially flat arrangement of horizontals and verticals created by the furniture and works of art owing much to his study of Japanese art. Note also how color is used to move one's gaze through the picture, as, for example, the pink in the parasol, the large cushion, and the cushion in the cane chair at the right, or the touches of scarlet on the tassels of the green cushion in the foreground that are repeated elsewhere.

One of the old masters that Chase most admired was Diego Velázquez, for both his technique and his modernity. As Chase put it, "A yellow dog with a tin can tied to his tail would have been enough inspiration for a masterpiece by a consummate genius like Velázquez." It has been suggested that the use of a mirror to show the door and a flight of stairs that led into the studio and to create a second profile of his wife is a device taken from Velázquez' famous painting *Las Meninas* (Museo del Prado, Madrid).

William Merritt Chase
(American, 1849–1916)
A Friendly Call
1895, oil on canvas
76.5 × 122.5 (30 ⅛ × 48 ¼)
Chester Dale Collection
1943.1.2

El Rio de Luz (The River of Light)

FREDERIC EDWIN CHURCH

• Landscape painting was a favored genre in America throughout the nineteenth century, and Church was among its premier practitioners. He had studied with Thomas Cole, the leading landscape artist of the first half of the century, and in 1849 Church became the youngest member elected to the National Academy of Design in New York. He was equally adept at creating imaginary scenes or recording actual sites that reflected his extensive travels throughout the United States.

The writings of the German naturalist Alexander von Humboldt had a decisive impact on Church. Humboldt encouraged artists to make detailed color sketches of flowers, trees, and plants directly from nature and urged them to visit the jungles of South America to find inspiration in the tremendous diversity of plant and animal life. In 1853 Church journeyed to Colombia and Ecuador for several months, and this was followed by a second trip to South America in 1857. During the 1860s Church established his reputation with large panoramic pictures that either depicted exotic locales, such as the *Heart of the Andes* (The Metropolitan Museum of Art, New York), or recorded unusual meteorological effects, such as the *Aurora Borealis* (Smithsonian American Art Museum, Washington). By the late 1870s, however, tastes had changed, and there was no longer the same demand for his paintings.

Morning in the Tropics, painted in 1877, does not depict an actual place; rather, it is based on Church's recollections of South America and the sketches he had made on his journeys. The composition is typical of the artist in certain respects. In the foreground the plants and birds are rendered with minute attention to detail, while the more generalized forms in the background are shrouded in a morning haze. Much less theatrical and dramatic than Church's earlier works, this painting is at once intimate and mysterious. There is something primordial about the lush vegetation, and the air is heavy with moisture; the solitude is underscored by the lone canoeist, who can barely be seen in the distance.

When the painting was exhibited in New York in 1877 and 1880, it was entitled "The River of Light," and it has been suggested that the painting may be interpreted in an allegorical, quasi-religious manner and that the unifying forces of the river and the light bring together foreground and background. Water and solid ground also join present to future or earth to heaven. In the silence of this primeval, tropical Eden one is encouraged to ponder the mysteries of creation and salvation.

Frederic Edwin Church
(American, 1826–1900)
El Rio de Luz (The River of Light)
1877, oil on canvas
138.1 × 213.7 (54 3/8 × 84 1/8)
Gift of the Avalon Foundation
1965.14.1

• Thomas Cole, the most important and influential American landscape painter in the first half of the nineteenth century, was born in England and received some training as an engraver before he and his family immigrated to the United States in 1818. Although he studied at the Pennsylvania Academy of the Fine Arts in Philadelphia, he was self-taught to a remarkable degree. In 1829, however, he went to England, where he became acquainted with Joseph Mallord William Turner and John Constable; he then continued on to France and Italy to study the old masters.

Although much of his success came from straightforward depictions of the American scene, Cole aspired to produce works, such as the *Voyage of Life*, that contained deeper religious or moral meaning. Cole was well read and could have drawn on an abundance of philosophical or religious sources for the central notion that time is a river which carries man through the course of his existence. But the challenge, which he met brilliantly, lay in visually expressing this idea in four large paintings. In "Childhood" a golden boat bearing an infant accompanied by a guardian angel emerges from a dark cave in the side of a mountain. As Cole himself wrote of the painting, "the rosy light of morning, the luxuriant flowers and plants, are emblems of the joyousness of life. The close

banks and the limited scope of the scene, indicate the narrow experience of Childhood." In "Youth" the landscape is more spacious, and the guardian spirit stands on the bank of the river as the young man glides past. A palace of clouds suggests the dreams and aspirations of youth. "Manhood" is a time of turbulence and danger, as the stream rushes toward the Ocean of Eternity, seen in the distance. Both the guardian angel and demons hover in the clouds above. In "Old Age" the voyage through this world has almost ended, and shafts of celestial light and an angel at the upper left welcome the old man, his hands clasped in prayer, into the next world.

Painted in Rome, this is the second version of the *Voyage of Life*. Following a dispute with the owners of the first set (now in the Munson-Williams-Procter Institute, Utica), Cole embarked on a second series. The National Gallery of Art's pictures were exhibited in Rome in 1842 and in the United States in 1843, 1848, and 1854, to increasing fame, particularly following the artist's much lamented death in 1848.

detail, *The Voyage of Life: Childhood*
(see pages 310–311)

247 248

Thomas Cole Thomas Cole
(American, 1801–1848) (American, 1801–1848)
The Voyage of Life: Childhood *The Voyage of Life: Youth*
1842, oil on canvas 1842, oil on canvas
134.3 × 195.3 (52 ⅞ × 76 ⅞) 134.3 × 194.9 (52 ⅞ × 76 ¾)
Ailsa Mellon Bruce Fund Ailsa Mellon Bruce Fund
1971.16.1 1971.16.2

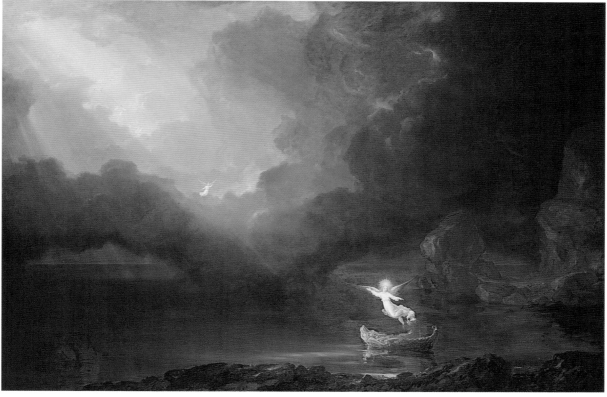

249

Thomas Cole
(American, 1801–1848)
The Voyage of Life: Manhood
1842, oil on canvas
134.3 × 202.6 (52 7/8 × 79 3/4)
Ailsa Mellon Bruce Fund
1971.16.3

250

Thomas Cole
(American, 1801–1848)
The Voyage of Life: Old Age
1842, oil on canvas
133.4 × 196.2 (52 1/2 × 77 1/4)
Ailsa Mellon Bruce Fund
1971.16.4

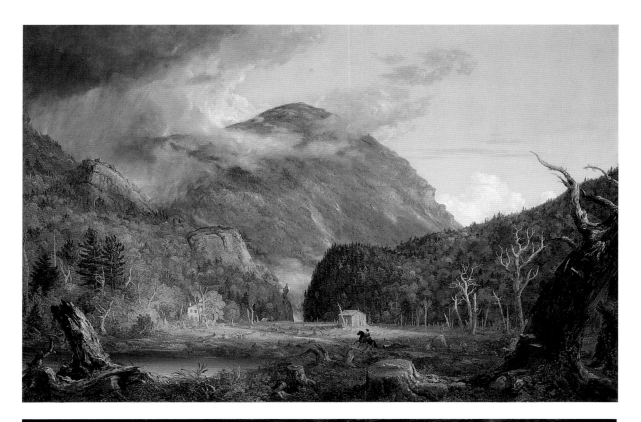

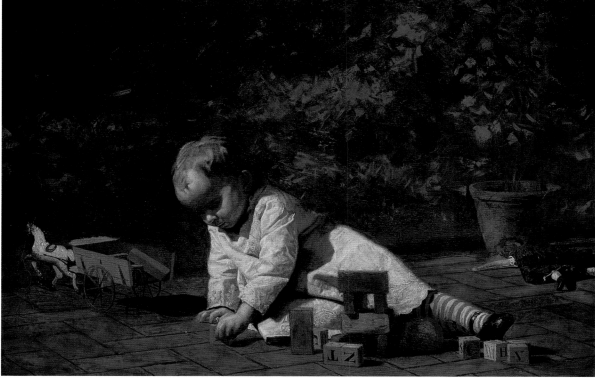

251

252

Thomas Cole
(American, 1801–1848)
A View of the Mountain Pass
Called the Notch of the
White Mountains (Crawford Notch)
1839, oil on canvas
102 × 155.8 (40 ⅛ × 61 ⅜)
Andrew W. Mellon Fund
1967.8.1

Thomas Eakins
(American, 1844–1916)
Baby at Play
1876, oil on canvas
81.9 × 122.8 (32 ¼ × 48 ⅜)
John Hay Whitney Collection
1982.76.5

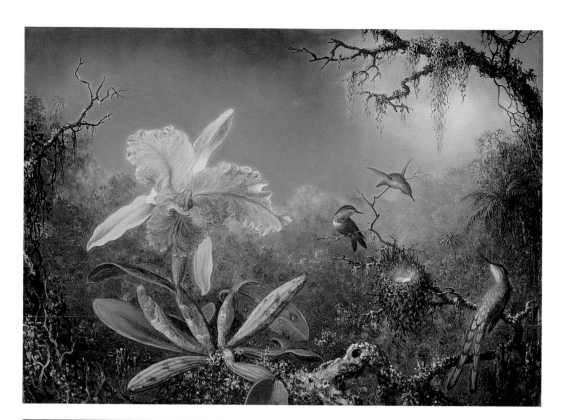

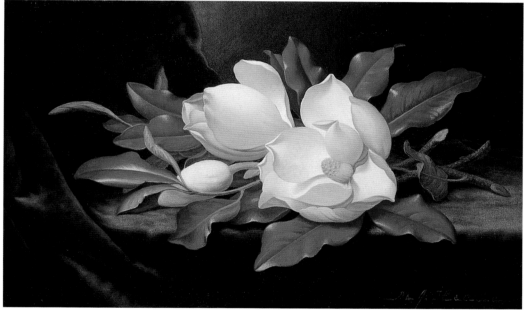

253

254

Martin Johnson Heade
(American, 1819–1904)
Cattleya Orchid and Three
Brazilian Hummingbirds
1871, oil on wood
34.8 × 45.6 (13 ¾ × 18)
Gift of The Morris and
Gwendolyn Cafritz Foundation
1982.73.1

Martin Johnson Heade
(American, 1819–1904)
Giant Magnolias on a Blue Velvet Cloth
c. 1890, oil on canvas
38.4 × 61.5 (15 ⅛ × 24 ¼)
Gift of The Circle of the National
Gallery of Art in Commemoration
of Its 10th Anniversary
1996.14.1

Autumn — On the Hudson River

JASPER FRANCIS CROPSEY

• Born on Staten Island, Cropsey began an apprenticeship in 1823 with an architect in New York City, but his real love was painting, especially landscapes, though his draftsmanship won praise and he occasionally turned to architectural design in later years. In the 1840s he made summer trips to New Jersey, Upstate New York, Vermont, and New Hampshire to sketch the scenery. In 1856 Cropsey and his wife moved to London, where they lived for seven years before returning to America.

Autumn — On the Hudson River was painted in London and took more than a year to complete. The scene is set about sixty miles north of New York City, between the towns of Newburgh and West Point. From a high vantage point on the west side of the Hudson River one looks across a wide expanse to the river itself and, at the right, to Storm King mountain, a distinctive landmark. A contemporary pamphlet, probably written by Cropsey himself, indicates that the month is October and the time of day is "about 3 o'clock of a dreamy, warm day."

Painted from memory and from sketches made earlier on the spot, this large painting was exhibited in London in 1860 to critical acclaim. Cropsey's intent, in part, was to impress the English with the vastness and splendor of the Hudson River valley in the autumn, a region they would have known about from the revolutionary war and from the writings of Washington Irving and others. Cropsey succeeded in creating a magnificent panorama, filled with limpid atmosphere and foliage of intense scarlet and smoldering reds and yellows. To silence complaints that these colors were artificially brilliant Cropsey displayed in proximity to the picture actual leaves in autumnal colors from North America. Part of the allure of *Autumn — On the Hudson River* is that it combines a breadth of vision with a careful attention to detail; for example, many of the trees, such as the birches in the foreground, are identifiable.

The painting is more than just a description of the beauties of nature. It is a landscape that may overwhelm but is hospitable and nurturing to man. At the left a group of hunters eats and drinks while enjoying the view. In the middle ground sheep and cattle graze peacefully, and in the distance one can make out a small town. The river is busy with boats traversing the water for pleasure or commerce. For Cropsey, the Hudson River valley — and by implication America — was a manifestation of God's abundance, which existed as a place for man to develop and make prosperous.

Jasper Francis Cropsey
(American, 1823–1900)
Autumn—On the Hudson River
1860, oil on canvas
151.8 × 274.9 (59 ¾ × 108 ¼)
Gift of the Avalon Foundation
1963.9.1

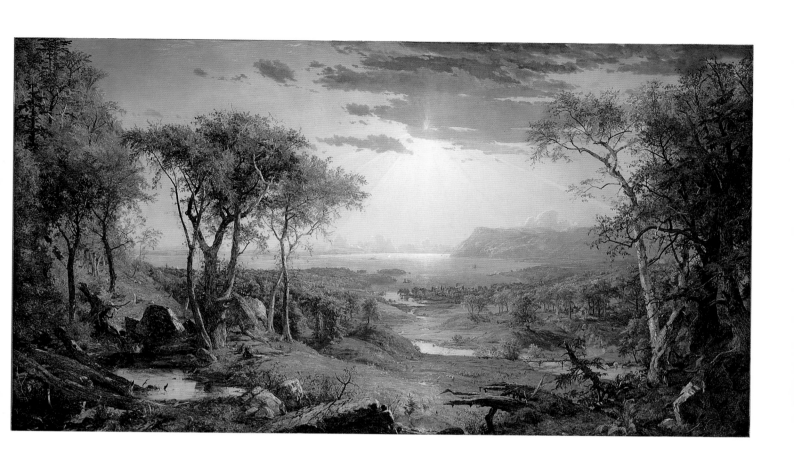

The Biglin Brothers Racing

THOMAS EAKINS

• The son of a Philadelphia calligrapher and writing master, Eakins studied at the Pennsylvania Academy of the Fine Arts and also attended lectures on anatomy at a medical college in Philadelphia. In 1866 he traveled to Paris, where he studied with Jean-Léon Gérôme and Léon Bonnat at the École des Beaux-Arts. Gérôme, as what might be called an academic realist, emphasized rigorously correct drawing and had his students work directly from the nude model. Eakins differed from Gérôme and Bonnat in that he had no desire to paint historical or biblical subjects but chose instead to depict the world around him. After six months in Spain, where he was especially taken with Diego Velázquez, Eakins returned to Philadelphia in 1869.

In the late 1860s and 1870s rowing was a popular sport in America, practiced by both men and women. Eakins himself was an avid rower, and he painted the subject several times. This particular version most likely had its origins in a race held on the Schuylkill River in Philadelphia on 20 May 1872 between professional oarsmen John and Bernard (Barney) Biglin in one scull and Harry Coulter and Lewis Cavitt (not shown) in the other boat. Attended by thousands of spectators, the five-mile race began with Coulter and Cavitt taking the lead, but the Biglin brothers pulled ahead and won handily, thanks to their steady stroke. The white sleeveless shirts and blue silk head kerchiefs worn by John and Barney Biglin are factually correct, but the race is shown in afternoon light whereas the start was delayed by rain until about 6:30.

Composed in the studio, the painting would have been preceded by a number of preparatory drawings as well as a precise perspective rendering. Striving for accuracy, Eakins went to great lengths to capture the reflections of light off the water. The same care was applied to the representation of the muscular bodies of the Biglin brothers. Athletic events such as rowing or boxing provided Eakins with the opportunity to observe nearly nude models. It was, in fact, his insistence on using nude models in the classroom that years later got him fired from a teaching position at the Pennsylvania Academy of the Fine Arts.

Although perhaps not at first apparent, the finely calibrated composition and certain telling details enhance the narrative impact of a moment frozen in time. In the immediate foreground is a sliver of the competitors' racing shell, and Barney Biglin, in the bow seat, glances over his shoulder at it, gauging his position. His brother John is completely focused and poised to begin his next stroke. Perfectly attuned to one another, the brothers' bodies are identical in posture. The angles of their torsos are repeated in the diagonal clouds and tops of the trees, while the shells and shoreline divide the space into stable horizontal bands.

Thomas Eakins
(American, 1844–1916)
The Biglin Brothers Racing
1872, oil on canvas
61.2 × 91.6 (24 1/8 × 36)
Gift of Mr. and Mrs. Cornelius
Vanderbilt Whitney
1953.7.1

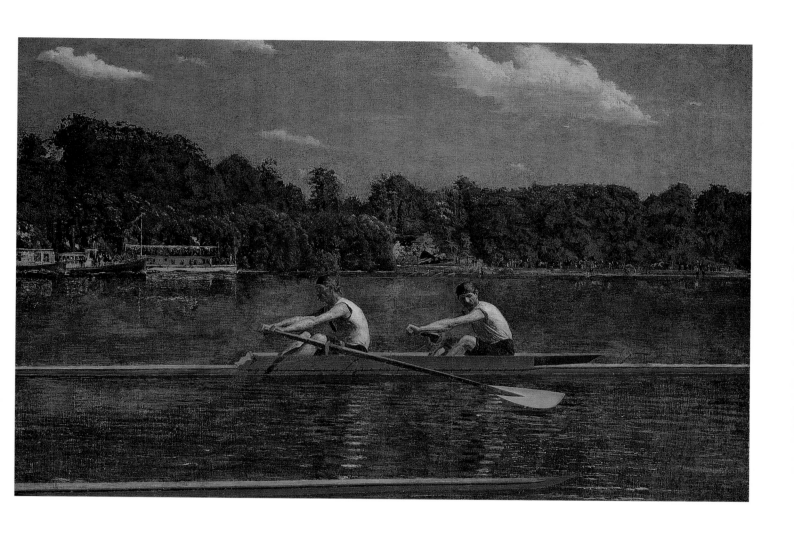

The Old Violin

WILLIAM MICHAEL HARNETT

• A splendid example of trompe l'oeil (literally "fool the eye"), this picture occupies a singular place in the history of American still-life painting. When first exhibited in Cincinnati, the work had to have a guard posted next to it to keep visitors from touching it. Harnett's most famous painting is easily his *Old Violin*; its first owner, Frank Tuchfaber, printed chromolithographic reproductions, and both these and the painting itself were copied by scores of artists.

The painting can be explored on several levels. At first glance it is a triumph of illusionism. A violin and bow are hung on the front of a weathered door, with two pages of sheet music behind them. Harnett replicated the exact tone, color, and texture of each object in an uncannily convincing manner. The violin was probably the Guarneri del Gesù from 1724 that Harnett had purchased in Paris, and the powdered rosin underneath the strings indicates that it had been played recently. As a backdrop, the door is old and worn, its wood cracked and pitted with nail holes, its hinges rusted and the bottom one broken.

Having persuaded the viewer of the reality of these objects, Harnett then proceeds to undermine the illusion. Despite the best efforts of many to read it, the newspaper clipping at the lower left of the violin is illegible. Further disruption of the painting's internal consistency occurs with the realization that the blue envelope is an actual envelope addressed to Harnett at his New York studio. Tucked under the edge of the frame, the envelope contradicts the painted illusion and calls into question its reality.

On another level the *Old Violin* alludes to the melancholy that accompanies the passage of time. One clue is the sheet music, which contains an aria from Bellini's opera *La Sonnabula*, "Vi ravviso a luoghi ameni" (O remembrance of scenes long vanished), and a popular song, "Hélas Quelle Douleur" (Alas, what sorrow), by Edmond Servel. Harnett painted this picture just after his return from six years of living in Europe, which included several months in Paris. The postmark on the blue envelope indicates that it was sent from Paris, the city where Harnett purchased the violin. One can imagine a certain nostalgia for that time in his life. Harnett's reputation continued to grow in the years following the completion of this painting, but his health soon declined, and he died in New York at the age of forty-four.

257

William Michael Harnett
(American, 1848–1892)
The Old Violin
1886, oil on canvas
96.5 × 60 (38 × 23 ⅝)
Gift of Mr. and Mrs. Richard Mellon
Scaife in honor of Paul Mellon
1993.15.1

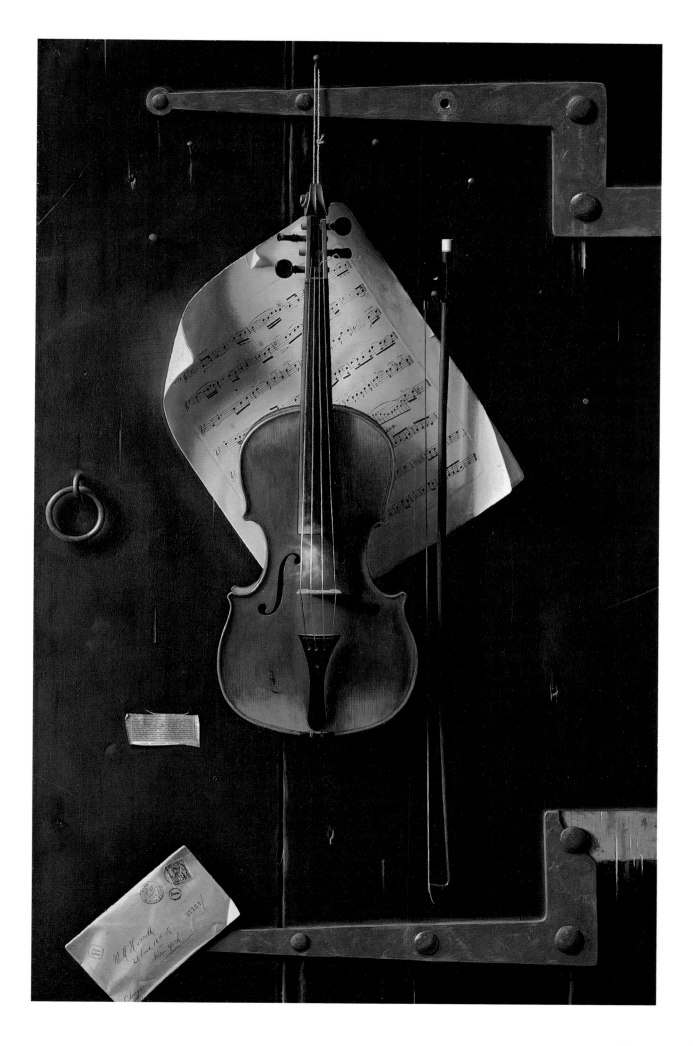

Home, Sweet Home

WINSLOW HOMER

• In the eyes of many, Homer was the foremost American artist of the nineteenth century. Born in Boston, he was first apprenticed to a lithographer. In 1859, as part of his decision to become a painter, he moved to New York City, where he received basic instruction in painting from Frédéric Rondel and attended a class at the National Academy of Design. To a large extent, however, Homer was self-taught. He had been working as a freelance illustrator for *Harper's Weekly*, and with the outbreak of the Civil War, he made two trips to the front; his sketches were translated into wood engravings and published in the magazine.

One of two pictures exhibited at the National Academy of Design in 1863, *Home, Sweet Home* marks Homer's professional debut as a painter. Two Union soldiers are listening to the regimental band shown in the distance. The insignia and the letter G on their kepis (caps) indicate that they are infantrymen. The papers with the soldier at the right suggest that the music has prompted him to pause in the midst of writing a letter home. Although recording a different event, a letter from Nelson A. Miles, a Union general, provides insight into the scene depicted in this painting. Describing how Union and Confederate bands would play tunes in the later afternoon appropriate to each side, such as "America" or "Dixie," Miles continued, "These demonstrations frequently aroused the hostile sentiments of the two armies, yet the animosity disappeared when at the close some band would strike up the melody which comes nearest the hearts of all true men, 'Home, Sweet Home,' and every band within hearing would join that sacred anthem with unbroken accord and enthusiasm." Homer's objectivity and emotional restraint were praised by the critics who saw the 1863 exhibition in New York. As one wrote, "there is no strained effect in it, no sentimentality, but a hearty, homely actuality, broadly, freely, and simply worked out."

If applied to the living conditions of the infantrymen, the painting's title takes on an ironic twist. Thanks to Homer's mastery of the telling detail, their home may be "ever so humble," but it is hardly "sweet." The soldiers wear soiled shoes and pants, and their rations consist of hardtack on a tin plate and whatever is in the small pot cooking over the fire. Even the tan blankets that are drying on top of the tent and in a makeshift support are tattered. With a clear eye based on first-hand experience, Homer represents not only the homesickness and loneliness but the facts of a difficult existence in the field.

Winslow Homer
(American, 1836–1910)
Home, Sweet Home
c. 1863, oil on canvas
54.6 × 41.9 (21 ½ × 16 ½)
Patrons' Permanent Fund
1997.72.1

Breezing Up (A Fair Wind)

WINSLOW HOMER

• Following his experiences in the American Civil War, Homer visited France in 1866–1867 and returned to New York City, but he then traveled regularly to Upstate New York, Massachusetts, and Maine. From late June to August 1873 he was in Gloucester, Massachusetts, where for the first time he began working in watercolor, a medium in which he achieved complete mastery. Although watercolor paintings could be made rapidly, often on the spot, Homer's oils, done in the studio, evolved more slowly. This was certainly the case with *Breezing Up (A Fair Wind)*, which depicts an adult and three boys and their catch of fish in a catboat. The locale can be determined by the word "Gloucester" on the stern of the boat. The painting is similar to a watercolor of a catboat done in Gloucester in 1873 and an oil sketch made the following year.

First exhibited in 1876 at the National Academy of Design in New York under the title *A Fair Wind*, the picture was hailed as among Homer's finest and most appealing, an appreciation that has justly continued to present day. (By 1879 *Breezing Up* was used as a title, apparently without objection from Homer.) As one critic wrote, "It is painted in his customary coarse and negligé style, but suggests with unmistakable force the life and motion of a breezy summer day off the coast. The fishing boat, bending to the wind, seems actually to cleave the waves. There is no truer or heartier work in the exhibition."

What appears fresh and spontaneous was in fact the result of almost three years' labor. An examination using infrared reflectography, which can visually penetrate paint layers, discloses several changes: at one point there were four boys in the boat; the man, not the boy, held the tiller; and there were more ships in the harbor. The final composition shows the influence of Japanese art on Homer's work, particularly in the way the catboat at the left is balanced against empty space and the silhouette of the schooner at the distant right as well as the flattened shape of the sails and mast, which are cropped by the left edge of the picture.

The painting's original title, *A Fair Wind*, refers to favorable weather conditions—no rain and a wind that sends the boat in the desired direction. It is also possible that Homer intended a sly reference to the fair that was the focal point of the American centennial celebration in Philadelphia in 1876. That Homer's painting might symbolize the optimistic hopes for the future of a young America was not overlooked by a contemporary critic who wrote about the boy holding the tiller, "whose bright eye evidently sees such enormous horizons."

Winslow Homer
(American, 1836–1910)
Breezing Up (A Fair Wind)
1873–1876, oil on canvas
61.5 × 97 (24 ¼ × 38 ⅛)
Gift of the W. L. and May T.
Mellon Foundation
1943.13.1

George Inness
(American, 1825–1894)
The Lackawanna Valley
c. 1856, oil on canvas
86 × 127.5 (33 ⅞ × 50 ¼)
Gift of Mrs. Huttleston Rogers
1945.4.1

Fitz Hugh Lane
(American, 1804–1865)
Lumber Schooners at Evening on Penobscot Bay
1863, oil on canvas
62.5 × 96.8 (24 ⅝ × 38 ⅛)
Gift of Mr. and Mrs. Francis W. Hatch Sr.
1980.29.1

262

Sanford Robinson Gifford
(American, 1823–1880)
Siout, Egypt
1874, oil on canvas
53.3 × 101.6 (21 × 40)
New Century Fund, Gift of
Joan and David Maxwell
1999.7.1

263

Winslow Homer
(American, 1836–1910)
Right and Left
1909, oil on canvas
71.8 × 122.9 (28 ¼ × 48 ⅜)
Gift of the Avalon Foundation
1951.8.1

Beach at Beverly

JOHN FREDERICK KENSETT

• Born in Connecticut, Kensett was first trained by his father as a draftsman and engraver and for a short time worked for an engraver in New York. He soon realized, however, that painting was his true vocation. In 1840 Kensett left the United States for Europe, and for the next seven years he studied, painted, and traveled on the Continent and in England. Returning to New York, he quickly built a successful career as a landscape painter; he became a full member of the National Academy of Design in 1849 and in the same year was elected into the prestigious Century Association. Endowed with a congenial temperament, Kensett was liked and admired by patrons and colleagues. In 1859 he became a member of the United States Capitol Art Commission, which supervised the decoration of the Capitol in Washington, and in 1870 he was a founding trustee of the Metropolitan Museum of Art in New York. His death from heart failure following pneumonia at the age of fifty-six was a shock to all, and Kensett was eulogized as "a man of great gifts and of the sweetest nature."

Unlike such contemporaries as Frederic Church or Albert Bierstadt, Kensett felt no need to travel to the tropics or the Far West to find interesting subjects. Instead he returned to a number of familiar locales in New York and New England where he explored the ways in which the same motif was altered by subtle differences in light and atmosphere. One of the places he visited on a regular basis was Beverly, Massachusetts. Situated on the North Shore

and accessible by train beginning in 1839, Beverly had become a popular vacation spot for prosperous families from Boston. This painting, done late in Kensett's career, depicts a stretch of shore between Curtis Point and Mingo Beach. In the foreground a man carrying a basket walks along the beach, and another person can be seen in the rowboat that has been pushed out of the water. At the upper left two figures, perhaps children, peer over a wall.

Despite this human activity, the scene is strangely still, as if subdued by the summer heat. The curve of the inlet leads to a large rock formation, surmounted by trees, that extends into the ocean. Juxtaposed with this solid mass is an expanse of water and sky. Painted thinly, in subtle gradations of blue and gray, the air and the ocean are nearly indistinguishable from one another, and it is only by searching for small distant sailboats that one can discern the horizon. The crystalline solidity of the rocks enhances the sense of limitless space, and conversely, the nearly monochrome atmosphere underscores the insistent reality of the rocks. In a kind of alchemy obtained through a precise calibration of tone, color, and composition, Kensett produced a painting that captures a sense of place and also creates a palpable, if indefinable mood.

John Frederick Kensett
(American, 1816–1872)
Beach at Beverly
c. 1869/1872, oil on canvas
55.8 × 86.4 (22 × 34)
Gift of Frederick Sturges Jr.
1978.6.5

The Last Valley — Paradise Rocks

JOHN LA FARGE

• La Farge was born in New York City to cultured, well-to-do parents who had emigrated from France; he received an excellent education in religion, literature, and the French language as well as lessons in drawing and watercolor. As a young man he studied law, but he continued to paint. In 1856 La Farge was in Paris, where he worked in the studio of Thomas Couture and traveled in Europe before returning to New York in 1857. In 1859 he was in Newport, Rhode Island, studying painting with William Morris Hunt. In 1861, a year after his marriage, La Farge made the region his home for a good part of his career, but especially during and just after the Civil War. During this period La Farge visited and lived in Paradise, on the southeastern tip of Aquidneck Island, a few miles from Newport.

La Farge's *Last Valley — Paradise Rocks* is a view from a rocky ledge into a deep valley, on either side of which we see steep ridges of a type of conglomerated rock specific to the region known as "puddingstone." The puddingstone formations, composed of quartz, slate, and other material, were of keen interest to geologists, who saw in their fissures evidence of glacial erosion and the shaping effects of the ocean over eons. In this painting the setting sun throws most of the valley into deep shadow and casts a reddish glow on the rocks at the left. In the distance is the Atlantic Ocean. In La Farge's own words, the picture was "painted from nature…and took a very long time to paint, so as to get the same light as possible.

By going very frequently, if necessary, everyday, and watching for a few minutes, I could occasionally get what I wanted."

Earlier, La Farge painted *Paradise Valley* (Terra Foundation for the Arts, Chicago), a view of an adjacent pasture that was much less dramatic. In both pictures the artist wished to observe and depict nature directly without recourse to the kinds of artistic conventions found in paintings of the Hudson River School. Instead, he seems closer to contemporary European trends, such as the Barbizon School or the realism of Gustave Courbet. In the National Gallery of Art's painting the rough, scumbled surfaces and thick layers of paint in several areas are evidence that the picture was built up over time; they are also manifestations of La Farge's idiosyncratic technique.

Painting was only one of La Farge's interests; he was also a talented designer of stained glass and an accomplished muralist, with works in these media installed in New York and Boston. He was influenced at a rather early date by Japanese art and made a trip to Japan in 1886. In 1890–1891 he and Henry Adams journeyed to Hawaii, Samoa, Tahiti, and Fiji, and La Farge recorded the experience in a series of watercolors. As a means of earning money for various projects he wrote and lectured extensively on art. John La Farge was one of the most complex, intelligent, and multifaceted artists of his day.

John La Farge
(American, 1835–1910)
The Last Valley—Paradise Rocks
1867–1868, oil on canvas
83.2 × 107.4 (32 ¾ × 42 ¼)
Gaillard F. Ravenel and Frances P.
Smyth-Ravenel Fund
2000.144.1

A Dessert

RAPHAELLE PEALE

· At a time when still life was considered among the lowest in the hierarchy of subjects, Raphaelle Peale was the first professional American artist to specialize in the genre, and as this panel amply demonstrates, he was a masterful practitioner. The pictorial components are quite ordinary: a lemon, a glass decanter, three perfectly round oranges placed in a porcelain bowl with nuts and raisins, and a few walnuts at the right next to a glass containing sweet wine or sherry. What makes the painting so alluring is Peale's uncanny ability to reproduce textures—such as the dimpled, pitted skin of the oranges or the hard, lustrous, nearly translucent surface of the bowl—as well as his creation of a composition that appears informal but is in fact carefully thought out. All of the fruits and nuts are either spherical or oval in shape, as is the bowl, and the stems of the oranges and raisins form a kind of linear arabesque that links one object to the next. The inscription at the lower right is as precise as Peale's technique: it includes the artist's signature, the date 5 August 1814, and the location, Philadelphia.

Raphaelle was the eldest son and pupil of Charles Willson Peale (1741–1827), a remarkable figure in early American art who was not only an artist but an inventor, founder of a natural history museum, and head of a large family that included several artists. The children of his first marriage, like Raphaelle, were named after famous painters, while those from his second marriage were given the names of well-known scientists.

Raphaelle's life was neither happy nor long. For most of his life he suffered from gout in his hands and feet. Working as a taxidermist in his father's museum had exposed him to both mercury and arsenic. In addition, he and his father disagreed on many issues; the elder Peale disapproved of his son's specialization in still life—the paintings sold for very little—and his choice of a wife. Ultimately, however, it was alcoholism that destroyed Raphaelle's life and marriage, causing his death at age fifty-one, two years before his father's. None of this is apparent in his paintings, which are marvels of technique and observation.

Raphaelle Peale
(American, 1774–1825)
A Dessert
1814, oil on wood
33.97 × 48.26 (13 3/8 × 19)
Gift (Partial and Promised) of
Jo Ann and Julian Ganz Jr.
in memory of Franklin D. Murphy
1999.44.1

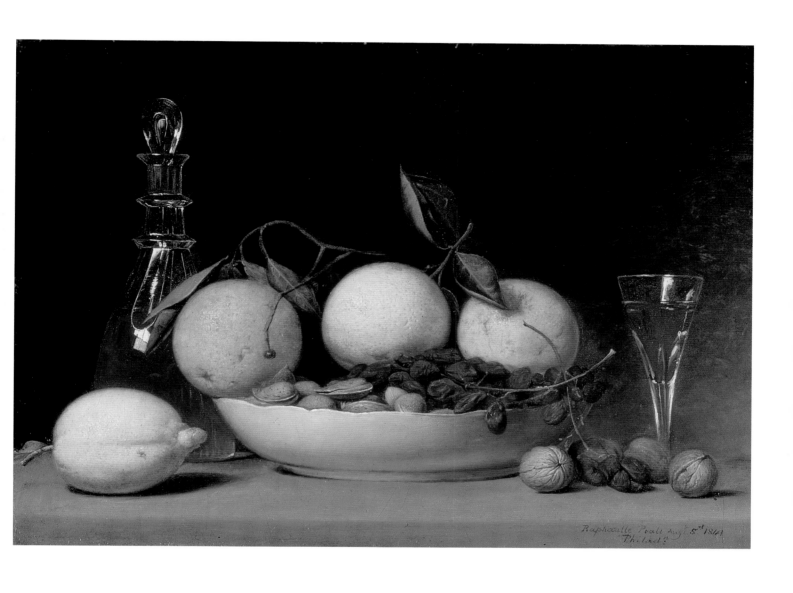

Rubens Peale with a Geranium

REMBRANDT PEALE

· In 1801 when he was twenty-three, Rembrandt Peale painted this striking portrait of his seventeen-year-old brother, Rubens. Rembrandt was the second son of Charles Willson Peale, and Rubens was the ninth of eleven children. While Rembrandt followed his father in pursuing a long and successful career as an artist, Rubens' talents lay elsewhere. As a child, he was able to tame birds and animals and had an equally strong interest in caring for plants. He grew up to become a botanist and naturalist, managing his father's natural history museums in Baltimore and New York as well as in his hometown of Philadelphia.

Shown alongside the sitter in this portrait, and given equal status, is a rare species of geranium, *Pelargonium inquinans*, that may have been one of the earliest of its type to arrive in America. Native to South Africa, geraniums were first imported to Europe, then to the United States around the middle of the eighteenth century. This painting depicts an exceptional, almost symbiotic, relationship between Rubens Peale and the geranium. He holds the terra cotta flowerpot with two fingers inside the vessel, as if he were testing the soil to make sure the plant had enough moisture. In return the upper leaves and tendrils appear to reach out and touch the young man's head.

Rubens Peale had extremely poor eyesight and wore glasses throughout his life; he is shown here with two pair, wearing one and holding another in his left hand. This duplication is something of a mystery, but the sitter's daughter Mary Jane later explained that Rembrandt originally depicted Rubens only holding the spectacles in his hand but perhaps realized that his face looked incomplete without the glasses and later added the second pair, along with the brilliantly observed pool of light reflected by the lenses onto his cheeks. Achieving the status of an icon of American art, this highly original, warmly sympathetic and affectionate portrait is immediate and universal in its appeal.

Rembrandt Peale
(American, 1778–1860)
Rubens Peale with a Geranium
1801, oil on canvas
71.4 × 61 (28 1/8 × 24)
Patrons' Permanent Fund
1985.59.1

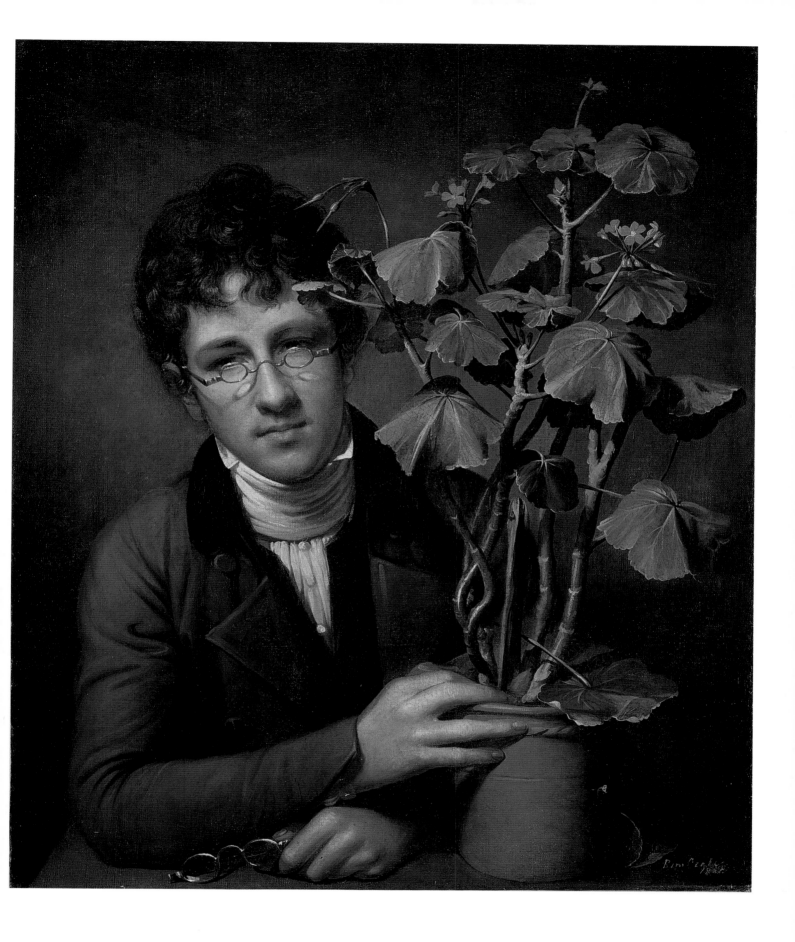

Thomas Sully
(American, 1783–1872)
Lady with a Harp: Eliza Ridgely
1818, oil on canvas
214.5 × 142.5 (84 ½ × 56 ⅛)
Gift of Maude Monell Vetlesen
1945.9.1

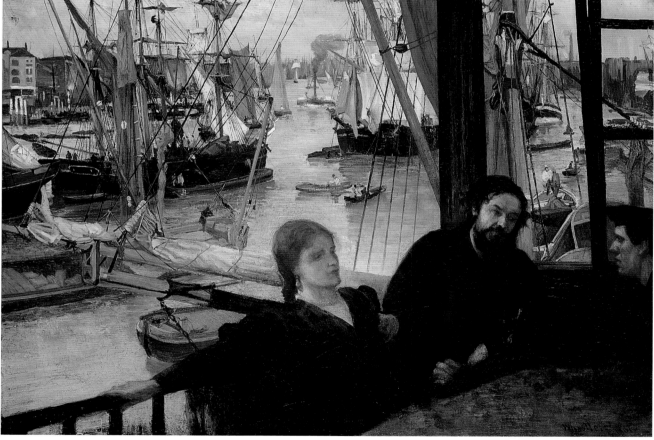

269

270

John Henry Twachtman
(American, 1853–1902)
Winter Harmony
c. 1890/1900, oil on canvas
65.4 × 81.1 (25 ¾ × 31 ⅞)
Gift of the Avalon Foundation
1964.22.1

James McNeill Whistler
(American, 1834–1903)
Wapping
1860–1864, oil on canvas
72 × 101.8 (28 ⅜ × 40 ⅛)
John Hay Whitney Collection
1982.76.8

Symphony in White, No. 1: The White Girl

JAMES MCNEILL WHISTLER

• In 1855 Whistler left America to study art in Paris, and by the early 1860s he was dividing his time between Paris and London. *The White Girl*, painted in his Paris studio, portrays his Irish mistress and model, Joanna Hiffernan. Whistler submitted the work to the annual exhibition of the Royal Academy of Arts in London in 1862, but the canvas was rejected. Undeterred, he showed it at a private gallery, where the painting attracted large crowds and considerable comment. In response to the suggestion that the picture should be associated with Wilkie Collins' popular novel, *Woman in White*, Whistler stated, "My painting simply represents a girl dressed in white standing in front of a white curtain."

Whistler next tried to have his *White Girl* included in the Paris Salon of 1863, hoping this would tweak the nose of the Royal Academy. The painting was again rejected, but it was shown at the now-famous Salon des Refusés, where, along with Manet's *Déjeuner sur l'herbe*, it was a sensation and a scandal. Although a number of artists and writers admired Whistler's *White Girl*, many critics, disturbed by absence of narrative, felt the need to create stories: the woman was in a spiritualist trance or was shown on the morning following her wedding night, no longer a virgin.

For the most part Whistler should be taken at his word: his aim was only to represent a model standing in a studio and to explore the different effects possible using white paint. Hiffernan's expressionless face was a deliberate attempt to avoid distraction. Whistler, who initially trained in an academic manner, naturally gravitated toward the avant-garde, and in France he was influenced by Gustave Courbet, whose realism and loose, heavy brushwork are reflected here. Interestingly, Courbet was unsettled and annoyed by this painting, calling it an "apparition." What he sensed may derive from Whistler's acquaintance with the artists of the Pre-Raphaelite Brotherhood in England; whether fully intentional or not, there are echoes of their works in *The White Girl*, including the type of dress worn by the model, her disheveled auburn hair, and the sexual overtones of the wilted white lily she holds and the flowers that have already fallen on the bearskin rug.

In 1863 the French critic Paul Mantz described the painting as a "Symphonie en blanc." Although never exhibited under this title, by 1867 it is evident that Whistler considered the picture to be the *Symphony in White, No. 1*. In this complex and provocative work the artist has moved away from realism and the Pre-Raphaelites into the aesthetic realm of "art for art's sake." The painting played a pivotal role for avant-garde art in the nineteenth century.

271

James McNeill Whistler
(American, 1834–1903)
Symphony in White, No. 1: The White Girl
1862, oil on canvas
213 × 107.9 (83 ⅞ × 42 ½)
Harris Whittemore Collection
1943.6.2

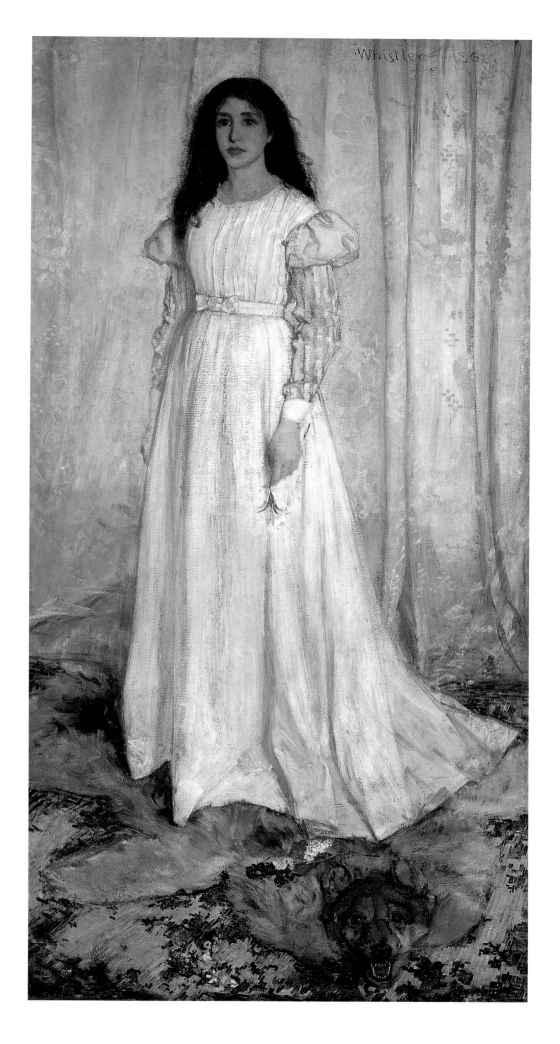

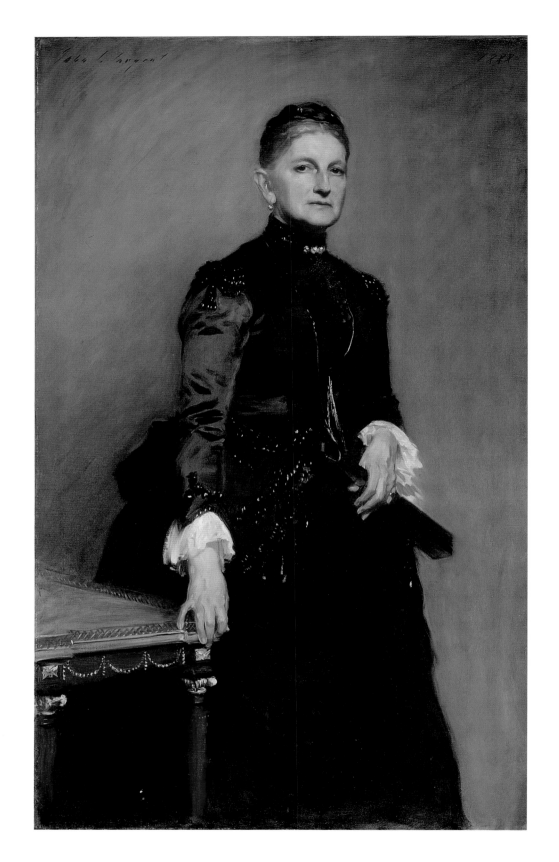

John Singer Sargent
(American, 1856–1925)
Eleanora O'Donnell Iselin
(Mrs. Adrian Iselin)
1888, oil on canvas
153.7 × 93 (60 ½ × 36 ⅝)
Gift of Ernest Iselin
1964.13.1

273

John Singer Sargent
(American, 1856–1925)
*Valdemosa, Majorca: Thistles
and Herbage on a Hillside*
1908, oil on canvas
55.8 × 71.1 (22 × 28)
Avalon Fund and Gift of
Virginia Bailey Brown
1991.177.1

274

John Singer Sargent
(American, 1856–1925)
Nonchaloir (Repose)
1911, oil on canvas
63.8 × 76.2 (25 ⅛ × 30)
Gift of Curt H. Reisinger
1948.16.

Job and His Daughters

WILLIAM BLAKE

• There was always a huge contrast between Blake's outwardly impoverished circumstances and the luminous intensity of his inner life, accompanied by visions that were, he said, revealed to him by heavenly messengers. Born in London, Blake received virtually no formal education yet was writing poetry by the age of twelve and indeed is as famous for his poems as for his art. He was apprenticed to a commercial engraver and for many years earned a meager living as a reproductive engraver, copying the designs of others.

One of Blake's few patrons was Thomas Butts, a civil servant in the War Office. Beginning around 1799, Butts commissioned from Blake more than one hundred and thirty-five paintings of biblical subjects. *Job and His Daughters* was among these. In one of the most unusual Old Testament books God allows Satan to torment Job as a test of his faith. Having passed the test, Job at last finds his fortunes restored, and he is blessed with a long life as well as seven sons and three daughters. This painting depicts Job at the end of his life recounting to his daughters the trials and afflictions he endured. Three events are illustrated on the walls behind him: beginning at the left, one sees the destruction of Job's servants by the Chaldeans, God appearing to Job in a whirlwind, and the extermination of the men tending his oxen as Satan hovers overhead.

As was so often true of Blake, his technique for this and other paintings in the series was highly personal. The paint is a mixture of glue and tempera, applied in thin washes over a thick white ground. He used a pen in several places to draw thin black lines. Although this method achieves soft and subtle colors that are in accord with Blake's lyrical style, the results are fragile, and the picture has suffered over time.

William Blake
(British, 1757–1827)
Job and His Daughters
1799/1800, pen and tempera on canvas
27.3 × 38.4 (10 ¾ × 15 ⅛)
Rosenwald Collection
1943.11.11

Wivenhoe Park, Essex

JOHN CONSTABLE

• Located near Colchester, Essex, Wivenhoe Park was the home of the Rebow family, constructed during the second half of the eighteenth century. Work on the brick manor house, visible in the center distance, began in 1758, while the surrounding park was landscaped in 1777. Major General Francis Slater-Rebow, a friend of Constable's, commissioned the artist to paint a view of the estate in 1816. The timing may have been intended in part to provide Constable with funds on the eve of his marriage to Maria Bricknell. The couple had been engaged for several years, but their union was opposed by members of her family.

In letters to his fiancée Constable indicated that he was working on the painting in August and September of 1816. He noted that it had been necessary to add a three-inch-wide strip of canvas at the right side because the Rebows wanted him to include a deer house; probably for the sake of symmetry a similar piece of canvas was attached at the left as well. Constable made several sketches of Wivenhoe Park and may have painted a good deal of the picture out-of-doors, but although he was interested in accuracy, he had no qualms about modifying appearances to improve the composition. The deer house is barely visible at the far right, and the black fallow deer who roamed the grounds until the 1940s are not shown; instead he included the more utilitarian cows and fishermen tending their nets. Two white swans add beautiful grace notes. In the background at the far left Rebow's daughter Mary can be seen driving a donkey cart. Today Wivenhoe Park is the home of the University of Essex; the manor house remains, but the grounds have been transformed.

Wivenhoe Park, Essex, magnificently illustrates Constable's ability to represent the dramatic and transient effects of light and atmosphere, showing a sky filled with thick cumulus clouds that produce areas of intense sunlight and deep shadow in the fields and trees below. The brilliance of Constable's brushwork is perhaps best displayed in the sparkling surface of the lake. Arguably the finest English landscape painter of the nineteenth century, Constable found inspiration not in exotic locales or extreme conditions but in the familiar terrain of his native Suffolk. Like William Wordsworth or John Keats, he responded with profound emotion to the natural world, saying once, "Painting is for me but another word for feeling."

John Constable
(British, 1776–1837)
Wivenhoe Park, Essex
1816, oil on canvas
56.1 × 101.2 (22 ⅛ × 39 ⅞)
Widener Collection
1942.9.10

Mortlake Terrace

JOSEPH MALLORD WILLIAM TURNER

• The house known as "the Limes," owned by a William Moffatt, was located at Mortlake on the south side of the Thames River, about seven miles from London. Turner painted two views of the house and grounds for Moffatt. The first, which belongs to the Frick Collection, New York, was exhibited at the Royal Academy of Arts in 1826; it looks eastward and depicts the house and terrace on an early summer morning. The National Gallery of Art's picture, exhibited in 1827, is a view from the house looking westward on a summer's evening. Scattered across the lawn are the remains of the day's activities: a child's wooden hoop, a parasol, clothing draped over a chair, a table with a portfolio next to it that seems to have held artworks. Three small figures gaze out at the ceremonial barge of the lord mayor as it makes its way up the Thames.

The composition is dominated by the receding diagonals of the terrace wall and the row of lime trees. Counterbalancing this progression are the lines of the shadows cast by the trees and, most potently, the setting sun, which blazes just over the horizon. Indeed the light from the sun has such palpable intensity that it appears to dissolve part of the wall. The small black dog atop the wall is cut out of paper and was affixed to the canvas apparently by

Turner himself and not by the animal painter Sir Edwin Henry Landseer, as is sometimes asserted. The dog establishes a spatial reference and a point of contrast to the warm enveloping haze of the summer evening.

Turner was born in London and was something of a prodigy, whose father, a barber and wigmaker, displayed the boy's works in his shop window. Turner first exhibited one of his watercolors at the Royal Academy in 1790 when he was fifteen, followed by an oil painting in 1796. He became a full member of the academy at age twenty-seven. He achieved early success as a topographical watercolorist, whose views were popular with engravers. Two critical influences on his art were seventeenth-century Dutch landscapes and seascapes and the seventeenth-century French landscapes of Claude Lorrain, whose works are filled with a golden, crepuscular glow (Claude also produced pairs of landscapes in morning and evening light). Turner quickly came to realize that light and atmosphere were tangible elements, and through them he pursued the drama and power of nature, often to the point of abstraction. Both the impressionists and the abstract expressionists found much in his paintings to inspire them.

Joseph Mallord William Turner
(British, 1775–1851)
Mortlake Terrace
1827, oil on canvas
92.1 × 122.2 (36 ¼ × 48 ⅛)
Andrew W. Mellon Collection
1937.1.109

Keelmen Heaving in Coals by Moonlight

JOSEPH MALLORD WILLIAM TURNER

• Like *Mortlake Terrace* (no. 277), this picture was conceived of as one of a pair. Its pendant, *Venice: The Dogana and San Giorgo Maggiore*, also belongs to the National Gallery of Art and was exhibited at the Royal Academy of Arts in 1834, while *Keelmen Heaving in Coals by Moonlight* was shown the following year. The pair was commissioned by Henry McConnel, a cotton manufacturer who lived in Manchester.

Set on the River Tyne in northeastern England, this painting depicts the part of South Shields where coal from the fields of Northumberland was brought by barges, known as "keels," and laboriously shoveled into "colliers" (sailing ships designed to transport coal). Illuminated by buckets of fire, the work was done at night so that the ships could depart on the morning tide. In this rendering, smokestacks in the distance can be discerned through the haze. At the left are square riggers and two men in a rowboat. England in the late eighteenth and nineteenth centuries became a highly industrialized nation, and coal was the essential source of power. It may have been McConnel who suggested the idea of pairing a sun-filled view of Venice with a night scene in northern England, but in any event Turner establishes an intentional contrast between Venice's decline into "picturesque impotence," as one critic put it, and Britain's expanding empire and industrial might.

Part of Turner's genius lay in his ability to transform the grim and gritty reality of manual labor into a haunting visual experience. It is light and air that are the true subjects of this painting. Turner opened up a broad channel of space in the center that allows the light from the full moon to fill the sky and create shimmering reflections in the water, perfectly capturing its glassy surface. Note too how the curved, arching clouds blend into the billows of smoke, increasing the tunnel-like spatial effect. The buoy at the left and the floating debris at the right are *repoussoir* elements that help define the composition.

Now acknowledged as a masterpiece of Turner's maturity, *Keelmen Heaving in Coals by Moonlight* elicited mixed reactions in its day. For some the sky was too blue for a nocturne. Others understood the picture's power. The critic for the *Literary Gazette*, for example, exclaimed, "And such a night!—a flood of glorious moonlight wasted upon dingy coal-whippers, instead of conducting lovers to the appointed bower."

Joseph Mallord William Turner
(British, 1775–1851)
Keelmen Heaving in Coals by Moonlight
1835, oil on canvas
92.3 × 122.8 (36 ³⁄₈ × 48 ³⁄₈)
Widener Collection
1942.9.86

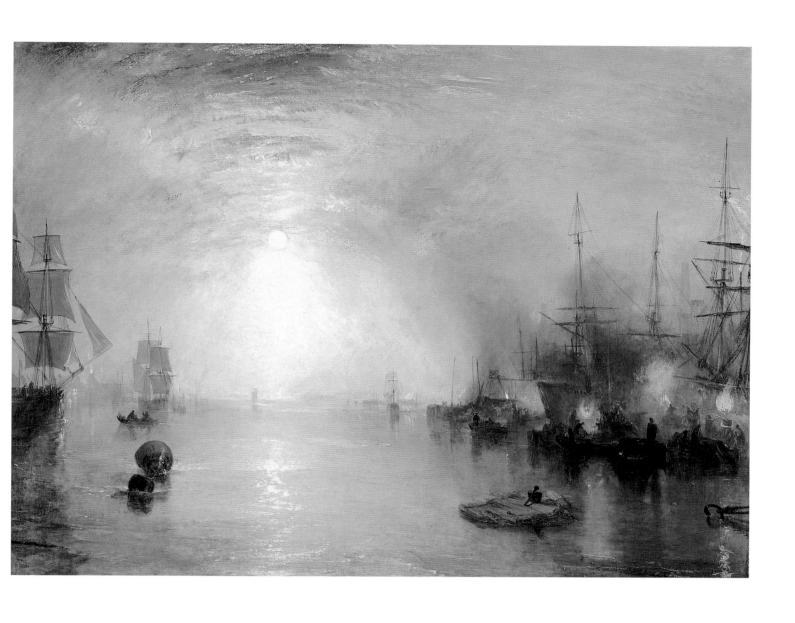

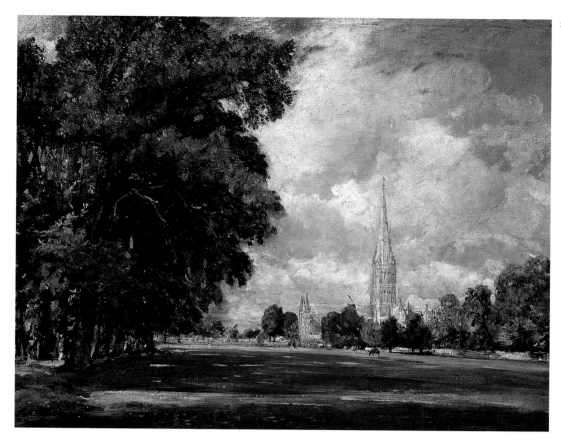

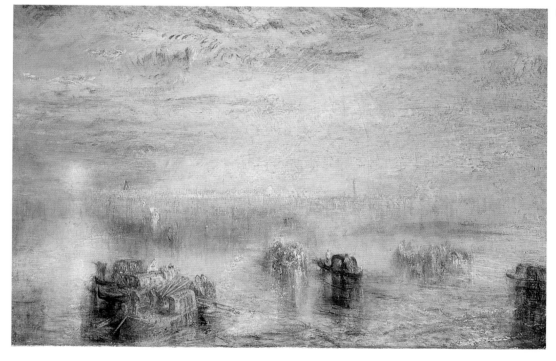

279

280

281

William Blake
(British, 1757–1827)
Evening
c. 1820/1825, watercolor and chalk on wood
91.8 × 29.7 (36 ⅛ × 11 ¾)
Gift of Mr. and Mrs. Gordon Hanes,
in Honor of the 50th Anniversary
of the National Gallery of Art
1990.22.1

John Constable
(British, 1776–1837)
*Salisbury Cathedral from
Lower Marsh Close*
1820, oil on canvas
73 × 91 (28 ¾ × 35 ⅞)
Andrew W. Mellon Collection
1937.1.108

Joseph Mallord William Turner
(British, 1775–1851)
Approach to Venice
1844, oil on canvas
62 × 94 (24 ⅜ × 37)
Andrew W. Mellon Collection
1937.1.110

The Emperor Napoleon in His Study at the Tuileries

JACQUES-LOUIS DAVID

• This famous portrait is filled with details that send a strong and deliberate political message. The emperor Napoleon is shown standing in his private study in the Tuileries. He wears the uniform of a grenadier of the Imperial Guard with the epaulettes of a general; this was his dress on Sundays and special occasions. The medals on his chest are the star of a commander of the Legion of Honor, the Order of the Iron Crown of Italy, and the large silver star of the Great Cross of the Legion of Honor. In a characteristic gesture, Napoleon places his right hand under his vest and holds a gold snuffbox in his left.

David makes it clear that Napoleon has been at work all night: the candles in the lamp have burnt down to stubs, and the tall clock in the background shows the time as 4:13 in the morning. One object of his attention can be identified by the word "code" that appears on a roll of paper atop the desk, referring to the Code Napoléon of 1804, part of a massive campaign to create a unified system of laws for all of France. The emperor has put down his pen, which lies on the table at the left, and will soon don his sword, lying on the chair, and leave to review his troops. The obvious implication was that Napoleon was equally adept at serving his country in legal and military matters.

Underneath the table is a copy of one of Napoleon's favorite books, Plutarch's *Lives*, suggesting perhaps that the emperor's achievements were on a par with those of great men from antiquity. Like the other furnishings, the massive gilt and red velvet chair is neoclassic in style and is decorated with the letter N as well as the bees that Napoleon adopted as his emblem. Although the objects in the picture are rendered with convincing reality, David was not always concerned with accuracy; the chair, for example, designed by the artist, belonged not to the study, but to a larger, more public chamber.

David's portrait was commissioned by a Scottish nobleman, Alexander, marquis of Douglas, who was an ardent admirer of Napoleon. The marquis believed that he was himself a direct descendant of James I of Scotland and heir to the Stuart throne. Unconcerned that Britain and France were at war in 1811–1812, the marquis ordered the picture for his palace in Strathclyde, Scotland, where it would hang with other depictions of noteworthy men.

David was often associated with partisan causes; he was a supporter of the Revolution and advocated beheading the king and queen. He designed the enormous pageants for Robespierre that indoctrinated the public. Following Robespierre's fall and his own imprisonment, David allied himself with Napoleon, who in turn appointed the artist "First Painter" and rewarded him with a series of commissions. In 1814, two years after the National Gallery of Art's portrait was completed, Napoleon was defeated at Waterloo, and David was exiled to Brussels, where he continued to paint until his death there in 1825.

Jacques-Louis David
(French, 1748–1825)
The Emperor Napoleon in His Study at the Tuileries
1812, oil on canvas
203.9 × 125.1 (80 ¼ × 49 ¼)
Samuel H. Kress Collection
1961.9.15

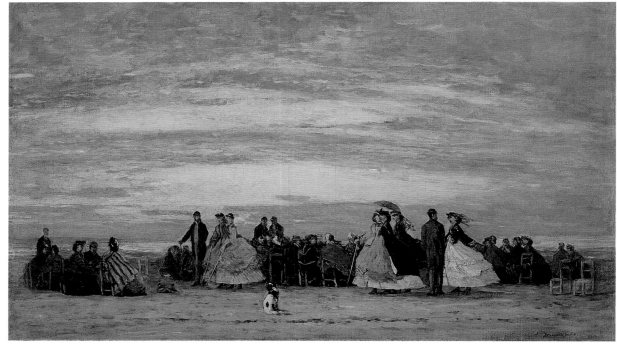

283

Jacques-Louis David
(French, 1748–1825)
Madame David
1813, oil on canvas
72.9 × 59.4 (28 ¾ × 23 ⅜)
Samuel H. Kress Collection
1961.9.14

284

Louis-Léopold Boilly
(French, 1761–1845)
A Painter's Studio
c. 1800, oil on canvas
73.5 × 59.5 (29 × 23 ⅜)
Chester Dale Collection
1943.7.1

285

Eugène Boudin
(French, 1824–1898)
The Beach at Villerville
1864, oil on canvas
45.7 × 76.3 (18 × 30)
Chester Dale Collection
1963.10.4

286

287

286

287

Honoré Daumier
(French, 1808–1879)
Wandering Saltimbanques
1847/1850, oil on wood
32.6 × 24.8 (12 ⅞ × 9 ¾)
Chester Dale Collection
1963.10.14

Honoré Daumier
(French, 1808–1879)
Advice to a Young Artist
1865/1868, oil on canvas
41.3 × 33 (16 ¼ × 13)
Gift of Duncan Phillips
1941.6.1

Madame Moitessier

JEAN-AUGUSTE-DOMINIQUE INGRES

• Of the hundreds of students who passed through the Paris studio of Jacques-Louis David, Ingres stood out by virtue of his talent, especially as a draftsman. In 1806 he began a four-year stay at the French Academy in Rome, where he was particularly impressed by the paintings of Raphael but also carefully studied other Renaissance works as well as medieval and Byzantine art. Ingres was a gifted portraitist, and when his stipend expired in 1810, he was able to support himself in Rome by painting and drawing likenesses of the French administrative community and visitors to the Eternal City.

Despite the demand for his skills, Ingres often complained about the need to paint portraits, believing that it took time away from the more important task of depicting historical and biblical subjects. Thus the artist was at first reluctant to accept the job of portraying Madame Moitessier but agreed after meeting her and being transfixed by her "terrible and beautiful" face. He began a seated portrait in 1844, then abandoned it for many years; it was completed in 1856 and hangs in the National Gallery, London. The National Gallery of Art's portrait was painted in 1851, when the artist was seventy-one.

Marie-Clotilde-Inès Moitessier was the daughter of Charles-Edouard-Armand de Foucauld, an inspector in the department of forests and waterways. Her husband, Paul-Sigisbert Moitessier, a prosperous merchant whose first wife had died in 1839, was much older than she.

Madame Moitessier is shown standing in front of a wall of dark magenta damask. She wears a black velvet dress, with a black lace bertha, or collar, around her shoulders, and pink silk roses in her hair. A critic who probably saw the picture in Ingres' studio wrote, "The general appearance of this portrait has the calm and majesty of antique art. One believes it is Juno in her proud gaze."

Careful preparation preceded the actual painting. Ingres made a number of drawings that explored different poses as well as an exquisite study of her face. He was also attentive to her accessories and instructed her, "Please then be so kind, Madame, as to bring on Monday, your jewel chest, bracelets, and the long pearl necklace."

The fascination of this portrait lies in the dichotomy between the scrupulous realism of its details—one has only to study the superbly rendered bracelets and rings—and the idealized, stylized figure. Madame Moitessier's impassive face is a nearly perfect oval whose curves are repeated in her hair and the halo of roses. Her shoulders are strangely boneless and anatomically unconvincing yet form a beautiful pattern that harmonizes with the curves of her pearl necklace. In contrast to the flatness of her head and shoulders, Ingres painted her fleshy arms and hands with tender voluptuousness.

Jean-Auguste-Dominique Ingres
(French, 1780–1867)
Madame Moitessier
1851, oil on canvas
147 × 100 (57 ¾ × 39 ⅜)
Samuel H. Kress Collection
1946.7.18

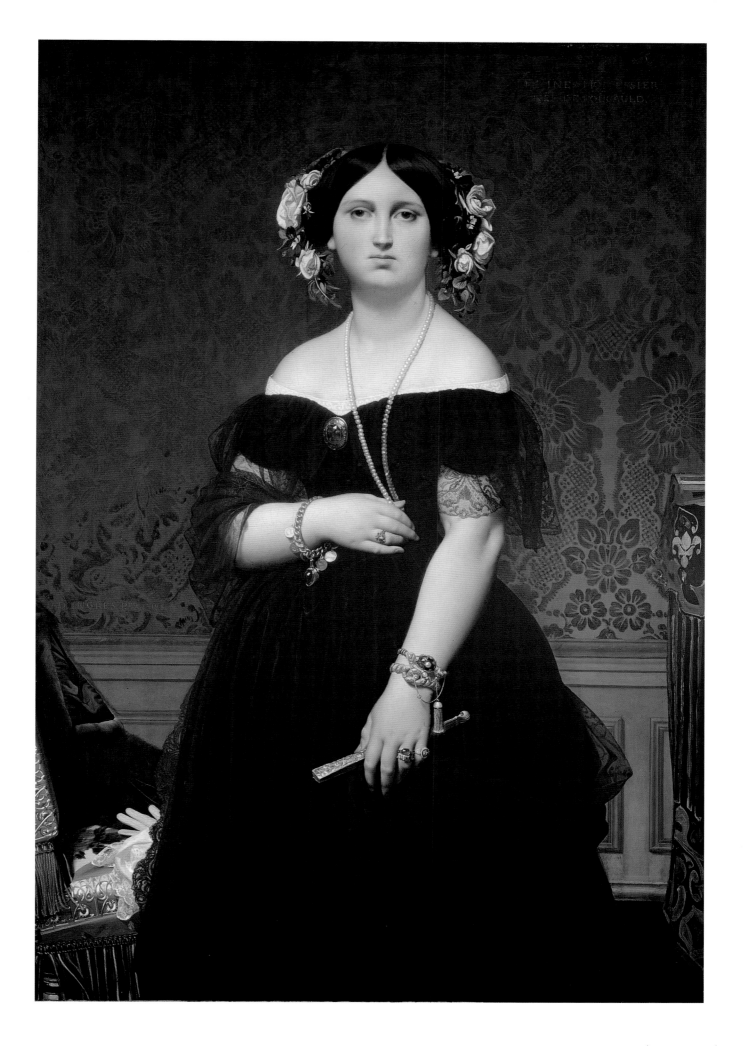

289

289

Jean-Baptiste-Camille Corot
(French, 1796–1875)
Forest of Fontainebleau
1834, oil on canvas
175.6 × 242.6 (69 ⅛ × 95 ½)
Chester Dale Collection
1963.10.109

Jean-Baptiste-Camille Corot
(French, 1796–1875)
A View near Volterra
1838, oil on canvas
69.9 × 95.5 (27 ½ × 37 ⅝)
Chester Dale Collection
1963.10.111

Jean-Baptiste-Camille Corot
(French, 1796–1875)
*The Island and Bridge of
San Bartolomeo, Rome*
1825/1828, oil on paper on canvas
27 × 43.2 (10 ⅝ × 17)
Patrons' Permanent Fund
2001.23.1

Jean-Baptiste-Camille Corot
(French, 1796–1875)
The Artist's Studio
c. 1868, oil on wood
61.8 × 40 (24 ⅜ × 15 ¾)
Widener Collection
1942.9.11

293

André Giroux

(French, 1801–1879)

Santa Trinità dei Monti in the Snow

1825/1830, oil on paper on canvas

22 × 30 (8 ⅝ × 11 ¾)

Chester Dale Fund

1997.65.1

294

Constant Troyon

(French, 1810–1865)

The Approaching Storm

1849, oil on canvas on board

116.2 × 157.5 (45 ¾ × 62)

Chester Dale Fund

1995.42.1

295

296

Eugène Delacroix
(French, 1798–1863)
Arabs Skirmishing in the Mountains
1863, oil on canvas
92.5 × 74.5 (36 ½ × 29 ½)
Chester Dale Fund
1966.12.1

Gustave Courbet
(French, 1819–1877)
A Young Woman Reading
c. 1866/1868, oil on canvas
60 × 72.9 (23 ⅝ × 29 ¾)
Chester Dale Collection
1963.10.114

The Railway

EDOUARD MANET

• Manet remained in his studio on the rue Guyot until the outset of the Franco-Prussian War of 1870, then left the city during the civil unrest of 1871 known as the Paris Commune. In July 1872 he moved to a spacious studio on the rue de Saint-Pétersbourg, close to the Gare Saint-Lazare, one of the largest and busiest train stations in Paris. In fact, the door and a window of Manet's studio are visible in the background at the left of *The Railway*.

The vantage point for this painting is on the other side of the tracks, from a building on the rue de Rome that had a small garden and housed the studio of Alphonse Hirsch, an artist and friend of Manet's. A young girl looks through the fence toward the tracks, which are obscured by the great clouds of steam from a passing train. The seated woman with pale skin and reddish brown hair is Victorine Meurent, a professional model who had posed for several of Manet's paintings, including the *Déjeuner sur l'herbe* that was among the sensations of the Salon des Refusés of 1863. Here she holds a book and a sleeping puppy in her lap as she forthrightly returns the viewer's gaze.

Although the picture gives the impression of having been painted *en plein air*, it was almost certainly composed in the studio. The two figures are simultaneously mirror images and opposites. One looks toward the viewer, while the other looks away; one wears a dark blue dress with white trim and bluish white buttons, while the other wears a white dress with a blue bow; the bell-like shapes of their dresses also echo each other. Manet had fallen under the spell of Japanese wood-block prints by this time, and he borrowed from them the device seen here of using the vertical bars of the iron fence, like a bamboo screen, to separate the foreground figures from the distant buildings. As always, Manet's brushwork is extraordinary in its assurance and directness; paint is applied boldly and with minimal modulation between strokes, yet the final effect is persuasively realistic.

The Railway was exhibited in the Salon of 1874 and like other submissions of Manet it was savagely criticized and caricatured in the press. The qualities that are now admired—the direct brushwork, inventive composition, incomplete figures, and absence of a clear-cut narrative—were neither understood nor appreciated by Salon audiences accustomed to smoothly finished paintings in which the story was easily perceived. Manet fought within the system for the acceptance of avant-garde painting, continuing to submit pictures to the Salon. Although Degas, Renoir, and Monet were friends and colleagues and he occasionally provided Monet with financial support, Manet never exhibited with the impressionists. And although sympathetic to their aspirations, he made it clear that he did not consider himself an impressionist.

Edouard Manet
(French, 1832–1883)
The Railway
1873, oil on canvas
93.3 × 111.5 (36 ¾ × 45 ⅛)
Gift of Horace Havemeyer
in memory of his mother,
Louisine W. Havemeyer
1956.10.1

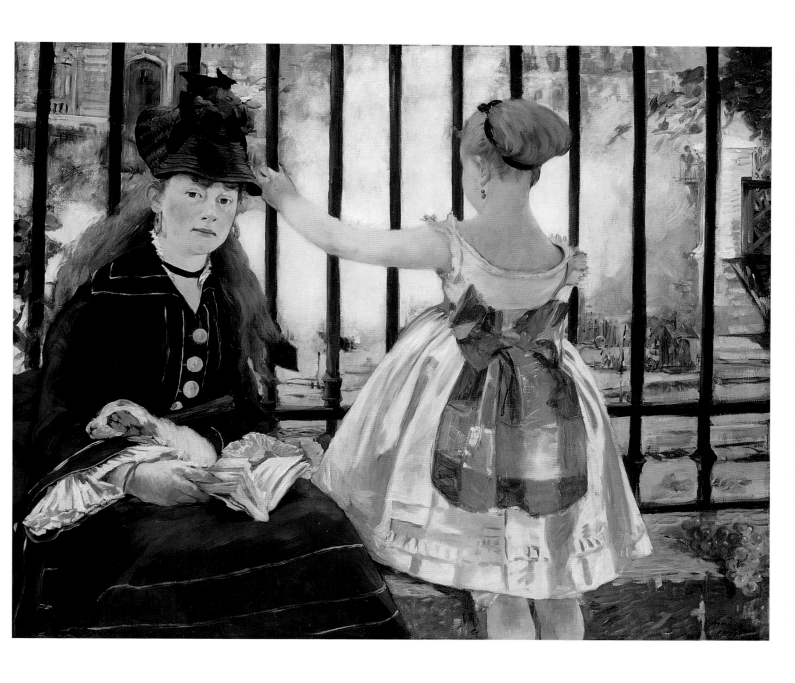

The Old Musician

• This large, complex, and enigmatic painting is a masterwork from Manet's early years, and despite its seemingly rural setting, it is distinctly urban and Parisian. At the beginning of the Second Empire Napoleon III authorized Baron Georges Eugène Haussmann to tear down slums, renovate housing, and build the broad boulevards that give Paris its present character and charm.

In July 1861 Manet moved to a new studio at the corner of the rue Guyot and avenue de Villiers in the district of Batignolles. Nearby was a sordid and dangerous area known as Petit Pologne (Little Poland), which was home to the poor and those on the margins of society, such as street musicians, who were being uprooted and displaced by urban renewal. Manet used several people from this neighborhood as models. The seated violinist is Jean Lagrène, a well-known gypsy who worked as an organ-grinder and artist's model. Standing behind him in top hat and opera cloak is Colardet, a rag-picker and ironmonger who was the subject of Manet's first important painting, the *Absinthe Drinker* of 1859. The old man with a white beard at the far right is Guéroult, who personifies the "wandering Jew"—an outcast literally and figuratively on the edge. The dark-haired street urchin is Alexandre who lived in Petit Pologne, while the blond boy is Léon Leenhoff, a member of the artist's household. The girl at the far left is apparently fictitious, taken from an etching by Manet; she may have originated in a popular print depicting gypsies who were said to steal infants.

Although its subject was contemporary, Manet enriched his *Old Musician* with borrowings from earlier art, seamlessly absorbed into his own painterly vocabulary. And whether recognized or not, the quotations help imbue this collection of social outcasts with a kind of dignity. The pose of the seated musician derived from a Roman statue of Chrysippos, a Stoic philosopher, while the stance of the fair-haired boy repeats that of Watteau's famous painting of *Gilles*, both works in the Musée du Louvre, Paris. There are similarities to the depictions of dignified peasants in a landscape by the seventeenth-century French artist Louis Le Nain. Manet was especially struck by the earthy realism of seventeenth-century Spanish painting, and the *Old Musician* owes much to the street urchins of Bartolomé Estaban Murillo and to Diego Velázquez' *Drinkers* (Museo del Prado, Madrid), which Manet knew from reproductions. Manet's palette of blacks, browns, and grays also reflects the influence of Velázquez.

Manet was most likely sympathetic to the poverty and imminent homelessness of the inhabitants of Petit Pologne. Likewise, in the minds of avant-garde critics and poets such as Baudelaire, rag-pickers could be philosophers, while gypsies were romanticized as free and noble spirits. Yet they are presented somewhat dispassionately here, with a certain detachment from the viewer and from each other.

Edouard Manet
(French, 1832–1883)
The Old Musician
1862, oil on canvas
187.4 × 248.2 (73 ¾ × 98)
Chester Dale Collection
1963.10.162

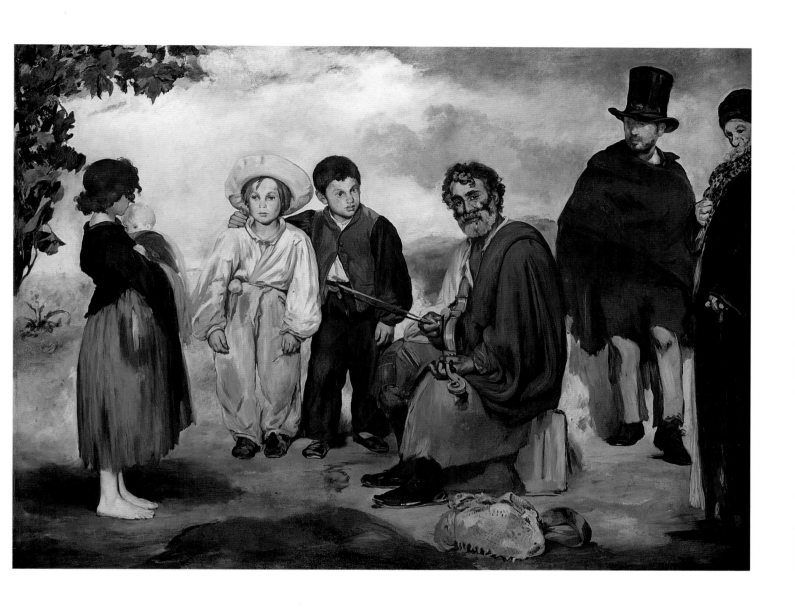

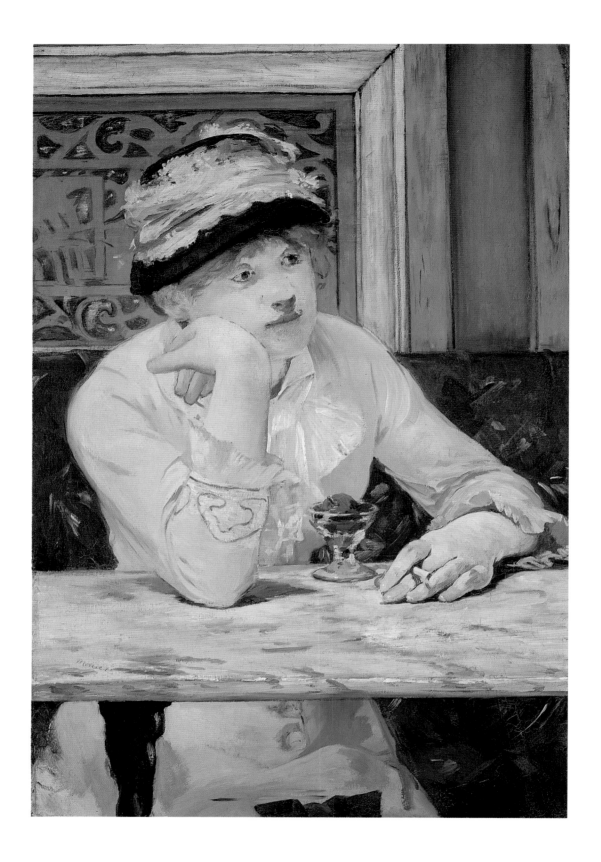

299

Edouard Manet
(French, 1832–1883)
Plum Brandy
c. 1877, oil on canvas
73.6 × 50.2 (29 × 19 ¾)
Collection of
Mr. and Mrs. Paul Mellon
1971.85.1

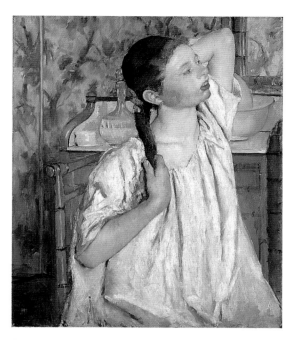

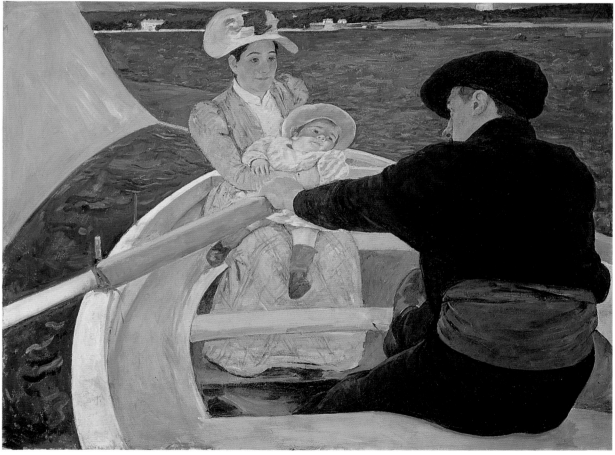

300

301

Mary Cassatt
(American, 1844–1926)
Girl Arranging Her Hair
1886, oil on canvas
75.1 × 62.5 (29 ⁵⁄₈ × 24 ⁵⁄₈)
Chester Dale Collection
1963.10.97

Mary Cassatt
(American, 1844–1926)
The Boating Party
1893/1894, oil on canvas
90 × 117.3 (35 ³⁄₈ × 46 ¹⁄₈)
Chester Dale Collection
1963.10.94

Little Girl in a Blue Armchair

• An expatriate who spent most of her life in Paris but remained resolutely American, Cassatt occupies a special place in the history of painting and collecting on both sides of the Atlantic. She was born in Pittsburgh into an upper middle-class family that lived in Paris, Heidelberg, and Darmstadt from 1851 to 1855 before returning to Pennsylvania. She studied at the Pennsylvania Academy of the Fine Arts in Philadelphia, but as a woman, she was excluded from life drawing classes. Despite her father's objections, Cassatt was determined to become a professional artist, and in 1865 she moved to Paris, where, like Thomas Eakins and other Americans, she studied with Jean-Léon Gérôme.

In 1868 one of her paintings was accepted by the Paris Salon, but the following year her submission was rejected, which probably helped foster a lifelong distaste for juried exhibitions. In 1872–1873 she traveled to Rome, Parma, Madrid, and Seville to paint and to visit the museums, then returned to Paris in 1874. As her style changed, becoming looser and more colorful, Cassatt moved further away from the Salon. She was drawn to the art of Edgar Degas before ever meeting him, and it was Degas who invited her in 1877 to exhibit with his friends, who preferred to be called "indépendants" but are now known as the impressionists. Kindred spirits who were lifelong friends, Cassatt and Degas were both fiercely independent and somewhat reactionary.

Cassatt first exhibited with the impressionists in 1879, and among her entries, *Little Girl in a Blue Armchair* had earlier been rejected for the American section of the 1878 Exhibition Universelle in Paris. The model was the daughter of friends of Degas', and the dog was Cassatt's Belgian griffon terrier, "Battie." As Cassatt later noted, Degas had liked the painting and worked on the background. The girl wears tartan socks and a tartan sash over a white dress. With wonderful understanding Cassatt captured the posture and expression of a young girl who, perhaps out of boredom, squirms and fidgets in an overstuffed chair, while, in contrast, the dog snoozes comfortably in the adjoining chair. Two other pieces of furniture covered in the same brilliant blue floral fabric can be seen in the background. Curiously, all of the furniture is cropped and fragmentary; only the dog and the girl—the center of attention—are shown in their entirety. The space in which the figures appear is also oddly truncated, while the floor appears to tilt upward. The effect is similar to that found in some of Degas' ballet scenes.

Toward the end of her career failing eyesight forced Cassatt to paint less. She spent more time offering advice on art acquisitions to American friends and collectors such as Henry and Louisine Havemeyer of New York or Potter Palmer of Chicago. Many of the finest impressionist paintings now in the American museums thus reflect Cassatt's taste and expertise.

Mary Cassatt
(American, 1844–1926)
Little Girl in a Blue Armchair
1878, oil on canvas
89.5 × 129.8 (35 ½ × 51 ⅛)
Collection of Mr. and Mrs. Paul Mellon
1983.1.18

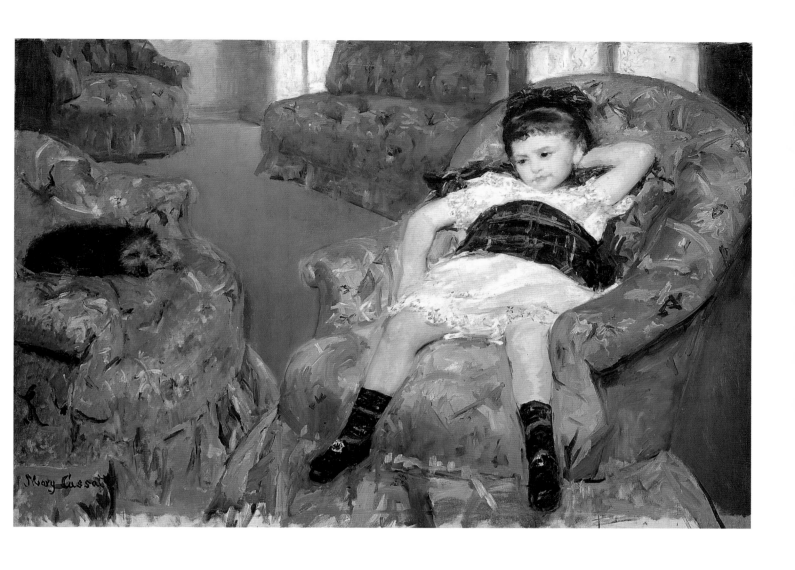

La Mousmé

VINCENT VAN GOGH

• In February 1888 van Gogh left Paris for Arles in the south of France. He had several reasons for moving: he wished to become a "peasant painter," living among the working class; and he wished to start an artist's colony and thought, as part of his fascination with Japan, that Arles could somehow be like Japan: "Here my life will become more and more like a Japanese painter's, living close to nature like a petty tradesman." Van Gogh painted *La Mousmé* in Arles in July 1888 and explained the picture to his brother Theo in a letter dated 29 July 1888: "And now you know what a 'mousmé' is (you will when you read Loti's *Madame Chrysanthème*). I have just painted one. It took me a whole week. I have not been able to do anything else, not having been very well either…but I had to reserve my mental energy to do the mousmé well. A mousmé is a Japanese girl—Provençal in this case—12 to 14 years old."

Pierre Loti's novel had just been published and had attracted van Gogh's attention for its picturesque though not always accurate descriptions of life in Japan. Van Gogh's mousmé holds a bouquet of oleander, a flower that the artist associated with this region, the Midi; it was also a symbol of innocence, perhaps referring both to the girl's virginity and to the unspoiled simplicity of Japanese life. Like other artists among his contemporaries, van Gogh was enthralled by Japanese color woodcuts; he studied, copied, and collected them. Their influence can be seen here in the flat, nearly monochrome background and the emphasis on the girl's silhouette and the outlines of the chair, creating contours that are at once decorative, descriptive, and expressive.

Although bright color is a feature of Japanese prints, van Gogh's ideas about color were strongly influenced by the theories and paintings of neo-impressionists such as Georges Seurat that he studied while living in Paris. In *La Mousmé* bright red and blue are juxtaposed in the girl's jacket, while her skirt scintillates with red and orange dots on a blue field. The predominant hues of red and orange are made even more vibrant by being set against their complement, the light green in the background.

Van Gogh's dream of establishing an artist's community in Arles never materialized. He did persuade Paul Gauguin to leave Brittany and come to Arles in October 1888. But despite their mutual respect, living and working in close proximity brought them into conflict. Van Gogh was unwilling to adopt Gauguin's theories of abstraction, and by December van Gogh's mental instability had begun to manifest itself. On 23 December, after an especially violent argument, van Gogh cut off a portion of his ear, and a few days later a frightened Gauguin departed for Paris.

303

Vincent van Gogh
(Dutch, 1853–1890)
La Mousmé
1888, oil on canvas
73.3 × 60.3 (28 7/8 × 23 3/4)
Chester Dale Collection
1963.10.151

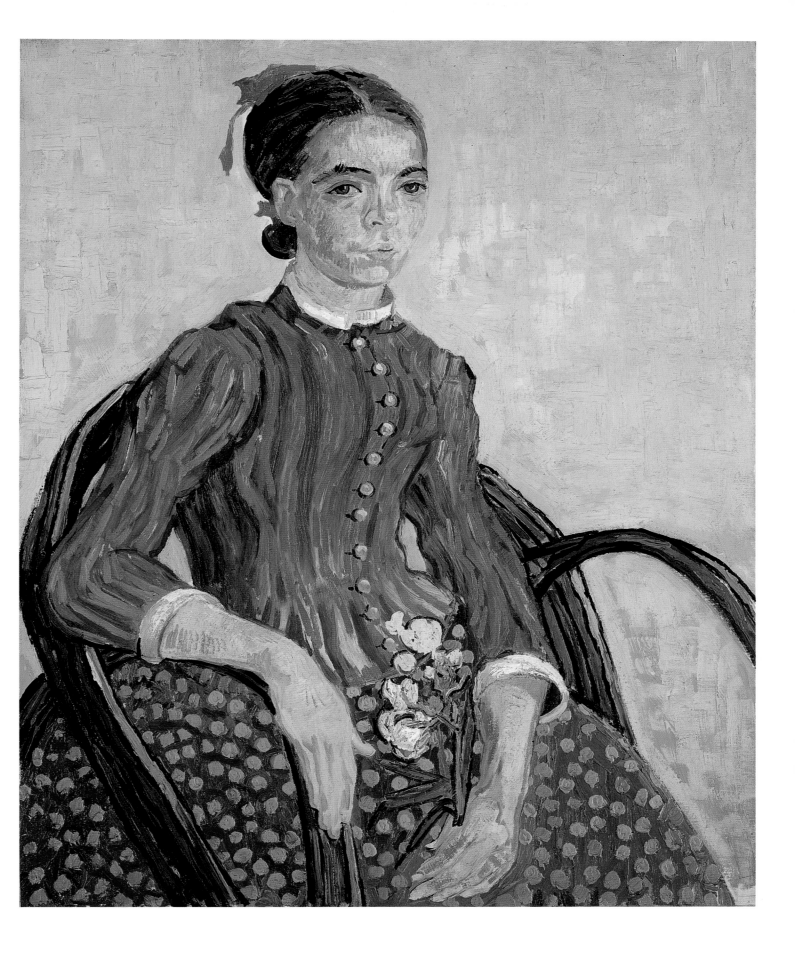

Self-Portrait

VINCENT VAN GOGH

• Although epilepsy has been suspected, the exact nature of van Gogh's mental disturbance has not been diagnosed. After it first manifested itself in 1888, van Gogh voluntarily entered an asylum at Saint-Paul-de-Mausole in Saint Rémy, not far from Arles. In July 1889 he suffered a major attack that left him incapacitated for several weeks, but not acquiescent. In September he wrote, "I am anxious to recover at present, like someone who, having tried to drown himself but having found the water too cold, tries to reach the shore." He was convinced that continuing to paint was an essential part of his recovery. In early September 1889 van Gogh wrote to his brother Theo:

"They say—and I am very willing to believe it—that it is very difficult to know yourself—but it isn't easy to paint yourself either. I am working on two portraits of myself at this moment—for want of another model—because it is more than time I did a little figure work. One I began the day I got up; I was thin and pale as a ghost. It is dark violet-blue and the head whitish with yellow hair, so it has a color effect. But since then I have begun another one, three-quarter length on a light background."

Considered a late work of surpassing power, this *Self-Portrait* shows him dressed in his smock and holding a palette and brushes, defining himself as a painter. His face is gaunt and angular as he intensely scrutinizes himself—and those looking at him. Particularly striking and expressive are the thick, sinuous brush strokes that form the background, curving around his head almost like a halo. In contrast to his reddish orange beard and hair van Gogh used green and yellow for the skin tones in his face. The second self-portrait mentioned in the letter, in the Musée d'Orsay, Paris, is predominantly light blue and quite different in effect.

Van Gogh's life and work hold a remarkable fascination in the popular imagination, perhaps fueled by a best-selling novel and motion picture about him or by the enormous prices his paintings now command. Born in Zundert in The Netherlands, van Gogh first worked as an art dealer in The Hague, London, and Paris, but he was unable to keep a job. His decision to become a minister led him to preach in the coal mines of Belgium, but he failed at this also. In 1880 he decided to become an artist and set about teaching himself: learning to draw by copying from books and prints and receiving a modicum of formal instruction in painting. In the course of a career that lasted only ten years, van Gogh produced a thousand drawings and watercolors and over twelve hundred paintings. In 1890 he moved to Auvers-sur-Oise, north of Paris, and finally began to receive favorable critical attention and an invitation to exhibit in Brussels. This was not enough, however, to assuage his mental anguish, and on 27 July 1890 van Gogh shot himself, dying two days later.

Vincent van Gogh
(Dutch, 1853–1890)
Self-Portrait
1889, oil on canvas
57.15 × 43.82 (22 ½ × 17 ¼)
Collection of Mr. and Mrs.
John Hay Whitney
1998.74.5

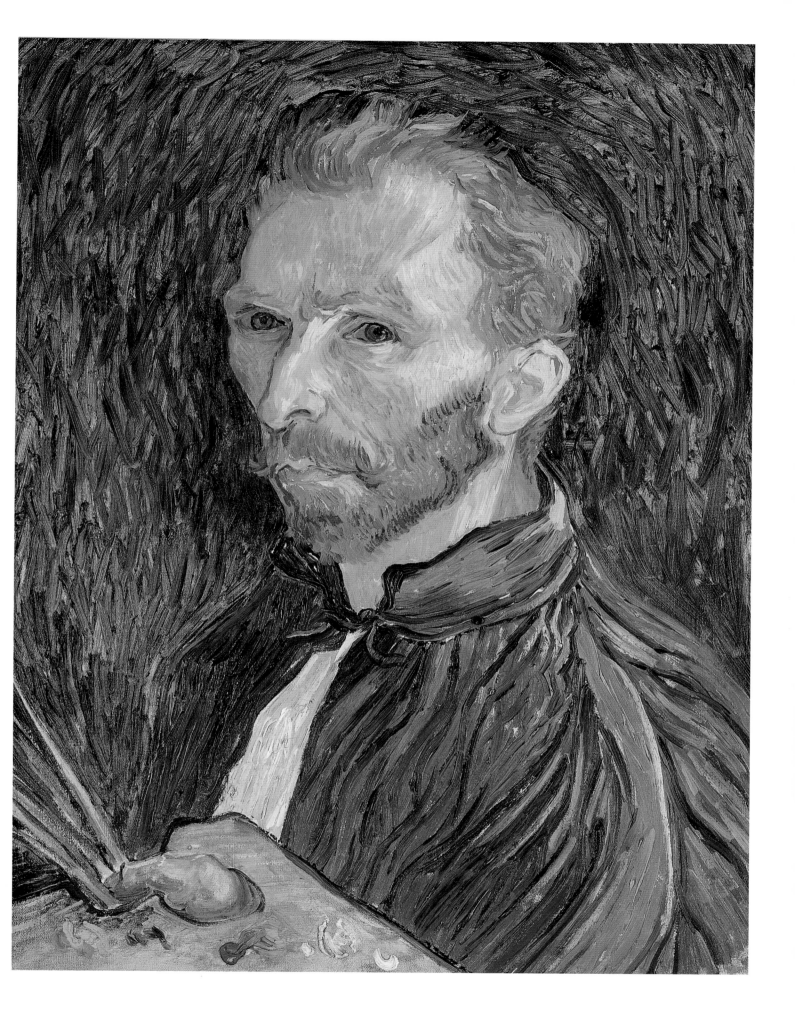

Self-Portrait

PAUL GAUGUIN

• In 1886 Gauguin spent several months in Pont-Aven in Brittany before traveling to Panama and Martinique. When he returned in 1889, he found that the town had become a tourist attraction and artists' colony; in Paul Signac's words, there were "everywhere painters in velvet garments, drunk and bawdy." So Gauguin moved to the nearby fishing village of Le Pouldu, which had the virtues of being primitive, isolated, and inexpensive. Joined by like-minded artists such as Paul Sérusier, Charles Filiger, and the Dutchman Jacob Meyer de Haan, Gauguin occupied the inn owned by Marie Henry, and the boarders proceeded to decorate the dining room with paintings, a mural, carvings, and ceramics. Gauguin painted this *Self-Portrait* on the upper panel of a cupboard door in the dining room, and he depicted Meyer de Haan (private collection), who was both his patron and pupil, on the other door.

Gauguin portrayed himself here as saint and sinner, savior and devil. He has a halo over his head but holds a serpent in his hand. Suspended from a branch next to his heads are two apples, which like the serpent, allude to temptation and sin. Some clues to the interpretation of this painting are contained in the two books included in the portrait of Meyer de Haan: Thomas Carlyle's *Sartor Resartus*, which states that all that man does is "symbolical: a revela-

tion to Sense of the mystic god-given force that is in him"; and John Milton's *Paradise Lost*, in which Satan, the fallen angel, is a heroic, almost engaging figure. As the leader of a group of artists engaged in forging a new symbolist style, Gauguin may have seen himself as a Christlike creator, yet at the same time, as an outlaw, a dark angel who was jealous of Meyer de Haan for having an affair with Marie Henry.

The way in which this *Self-Portrait* is painted is as important as its content; the articulation of elements is self-consciously primitive, and the shapes severely simplified. Abstracted beyond recognition, the flowers and their stems form decorative patterns, while Gauguin's head, with its sardonic sidelong glance, is without a body, suspended between two flat planes of intense color. This represents one of several reactions against the ephemerality of impressionism that occurred at the end of the nineteenth century, with Gauguin looking to create a visual language that uncovered a world of thought and emotion that lay behind appearances. Ever restless, Gauguin found even Brittany too civilized, and in 1891 he left for Tahiti where, except for a brief return to France, he would spend the rest of his life.

Paul Gauguin
(French, 1848–1903)
Self-Portrait
1889, oil on wood
79.2 × 51.3 (31 ¼ × 20 ¼)
Chester Dale Collection
1963.10.150

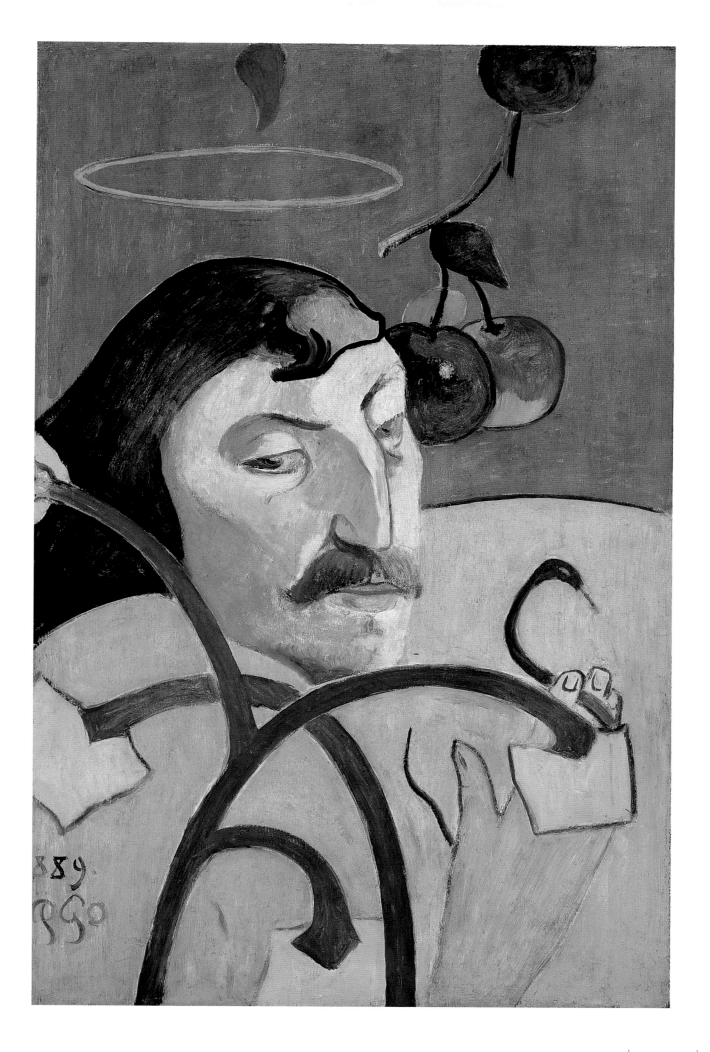

Scene from the Steeplechase: The Fallen Jockey

EDGAR DEGAS

• Perhaps because both involved movement, horse racing and dancers proved almost equally captivating to Degas. This large painting is among Degas' earliest depictions of jockeys and horses. It was exhibited in the Paris Salon of 1866, where it received mixed reviews. The artist kept the picture in his possession until his death.

For most of his life Degas enjoyed financial security and did not need to sell his works, thus it is possible that he retained this painting because he was not entirely satisfied with it. Around 1866 he redrew a horse, whose dark shape can be discerned at the upper right; in 1880–1881 he reworked the canvas, adding a second riderless horse; and about 1897 he returned to the picture again. He made a number of preparatory drawings of horses and jockeys in 1866 and in 1880–1881. And as part of his study of anatomy, musculature, and movement from the 1870s into the 1890s, he made wax sculptures of horses, many of which belong to the National Gallery of Art, thanks to the generosity of Mr. and Mrs. Paul Mellon. Degas was also aware of the sequential frames of horses in motion taken by American photographer Eadweard Muybridge and published in 1887.

France imported both thoroughbred and steeplechase racing from England in the late eighteenth century (consequently much of the vocabulary, such as "le jockey," is English),

and significant differences distinguished the two types of racing. Professional jockeys rode in the thoroughbred races, for one thing, whereas steeplechases were ridden by "gentlemen": that is to say, amateurs. The steeplechase held more inherent danger, with its series of obstacles and jumps, and in Degas' painting there is a legitimate question as to whether the jockey is alive or dead. For the aristocracy and upper classes, however, the element of risk and the chance to test one's skill were alluring. Here Degas conveys the headlong rush and instability of the race through the simple but effective compositional device of placing the horses and fallen jockey on a diagonal. The low vantage point puts the viewer alarmingly close to the action.

Although Degas was a founding member of the impressionist movement and exhibited with the group until 1886, his vision differed in fundamental ways. His classical training, which included the École des Beaux-Arts in Paris and years spent studying and copying Renaissance art in Italy, fostered an interest in the human figure and a love of drawing. A lifelong Parisian, his subjects were most often taken from the urban milieu and were carefully composed in the studio from memory and from sketches. He had no interest in the ephemeral aspects of impressionism, saying, "My art has nothing spontaneous about it, it is all reflection."

Edgar Degas
(French, 1834–1917)
*Scene from the Steeplechase:
The Fallen Jockey*
1866, reworked 1880–1881
and c. 1897, oil on canvas
180 × 152 (71 × 59 ½)
Collection of
Mr. and Mrs. Paul Mellon
1999.79.10

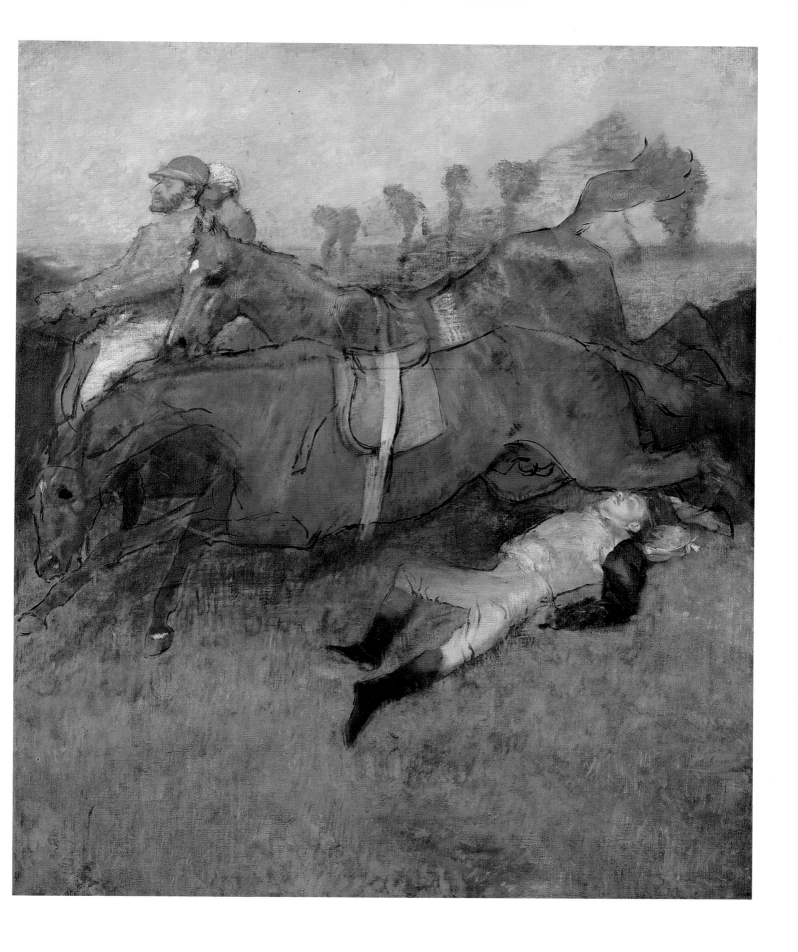

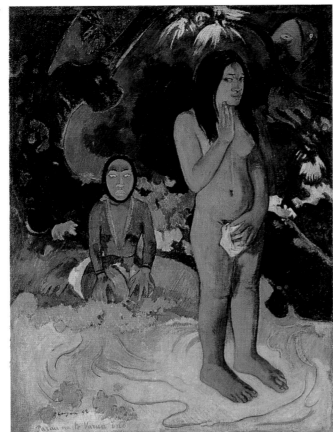

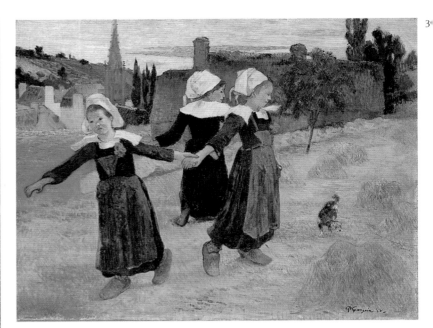

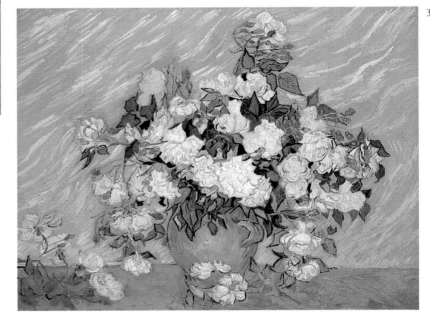

307

Paul Gauguin
(French, 1848–1903)
Parau na te Varua ino
(Words of the Devil)
1892, oil on canvas
91.7 × 68.5 (36 ⅛ × 27)
Gift of the W. Averell
Harriman Foundation in
memory of Marie N. Harriman
1972.9.12

308

Paul Gauguin
(French, 1848–1903)
Breton Girls Dancing, Pont-Aven
1888, oil on canvas
73 × 92.7 (28 ¾ × 36 ½)
Collection of
Mr. and Mrs. Paul Mellon
1983.1.19

309

Vincent van Gogh
(Dutch, 1853–1890)
Roses
1890, oil on canvas
71 × 90 (28 × 35 ½)
Gift of Pamela Harriman
in memory of W. Averell Harriman
1991.67.1

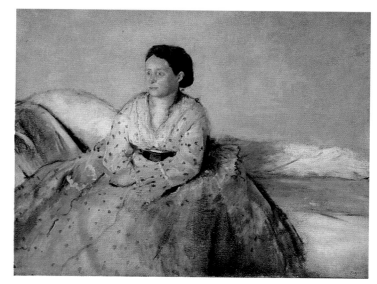

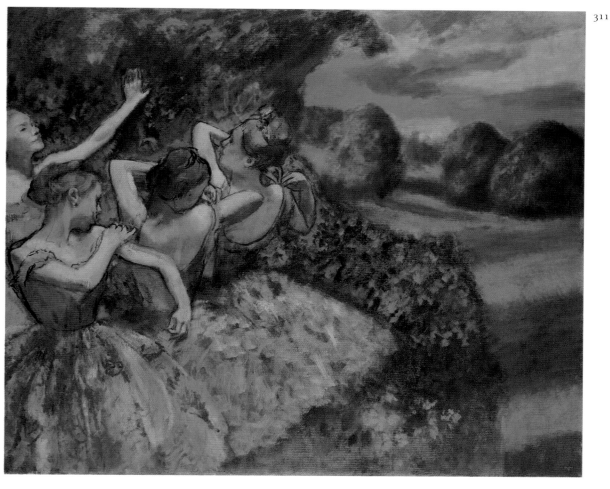

310

311

Edgar Degas
(French, 1834–1917)
Madame René de Gas
1872/1873, oil on canvas
72.9 × 92 (28 ¾ × 36 ¼)
Chester Dale Collection
1963.10.124

Edgar Degas
(French, 1834–1917)
Four Dancers
c. 1899, oil on canvas
151.1 × 180.2 (59 ½ × 71)
Chester Dale Collection
1963.10.122

Diana

AUGUSTE RENOIR

• Renoir was born in Limoges into a family of modest means that moved to Paris when he was three years old. His artistic gifts became apparent early, and when he was thirteen he worked as a porcelain painter, decorating plates and vases with flowers and goddesses. When he was twenty he began to visit the studio of the academic painter Charles Gleyre, who, in Renoir's words, "was incapable of providing any assistance to his students…but at least he had the decency to leave them to do exactly as they pleased." It was here that Renoir met Alfred Sisley, Frédéric Bazille, and Claude Monet, whose careers were also just beginning. In addition, Renoir copied paintings in the Musée du Louvre, won admission to the École des Beaux-Arts, and painted out-of-doors with his friends in the forest of Fontainebleau.

Diana is a large and major early work. The model is Lise Tréhot, who was the artist's favorite model and mistress from 1866 until her marriage in 1872. Her pose is typical of those assumed by models in an academic studio class, and it is likely that she originally held a staff. According to Renoir, the painting began as a straightforward depiction of a nude, but he was concerned that the figure was too blatantly naked and added the animal skin that is draped across her thighs, the dead deer in the foreground, and the bow in her hands. With these attributes he created a representation of the mythological figure of Diana, goddess of the hunt.

Renoir submitted the picture to the Salon of 1867, where it was refused. One can imagine that the jury would have found the distinctly unclassical proportions and palpable flesh of the model's body insufficiently idealized. Renoir was influenced here by the realism of Gustave Courbet and by Courbet's technique, as can be seen especially in the rocks and the tree trunk where he used a palette knife to apply the paint. The influence of Manet has also been observed. And even though the work was composed in the studio, the setting is derived in part from Renoir's expeditions in Fontainebleau and in part from the landscapes of the Barbizon artist Narcisse Diaz.

One might expect the young artist in the course of finding his way to call on the example of those he admires, but what is notable about *Diana* is how Renoir has successfully fashioned a coherent and pleasing image out of different and sometimes divergent elements. Although his style changed over the course of his long career, which saw the production of more than five hundred paintings, his appreciative representations of the female nude remained a constant.

Auguste Renoir
(French, 1841–1919)
Diana
1867, oil on canvas
199.5 × 129.5 (77 × 51 ¼)
Chester Dale Collection
1963.10.205

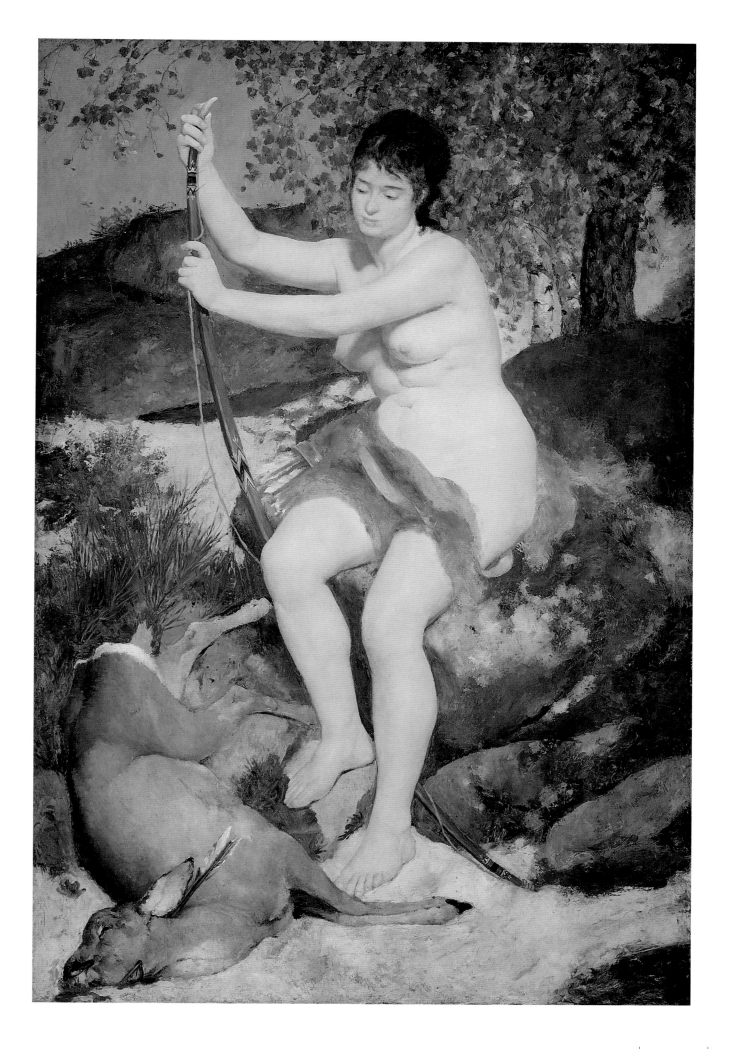

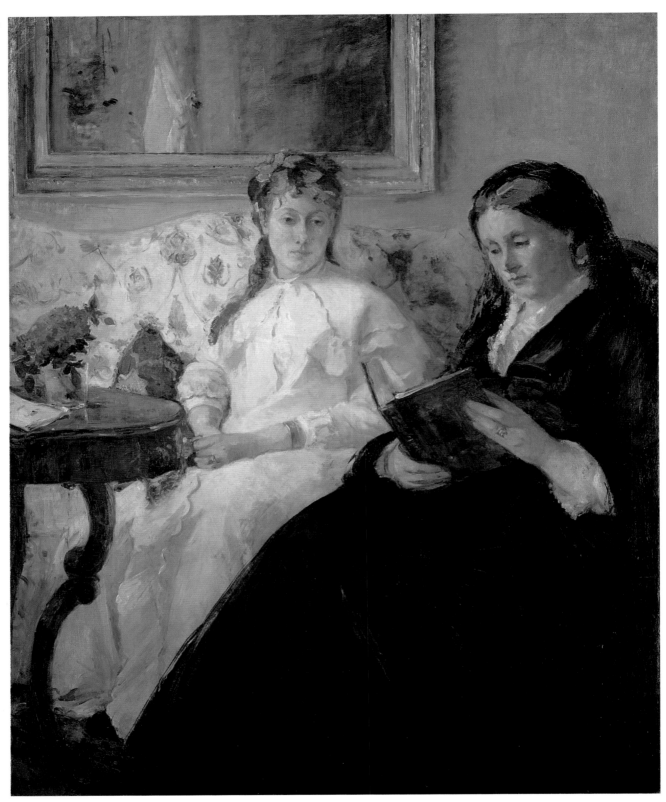

313

Berthe Morisot
(French, 1841–1895)
The Mother and Sister of the Artist
1869/1870, oil on canvas
101 × 81.8 (39 ½ × 32 ¼)
Chester Dale Collection
1963.10.186

314

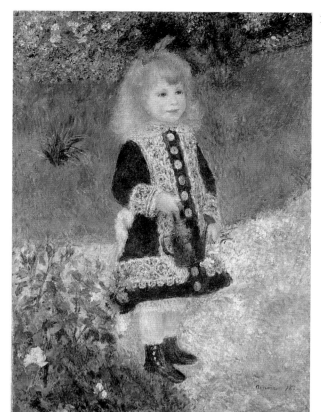

316

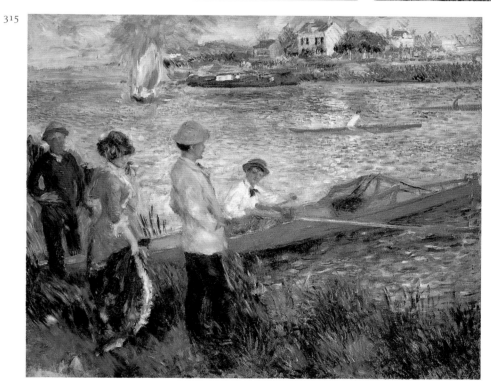

315

314	315	316

Alfred Sisley
(French, 1839–1899)
Flood at Port-Marly
1872, oil on canvas
46.4 × 61 (18 ¼ × 24)
Collection of
Mr. and Mrs. Paul Mellon
1985.64.38

Auguste Renoir
(French, 1841–1919)
Oarsmen at Chatou
1879, oil on canvas
81.2 × 100.2 (32 × 39 ½)
Gift of Sam A. Lewisohn
1951.5.2

Auguste Renoir
(French, 1841–1919)
A Girl with a Watering Can
1876, oil on canvas
100.3 × 73.2 (39 ½ × 28 ¾)
Chester Dale Collection
1963.10.206

Woman with a Parasol — Madame Monet and Her Son

CLAUDE MONET

• With the onset of the Franco-Prussian War in 1870 Monet left France to live first in England and then in the Netherlands. In December 1871 he and his family moved to Argenteuil, a small town on the Seine not far from Paris and connected to the capital by the railway. Monet remained in Argenteuil until 1878, and his years there were quite productive. Other artists often joined him, among them Sisley, Renoir, Manet, Degas, and Cézanne, and together or individually they painted out-of-doors in the town and surrounding countryside.

This painting, an icon of impressionism, was executed in Argenteuil. The artist added the date and signature later, perhaps when he showed the picture in Paris in 1876 at the second impressionist exhibition. He has depicted his model and mistress, Camille, whom he married in 1870, and their son, Jean, who was born in 1867 and is thus seven or eight years old here. Standing on a grassy hill bedecked with wildflowers, the two are seen from below, dramatically silhouetted against a cerulean sky and feathery clouds. A strong wind plays with Camille's veil and the folds of her dress.

Painted *en plein air*, this picture captures with breathtaking verve and immediacy the effects of light, shadow, and wind on a late spring or summer day. Monet's brushwork dances across the surface and is most animated in the strokes that define the clouds and Camille's dress. The artist also showed exquisite sensitivity to the effects of reflected light, as can be seen here in the yellow glow that the flowers cast on the underside of Camille's arm. In pictures such as this Monet and other impressionists created a kind of earthly paradise, which celebrated the pleasure of the moment. The reality of Monet's poverty is nowhere to be seen, but it is known that Camille, in addition to receiving money from Manet, agreed in October 1875 to give an art supply dealer her rights to a future inheritance in order to pay off her husband's debts.

Claude Monet
(French, 1840–1926)
Woman with a Parasol—
Madame Monet and Her Son
1875, oil on canvas
100 × 81 (39 3/8 × 31 7/8)
Collection of
Mr. and Mrs. Paul Mellon
1983.1.29

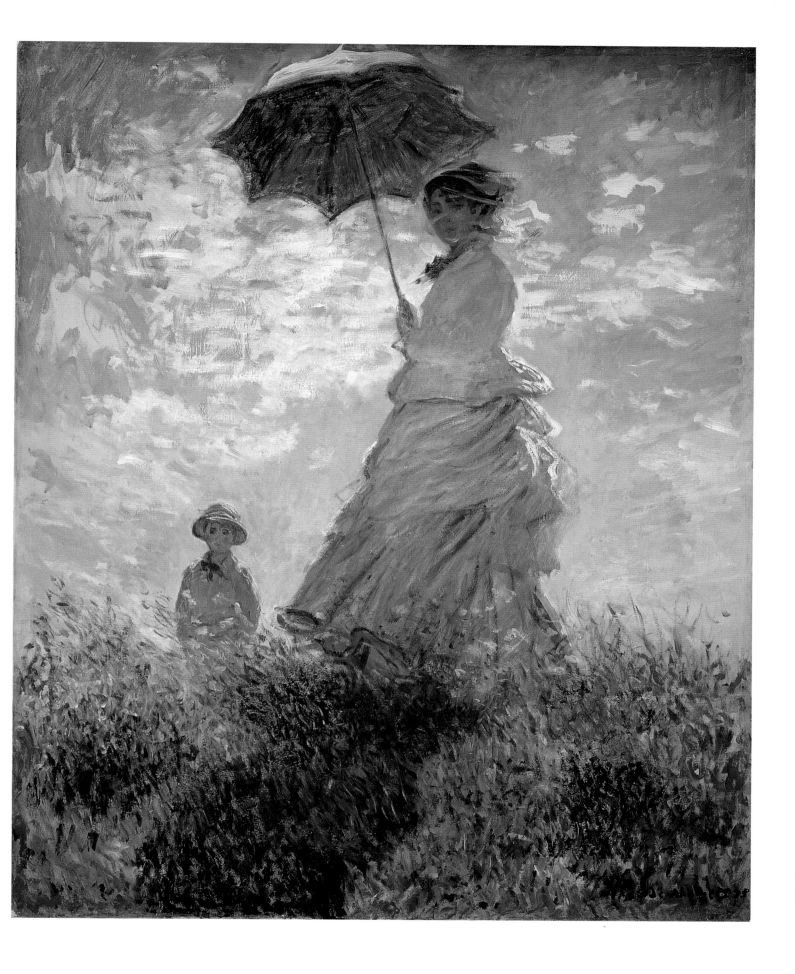

Rouen Cathedral, West Façade

CLAUDE MONET

• The so-called crisis of impressionism that occurred in the 1880s was in fact as much evolution as revolution, as the artists, many now in middle age and midcareer, began to move in different directions. Monet turned to the production of serial images. In 1884–1885 he painted a series of pictures of haystacks, and in 1891, a series of poplars.

In 1892 Monet went to Rouen, in Normandy, and rented a room facing the city's Gothic cathedral. There he began a number of canvases showing the cathedral at various times of the day and under varying atmospheric conditions. He could work on one picture for only about an hour before the light would change noticeably, and he would move on to another canvas. Breaking with his normal procedure, Monet did not complete the paintings in Rouen but brought them back to his studio in Giverny to be finished. This project occupied him for three years and resulted in at least thirty paintings, twenty-seven of which are still extant. In 1895 twenty pictures from the series, including *Rouen Cathedral, West Façade*, were exhibited at the Galerie Durand-Ruel, Paris.

For Monet the choice of architecture as the object of study had certain advantages over haystacks or poplars. Of paramount consideration, the stone building, unlike organic things, experienced minimal change with the passage of time or seasons. Because the cathedral itself remained the same, the real subject of Monet's paintings became the artist's perceptions of changing light.

In *Rouen Cathedral, West Façade*, the light of early morning has been translated into shimmering skeins of brush strokes in shades of blue, peach, and orange. The paint application is quite varied, ranging from thin washes to thick impasto; in some areas thinned paint was even dragged rapidly over the dried impasto. While the many touches and strokes of pigment coalesce into an image of the cathedral, they also have inherent energy and attraction. And by completing the painting in his studio, Monet may be said to have distanced himself from the motif and could focus more with recording his subjective experience of visual sensation.

Monet's serial paintings defined one path that led to abstract art in the twentieth century. For Wassily Kandinsky the experience of seeing one of Monet's haystacks in an exhibition in Moscow shook him, as he says, "to the depths of my being" and led to the revelation that objects were not essential to a work of art.

318

Claude Monet
(French, 1840–1926)
Rouen Cathedral, West Façade
1894, oil on canvas
100.05 × 65.9 (39 ⅜ × 26)
Chester Dale Collection
1963.10.49

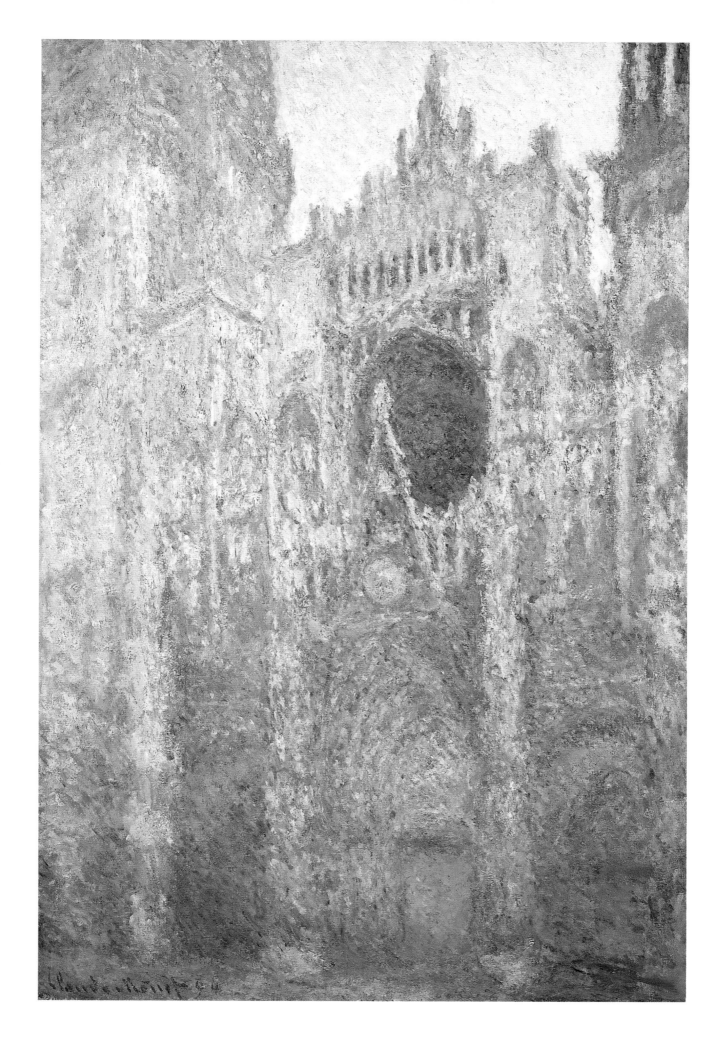

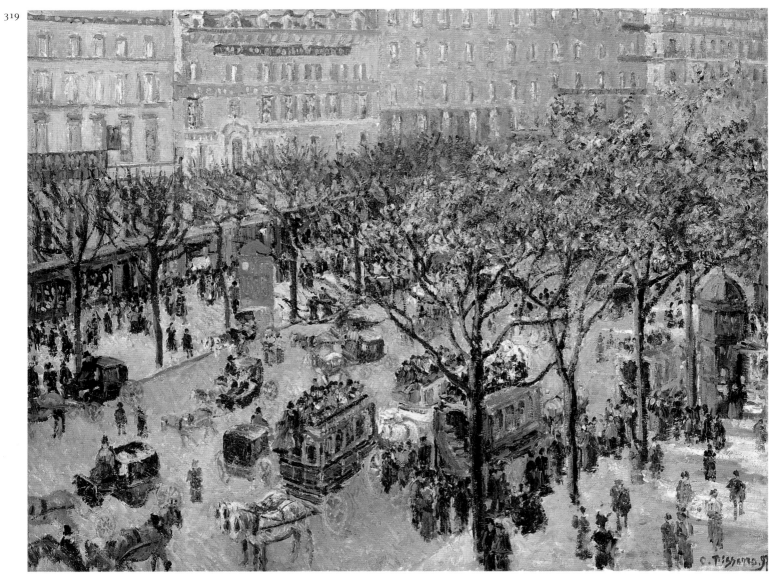

Camille Pissarro
(French, 1830–1903)
Boulevard des Italiens,
Morning, Sunlight
1897, oil on canvas
73.2 × 92.1 (28 7/8 × 36 1/4)
Chester Dale Collection
1963.10.198

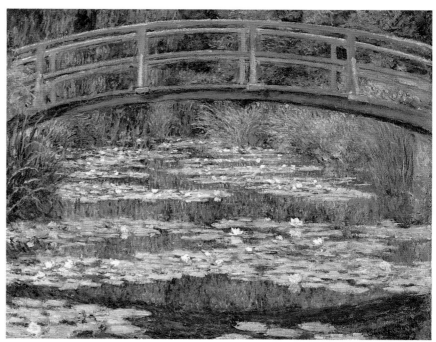

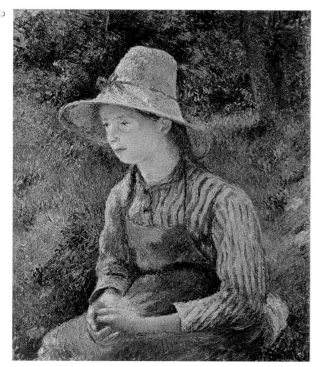

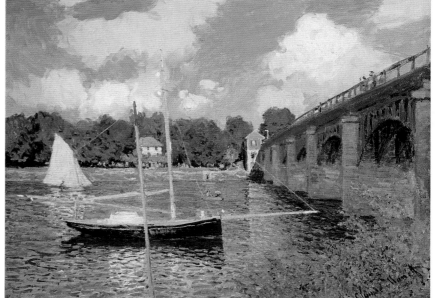

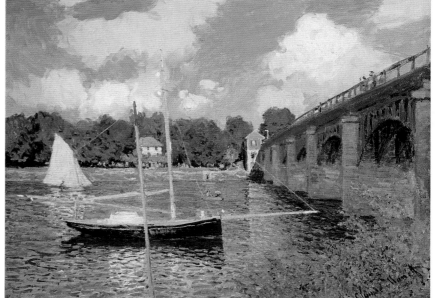

320

Camille Pissarro
(French, 1830–1903)
Peasant Girl with a Straw Hat
1881, oil on canvas
73.4 × 59.6 (28 ⅞ × 23 ½)
Ailsa Mellon Bruce Collection
1970.17.52

321

Claude Monet
(French, 1840–1926)
The Japanese Footbridge
1899, oil on canvas
81.28 × 101.6 (32 × 40)
Gift of Victoria Nebeker Coberly,
in memory of her son John W. Mudd,
and Walter H. and Leonore Annenberg
1992.9.1

322

Claude Monet
(French, 1840–1926)
The Bridge at Argenteuil
1874, oil on canvas
60 × 79.7 (23 ⅝ × 31 ⅜)
Collection of
Mr. and Mrs. Paul Mellon
1983.1.24

The Artist's Father

PAUL CÉZANNE

• Although his situation is hardly unique, Cézanne exemplified the artist who faces opposition at home over his or her choice of profession. Born in Aix-en-Provence, in the south of France, he received a solid classical education at the local Collège Bourbon, where Émile Zola was a close friend. Cézanne's father, Louis-Auguste, was shrewd businessman who, by virtue of owning the only bank in town, became one of the wealthiest men in Aix. In 1857 Cézanne began to attend free drawing classes and to study paintings in the Musée Granet, but his desire to become an artist was thwarted by his father, who persuaded him to study law at the university in Aix in 1858, saying "think of the future; one dies with genius, but one eats with money!"

Cézanne soon regretted this decision and struggled with his father for permission to become a painter. In 1861 Louis-Auguste finally relented and allowed his son to go to Paris, where Zola was already working as a writer. By turns shy, temperamental, and immature, Cézanne did not enjoy his initial stay and was back in Aix after five months. Subsequently he divided his time between Paris and Aix. In 1863 he was primarily in Paris and exhibited in the Salon des Refusés. Between August and December 1866 he was in Aix, where he painted this portrait of his father. Cézanne often used members of his family as models, and Louis-Auguste, who was then sixty-eight years old, apparently agreed to pose only if he could read the newspaper. A staunch conservative, Louis-Auguste usually read *Le Siècle*, whose editorials mirrored his own dislike of the Second Empire under Napoleon III. But Cézanne changed the masthead to *L'Événement*, a short-lived Parisian newspaper (it folded in November 1866) that had hired Zola as its art critic and had printed his articles defending Manet and attacking the jury for the Salon of 1866.

Cézanne followed the example of Gustave Courbet in using a palette knife to apply paint throughout most of the picture, but if anything, he outdid Courbet in laying the pigment on the canvas in thick slabs. The heavy surface aptly reinforces the powerful presence and obdurate character of the sitter. Cézanne produced a number of palette-knife paintings in 1866, including *Still Life: Sugar Pot, Pears, and Blue Cup*, which is represented here hanging on the wall behind his father (now in the Musée Granet, Aix, on loan from the Musée d'Orsay, Paris). Even in an early work such as *The Artist's Father* one can see Cézanne's skill at composition. The one note of youthful awkwardness is the disconcerting placement of a frontal figure in an armchair seen at an angle.

323

Paul Cézanne
(French, 1839–1906)
The Artist's Father
1866, oil on canvas
198.5 × 119.3 (78 ⅛ × 47)
Collection of
Mr. and Mrs. Paul Mellon
1970.5.1

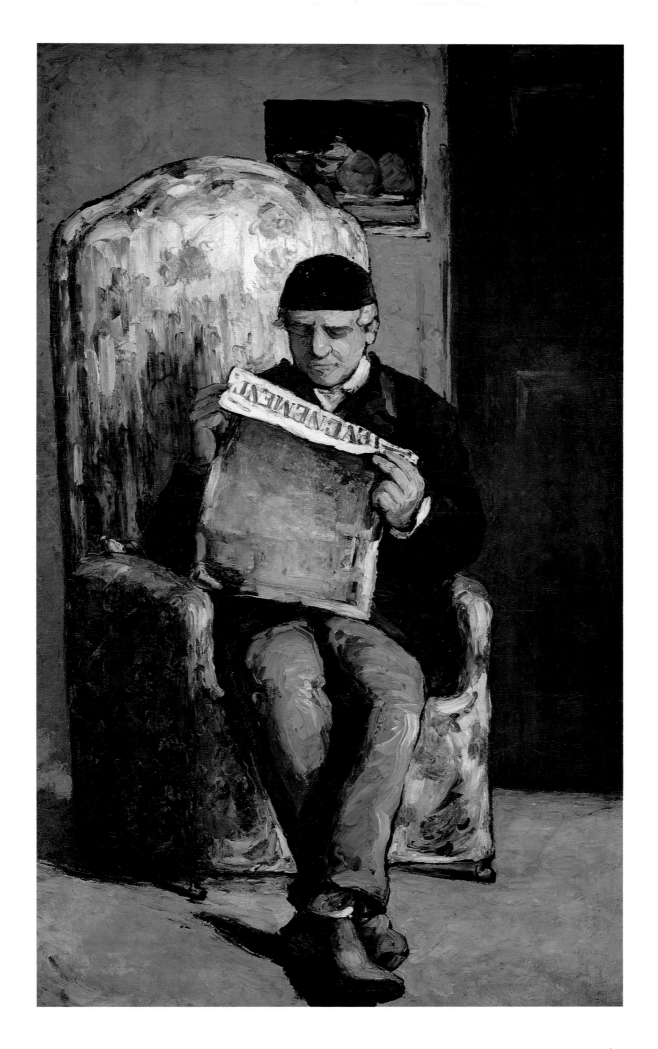

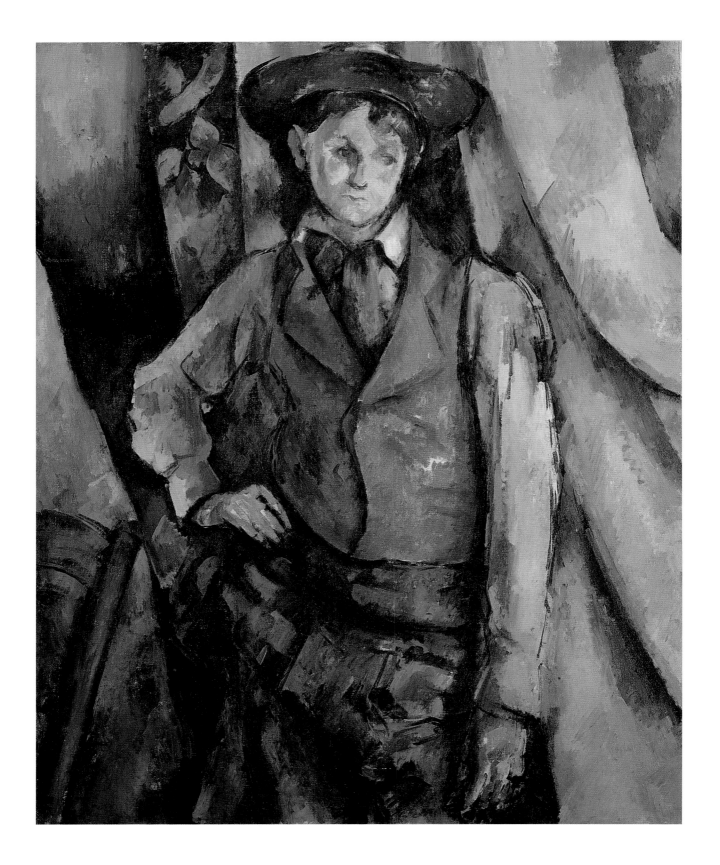

324

Paul Cézanne
(French, 1839–1906)
Boy in a Red Waistcoat
1888–1890, oil on canvas
89.54 × 72.39 (35 ¼ × 28 ½)
Collection of Mr. and Mrs. Paul Mellon,
in Honor of the 50th Anniversary
of the National Gallery of Art
1995.47.5

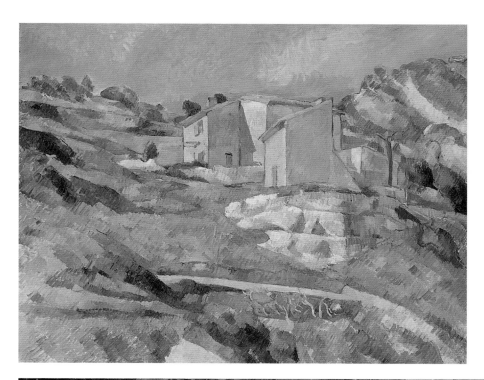

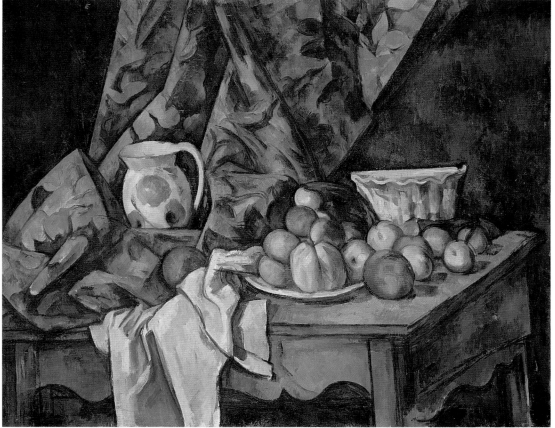

325

326

Paul Cézanne
(French, 1839–1906)
Houses in Provence
c. 1880, oil on canvas
65 × 81.3 (25 ⅝ × 32)
Collection of
Mr. and Mrs. Paul Mellon
1973.68.1

Paul Cézanne
(French, 1839–1906)
Still Life with Apples and Peaches
c. 1905, oil on canvas
81 × 100.5 (31 ⅞ × 39 ½)
Gift of Eugene and Agnes E. Meyer
1959.15.1

The Lighthouse at Honfleur

GEORGES SEURAT

• Seurat was the originator and chief proponent of the movement known as neo-impressionism. Essentially, he took the impressionists' approach to rendering color and light and rigorously systematized it. He had studied the writings of the American physicist Ogden Rood as well as an 1839 book by Michel-Eugène Chevreul on the simultaneous contrast of colors. He also carefully examined the paintings of Delacroix, an innovative colorist. Luminosity and vibrancy, he found, could be enhanced through the juxtaposition of individual strokes of complementary colors, which would form an optical mixture when viewed from a distance. In place of the spontaneous, personal brushwork of Monet or Renoir, the neo-impressionists applied paint in small controlled dots, in a style known as pointillism, or in short uniform strokes, known as divisionism. The process was laborious and mechanical, and it was usually done in the studio rather than in the open air. As Seurat wrote to his friend Émile Verhaeren, a Belgian poet, critic, and first owner of the *Lighthouse at Honfleur*, two and a half months were required to complete the picture.

Seurat spent the summer of 1886 at Honfleur, which is situated on the Normandy coast. The view he has captured here looks east across the mouth of the Seine toward Le Havre. The region had long been popular with artists, including Monet, Eugène Boudin, and Johan Barthold Jongkind. This picture, a splendid example of divisionism, is constructed of innumerable discrete touches of paint. The roof of the building at the right, which appears gray, is an optical mixture of green, blue, pink, cream, light brown, and orange. The granite lighthouse is created with small strokes of orange and blue of various intensities. And the contrast between the lighthouse and the sky has been strengthened by making the sky lighter on the dark side of the structure and darker on the sunlit side. Seurat's composition is equally meticulous, using horizontals, verticals, and a few diagonals to define a stable arrangement that, when combined with a nearly complete lack of human activity, evokes the heat and stillness of a summer day.

A silent, secretive man, Seurat was only thirty-one when he died, and although neo-impressionism was also relatively short-lived, being in vogue from only 1886 to 1906, both its theoretical basis and emphasis on formal compositions that tended toward flatness and abstraction inspired avant-garde artists.

Georges Seurat
(French, 1859–1891)
The Lighthouse at Honfleur
1886, oil on canvas
66.7 × 81.9 (26 ¼ × 32 ¼)
Collection of
Mr. and Mrs. Paul Mellon
1983.1.33

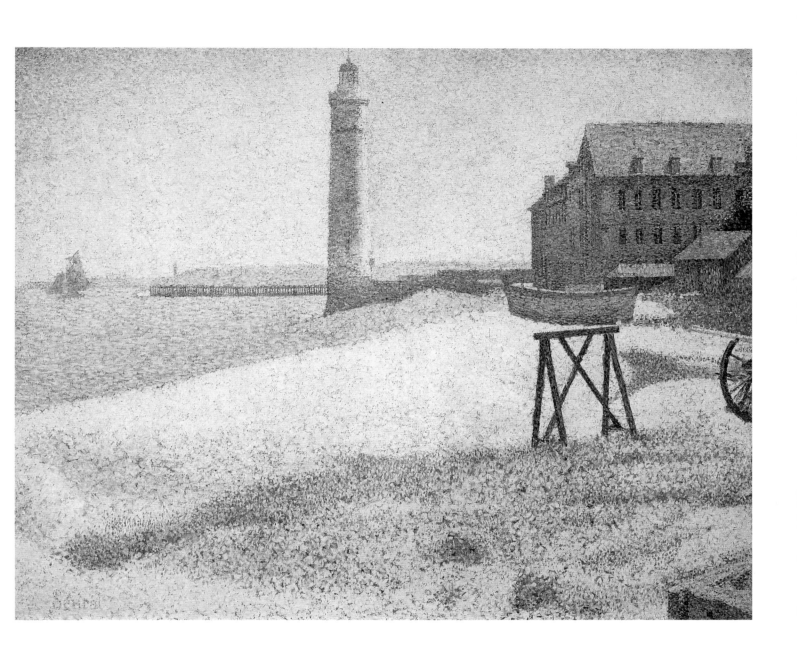

A Corner of the Moulin de la Galette

HENRI DE TOULOUSE-LAUTREC

• Lautrec was born in Albi, in the south of France, into a wealthy and aristocratic family, which was the cause of much misfortune. Because his parents were first cousins, he inherited a genetic bone disorder that stunted his growth and left him crippled after both his legs broke in 1878 and 1879. His father was an eccentric who alternated between reclusiveness and outrageous public behavior. His mother, going to the other extreme, was often overly protective and stifling. Encouraged by both his father and his uncle, who were amateur artists, Lautrec drew constantly, especially during his convalescence, and he was particularly adept at sketching the horses and other animals that populated the family estate.

In 1882, accompanied by his mother, Lautrec went to Paris, where he received conventional academic training in art from Léon Bonnat and Fernand Cormon. The avant-garde interested him, but he never allied himself with any particular movement. In 1884, he moved to Montmartre, a section of Paris that had escaped much of the urban renewal of the 1860s; it was a haven for the poor and those on the margins of society, and because rents were low, several artists had studios here. The area also boasted numerous bars, cabarets, brothels, and dance halls that attracted a diverse and often dangerous clientele in the 1890s. As Lautrec descended into alcoholism, he became a regular at such establishments as the Moulin Rouge and the Chat Noir.

It is generally agreed that this painting depicts the Moulin de la Galette. Located on the rue Lepic, not far from Lautrec's studio, it was notable for having what was probably the largest open-air dance hall in the city. Shown here, an anonymous group sits and drinks indoors, while others stand about. Lautrec's genius lay in his ability to convey essential aspects of mood and character through facial expression, gesture, and posture. The man and woman at the right, for instance, seem estranged from each other, even though they sit at the same table, their senses perhaps dulled by alcohol. The standing woman in dark blue appears equally vacant and isolated. In fact, there is no interaction among the figures represented in this picture.

One artist that Lautrec keenly admired was Edgar Degas, and the cropped figures and low vantage point that puts the viewer into the pictorial space are devices adopted from Degas. This picture is an excellent example of a technique called *à l'essence*, often used by Lautrec, in which oil paint greatly diluted with turpentine was applied on unprimed cardboard. Absorbed by the raw cardboard, the mixture has dried to a matte surface. This was not only Lautrec's aesthetic preference, but it indicated his disdain for what he saw has the trickery and affectation of the highly reflective, heavily varnished surfaces typical of Salon paintings.

Henri de Toulouse-Lautrec
(French, 1864–1901)
A Corner of the Moulin de la Galette
1892, oil on cardboard
100 × 89.2 (39 3/8 × 35 1/8)
Chester Dale Collection
1963.10.67

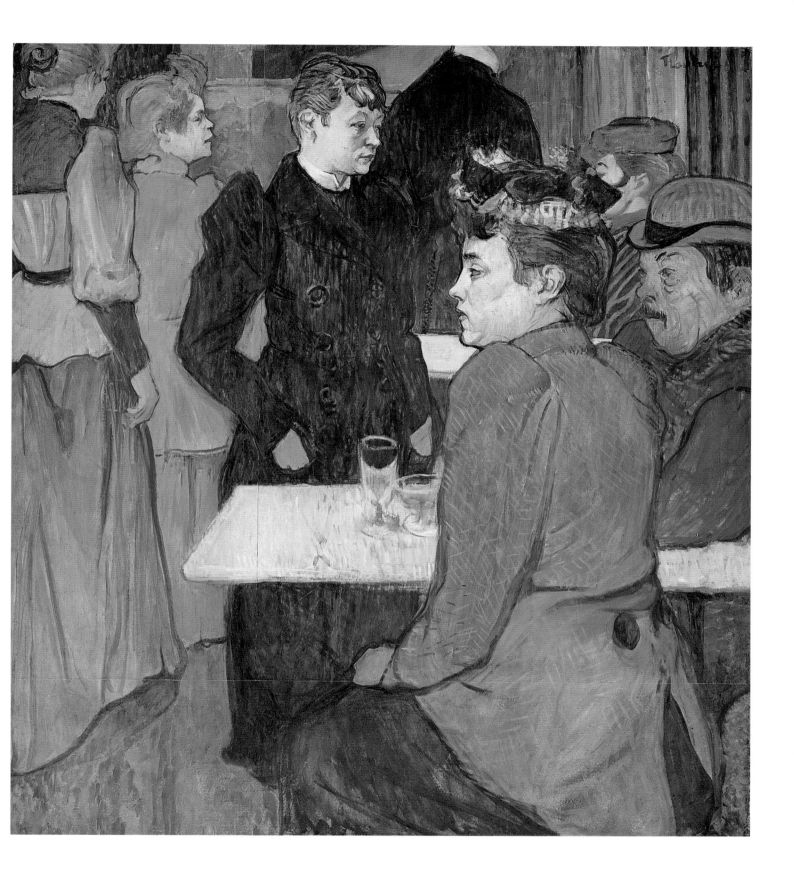

Marcelle Lender Dancing the Bolero in "Chilpéric"

HENRI DE TOULOUSE-LAUTREC

• In addition to his other nocturnal entertainments, Lautrec was an avid theatergoer. He became fascinated to the point of obsession with the actress, singer, and dancer Marcelle Lender. It is reported that he attended at least twenty performances of *Chilpéric* and forced his friends to accompany him. He would make rapid pencil sketches that seized in a few strokes the essentials of the action; these functioned, as did Degas' drawings, more as a repertoire of poses than as preparation for a specific project. Although Lautrec considered Lender's back "sumptuous" and "magnificent," the emphasis here is on her slender leg and foot, ample bosom, and flaming red orange hair.

First performed in 1868, *Chilpéric*, a comic opera (*opéra bouffe*), was revived in 1895 and presented at the Théâtre des Variétés in Paris. Both the music and the libretto were written by Hervé, the pseudonym of Louis Auguste Ronger, who along with Jacques Offenbach, was one of the main creators of the operetta in France.

The plot of the opera, set very loosely in sixth-century France, revolved around the antics of the Merovingian king Chilpéric, his mistress Frédégond, and his bride, the Spanish princess Galswinthe. Lautrec's painting depicts the moment in the second act when Galswinthe, played by Marcelle Lender, dances the bolero of her native Spain for the assembled members of the court. At the left King Chilpéric is on his throne flanked by members of his entourage, two of whom are sneezing. At the right are two female pages in blue and Galswinthe's brother, Don Nervoso, who ogles her appreciatively. One indication of the lack of concern for historical accuracy is that, while most of the cast wear quasi-medieval garb, Don Nervoso is dressed as a toreador, and Galswinthe wears a contemporary Spanish costume in pink and black with two enormous pink silk flowers in her hair. In revival *Chilpéric* was a great success and was sold out for many weeks.

In 1882 the Théâtre des Variétés was the first theater in Paris to have electric lights, and the artist has captured the particular quality of the artificial illumination as well as Lender's movements and the colorful costumes and scenery. This is the largest and most important of Lautrec's theatrical paintings, and it was never exhibited, remaining in his studio until his death. The artist supposedly offered the picture to the actress, but both his attentions and his art were rejected. As Lender put it, "he indeed loves me….But the painting, you can have it."

329

Henri de Toulouse-Lautrec
(French, 1864–1901)
Marcelle Lender Dancing the Bolero in "Chilpéric"
1895–1896, oil on canvas
145 × 149 (57 ⅛ × 59)
Collection of Mr. and Mrs. John Hay Whitney
1990.127.1

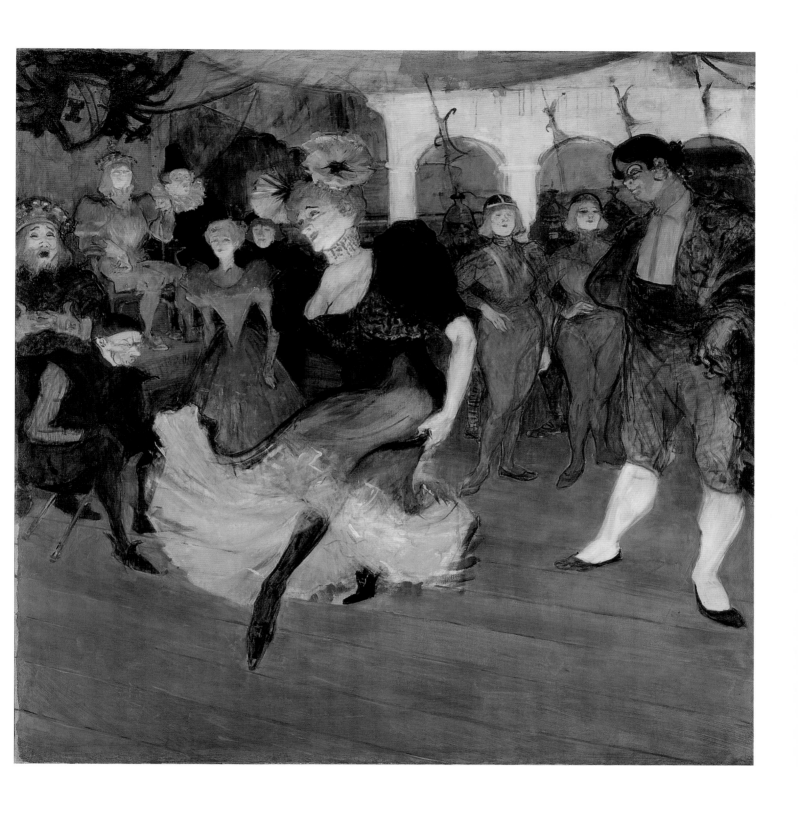

Two Dogs in a Deserted Street

PIERRE BONNARD

• Bonnard was born in the village of Fontenay-aux-Roses, south of Paris, and his childhood was spent in Fontenay, in Paris, or at the family estate at Grand-Lemps, near Lyon. Country living fostered in him a lifelong love of nature and animals. Uncertain as to a choice of career, Bonnard acceded to his father's wishes and began law school in Paris in 1885, becoming a lawyer in 1889. Yet he was always interested in painting and drawing, and in 1887 he enrolled at the Académie Julian in Paris.

There Bonnard met Paul Sérusier and Maurice Denis. Sérusier had studied with Gauguin at Pont-Aven, and both he and Denis were strongly influenced by Gauguin's ideas about symbolism and his use of flat areas of intense color. The following year, 1888, Sérusier formed a group called the "Nabis," a name derived from the Hebrew word for "prophet." Bonnard and Denis were members and were soon joined by Édouard Vuillard and Ker-Xavier Roussel. Bonnard was enamored not only of Gauguin but of Japanese art, especially the wood-block prints in the collection of Stanley Bing that were exhibited at the École des Beaux-Arts in 1891. In fact, Bonnard was called the "very Japanese Nabi" by his colleagues.

Even in his early works Bonnard had developed his own style and technique and had demonstrated a remarkable knack for capturing those moments, easily overlooked, that are at once ordinary and transfixing. In June 1893 Bonnard visited the town of Eragny-sur-Oise, which lay northwest of Paris. What caught his eye was a street, empty except for two dogs and a wheelbarrow. The encounter may have been accidental, but the composition is anything but haphazard. Against the regular, almost gridlike pattern of shuttered windows and doorways are set the irregular, somewhat indistinct shapes of the dogs and wheelbarrow. Although he was working with a basic juxtaposition of warm and cool colors, Bonnard chose hues that were very subtle and personal: the bluish white walls and pale blue gray shutters are complemented by the pink street and tan window boxes. The only strong colors are the reddish brown door and the three small squares of intense cobalt blue that help anchor the composition and create the visual equivalent of musical beats. This delightful painting was part of the Nabis exhibition of 1893 at Barc de Boutteville and included in Bonnard's first one-man show in Paris in 1896.

Pierre Bonnard
(French, 1867–1947)
Two Dogs in a Deserted Street
c. 1894, oil on wood
35.1 × 27 (13 7/8 × 10 5/8)
Ailsa Mellon Bruce Collection
1970.17.3

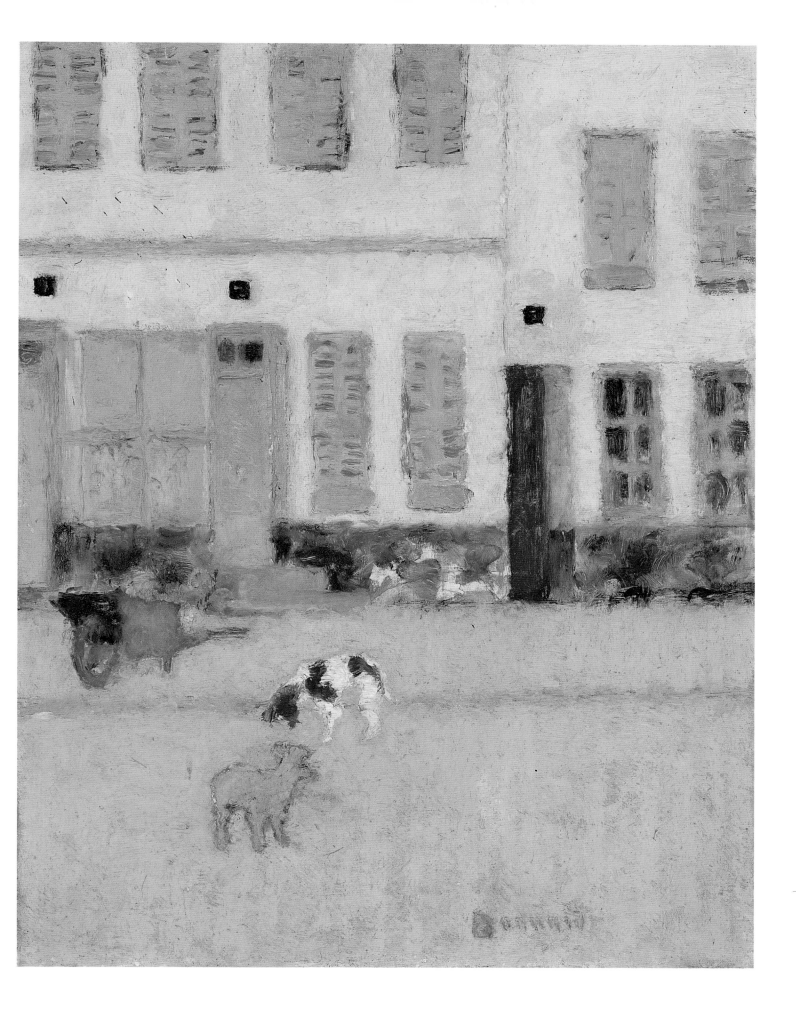

Place Vintimille

EDOUARD VUILLARD

• In 1877 when he was eleven years old, Vuillard and his family moved from Cuiseaux (Saône-et-Loire) to Paris. At the Lycée Condorcet he met Maurice Denis and Ker-Xavier Roussel, who were destined to become artists and life-long friends. In 1886 Vuillard began studying art at the Académie Julian, where he met a kindred spirit, Pierre Bonnard. Three years later Vuillard became associated with the group known as the "Nabis," led by Paul Sérusier and including Denis, Bonnard, and Roussel. One aim of the Nabis was to break down the barriers separating fine and applied art and to challenge the idea that easel pictures were somehow better and more important than decorative works. As a result the artists happily produced posters, prints, theatrical sets, murals, interior decorations, and screens.

In 1910 Marguerite Chapin, a young American living in Paris, commissioned from Vuillard a large decorative canvas, *The Library* (Musée d'Orsay, Paris), for her apartment. The following year she ordered *Place Vintimille* from the artist, and the five-panel folding screen was probably ready for installation by summer. In 1908 Vuillard and his mother, a seamstress and corset maker, had moved to an apartment on the rue de Calais, which offered a direct view onto the Place Vintimille (now called Place Adolphe Max) and the small park at its center. Vuillard remained at rue de Calais until 1927, and he often depicted the view from his window and also took photographs of the site.

Here Place Vintimille is shown in the spring-time, with a profusion of light green and yellow leaves and some trees beginning to flower. The scene is filled with Parisians going about their daily tasks—with one exception: a figure in light blue pants (worker or vagrant?) at the bottom of the center panel seems to be sleeping on the sidewalk. Although the overall design is visible when the screens are flat, Vuillard was aware that the screen would be folded and was careful to make each panel a unified vignette.

Vuillard's love of Japanese art—shared by the other Nabis—is evident in several characteristics of *Place Vintimille*, the most immediate being the folding-screen format. The high vantage point, emphasis on decorative pattern at the expense of detail, and even the choice of a motif from modern urban life are also elements found in Japanese popular prints. To achieve the effects he desired, Vuillard abandoned oil paint and beginning around 1900 preferred to use distemper, or *peinture à la colle*, a water-based paint that was mixed with glue and applied to paper or cardboard. Distemper dried very quickly to form a matte surface, allowing the artist to apply multiple layers and create a richly textured surface.

331

Edouard Vuillard
(French, 1868–1940)
Place Vintimille
1911, five-panel screen, distemper
on paper laid down on canvas
each of five panels: 230 × 60 (90 ½ × 23 ⅝)
Gift of Enid A. Haupt
1998.47.1

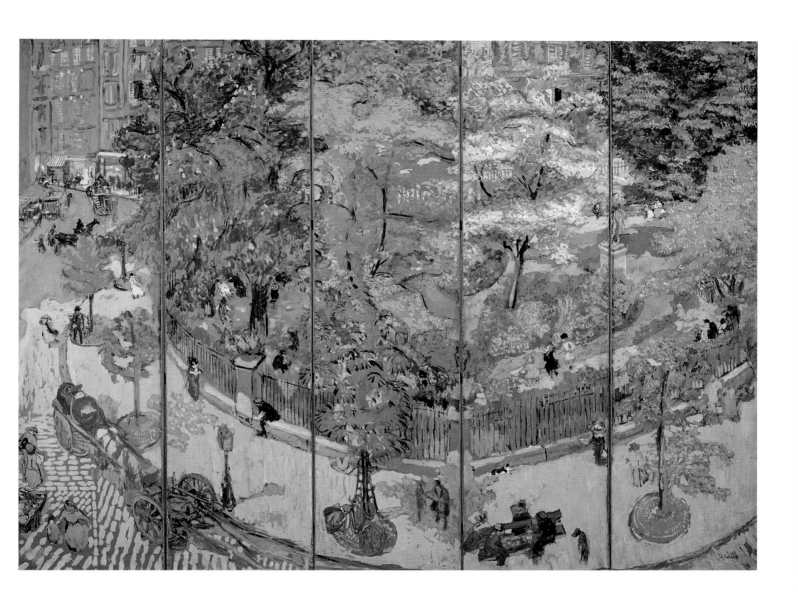

20th century

| | 1200 | 1300 | 1400 |

1500 1600 1700 1800 1900

332

3

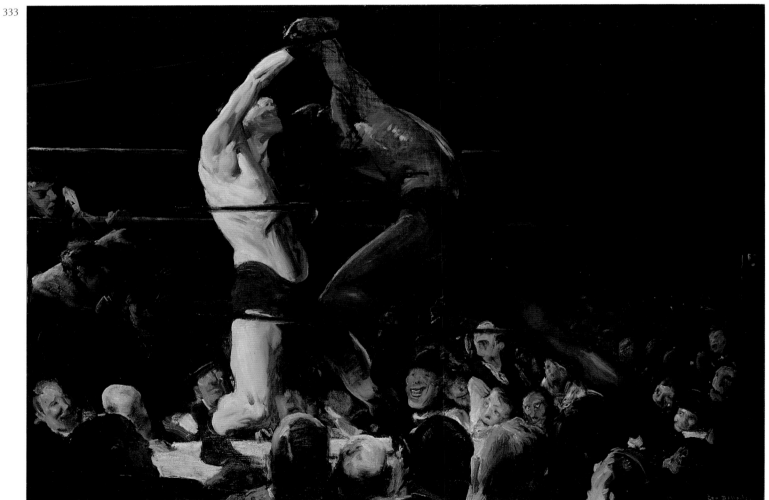

333

332

George Bellows
(American, 1882–1925)
The Lone Tenement
1909, oil on canvas
91.8 × 122.3 (36 1/8 × 48 1/8)
Chester Dale Collection
1963.10.83

333

George Bellows
(American, 1882–1925)
Both Members of This Club
1909, oil on canvas
115 × 160.5 (45 1/4 × 63 1/8)
Chester Dale Collection
1944.13.1

334

John Sloan
(American, 1871–1951)
The City from Greenwich Village
1922, oil on canvas
66 × 85.7 (26 × 33 3/4)
Gift of Helen Farr Sloan
1970.1.1

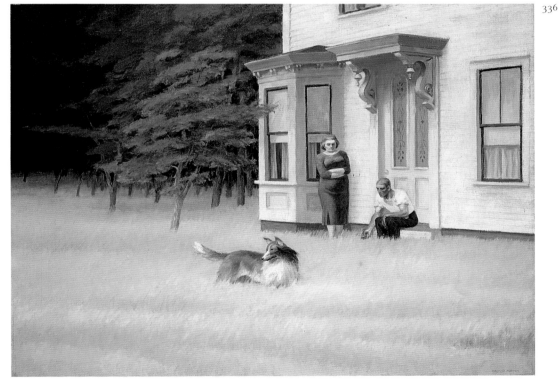

335

336

Childe Hassam
(American, 1859–1935)
Allies Day, May 1917
1917, oil on canvas
92.7 × 76.8 (36 ½ × 30 ¼)
Gift of Ethelyn McKinney in memory
of her brother, Glenn Ford McKinney
1943.9.1

Edward Hopper
(American, 1882–1967)
Cape Cod Evening
1939, oil on canvas
76.2 × 101.6 (30 × 40)
John Hay Whitney Collection
1982.76.6

Family of Saltimbanques

PABLO PICASSO

• In 1904, having previously divided his time between Barcelona and Paris, Picasso decided that his career would be best served by staying in Paris, and he moved into a studio in the Montmartre section of the city. He was soon joined there by Fernande Olivier, a model. *Family of Saltimbanques* was completed the following year. A large work, it is a summation of the major theme of his work at the time: the world of itinerant circus performers, *saltimbanques*. In particular, Picasso was entranced by the Cirque Médrano, a group that was based in Montmartre, not far from his studio. He and Fernande often went with the poets Guillaume Apollinaire and Max Jacob to watch these performances but got to know the clowns and acrobats as individuals as well.

Family of Saltimbanques can be seen as belonging to a broader tradition that includes such paintings as Watteau's *Italian Comedians* and Manet's *The Old Musician* (see nos. 214 and 298), which depict actors and street performers as poor and socially marginalized. Picasso doubtless identified with these wandering outcasts, having gone through periods of poverty himself. In fact, a convincing case has been made that the painting symbolically represents the artist's close friends: it may refer to an unfortunate event in which Picasso and Fernande had adopted a young girl named Raymonde on a trial basis but had returned her to the orphanage at Olivier's insistence, much to the distress of Max Jacob and André Salmon, who had become very fond of the child. In this reading Picasso is said to have portrayed himself as Harlequin at the left, holding the hand of a young girl, while two acrobats (Jacob and Salmon?) stare disapprovingly in the direction of Fernande, sitting apart from the group at the far right.

The setting is a bleak and featureless landscape, and the figures are physically close but emotionally remote. This creates a strong sense of existential isolation and estrangement. Technical examinations have established that Picasso modified the composition before arriving at its present state. Yet not all areas are resolved; for example, the woman's hat appears to be floating above her head. The reworked image reflects not only Picasso's evolving conception of the subject but also his pragmatism: the canvas was too large and costly to be wasted.

337

Pablo Picasso
(Spanish, 1881–1973)
Family of Saltimbanques
1905, oil on canvas
212.8 × 229.6 (83 ¾ × 90 ⅜)
Chester Dale Collection
1963.10.190

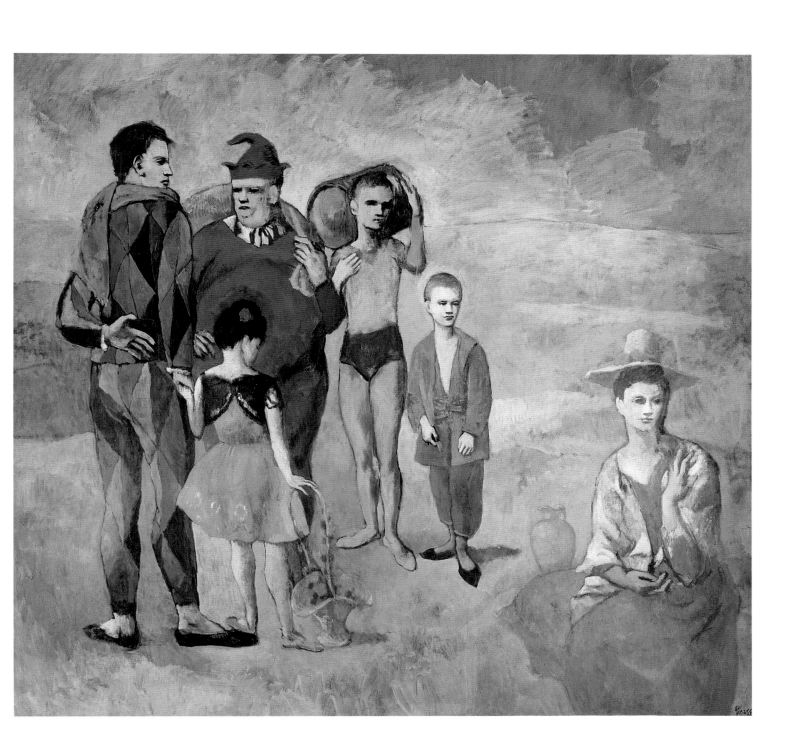

339

338	339	340
Henri Rousseau	Francis Picabia	Pablo Picasso
(French, 1844–1910)	(French, 1879–1953)	(Spanish, 1881–1973)
Tropical Forest with Monkeys	*The Procession, Seville*	*Nude Woman*
1910, oil on canvas	1912, oil on canvas	1910, oil on canvas
129.5 × 162.5 (51 × 64)	121.92 × 121.92 (48 × 48)	187.3 × 61 (73 ¾ × 24)
John Hay Whitney Collection	Chester Dale Fund and	Ailsa Mellon Bruce Fund
1982.76.7	Gift of Barbara Rothschild Michaels	1972.46.1
	from the Collection of Herbert and	
	Nannette Rothschild, 1997	
	1997.43.1	

342

341

Lyonel Feininger
(American, 1871–1956)
The Bicycle Race
1912, oil on canvas
80.3 × 100.3 (31 5/8 × 39 1/2)
Collection of
Mr. and Mrs. Paul Mellon
1985.64.17

Georges Braque
(French, 1882–1963)
Still Life: Le Jour
1929, oil on canvas
115 × 146.7 (45 1/4 × 57 3/4)
Chester Dale Collection
1963.10.91

MODERN AND CONTEMPORARY | 20th Century | 409

The Aero

MARSDEN HARTLEY

• Hartley was born and died in Maine, but in between he was constantly on the move, rarely spending more than a year or two in the same place. After studying in Cleveland and New York, he moved to Boston. But in 1909 he returned to New York, where he made the acquaintance of Alfred Stieglitz, who gave him a one-man exhibition at his gallery "291," a center for avant-garde art. Stieglitz became Hartley's friend, advisor, and dealer; and in 1912 Hartley went to Paris, armed with introductions from Stieglitz. There he befriended Gertrude Stein and, through her, got to know the work of Cézanne, Matisse, and Picasso. At the same time, Hartley began to think of his art as an expression of his intuitive and mystical feelings. His association of abstraction and spirituality was intensified by his study of the writings and paintings of Franz Marc. In the spring of 1913 Hartley moved to Berlin, a city he found more to his liking than Paris. He was especially struck by the military costumes and displays such as the parades of Prussian cavalry that accompanied the movements of Kaiser Wilhelm II. Moreover, Hartley had formed an intense friendship with two young Prussian officers, Arnold Rönnebeck and Karl von Freyburg, whom he first met in Paris.

The Aero is an outstanding example of the distinctive abstractions Hartley created while in Berlin. It has been suggested that the title refers not to an airplane, but to a German dirigible, the L2, which crashed and burned in 1913, killing twenty-seven people, including a number of prominent scientists. The zeppelin is symbolized by the blood red fireball out of which spurt three sets of flames. There are also references to military insignia, the bold colors and patterns of flags and banners, and the colors of the German flag. Out of these elements Hartley forged a cohesive and coherent design that perhaps owes something to the formal concerns of synthetic cubism. The effect of these paintings was, in Georgia O'Keeffe's famous dictum, "like a brass band in a small closet," and Hartley never quite equaled their power again.

The First World War changed everything. Hartley's friend Karl von Freyburg was killed in action, and Arnold Rönnebeck was wounded and hospitalized. Berlin was a city at war, food was in short supply, and it was no longer safe. In December 1915 Hartley sailed for New York to begin a new chapter in his nomadic life.

Marsden Hartley
(American, 1877–1943)
The Aero
1914, oil on canvas
100.3 × 81.2 (39 ½ × 32)
Andrew W. Mellon Fund
1970.31.1

Fantômas

JUAN GRIS

• Revolutionary is not too strong a word to describe the effects of cubism, developed in the early years of the twentieth century by Georges Braque and Pablo Picasso. Destroyed forever was the idea that painting was the simulation of solid objects seen from a single perspective. Instead Braque and Picasso used multiple views of objects and the reduction of both mass and space to thin planes to forge a new pictorial reality that did not need to obey the same laws as the external world. Juan Gris was present at the creation of this new mode of seeing. Born in Madrid and trained in mathematics and engineering as well as art, Gris moved to Paris in 1906, became acquainted with Picasso and his circle of friends, and by 1908 had a studio in the same building as Picasso: the Bateau Lavoir (Laundry Barge).

Painted in 1915, *Fantômas* reflects the clarity, logic, and strong color of Gris' individual style and his assimilation of many of the typical devices of cubism. Some objects, such as the black pipe, can be spotted readily, while others, such as the fragmented glass below it drawn in white, are less immediately recognized. The cubists often incorporated words and music into their paintings, and here one finds "Le Journal," a popular French newspaper. More intriguing is the green book at the left, entitled *Fantômas* and decorated with a black mask. Fantômas, a master criminal who used deception and surprise to be "nowhere and everywhere at one and the same moment," was the subject of a series of detective novels written by Pierre Souvestre and Marcel Allain that began in 1911. Then, as perhaps now, detective stories were considered popular entertainment, and in 1913 Apollinaire created a stir by proposing that they be considered the equal of serious literature. He and Picasso formed what was essentially a Fantômas fan club. For Gris, Picasso, and their friends, a large part of the appeal of Fantômas was that, like the *saltimbanques* of Montmartre, the figure was an outcast who lived by his wits.

In this painting Gris also plays with illusion and reality. The cubists often used pieces of actual wallpaper in their compositions, including *faux bois*, paper printed to look like wood. Here, however, the wood grain is painted, probably with a housepainter's "comb," so it is simultaneously real and false. Similarly, the wainscoting is rendered with great precision but is in deliberate contrast to the flat, abstract black and yellow shapes placed over it. In the cubist realm, objects have the ability to interpenetrate, defying their normal boundaries. Thus the wooden tabletop overlaps both the newspaper and the detective novel, with each in effect becoming part of the other. Gris takes these elements of the physical world and rearranges and reorganizes them into an elegantly balanced and coherent design.

344

Juan Gris
(Spanish, 1887–1927)
Fantômas
1915, oil on canvas
59.8 × 73.3 (23 ½ × 28 ⅞)
Chester Dale Fund
1976.59.1

Open Window, Collioure

HENRI MATISSE

• Matisse and André Derain spent the summer of 1905 at Collioure, a Mediterranean fishing village not far from the Spanish border. It was there that Matisse created this small painting, which became a talisman for the movement known as fauvism. The picture was shown at the 1905 Salon d'automne along with other works by Matisse, Derain, Maurice de Vlaminck, and Georges Braque, all notable for their expressive use of intense, non-illusionistic color. The exhibition galvanized public and critics alike. In discussing two pieces of sculpture in the show, the critic Louis Vauxcelles wrote, "in the midst of the orgy of pure color: Donatello among the wild beasts (*fauves*)." Vauxcelles also used the word "fauve" to describe a hostile, insensitive public that stood ready to devour Matisse. As an art movement ostensibly led by Matisse, fauvism did not last long, and by 1907 its practitioners had moved in different directions.

This painting is made up of simple elements: window shutters, pots of geraniums, a balcony, and a few fishing boats. Not simple are the composition and Matisse's extraordinary use of color, "seeking light through the opposition of color," as he once put it. The walls of the room—blue green on the left, purplish red on the right—are a high-keyed variant of the red-green complementary contrast that one finds in the geraniums. Contrasts of blue and orange are seen throughout the picture. Note also how the blue green in the right-hand shutter and the purple and pink in the left-hand shutter intensify the surrounding colors. Another device that Matisse was to use often was allowing the light beige ground to show through in several places, isolating areas of color and thus increasing their luminosity and vibrancy. Equally noteworthy is the composition, which is essentially a series of pictures within pictures. The walls frame the window shutters, which frame the plants and the balcony, which in turn frame the boats and water. Each region or zone is rendered in a distinct type of brushwork. Yet despite the variety of brush strokes and colors, equilibrium is maintained.

Open Window, Collioure, marks a decisive moment in Matisse's career and in the history of modern art. Previously, the artist had been working in a neo-impressionist style, using color descriptively. With this painting, color was set free to function in an autonomous, nearly abstract manner, gaining enormously in power and exuberance. Matisse is justly regarded as an incomparable colorist in twentieth-century art.

345

Henri Matisse
(French, 1869–1954)
Open Window, Collioure
1905, oil on canvas
55.25 × 46.04 (21 ¾ × 18 ⅛)
Collection of Mr. and Mrs.
John Hay Whitney
1998.74.7

346

347

André Derain
(French, 1880–1954)
Mountains at Collioure
1905, oil on canvas
81.3 × 100.3 (32 × 39 ½)
John Hay Whitney Collection
1982.76.4

Henri Matisse
(French, 1869–1954)
Pianist and Checker Players
1924, oil on canvas
73.7 × 92.4 (29 × 36 ⅜)
Collection of
Mr. and Mrs. Paul Mellon
1985.64.25

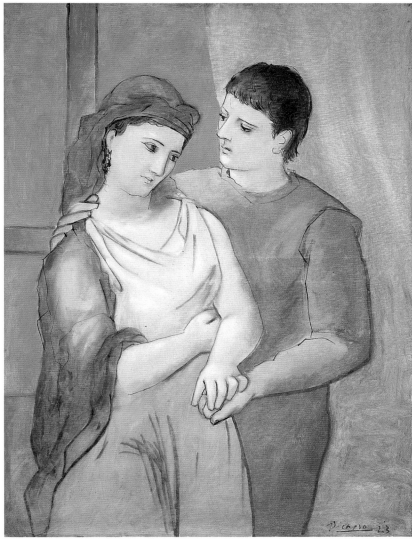

348

349

Amedeo Modigliani
(Italian, 1884–1920)
*Madame Amédée
(Woman with Cigarette)*
1918, oil on canvas
100.3 × 64.8 (39 ½ × 25 ½)
Chester Dale Collection
1963.10.172

Pablo Picasso
(Spanish, 1881–1973)
The Lovers
1923, oil on linen
130.2 × 97.2 (51 ¼ × 38 ¼)
Chester Dale Collection
1963.10.192

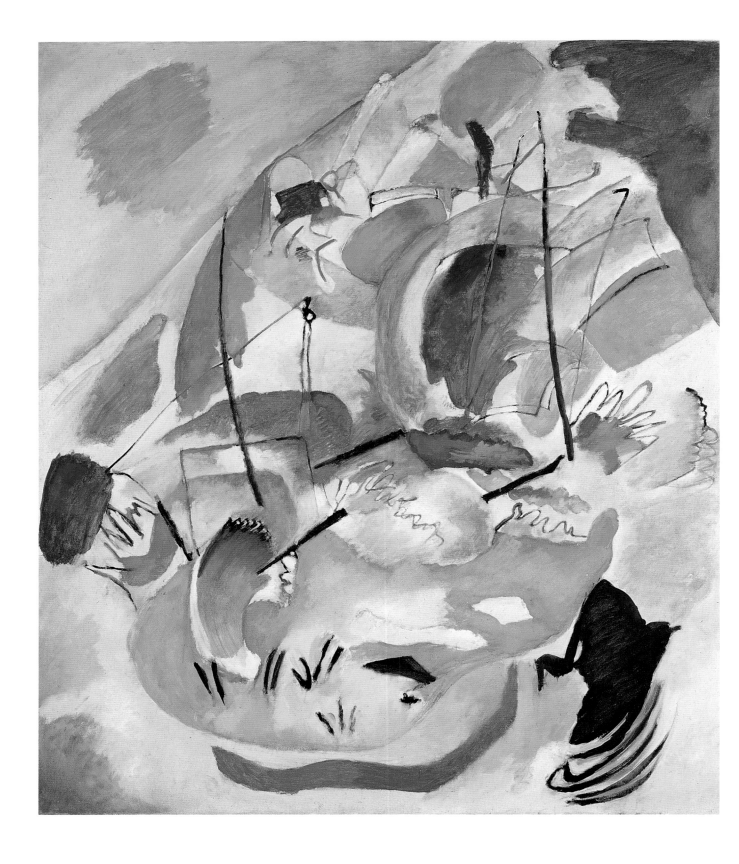

350

Wassily Kandinsky
(Russian, 1866–1944)
Improvisation 31 (Sea Battle)
1913, oil on canvas
140.7 × 119.7 (55 ³⁄₈ × 47 ¹⁄₈)
Ailsa Mellon Bruce Fund
1978.48.1

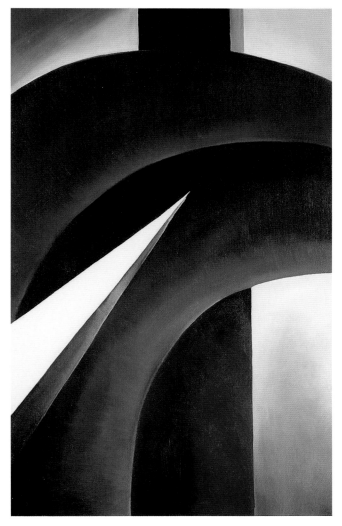

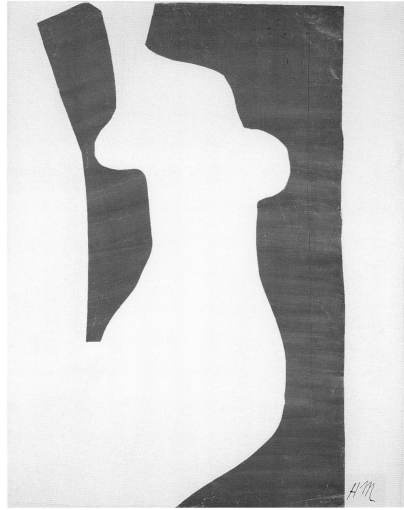

351 352

Georgia O'Keeffe Henri Matisse
(American, 1887–1986) (French, 1869–1954)
Black, White and Blue *Venus*
1930, oil on canvas 1952, paper collage on canvas
121.9 × 76.2 (48 × 30) 101.2 × 76.5 (39 7/8 × 30 1/8)
Gift (Partial and Promised) Ailsa Mellon Bruce Fund
of Mr. and Mrs. Barney A. Ebsworth 1973.18.2
1998.93.1

Classic Landscape

CHARLES SHEELER

• A native of Philadelphia, Sheeler first studied at the Philadelphia School of Industrial Design and with William Merritt Chase at the Pennsylvania Academy of the Fine Arts. A trip to Europe in 1908–1909 exposed him to the modernism of Cézanne and Matisse, and in succeeding visits he was strongly influenced by the cubism of Picasso and Braque.

Concerned that he would not be able to earn a living as a painter, however, Sheeler also learned commercial photography, and in 1927 he was commissioned to photograph the Ford Motor Company plant at River Rouge, Michigan, not far from Detroit. This facility, employing more than seventy-five thousand workers and spread over two thousand acres, was devoted to the manufacture of the Model A automobile and was the largest industrial complex in the world at the time. The resulting photographs are among Sheeler's surpassing achievements. And they led to the realization that photographs could also serve as a point of departure for paintings: between 1930 and 1936 Sheeler produced a series of canvases inspired by the River Rouge plant.

Classic Landscape, one of the most famous in the series, depicts the area where by-products from the molten iron were used to make cement. Small mountains of raw materials—coal, ore, and limestone—were kept outside, while the orange silos at the left were used to store the cement. Soaring into the sky at the right is the smokestack of the cement factory itself. The composition, balancing strong diagonals against horizontals and verticals, is rendered with immaculate precision. There are no traces of dirt or disorder, indeed no trace of people.

The word "classic" in the title suggests a comparison between these factory buildings and the temples of Greece and Rome, and for Sheeler and others the designs dictated by industrial function were as beautiful and timeless as those of the ancient world. The scene is painted crisply and in full light; objects are simplified yet described with incisive accuracy. *Classic Landscape* is a stunning affirmation of Sheeler's belief "that a picture could have incorporated in it the structural design implied in abstraction and be presented in a wholly realistic manner."

Charles Sheeler
(American, 1883–1965)
Classic Landscape
1931, oil on canvas
63.5 × 81.9 (25 × 32 ¼)
Collection of Mr. and Mrs.
Barney A. Ebsworth
2000.39.2

The Farm

JOAN MIRÓ

• Miró was born, educated, and received his artistic training in Barcelona, but his one-man show there in 1918 was not particularly successful, and although the city's art scene was lively, Miró felt the need of a more cosmopolitan environment and moved to Paris in 1920. As he once said, "You have to be an international Catalan; a homespun Catalan is not, and never will be, worth anything in this world." At the same time, he was firmly attached to his native land and returned each summer to his family's farm in Montroig in the Tarragona province of Catalonia. *The Farm*, begun in Montroig and Barcelona in the summer of 1921 and completed in Paris the following year, is a portrait of a cherished place. In Miró's words, "I wanted to put everything I loved about the country in that canvas—from a huge tree to a tiny little snail."

Miró's style, wonderfully detailed and descriptive, creates a kind of magical realism: a watering can, rabbits, a goat, chickens, a large eucalyptus tree in the center, and a woman bending over a trough in the back are all presented with brilliant clarity; yet the overall effect is strangely dreamlike. There are unexplained mysteries, such as the footprints on the path that begin and suddenly end. Moreover, while some believe the scene takes place during the day, the present author would suggest that it is a full moon in the deep blue sky and

that the first light of morning can be seen behind the distant hills. With an awareness of both Cézanne and cubism, Miró created an informative display of plants and objects by tilting upward the plane of the foreground field but depicted the buildings at eye level and shows simultaneously the interior and exterior of the chicken coop at right.

Although *The Farm* had enormous personal significance for Miró and is now considered an exemplar of his early work, the artist was poor at the time and consigned the painting to a Paris dealer. In 1925/1926 Ernest Hemingway purchased the picture as a birthday present for his first wife, Hadley, and recounts frantically borrowing money for the final payment and transporting the canvas on top of a taxi. The painting hung in Hemingway's homes in Key West, Florida, and Havana, Cuba, and the author wrote of it that "Miró was the only painter who had been able to combine in one picture all that you felt about Spain when you were there and all that you felt when you were away and could not go there." In 1987 the writer's widow, Mary Hemingway, donated *The Farm* to the National Gallery of Art.

Joan Miró
(Spanish, 1893–1983)
The Farm
1921–1922, oil on canvas
123.8 × 141.3 (48 3/4 × 55 5/8)
Gift of Mary Hemingway
1987.18.1

La condition humaine

RENÉ MAGRITTE

• It was Magritte's genius to find profoundly unsettling ideas in everyday scenes. Here, in an exemplary work, a window opens onto an unremarkable landscape. On an easel inside the room is a painting of a landscape that would seem to correspond in every detail and thus be an extension of the exterior view. When Magritte lectured in Antwerp in 1938 on this image, he observed that for the spectator the prominent tree "was both inside the room within the painting and outside in the real landscape. The simultaneous existence in two different spaces is like living simultaneously in the past and the present, as in some cases of déja vu."

The artist also said, "visible things always hide other visible things," and in this regard one soon understands that there is no guarantee that the painting on the easel accurately represents what is behind it. On further reflection, the viewer is led to the realization that both the "painting within a painting" and the "window on reality" are illusions, both are fabricated by the artist. The reality of art is here used to undermine and disrupt our notions about the "real" world.

Magritte was born in Lessines, in the province of Hainaut in Belgium, and from 1916 to 1918 he studied at the Académie des Beaux-Arts in Brussels. After working for a time in a nearly abstract style influenced by cubism and futurism, he was prompted by the paintings of Giorgio de Chirico to reassert the importance of objects. In the mid-1920s he became a founder and the leading theoretician of the Belgian surrealist movement, and while in Paris from 1927 to 1930 he was in close contact with the French surrealists. A literary and artistic movement that flourished from 1917 on, surrealism sought to uncover insights into the mysterious realms of life by exploring dreams, the unconscious mind, and accidental, unexpected juxtapositions—in the words of the writer Lautréamont, "Beautiful as the chance encounter of a sewing machine and an umbrella on an operating table." Although he exhibited with the surrealists, Magritte went his own way, living in a middle-class suburb of Brussels, and developed what has been called a "deadpan form of representation," creating images that had a strong impact on artists such as Jasper Johns, whose sculpture of beer cans mimics reality. Magritte is easily the best-known Belgian artist of the twentieth century. For better or worse, his images have a graphic simplicity and appeal that is easily adapted to commercial uses.

René Magritte
(Belgian, 1898–1967)
La condition humaine
1933, oil on canvas
100 × 81 × 1.6 (39 3/8 × 31 7/8 × 5/8)
Gift of the Collectors Committee
1987.55.1

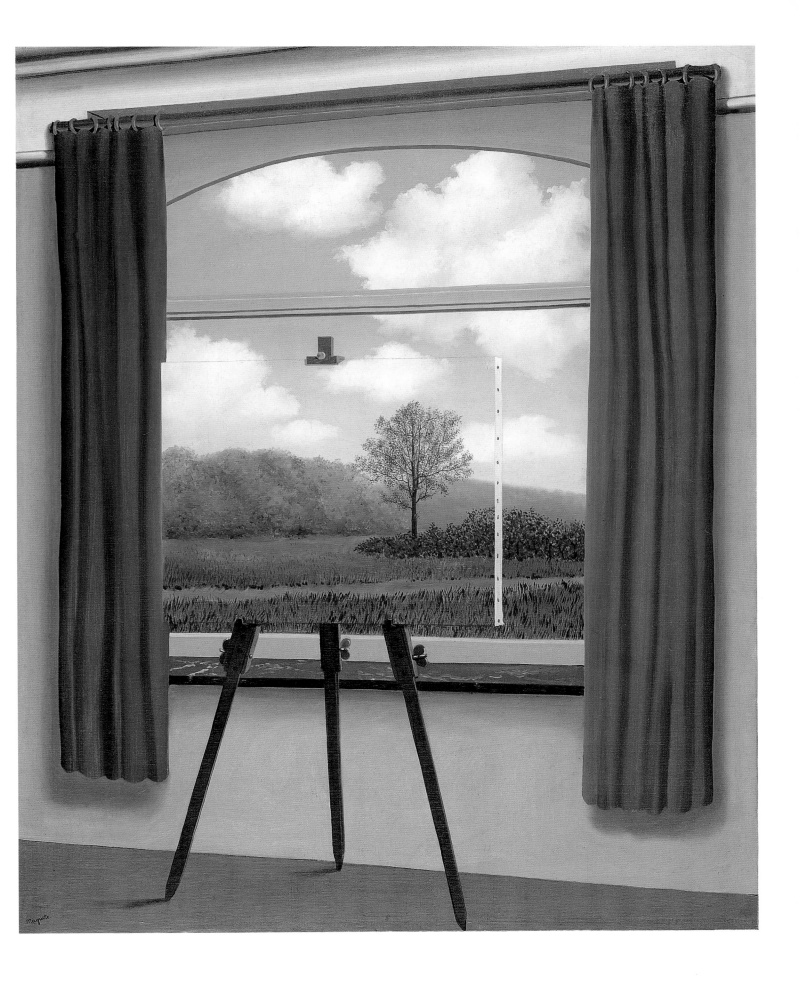

Artists' careers develop at different speeds; some are hares, others are tortoises. Mondrian's most important work did not begin until he was almost fifty years old. In his early pictures, produced in the Netherlands, he assimilated successively the styles of the Hague School, symbolism, and neo-impressionism. Beginning in 1912, however, he began to spend time in Paris, where analytical cubism, then in full flower, had a decisive impact on him.

In his highly individual response, Mondrian was struck by the cubist's use of geometric grids to organize flat, nearly abstract shapes. In 1919 Mondrian moved to Paris and began to make known his theories about art, which were given the rather ungainly label of "neo-plasticism." For Mondrian "the truly modern artist is aware of abstraction in an emotion of beauty... the emotion of beauty is cosmic, universal." Abstract beauty was reduced to its essentials of line and color, and these were even further reduced. Feeling that "the colors of nature cannot be reproduced on canvas," he restricted himself to the primary hues of red, yellow, and blue, plus gray and white. He also limited himself to black lines that intersected at right angles. Around 1924 he began making diamond-shaped paintings by rotating a square canvas 45 degrees. As can be seen in *Tableau No. IV,* the black lines retain a vertical and horizontal orientation and color is kept on the periphery. The diamond, or "lozenge," compositions have their own particular energy caused in part by the feeling that the shapes and lines continue outside the edges of the canvas.

It is important to realize that Mondrian kept theory separate from practice and that there was nothing mechanical or doctrinaire about the way he actually made paintings. Intuition was a universal, governing component of creativity, and in order to achieve a dynamic equilibrium Mondrian spent long periods carefully calibrating and adjusting the exact position and size of each element in his compositions. Scientific examination has determined that *Tableau No. IV* was painted in two distinct stages.

When Mondrian moved into his Paris studio, he applied the principles of neo-plasticism to the interior, painting pieces of cardboard in primary colors, light gray, and white and positioning them on the walls. His studio and his ideas were to have an effect on architectural design beginning in the 1930s. In 1937 Mondrian was included in the "Degenerate Art" exhibition in Berlin, and the impending war caused him to leave Paris for Britain the following year. In 1940 he emigrated to New York, where in 1942–1943 he painted *Broadway Boogie Woogie* (The Museum of Modern Art, New York), testimony to his love of jazz and swing.

Piet Mondrian
(Dutch, 1872–1944)
*Tableau No. IV; Lozenge Composition
with Red, Gray, Blue, Yellow, and Black*
c. 1924/1925, oil on canvas on hardboard
diamond: 142.8 × 142.3 (56 ¼ × 56)
Gift of Herbert and Nannette Rothschild
1971.51.1

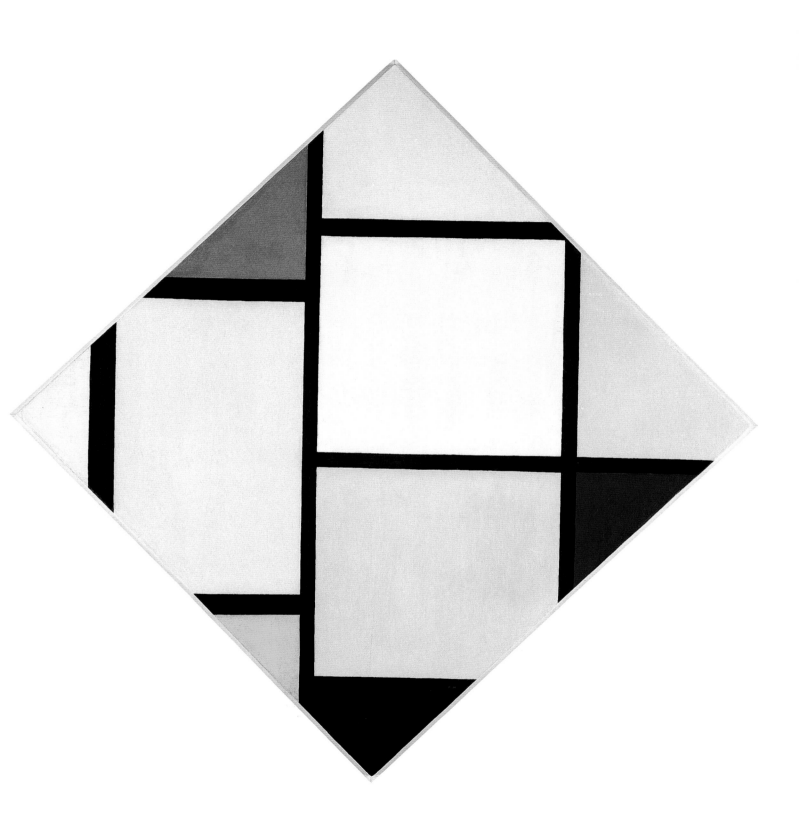

The Argonauts

MAX BECKMANN

• A physically imposing, independent-minded autodidact, Beckmann was one of the preeminent German artists of the modern era. Born in Leipzig and trained in Weimar, he won early successes, with a one-man show in Berlin in 1913 and publication of the first monograph and catalogue of his work. Following World War I, when he was deeply affected by his experiences in the army medical corps, he settled in Frankfurt and obtained a teaching position. With the rise of the Nazis in 1933, however, he was dismissed from his job, his paintings were removed from view in German museums, and in 1937 ten of his pictures were displayed in the infamous exhibition of "Degenerate Art" in Berlin. Beckmann fled to Amsterdam, where he lived until 1947; he was then able to emigrate to the United States, where he taught in St. Louis and Brooklyn.

In 1932 Beckmann began a series of triptychs; his use of this format, with its religious overtones, underscores their serious content. *The Argonauts*, his ninth and last triptych, was begun in St. Louis in April 1949 and completed in New York on 26 December 1950. The next day Beckmann suffered a fatal heart attack while walking in Central Park.

Here he has taken the Greek legend of the search for the Golden Fleece and in a very personal manner equated Jason's journey with the path of the artist. On the left wing the painter,

based on Gauguin's portrait of van Gogh, works furiously on a canvas. The nearly naked woman holding a sword and sitting on what may be a mask is at once his muse and his model; she may also be Medea, the sorceress who aided Jason. The center panel depicts Jason with a magical bird perched on his wrist. The lyre on the ground identifies the second youth as Orpheus, first to join the Argonauts. The figure emerging from the water has been identified variously as the sea god Glaucus, or King Phineus, or simply as the Old Man of the Sea; all were endowed with the gift of prophecy. The ladder refers to upward striving and ambition as well as to the religious symbol of Jacob's ladder (Genesis 28:12), which leads to heaven. Inexplicably the sky contains what appears to be a purple sun and a black crescent moon. Beckmann spent the summers of 1949–1950 in Nevada and Wyoming, and it has been suggested that the red rocks next to Jason were inspired by the Western scenery. On the right wind a group of women singers and instrumentalists form a Greek chorus whose traditional function was to comment on and interpret events.

The idea for this triptych may have come from Wolfgang Frommel, a poet and writer in Amsterdam, who referred to his artist friends, including Beckmann, as Argonauts.

Max Beckmann
(German, 1884–1950)
The Argonauts
1949/1950, oil on canvas
left panel: 184.1 × 85.1 (72 ½ × 33 ½)
center panel: 205.8 × 122 (81 × 48)
right panel: 185.4 × 85 (73 × 33 ½)
Gift of Mrs. Max Beckmann
1975.96.1 a–c

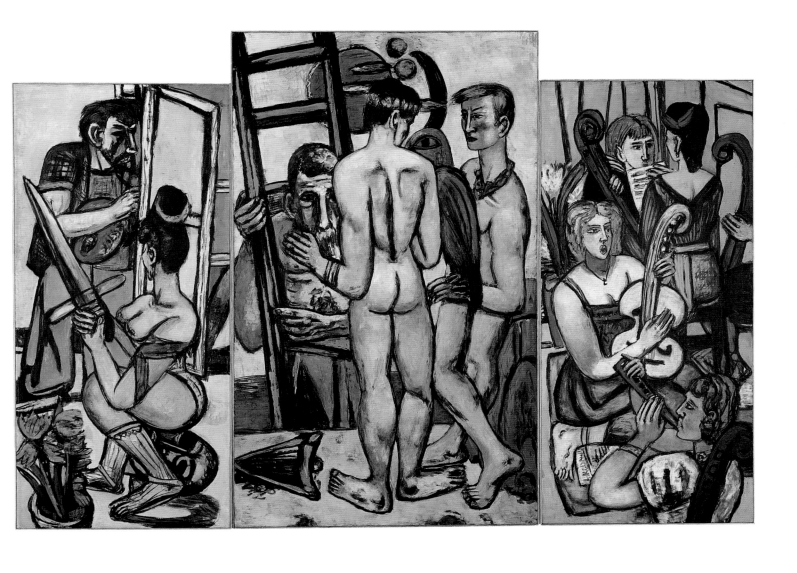

The Artist and His Mother

ARSHILE GORKY

• Among the most poignant and transcendent of modern portraits, *The Artist and His Mother* testifies both to a personal tragedy and to the misfortunes of many. Gorky, whose real name was Vosdanig Manoog Adoian, was born in the province of Van in Turkish Armenia. In 1908 his father fled to America to avoid conscription into the Turkish army, which would have forced him to fight against his own people. Beginning in 1915, the Ottoman Turks began systematically exterminating Armenians; over a million died and hundreds of thousands more were forced into exile. Along with his mother and sister, Gorky was part of a death march of more than one hundred miles, which took them westward into Caucasian Armenia. In March 1919, when he was fourteen years old, his mother, Lady Shushanik, died of starvation in his arms.

Gorky and his sister survived and made their way to America, arriving at Ellis Island in February 1920 and eventually joining their father in an awkward, short-lived reunion. In 1924 Vosdanig Adoian changed his name: Arshile is Russian for Achilles, while Gorky, which means bitter, alludes to the Russian novelist and playwright Maxim Gorky. Often vague about his personal history and cavalier about facts, the artist would sometimes claim to be a cousin of the literary Gorky.

In 1912 a photograph of the eight-year-old Gorky with his mother was taken and sent to his father. Gorky retrieved the photograph, and it served as the inspiration for two paintings, both begun around 1926. The version in the Whitney Museum of American Art, New York, was probably finished in 1936 and exhibited in 1946. The National Gallery of Art's portrait remained in Gorky's studio until after his death, and it is likely that he periodically revisited it to rework and revise various parts. In the area of his mother's face he would scrape and polish layers of paint until they acquired the smoothness of bone or ivory.

Gorky was self-taught as an artist, and especially after moving to New York in 1924/1925, he haunted the museums, absorbing a wide range of cultures and eras. Consequently, art historians have been able to recognize the influence of Picasso in his Blue and Rose periods, the portraits of Ingres and Cézanne, and late antique Egyptian Fayum portraiture. Gorky carried Armenia within him, however; his exposure to art began there with his mother, a noblewoman associated with the Armenian Apostolic Church; and in the frontal, hieratic poses and staring almond-shaped eyes he used to depict himself and his mother here, one sees echoes of the figures in Armenian churches and illuminated manuscripts. *The Artist and His Mother* is an evocation of survival and loss. Rendered as semi-abstract shapes, the bodies begin to dematerialize, to fade into memory, and their hands are oddly mute and incomplete, perhaps a sign that mother and son would never again touch one another.

Arshile Gorky
(American, 1904–1948)
The Artist and His Mother
c. 1926–c. 1942, oil on canvas
152.3 × 127 (60 × 50)
Ailsa Mellon Bruce Fund
1979.13.1

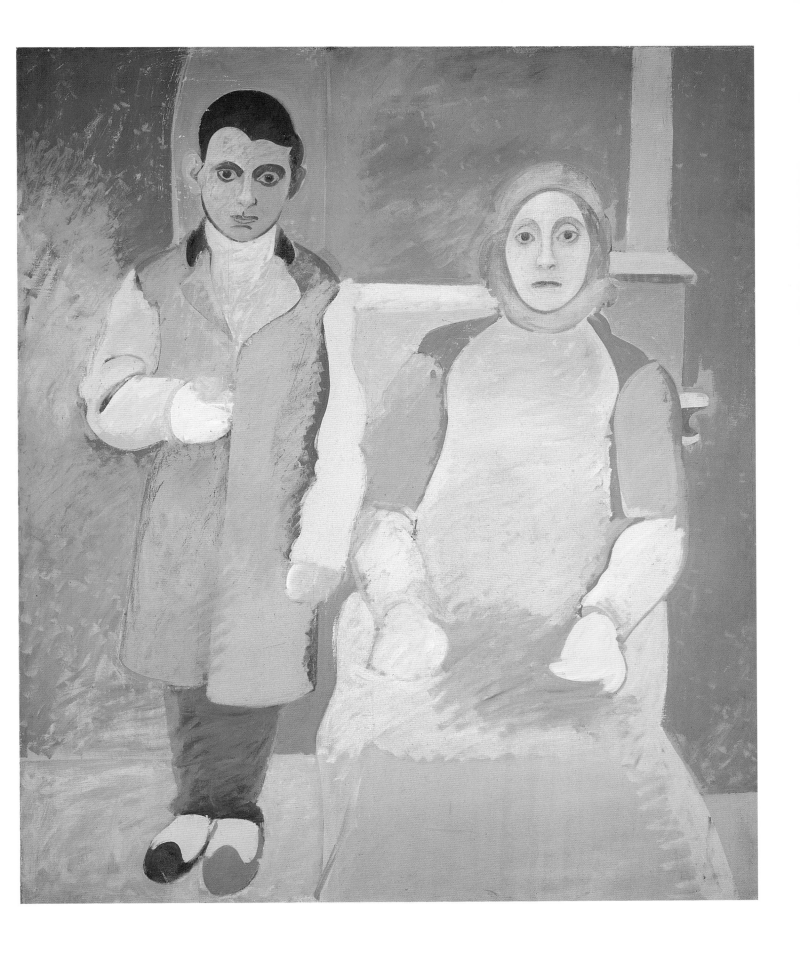

Bertelé bouquet fleuri, Portrait de Parade

JEAN DUBUFFET

• For many artists and intellectuals in Europe the years following the Second World War were a time of indecision and existential crisis as they searched for new modes of seeing and thinking to replace the structures and traditions that had been destroyed by the war. Out of this milieu Dubuffet emerged as an unusually influential artistic personality in France. His father was a well-to-do wine merchant in Le Havre, and Dubuffet spent several years alternating between the study of art and the comfortable middle-class life of a wine merchant. Finally in 1942 he left the wine business and devoted his full energies to painting. Rebelling against authority and traditional conventions of beauty, Dubuffet began to study and collect the art of children and those in mental institutions, street graffiti, and the art produced by so-called "primitive" societies. With these as his models, he produced what he called *art brut,* or "raw art."

A dramatic early example of this style, *Bertelé bouquet fleuri, Portrait de Parade,* depicts René Bertelé, a writer, poet, and friend of the artist. In a somewhat surreal touch, Bertelé is compared both to an unfolding bouquet of flowers and to something grotesque and unnatural, a sideshow attraction. Bertelé's head is a skull set precariously on a small round body from which spring arms with twiglike fingers. Rejecting traditional techniques, Dubuffet here mixed plaster and sand into the oil paint to create what was called *haute pâte,* a thick, uneven material that could receive the graffiti-like markings gouged into Bertelé's head and body. The picture's graphic, powerful crudeness evokes a caricature or a sinister child's drawings.

This work was first displayed in Paris in 1947 in a one-man exhibition entitled *People Are More Beautiful than They Think.* The show comprised seventy-two paintings and drawings of the artists, writers, critics, and dealers in Dubuffet's circle and helped secure his reputation. There is a certain irony in the fact that over time Dubuffet's fight against conformity and good taste, his outlaw persona, and espousal of the grotesque brought him success, acceptance, and respectability. Late in life he was one of the artists invited to submit a design for a sculpture at the entrance to the East Building of the National Gallery of Art, and thanks to the generosity of Stephen Hahn the institution owns a number of Dubuffet's paintings, drawings, and sculptures.

Jean Dubuffet
(French, 1901–1985)
*Bertelé bouquet fleuri, Portrait
de Parade (Bertelé as a Blossoming
Bouquet, Sideshow Portrait)*
1947, oil, plaster, and sand on canvas
116 × 89 (45 5/8 × 35)
The Stephen Hahn Family Collection
(Partial and Promised Gift)
1995.29.5

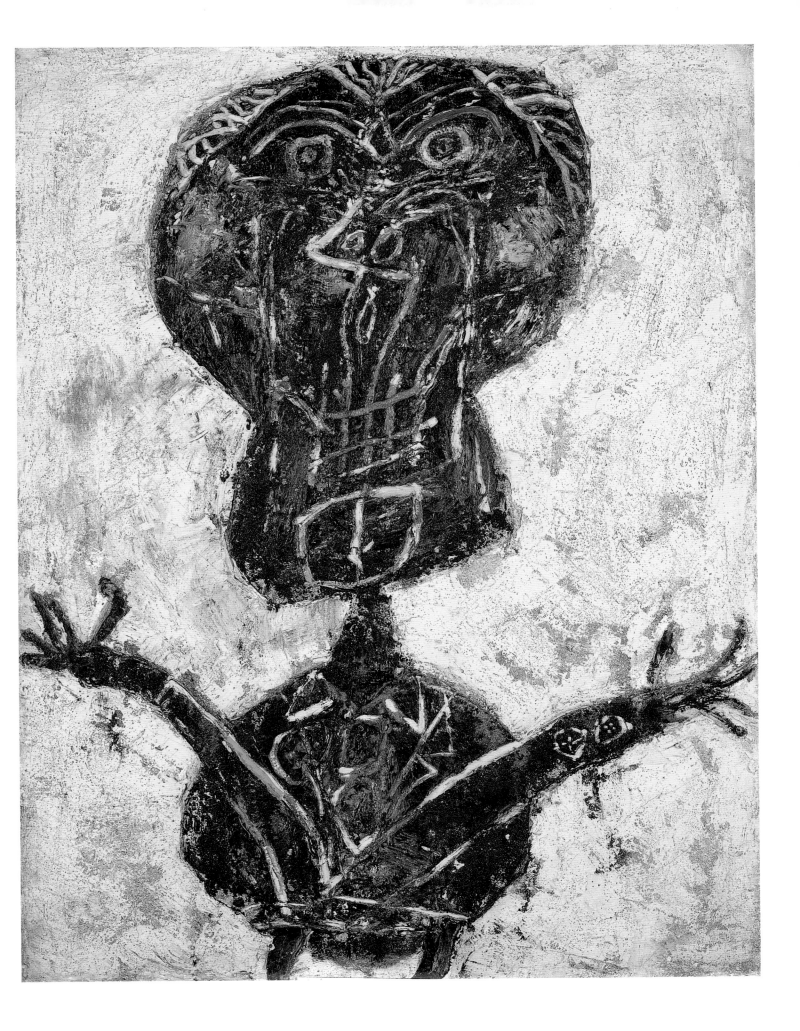

Untitled

MARK ROTHKO

• Born Marcus Rothkowitz in Dvinsk, Russia, Rothko emigrated to the United States with his mother and sister in 1913, when he was ten years old. They rejoined his father and brother, who had earlier resettled in Portland, Oregon. A gifted student, Rothko attended Yale University on a scholarship but dropped out in his third year to move to New York and become an artist. Although he attended a few classes at the Art Students League, he was essentially self-taught and was a constant visitor to exhibitions and artist's studios. As he moved from a figurative style to abstraction, Rothko shared with others of his generation a number of formative influences. Like Jackson Pollock, he was for a time under the spell of Jung's theories of collective archetypes and related surrealist investigations of the unconscious; and like fellow New Yorker Barnett Newman or Clyfford Still, whom he first met in California in 1943, Rothko believed that abstract art, like music, could and should induce spiritually transcendent states of mind.

By 1949, when he painted this picture, Rothko had by a process of reduction arrived at the essential elements of his style: rectangular forms with rounded edges stacked within a monochromatic field. Although he would often limit himself to two or three large shapes, here there are numerous bands of color of varying width. White paint applied around the edges of the rectangles blurs and softens the transitions to the surrounding yellow ground and reverses the figure/ground relationship so that the yellow appears to be on top of the darker shapes. Paint is brushed on the canvas in thin layers, and strokes of dark orange on top of green in the bottom rectangle recall the evanescent effects that he achieved in his earlier watercolors.

Through an alchemical transmutation, Rothko's extraordinary brushwork and sensitivity to color combine to produce pictures that appear to glow from within, producing sensations more easily felt than described. In explaining the impact of his painting, the artist said in an interview in 1957, "I'm interested only in expressing basic human emotions—tragedy, ecstasy, doom…And if you…are moved only by their color relationships, then you miss the point." The point in Rothko's reductive abstraction was to achieve "clarity," which he defined as "the elimination of all obstacles between the painter and the idea, and between the idea and the observer."

360

Mark Rothko
(American, 1903–1970)
Untitled
1949, oil on canvas
206.7 × 168.6 (81 3/8 × 66 3/8)
Gift of The Mark Rothko Foundation, Inc.
1986.43.138

Number 1, 1950 (Lavender Mist)

JACKSON POLLOCK

• In the years after the Second World War the United States surpassed Europe as the crucible of avant-garde artistic activity. The movement known variously as abstract expressionism, the New York School, or action painting was a watershed in American painting, and at its center was Jackson Pollock. Born in Cody, Wyoming, he grew up in California and Arizona, then moved to New York in 1930. There he enrolled in the Art Students League, studying with Thomas Hart Benton, a muralist who was essentially a realist. Pollock, however, followed a path of increasing abstraction that grew out of the study of Picasso and Miró but was also affected by a diverse range of experiences and ideas: following psychiatric treatment for alcoholism in 1938, he underwent Jungian analysis, with its emphasis on dreams and archetypes; this related to his exposure to surrealist writers and artists, a number of whom had emigrated to New York; the surrealists taught that the subconscious mind could be freed to act directly, almost automatically, to create a work of art.

In 1947 Pollock achieved a breakthrough and began to think about and make paintings in an entirely new way. The canvas was attached to the studio floor, and he walked around it either pouring or using sticks or worn brushes to propel the paint onto the canvas. He claimed that he was inspired by the procedure used for Western Native American sand paintings. It was during this "drip" period, which lasted until 1951, that Pollock created his classic images, and the National Gallery of Art's picture is a brilliant example. Using conventional oil paints as well as industrial materials—enamel and aluminum paint—that were more free flowing, Pollock dripped, poured, and threw paint on a canvas that is close to ten feet long and over seven feet high. The resulting skein of slashing lines, puddles, and drips built up in multiple layers has a surprising delicacy and spatial depth, combined with an energy that animates the entire surface. Like the brushwork of Zen calligraphers, Pollock's painting is at once spontaneous yet controlled, intuitive yet thoughtfully considered.

Long periods of meditation alternated with bursts of focused physical activity. To quote the artist himself, "When I am *in* my painting, I'm not aware of what I am doing. It is only after a sort of 'get acquainted' period that I see what I have been about. I have no fears about making changes, destroying the image, etc., because the painting has a life of its own." Pollock gave the National Gallery's canvas the title *Number 1, 1950*, to discourage viewers from thinking about anything but the painting itself. The title *Lavender Mist* was proposed by the influential critic and champion of abstract expressionism Clement Greenberg and accepted by the artist.

361 (detail opposite, see pages 438–439)

Jackson Pollock
(American, 1912–1956)
Number 1, 1950 (Lavender Mist)
1950, oil, enamel, and aluminum on canvas
221 × 299.7 (87 × 118)
Ailsa Mellon Bruce Fund
1976.37.1

The Stations of the Cross / Be II

BARNETT NEWMAN

• Newman was a leading theorist and polemicist of abstract expressionism, and in his writings of the late 1940s and 1950s as well as his paintings he confronts and affirms a central issue of the style: the belief that pure abstraction, stripped of decorative, sentimental, or spatial associations, could invoke in the viewer heroic, even sublime feelings. His mature style was characterized by what he called "zips," or stripes, usually vertical, set against a monochromatic field.

In 1957 Newman suffered a heart attack, which, as he said, was like "instant psychoanalysis" and caused him to take stock of his life and his art. The following year he resumed painting, restricting himself to black paint applied to raw, unprimed canvas. He created two paintings of equal size and produced another pair in 1960. It was only at this point, after considerable thought, that he realized he wanted to make a series of fourteen paintings. Producing only two or three pictures a year, he began the final one in 1965 and completed it in 1966. The paintings were exhibited together at the Guggenheim Museum in New York in 1966 under the title *The Stations of the Cross*; this was also Newman's first one-man show in the United States.

The "Stations of the Cross" traditionally correspond to fourteen episodes in the Passion of Christ, from his condemnation to his entomb-ment. Newman's interpretation was different, for as he wrote in 1966, "Just as the Passion is not a series of anecdotes but embodies a single event, so these fourteen paintings, even though each one is whole and separate in its immediacy, all together form a complete statement of a single subject." That subject was the utterance of Jesus in the ninth hour of his Crucifixion, "Eloi, Eloi, lema sabachthani?" (My God, my God, why hast thou forsaken me?) (Mark 15:34). For the artist these words called up the unanswerable question, "To what purpose is human suffering?" Like pilgrims on a holy journey, viewers would ideally find in the paintings, collectively and individually, some insight into the agony and despair of human existence.

Newman later appended a fifteenth painting, entitled *Be II*, that strictly speaking is not part of the series. A cadmium red and a black "zip" flank an area that is painted white, not left raw. This picture may be interpreted as life affirming: as critic Thomas B. Hess wrote, "Man should *be*; he should work in the Lord's way in order to be able to stand before Him."

In the 1950s especially Newman's uncompromising, austere paintings were often reviewed unfavorably, but in terms of both theory and practice he is now acknowledged as a seminal influence on color-field and hard-edge painting as well as minimalist art.

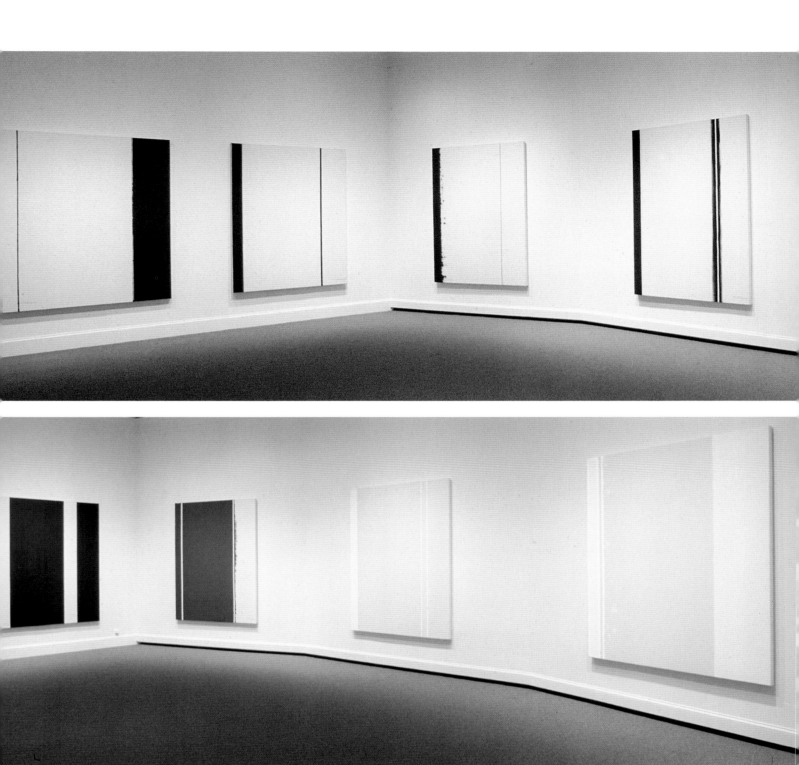

top: (left to right) Seventh, Sixth, Fifth, Fourth Stations
bottom: (left to right) Thirteenth, Twelfth, Eleventh, Tenth Stations

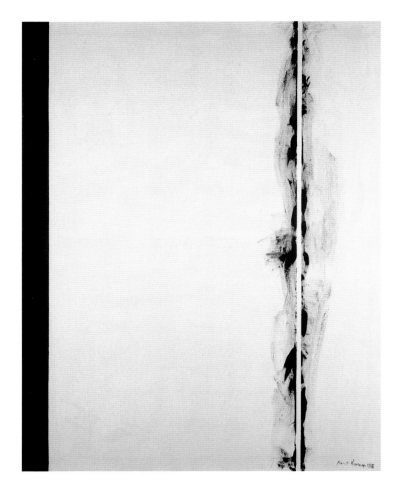

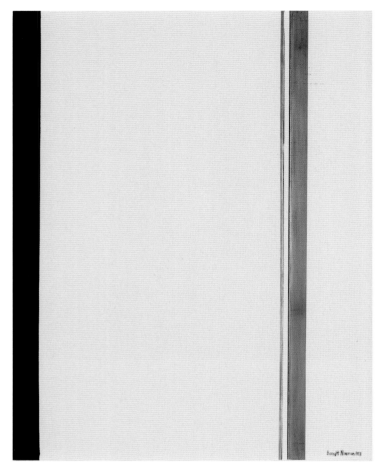

Barnett Newman
(American, 1905–1970)
First Station
1958, Magna on canvas
197.8 × 153.7 (77 ⅞ × 60 ½)
Robert and Jane Meyerhoff Collection
1986.65.1

Barnett Newman
(American, 1905–1970)
Second Station
1958, Magna on canvas
198.4 × 153.2 (78 ⅛ × 60 ½)
Robert and Jane Meyerhoff Collection
1986.65.2

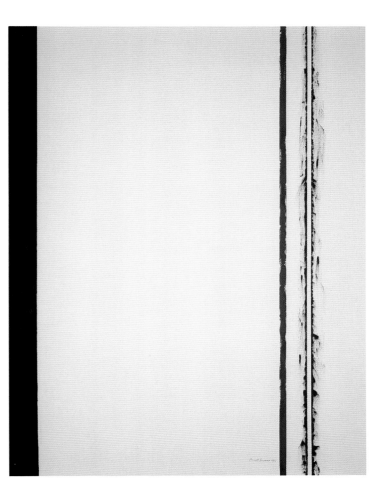

364

365

Barnett Newman
(American, 1905–1970)
Third Station
1960, oil on canvas
198.4 × 152.1 (78 ⅛ × 59 ⅞)
Robert and Jane Meyerhoff Collection
1986.65.3

Barnett Newman
(American, 1905–1970)
Fourth Station
1960, oil on canvas
198.1 × 153 (78 × 60 ¼)
Robert and Jane Meyerhoff Collection
1986.65.4

366

367

Barnett Newman
(American, 1905–1970)
Fifth Station
1962, oil on canvas
198.7 × 153 (78 ¼ × 60 ¼)
Robert and Jane Meyerhoff Collection
1986.65.5

Barnett Newman
(American, 1905–1970)
Sixth Station
1962, oil on canvas
198.4 × 152.1 (78 ⅛ × 59 ⅞)
Robert and Jane Meyerhoff Collection
1986.65.6

368

369

Barnett Newman
(American, 1905–1970)
Seventh Station
1964, oil on canvas
198.1 × 152.4 (78 × 60)
Robert and Jane Meyerhoff Collection
1986.65.7

Barnett Newman
(American, 1905–1970)
Eighth Station
1964, oil on canvas
198.4 × 152.4 (78 ⅛ × 60)
Robert and Jane Meyerhoff Collection
1986.65.8

Barnett Newman
(American, 1905–1970)
Ninth Station
1964, acrylic on canvas
198.1 × 152.7 (78 × 60 ⅛)
Robert and Jane Meyerhoff Collection
1986.65.9

Barnett Newman
(American, 1905–1970)
Tenth Station
1965, Magna on canvas
198.1 × 152.5 (78 × 60)
Robert and Jane Meyerhoff Collection
1986.65.10

 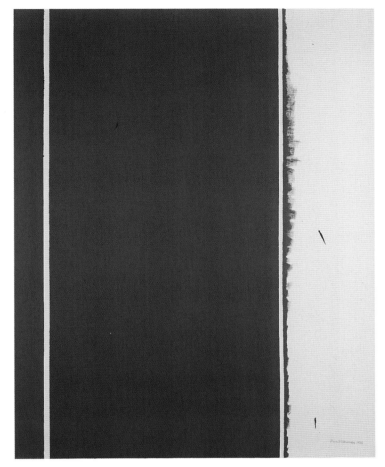

372

373

Barnett Newman
(American, 1905–1970)
Eleventh Station
1965, acrylic on canvas
198.1 × 152.4 (78 × 60)
Robert and Jane Meyerhoff Collection
1986.65.11

Barnett Newman
(American, 1905–1970)
Twelfth Station
1965, acrylic on canvas
198.1 × 152.4 (78 × 60)
Robert and Jane Meyerhoff Collection
1986.65.12

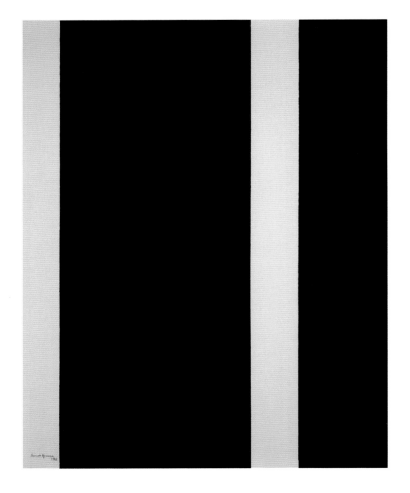

374

375

Barnett Newman
(American, 1905–1970)
Thirteenth Station
1965/1966, acrylic on canvas
198.2 × 152.5 (78 × 60)
Robert and Jane Meyerhoff Collection
1986.65.13

Barnett Newman
(American, 1905–1970)
Fourteenth Station
1965/1966, acrylic and Duco on canvas
198.1 × 152.2 (78 × 59 7/8)
Robert and Jane Meyerhoff Collection
1986.65.14

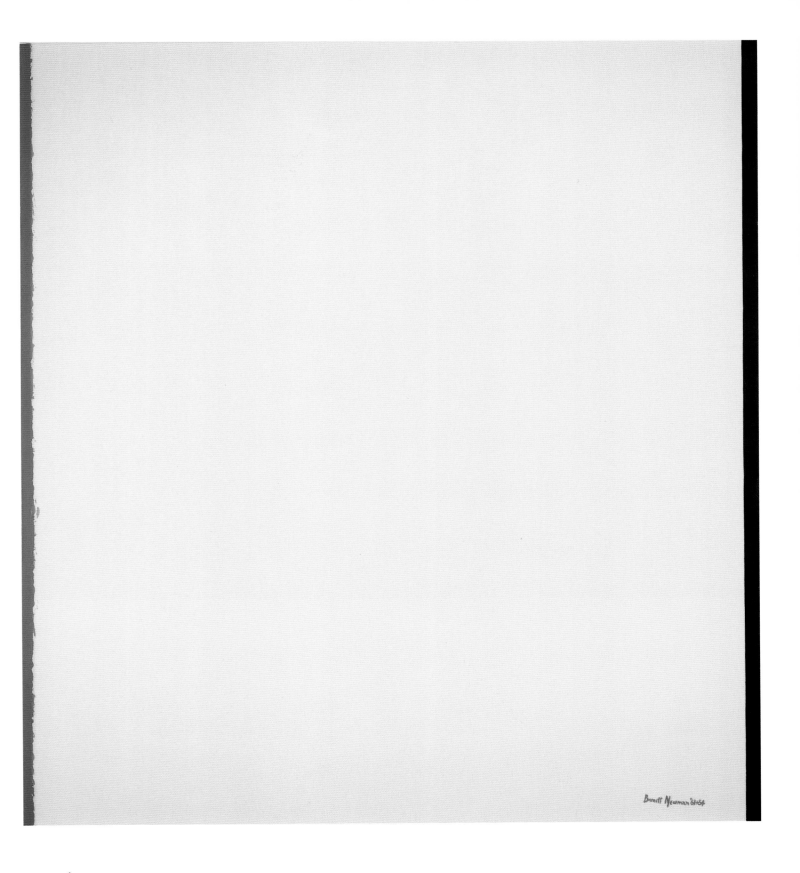

376

Barnett Newman
(American, 1905–1970)
Be II
1961/1964, acrylic and oil on canvas
204.5 × 183.5 (80 ½ × 72 ¼)
Robert and Jane Meyerhoff Collection
1986.65.15

377

Arshile Gorky
(American, 1904–1948)
One Year the Milkweed
1944, oil on canvas
94.2 × 119.3 (37 × 47)
Ailsa Mellon Bruce Fund
1979.13.2

378

Richard Diebenkorn
(American, 1922–1993)
Berkeley No. 52
1955, oil on canvas
148.9 × 136.8 (58 5/8 × 53 7/8)
Gift of the Collectors Committee
1986.68.1

379

Clyfford Still
(American, 1904–1980)
Untitled
1951, oil on canvas
274.3 × 234.9 (108 × 92 1/2)
Gift of Marcia S. Weisman,
in Honor of the 50th Anniversary
of the National Gallery of Art
1990.126.2

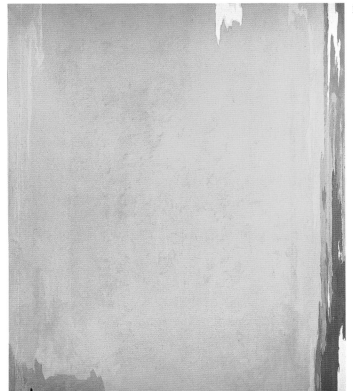

380

381

Mark Rothko
(American, 1903–1970)
No. 1
1961, oil and acrylic on canvas
258.8 × 227.6 (101 ⁷/₈ × 89 ⁵/₈)
Gift of The Mark Rothko Foundation, Inc.
1986.43.151

Franz Kline
(American, 1910–1962)
C & O
1958, oil on canvas
195.6 × 279.4 (77 × 110)
Gift of Mr. and Mrs. Burton Tremaine
1971.87.4

Look Mickey

ROY LICHTENSTEIN

• Lichtenstein was one of the key Americans involved in the international movement known as pop art, and as the first picture in the new style, *Look Mickey*, painted in 1961, is a historical and artistic landmark. A few months earlier Lichtenstein had been working in an abstract expressionist style, and this, as he noted, was "the first painting with no expressionism in it."

The artist's recollection was that the idea originated with a bubblegum wrapper depicting Donald Duck and Mickey Mouse. Lichtenstein did not alter the image but increased the size enormously from a few inches to four by almost six feet, "just to see what it would look like." He also decided to make the painting look as much like a cartoon as possible: this meant thick, even contour lines; flat, unmodulated areas of bright colors—the primaries red, yellow, and blue; and in Donald's eyes and Mickey's face an approximation of the halftone used by commercial printers. *Look Mickey* invites the viewer to consider the visual language and representational devices of cartooning in a new light. Realizing the picture's significance, Lichtenstein kept it in his possession until he and his wife gave it to the National Gallery of Art on the occasion of the institution's fiftieth anniversary.

Leaving behind the heroic aspirations of the abstract expressionists and their emphasis on personal handwriting, pop artists such as Lichtenstein were fascinated by the icons of consumerism and popular culture. Cartoons, comic strips, Brillo boxes, and cans of Campbell's soup all became fit subjects for the artist, but they were presented in an impersonal manner, often using industrial reproductive techniques. It has been noted that there is an irony in Lichtenstein's adoption of anonymity as a personal style. In the numerous paintings, prints, and sculpture he produced during his long career, one senses his abiding interest in the act of perceiving and his deadpan humor and wry detachment.

Roy Lichtenstein
(American, 1923–1997)
Look Mickey
1961, oil on canvas
121.9 × 175.3 (48 × 69)
Dorothy and Roy Lichtenstein,
Gift of the Artist, in Honor
of the 50th Anniversary of
the National Gallery of Art
1990.41.1

Andy Warhol
(American, 1928–1987)
A Boy for Meg
1962, oil on canvas
182.9 × 132.1 (72 × 52)
Gift of Mr. and Mrs. Burton Tremaine
1971.87.11

384

Edward Ruscha
(American, born 1937)
Lisp
1968, oil on canvas
150.18 × 139.07 (59 1/8 × 54 3/4)
Gift of the Collectors Committee
2001.56.1

Fanny/Fingerpainting

• Since 1968 Close has been doing what appears to be the same thing over and over: that is, taking head-and-shoulder photographs of friends and family and painstakingly copying them on a vastly enlarged scale. Yet working within a strictly defined format has allowed him to make images in a wide variety of ways. Close has said, "I wanted to paint people the way a camera sees them. In this way, I would free myself from inventing the content of my images and concentrate on the means of producing them."

Fanny/Fingerpainting depicts the artist's grandmother-in-law, the only member of a large family to survive the Holocaust. The painting exerts its fascinating hold on the spectator in two seemingly contradictory ways. Seen from a distance, the painting has an immediate and, for some, a disconcerting presence as well as the detail of a photograph. Wrinkles and blemishes are recorded with merciless veracity. True to his photographic source, Close has even rendered certain areas slightly out of focus. Seen close-up, however, the picture is a technical tour-de-force, for the artist applied the paint to the canvas with his fingers, subtly altering the pressure to deposit greater or lesser amounts of pigment on the canvas. On inspection, the whorls and ridges of his fingerprints are clearly visible, and the painting truly bears the touch of the artist.

At different times Close has used an airbrush, fragments of pulp paper, and large Polaroid photographs as well as traditional oil and acrylic paints to create his portraits. Whatever the medium, the process proceeds in square inches, and the large paintings require many months of concentrated labor. While the art that he produces is realistic, the kinds of problems and limitations that he sets for himself as part of his systematic technique ally him with minimalist or conceptual artists such as Sol LeWitt. LeWitt offers a statement that has some bearing on Close's extraordinary pictures: "When an artist uses a conceptual form of art, it means that all of the planning and decisions are made beforehand and the execution is a perfunctory affair. The idea becomes a machine that makes the art."

385

Chuck Close
(American, born 1940)
Fanny/Fingerpainting
1985, oil on canvas
259.1 × 213.4 × 6.3 (102 × 84 × 2 ½)
Gift of Lila Acheson Wallace
1987.2.1

386

386

387

Frank Stella
(American, born 1936)
Chyrow II
1972, mixed media
284.5 × 254 (112 × 100)
Gift of the Collectors Committee
1979.29.1

Ellsworth Kelly
(American, born 1923)
Tiger
1953, oil on canvas (five joined panels)
overall: 205.1 × 217.2 (80 ¾ × 85 ½)
Gift (Partial and Promised) of the Artist
1992.85.1

388

Robert Ryman
(American, born 1930)
Untitled
1961, oil on linen
179.7 × 179.7 (70 ¾ × 70 ¾)
Patrons' Permanent Fund
2001.61.1

Perilous Night

JASPER JOHNS

• Since his first appearance on the art scene in the mid-1950s Johns has been recognized as an exceptionally innovative and influential American master. From his flags and targets of the 1950s to his cross-hatch pictures of the 1970s, Johns' paintings have been implacably impersonal and unemotional. In the 1980s, however, he began to produce works that are more personal, even moody, yet far from being easily or immediately deciphered. *Perilous Night* is such a picture.

Painted in encaustic, a wax-based medium that Johns favored because it dried quickly, the work is composed as a diptych. Contained in the inky darkness of the left half is a detail from the Resurrection panel of the Isenheim Altarpiece (Musée d'Unterlinden, Colmar) by Matthias Grünewald. Johns visited Colmar twice in the 1970s and later began making tracings in Mylar from reproductions, investigating the relationship among meaning, information, and pattern. Here the image has been turned ninety degrees and is thus especially hard to recognize. On the right side of the painting is a smaller version of the Grünewald detail in the correct orientation.

Other references to art include, outlined in white at the lower left of the right half, the handkerchief from Picasso's *Weeping Woman*, attached by an illusionistic nail to a piece of blatantly faux-grained wood (inspired by the front door of Johns' house). At the top, hanging from hooks left to right, are progressively larger casts of a human arm and hand, "camouflaged" and painted red, yellow, and blue. Behind the center arm is one of Johns' cross-hatchings, a picture with-in a picture hanging from trompe-l'oeil but cartoonlike nails casting shadows. At the right edge is a strip of wood that could either function as a painter's maulstick or a straightedge.

The key to the picture's title is to be found at the upper right, obscured by the wooden strip and the cast arm. Here Johns has reproduced the musical score and title page of the song "Perilous Night" by John Cage. Along with Robert Rauschenberg and Merce Cunningham, Cage was among Johns' closest friends. The song was composed in 1943 as Cage's marriage was dissolving, and it tells of "the loneliness and terror that comes to one when love becomes unhappy." In this remarkable but difficult work allusions to the making of art, the tricks of perception, and the furnishings of the artist's studio are joined to dark imitations of loss and death. Johns is self-referential, but self-revelation ultimately remains out of reach.

389

Jasper Johns
(American, born 1930)
Perilous Night
1982, encaustic on canvas with objects
170.5 × 244.16 × 15.88 (67 1/8 × 96 1/8 × 6 1/4)
Robert and Jane Meyerhoff Collection
1995.79.1

Zim Zum

ANSELM KIEFER

• Composed of horizontal sheets of lead weighing close to half a ton and together measuring more than twelve feet high and eighteen feet across, this work is appropriately cosmic in theme. The title, *Zim Zum*, written in chalk at the top, refers to *tsimtsum* (Hebrew for "contraction"), the kabbalistic concept of the moment of creation. According to the Kabbalah—the mystical theosophy of Judaism that developed in the late thirteenth century—the infinite, all-encompassing Godhead withdrew into itself, and this divine "contraction" left an empty point that enabled the finite world to come into existence. During *tsimtsum*, forces of evil (*sitra achra*) were also created that inhabit the material domain and lead man into sinful behavior.

In Kiefer's painting the sheets of lead are wrinkled, corroded, and discolored. In the lower portion a canvas attached to the lead is used to create a lake and a vast desolate landscape. The canvas is scorched and torn and encrusted with paint, shellac, and ashes. The total resulting image not only evokes the elemental forces unleashed by *tsimtsum* but also conveys the idea that the seeds of destruction are contained in the instant of creation.

Kiefer was born in Donaueschingen and studied law, French, and art in Freiburg. After a year in Karlsruhe he moved to Düsseldorf in 1970 and studied informally with Joseph Beuys, a conceptual artist who often used unusual materials. One of the most serious and forceful German artists working today, Kiefer is not one to shy away from controversy and has used his work to confront painful issues from Germany's past. His paintings and sculpture investigate grand historical, religious, and mythological themes in a highly personal way.

Anselm Kiefer
(German, born 1945)
Zim Zum
1990, acrylic, emulsion, crayon,
shellac, ashes, and canvas on lead
380.3 × 560.1 (149 ¾ × 220 ½)
Gift of the Collectors Committee
1990.82.1